GALLERY GOING

GALLERY GOING
FOUR SEASONS IN THE ART WORLD

J E D P E R L

HARCOURT BRACE JOVANOVICH, PUBLISHERS

San Diego ▪ New York ▪ London

Library of Congress Cataloging-in-Publication Data
Perl, Jed.
 Gallery going/Jed Perl.—1st ed.
 p. cm.
 Includes index.
 1. Art, Modern—19th century—Exhibitions. 2. Art, Modern—20th century—
Exhibitions. 3. Photography, Artistic—Exhibitions. 4. Art galleries, Commercial—
Exhibitions. 5. Art museums—Exhibitions. 6. Art criticism—History—20th century.
 I. Title.
ISBN 0-15-134260-1
N6447.P38 1991 90-46407
709'.04'0074—dc20

Designed by Lydia D'moch

Printed in the United States of America

First edition
ABCDE

To my son, Nathan

CONTENTS

Illustrations follow page 228.

ACKNOWLEDGMENTS

New York, with its grid of streets running north and south, east and west, is a game board on which careers are played through to their various ends. And if the stakes are very high, it is all the more important to remember that the players are individuals, with their particular personalities and feelings. One's taste evolves amidst the hullabaloo; anyone who claims perfect detachment is too detached to respond. I rarely meet a non-artist who understands as much about art as some of the artists I know. As I see it, the critic just clears away a bit of the underbrush that has been left along a path that the artists forge as they move ahead. When the critic is in his glory days, he's just a step behind the artists, and the artists are doing the unimaginable. Without the artists, I could never have imagined a history of art since World War II other than the arid accounts in the standard texts.

One that I could not write about here (after eighteen years of marriage, criticism becomes memoir) is Deborah Rosenthal, who has provided me—and many of her students and fellow artists—with an answer to the question: "What does a tradition-conscious abstract art look like today?" What I have written about Klee, Masson, Constructivism, and abstract art in general is as indebted to Deborah's evolving reconsideration of classic European abstraction as what I've written about representation is indebted to the ideas of Gabriel Laderman, Leland Bell, and David Carbone (whom I reviewed in the season before this book begins).

The music and dance critic David Daniel is another person whose ideas have helped me shape these pages. For me the city would be a poorer place without our phone conversations about the artist and the audience, tradition and innovation, liberalism and conservatism, the

nature of classicism—conversations that are interrupted only when David and I put down the receivers to try to get something done. "Pressing on," David calls it. It's been a particular joy of the past few years to be vis-à-vis David in the pages of *Vogue*.

I'd been writing criticism of one sort or another for a decade when Hilton Kramer opened the pages of the *New Criterion* to me, and I am forever in his debt for his unstinting support and for his letting me do it my way. Our disagreements about politics, large and largely unspoken as they are, have in the circumstances been outweighed by our shared passion for a straight-talking criticism, a criticism oriented to the experience of the eye.

The painter, sculptor, and photographer Alexander Liberman, in his capacity as editorial director of Condé Nast, has for years insisted that serious criticism can appeal to a wide audience. (As an adolescent, I had pored over Liberman's magical book, *The Artist in His Studio*, never imagining that we would one day be friends . . .) I am grateful to both Liberman and Anna Wintour, editor in chief of *Vogue*, for the place they have given me at *Vogue*.

Others who've given invaluable assistance include: Erich Eichman, the former (and much missed) managing editor of the *New Criterion*; Chris Carduff, now the magazine's assistant managing editor; Michael Boodro, features editor at *Vogue*; Amy Gross, who was features editor at *Vogue* when I first came there; Leon Wieseltier, literary editor of the *New Republic*; Jeff Schaire, editor of *Art and Antiques*; and William Phillips and Edith Kurzweil, the editor and executive editor of *Partisan Review*. Cork Smith, at Harcourt Brace Jovanovich, is the dream editor they told me did not exist. Marianna Lee, managing editor at HBJ, has been magnificent. And Susan Bergholz remains, as ever, that agent extraordinaire.

All the essays have been somewhat revised since publication, with the idea of clarifying my original impressions rather than altering or second-guessing them. The essays first appeared in the *New Criterion*, with the following exceptions. "Letter from Paris: Whose Century Was It, Anyway?," "Working Stella," "King of Dropouts," "Yup Pups Love Babar," "Being Balthus," and "Falling Out of Love with Photography" appeared in the *New Republic*. "Avida Dollars" and "Seeing Mapplethorpe" were published in *Partisan Review*; "Paradise Now" in *Vogue*;

"Notes on Art and Politics" in the *Journal of Art*; and "That Was the Season That Was" in *Salmagundi*. In a number of cases, the titles here differ from those under which the pieces initially appeared. The date at the end of each piece indicates original publication.

INTRODUCTION:
THE HI-TECH AND
THE HANDMADE

In the 1980s the art world grew by leaps and bounds. The expansion was unruly and precipitous and multilayered, with styles appearing and disappearing in a matter of a couple of years. Artists who loomed large in one part of this behemoth of an art world were unknown in other parts. Depending on one's vantage point, the scene could look like paradise, the beginning of the end, or business as usual. This art world was a spectacle all right, but the spectacular nature of the scene had the effect of obscuring as much contemporary art as it brought to the fore. If one wanted to see contemporary art, one had to go directly to the work in the galleries. And while the scale of the scene increased geometrically, gallery going remained an antediluvian activity, a matter of pounding pavements, waiting for elevators, climbing stairs.

How one chose to make sense of this tumultuous time was, at bottom, a question of aesthetics: at a particular moment, one would probably like the scene as much as one liked the art that the scene brought to the fore. Yet in the art world the social and economic pressures had become so intense that aesthetic matters had a way of drifting—or being shoved—into the background. Some of the people who had a hunger for painting and sculpture simply stopped looking at new work. They were overwhelmed; they didn't know where to look. The size of the art scene had expanded so dramatically—and so much of the expansion added so little to the general level of quality—that while there was certainly as much good work being done in the 1980s as there had been in the 1950s, it was now impossible for any but the most assiduous gallery-goer to pick out the artists who were really working along, pursuing personal views. What kept impinging on one's consciousness were the through-the-roof auction prices and the supermarket-size gal-

leries that were opening in New York City's SoHo. These developments told us that contemporary painting and sculpture had become liquid assets in a go-go economic atmosphere. The art world was hot; and Hollywood movies used the art scene, often represented by galleries full of photographic or photo-related work, as a backdrop that was glamorously hi-tech.

Much of what one saw in the galleries was slick and impersonal; it looked robotized, vacuum-sealed. The art of the 1980s was full of machine-tooled surfaces, of photo-related and advertising-related imagery. This was work that often set out to critique the technocracy, but in the technocracy's own terms. The hi-tech stuff impressed many gallery-goers: it reflected an artist's sense of ease with the ways of the world; it told the audience that artists were keeping up. And it garnered a lot of prestige, because it fit so neatly into the hi-tech fantasy world that was featured on the life-style pages of the newspapers and magazines. The argument for hi-tech art was very simple: if art is to survive, it will have to adjust itself to a changing world. Many people felt that a technologically minded society could only see itself reflected in a technologically minded art.

But the hi-tech art that we saw in the 1970s and 1980s could also serve to underscore the value of older, artisanal traditions. What besides a painting or a sculpture, after all, was still handmade, the product of a solitary individual? A gallery-goer whose senses had been dulled by all the hi-tech work could almost always be revived by an artist who knew how to make something happen with a brush. The controlled hedonism of Joan Mitchell's work looked better and better as the decade went on. There was such nervous yet easy-flowing power in Mitchell's semiabstract landscapes. Brushwork doesn't have to be loose to be effective; but in the second half of the 1980s more and more of the significant work was loosely brushed, perhaps because this was the most natural way imaginable to express one's sense of alienation from the hi-tech.

What we want are artists who know how to shape the medium into a compelling imaginary world. We want the basic materials—paint and canvas, clay, stone, plaster, wood, metal—to come together in new, unexpected ways. And there's nothing quite like going to the galleries

and seeing this process at work in our own time. The artist is taking us around a corner, showing us something we've never seen before. And much of the excitement has to do with the turning of the old materials to new ends. There's a going into the materials to find the means to invent the world, and a coming out of the materials with the elements that add up to the world.

Nowhere but in painting and sculpture is an imaginary world bodied forth in the artist's autograph. A painter or sculptor makes things by hand, and this distinguishes the visual artist from the author (whose world comes to us in a printed book) and the composer (who speaks through musicians) and the choreographer (who uses dancers). It's the sense in which paintings and sculptures are made by hand that gives them their special magic. Even in cases where the autograph is under-played—Ingres in his porcelain-smooth portraits, Picasso in the sculp-tures that he assembled from found objects—we're drawn into the particular drama of a made thing.

Looking at a marvelous work of art, a viewer has the sense that even the most highly articulated forms are in danger of falling back into inchoate form. The miracle of formal resolution cannot be separated from our sense of the irresolution that surrounds us in the world. Ingres's smooth surfaces are taut with emotion; their very coolness suggests the *effort* that it takes to achieve an egoless brush. In contemporary art, there's a particular pleasure to be found in the handmade object that risks impersonality—that risks being mistaken for something hi-tech. Trevor Winkfield takes precisely this risk in his comic paintings, with their flat surfaces and crisp silhouettes and wackily cobbled together figures. When I spoke with Winkfield about his paintings, he told me that he'd known reproductions and advertisements long before he ever saw a painting. His paintings are about the deep feelings that one can have for mechanical images; but he expresses his feeling for mechanical things in an antimechanical way. His surfaces are warmly impersonal; they present impersonality as a human value.

When the work of art reaches the gallery, the artist must stand aside; but a work of art cannot succeed unless the artist's sensibility is knit into the facture of the work. There are a great many ways for the artist to use his hand: "good drawing" is too limited and academic an idea, an idea that will not explain, to give but one example, the brilliance of

Mondrian's hand in his Neoplastic paintings. The point is that what the artist's hand constructs, the viewer's eye reconstructs: it's the eye's response to the aliveness of the surface that gives the visual arts their quality of potentiality, of becoming. This was even true in premodern times, when masters had their students and assistants do part of the work. In those periods it was possible to assume some generally high level of painting craft, and the hand of the assistant was seen as an extension of the master's hand. Nowadays, terrific brushwork—brushwork that acts on us both emotionally and metaphorically—strikes like a bolt from the blue. We're unprepared for the directness of the artist's hand. The surface of one of Louisa Matthiasdottir's great still lifes—a surface on which the brush composes forms that are at once flat and volumetric, crystalline and opaque—tells us that an individual can still take command.

Looking back on the 1980s, it seems that a widespread obsession with the visual arts was tied into the ambivalence of the technocracy, into the inability of the computer culture to decide whether or not it was nostalgic for its artisanal past. In fashionable lofts all around the world a few new paintings (that the galleries were careful to describe as being in oil on linen: the old techniques resurgent) and a few old patinaed pieces of furniture were set off against vast, neatly engineered white spaces. It was as if the preindustrial world were now something to be presented in quotation marks. (An elegantly renovated SoHo loft is itself a case of the past put in quotation marks.)

The handmade was both very much in fashion and very much out of fashion. There were moments when the idea of paint-on-canvas appeared to be the latest thing: the Neo-Expressionism of the beginning of the decade alluded to the emotions of an older kind of art, while the heavily varnished surfaces that many artists were using at the close of the decade were meant to invoke the craftsmanship of earlier periods. These returns to painting were set in the context of an ongoing preoccupation with machine-tooled surfaces and impersonal materials: the decade-long taste for photo-related work, a revival of Minimalism around 1985. Frequently, the handmade object was presented as a response to the hi-tech, a response that could take the form of parody or nostalgia. But painting and sculpture carried the most conviction when they were

produced by artists who regarded the idea of the handmade without irony and could not imagine returning to it for the simple reason that they could not imagine giving it up. It was not a question of style—abstract or representational, tightly or loosely painted—it was a question of the integrity of the object as a made thing.

In the art press this unabashedly sincere work was sometimes attacked as out-of-it and was more often ignored altogether. Artists who were going deeper into painting or sculpture were perceived as isolating themselves from the public. To be with-it an artist had to be technologically minded, had to present surfaces that were hard, closed, severe. Or else the with-it artist presented brushwork that was hard enough and closed enough to stand up to the hi-tech stuff. In *The Real Life of Sebastian Knight*, Vladimir Nabokov observes that "super-modern things have a queer knack of dating faster than others." Yet it is sometimes very difficult to interest people in the others. The blue-green figures and interiors of John Heliker, a painter who entered his eighties in the 1980s, are so casually and naturally brushed, a viewer can at first mistake the sketchiness for a kind of indecision. Nothing could be further from the truth. When Heliker paints three figures around a piano, or two adolescent boys sunbathing in the buff, he uses his battery of brushstrokes to hold the recollected scene at a precise distance from the viewer. In these ravishing and melancholy Helikers—they're often among his smaller canvases—painterliness suggests an elusive lyricism that we associate with the poetry of Rilke and the prose of Gide.

Public culture, with its immense heterogeneous audience, forces the artist who wants to get a message across to operate in relatively broad terms. And these terms necessitate a rejection of the obsessive, private meditation on high-art traditions—the cultivation of the handmade—that is central to painting and sculpture. Painting and sculpture aren't impossible today; but a certain kind of direct access to culture at large is no longer within their reach. The scale of much contemporary life fits the movie screen and the electronic billboard, not the easel. And so, in order to sustain themselves, artists may have to admit—more than they like—their marginality, their peculiarity in relation to the present.

In Gabriel Laderman's roughly eight-by-eleven-foot painting *The House of Death and Life*, which was first shown at the Robert Schoelkopf

Gallery in March 1986, marginality becomes heroic. This is a psychodrama in a six-room dollhouse, where miniaturized people brood, dispute, and die amid eye-popping burnished copper-orange highlights and shadows of blackish navy blue. In the world of *The House of Death and Life*, a story painting without beginning or end, the very idea of a Western tradition of narrative painting becomes an outsider's desperate—despairing—idea. This painting is a dark mirror held up to the mess of the present.

It happened that the Laderman painting was exhibited at the Robert Schoelkopf Gallery during the same season that Eric Fischl had two shows in New York: a retrospective at the Whitney and a group of new paintings at Mary Boone. Fischl's backyards and bedrooms and overheated atmosphere seemed to refer to the same world of domestic troubles as Laderman's *House of Death and Life*. But it wasn't hard to understand why Fischl, by far the less interesting of the two artists, was also far better known. Fischl is a prime example of the artist who gives us the look of the handmade without its emotional content: his paint surfaces say, "This is paint," but they say no more. His paintings are big, semipornographic tinted photographs. There is this numbing broadness to Fischl's effects: you take in the painting in a flash, you're engaged for a few minutes by the overall look of the thing, but you're not pulled into the specificity of this or that part. And the overallness of the image engenders responses that have more to do with pop sociology than with the exhilaration of art. "There's nothing out of the ordinary, unimagined, in seeing a solitary boy masturbate, as in *Sleepwalker*, 1989," says the critic Donald Kuspit of one of Fischl's paintings. "What else is one to do with one's solitude in America?"

Laderman's painting doesn't hit you all at once. You can't really deduce a message from it; it's too integrated an experience for that. *The House of Death and Life* draws you in; and the very intricacy involved in putting this painting together in your eye and mind echoes the intricacy of the painting process. Based on one of Georges Simenon's Maigret novels, the painting contains six discrete rooms: people contemplate or converse; one person attempts to strangle another; a person lying on the floor (dead? asleep?) has a vision. Laderman's figures—roughly two feet high—are like the figures of the Bunraku puppet theater of Japan: these people are dwarfed in the distorted perspectives of a dream. This artist

is playing off the boxlike space of Duccio's *Maestà* altarpiece in one scene, he's thinking about Mantegna's frantically foreshortened figures in another scene; yet the associations are so private, so jumbled up, as to feel murky, subterranean.

Laderman hangs onto the wreckage of the old naturalistic conventions. As your eyes wander through *The House of Death and Life*, you get caught up in a multiplicity of incidents. You trace the trajectory of two overturned chairs that make a delicately curved, inward-turning path. Or you follow the enormous shadow of a seated figure as it creeps along a floor and climbs halfway up a wall. The elaborate overlappings of shapes and ingenious articulations of space offer to the eye and the mind pleasures of a variety that Eric Fischl probably doesn't even know exists. But Fischl probably wouldn't want these effects, either, because they have a concentrated intricacy that spells inwardness and has nothing to do with Hollywood or Madison Avenue. The force of the Laderman—and perhaps this is true of much of the valuable art being done right now—comes out of the artist's sense of the pressures involved in following the logic of a handmade thing. The inwardness, the self-involvement, gives the work its quality of being out-of-it, naive in the ways of art world politics. But then these are the peculiar conditions under which art goes on right now.

New York remains, for better and for worse, the art capital of the world, the place where all aspects of art—the making of it, but also the promotion and buying and selling of it—go on. Not everything originates in New York; but in spite of all the attention lavished on European developments in the 1980s, developments beyond New York are only as relevant as New York judges them to be. This makes for a situation both exhilarating and oppressive: the sense of empowerment spurs artists on but also produces its own forms of cant and academicism.

While New York cannot claim to rival the range and depth of artistic achievements we know from the great days of Paris, there is no doubt that art life in New York has by now come to rival the Balzacian complexity of Parisian art life a century and more ago. One has only to look at the prints of Daumier—at the baffled embittered faces of his artists, the sneering curiosity of his salon-goers, the officiousness of his critics—to see a world much like our own. On one side is the hungry

audience, jostling for a place, shooting off wisecracks; on the other side are the paintings, mute in their frames, looking very much up against the wall. The modern system of galleries and museums is supposed to play a mediating role in this unequal confrontation; unfortunately, it rarely does. If the feeding-frenzy atmosphere in Daumier's salon offers any consolation, it may be that the feeding frenzy that so many of us see in the contemporary scene is by no means a new thing. In New York today (as in the Paris of Daumier) the audience has become a subject: critics analyze its appetites and prejudices; and sometimes, when the audience pays top dollar at the auctions or converges on a new gallery neighborhood, the story of the audience eclipses any story that the art has to tell.

We hear too much about the public's relation to contemporary art. Often it seems as if the essential question is no longer one of style or quality but what needs are served by a particular style or quality. These are by no means uninteresting questions; but they are now insisted upon to such an extent that they have become insidious, obfuscating questions. The discussions about the place of political issues within the museums, about the rival claims of public funding and freedom of speech, about the relation of egalitarianism to excellence and of excellence to aesthetics and of aesthetics to politics—these discussions aren't pursued on their merits so much as in order to aggrandize the role of the public. We're being told that art cannot have any distance from our technologically oriented world, that no handmade masterpiece is worth so much as a billboard, that the next masterpiece will *be* a billboard.

The commodification of culture, the death of the original: these are themes that engage the museum director who manages a multimillion-dollar budget, the critic who explicates the artist's rejection of the hand-made, and the artist who embraces the hi-tech in the first place. For the museum director, the original dies amidst the audio tours and gift shops. For the critic, art exists only in relation to the attention of the audience, which would probably rather be at the movies anyway. For the artist, the question is how to please this audience that knows only the movies and the advertisements. Can there be any wonder why, by the middle of the eighties, the art that critiqued the commodification of art had become the latest in deluxe commodities?

Yet one would not, even if it were possible, want to wish away the

social pressures under which art goes on—the pomp and peril of it all. It is in the nature of the enterprise that is art that personal fortunes come to be knit up with the larger movements of the art world. (This could be a definition of cosmopolitanism.) In the metropolis—Paris then, New York now—the way in which an artist succeeds or fails has its part to play in the culture at large. Though not sentimentally so: some failures are personal and, as Daumier understood, can be blamed on others only at the risk of an unseemly vanity. Nevertheless, in the most exciting contemporary art, a private discovery becomes a public discovery, and the artist's hand—our record of discovery—is pointing the way for all of us.

In the spring of 1984 *Gersaint's Shopsign*, Watteau's masterpiece in which the art market becomes a subject for art, arrived at the National Gallery in Washington, D.C., as part of the first-ever retrospective of the early eighteenth-century master. In the couple of months that the painting was in the United States—mostly in Washington, then briefly at the Metropolitan Museum in New York City—the *Shopsign* caught artists and critics up in its magically informal atmosphere. This long, horizontal composition, which represents the goings-on in an early-eighteenth-century antique and art shop, had started life as a sign above the shop of Watteau's dealer, Gersaint. Appearing in the United States for the first time in the midst of the art-and-commerce-besotted 1980s, it couldn't help but suggest to some a Mozartean apotheosis of a Pop Art sensibility. Here was a billboard that really was a work of art. Here was a big painting set in a contemporary art gallery, a painting in which elegantly dressed people talked about painting, and looked at paintings and at one another, and, maybe, fell in love. The *Shopsign* was the ultimate afternoon-in-SoHo painting: no wonder people went and looked at that Watteau and said, "This is our life." And, as one thought about the *Shopsign*, the parallels multiplied.

Watteau's people lived in a period of transition; their fashionable world had turned away from the formal geometries of Versailles, with its strict, deep perspectives. At the left-hand side of the *Shopsign*, in one of the great, casual incursions of history into art, a portrait of Louis XIV, whose recent death had signaled the end of a whole courtly Baroque world, is being packed away in a crate. His courtiers had gone

in search of adventure in the new, more informal life of the town. These figures were witnessing the afterlife of the courtly Baroque; and who could doubt that in New York in the 1980s we were witnessing the afterlife of the capitalist Baroque—of the age when the modern art museums canonized the values of the modern movement and achieved their own overwhelming power? But in the canonization process, the handmade turned into the hi-tech. Frank Stella, our impresario of the hi-tech Baroque, held sway as court painter. His court was the Museum of Modern Art, which gave him enormous retrospectives, and the lobbies of corporate headquarters, which he filled with his overscaled wall reliefs.

The hi-tech is the academy of the present. Like all artistic ortho-doxies, it can be undone only by the artist's absolute confidence in the autograph as metaphor. Watteau, in his rapidly brushed *Shopsign*, sig-nifies the collapse of orthodoxies: when the Academy admitted him, it had to create a category just for him. Watteau emerged, in the middle of the 1980s, as a hero of the handmade. His art is improvisational yet complete: the first glint of inspiration is still alive in the painting's final form. By the second half of the 1980s, Watteau's appeal ran so deep that even David Salle, a parodist of the handmade if ever there was one, felt the need to co-opt Watteau by appropriating some of his imagery. But the autograph can never be appropriated. Watteau uses his brush to anatomize Gersaint's little art shop, the shop in which we recognize the granddaddy of all the galleries and auction houses of today. At the very moment when Watteau's brush is working its most sophisticated wonders, it is also collapsing a modern civilization back into a primal world of form. The *Shopsign* is a triumph of art culture over commercial culture. At the National Gallery, we experienced this triumph viscer-ally, painted inch by painted inch. And in the 1980s there was no triumph that we more desperately needed to believe in.

FIRST SEASON: 1986–1987

A CASE OF
RETRO MADNESS

Imagine the visual culture of the past four decades—everything from comic strips and psychedelic posters to Abstract Expressionist classics—gathered into one big sloppy playpen, and you have some idea of the jumble from which the young American painter Carroll Dunham pieces together his abstract paintings. Dunham can't get his scrapbook-style paintings to cohere, but he has more gut pictorial sense than most of the other artists who are wrapped up in the retro-this-and-neo-that craziness of the past few years. Dunham, who was born in 1949 and has had two one-man shows at Baskerville & Watson (the most recent was last spring), picks and chooses amidst the image bank of post-World War II America with a dandy's sense of style. Who but a dandy would paint on thin sheets of wood veneer, as Dunham invariably does? This artist is a connoisseur of materials: he likes to combine paint, powdered pigments, and lots of different graphic media. The paintings have the light, vibrant color of fifties moderne. Dunham seems to want to get lost in his flights of fancy, and he certainly knows how to embroider a surface. As compositions, the paintings are limp—they hardly exist—and yet there's an unusual intensity to some of the bits and pieces.

If there's any single impulse dominating the art and fashion world today, it's retro madness. Retro is about remembering; it's prepackaged nostalgia. But the pose is street-smart, canny, never sentimental, and the images tend to be raucous, flashbulb bright, rather than mist-shrouded or sepia-toned. Retro, of which Dunham's paintings are a super-sophisticated, abstract version, is a game of period-style free association that both artists and gallery-goers can play.

What beguiles people about the retro style—and what wreaks chaos on our attempts to disentangle the stuff—is the multitextured hash that painters and sculptors are making of the recent past. These artists don't seem to have an attitude toward their sources—but they definitely have *attitude*. They're wallowing in the junk shop of postwar style the way the people who made the recent movie musical *Absolute Beginners* were wallowing in a mix of 1950s and 1960s urban youth styles. And as in that movie, in the work of an artist like Carroll Dunham you feel enormous energy being expended helter-skelter and to too little ultimate effect.

What immediately catches you in Carroll Dunham's paintings are the surfaces of wood veneer. The veneer—which is both natural (it comes from trees) and artificial (the stuff of fine furniture, such as the Danish modern of our youth)—sets the stage for Dunham's ironic style. Most of the paintings (they range from four to seven feet high and are usually vertical) are subdivided into a few rectangular areas, each consisting of a separate piece of veneer. These pieces are often of different woods and thus have different colors and grains. (The wood lends to the paintings a warm, tawny hue.) Dunham likes to set a sheet of veneer with a dark, whorly look against a sheet with a pale, looser grain, and in some paintings the differently toned veneers create a big pattern of rectangles to which everything else in the painting is related. Most of the best incidents in Dunham's paintings involve his playing around with the grain in the veneer. He likes the organic flow of the patterns, which he picks out in pencil or paint, turning the natural into the artificial. (He uses paint on veneer the way actors use makeup on their faces.) Dunham will outline a group of roughly circular forms in pencil; or he'll use a section of grain as if it were a paint-by-number game and fill in the whorls with super-artificial Day-Glo tones of purple and orange and yellow. In the veneer Dunham looks for the kind of rough-edged Surrealist forms we see in Kurt Seligmann's paintings, and for the melting, Jugendstil shapes of 1960s acid-dream posters. Whether consciously or unconsciously, he is exploring the mystery of style in nature—the mystery, for example, of how a plant can look "medieval" or "Art Nouveau."

Dunham's wood-grain meditations are flat, surfacey, anti-illusionistic. Some of the other elements that he doodles on the veneer—such

as passages of scribbly drawing in pencil or pen, or opaque, cartoony phallus- and cloud-forms—have a more ambiguous, 3-D quality. One never feels sure why Dunham has put a particular event in a particular place; the thinly painted or lightly scratched forms and the more opaquely treated ones could come from different galaxies. This isn't a case of sloppiness. Dunham's paintings are worked on over a long period of time (he apparently regards each painting as a notebook page to be returned to when the spirit moves him), and they carry, often right in the middle of the space, an inscription such as "Dec 1984–May 1985." In one painting he'll have, in addition to the wood-grain routines, some chicken scratchings that recall Cy Twombly; a big, dark-toned penis shape; some globs of bright, smudged color; a fragment of Matta-like architecture in black ink; and a little hurricane of brilliant-colored Os that fall through the painting like a confetti shower at a TV sit-com wedding. If the incidents seem unrelated, it's probably because they aren't related in any conscious way. To the limited extent that the events do hang together, the glue is in the sensibility, in the taste for variety, for keeping oneself amused.

Dunham's paintings keep bringing to mind the work of Cy Twombly. If you think Twombly is a master, then you may think Dunham is a little master or a developing master. But I'm underwhelmed by Twombly's scrabbly form of elegance—it just looks like bad drawing to me—and as a draftsman Dunham seems, like Twombly, overly impressed with every squiggle produced by his hand. (The washy drawings that Dunham exhibited at both Baskerville & Watson and Jeffrey Hoffeld and Company last spring are maddeningly uncomposed.) When Dunham offers doodling as draftsmanship, one doesn't get the sense he can do it any other way. His studied informality—in drawing, in composition—doesn't seem to have developed in reaction to anything. His compositions flout every law of unity and coherence, yet they aren't acts of rebellion. These are paintings you take in slowly; but their tongue-in-cheek effects don't build. They're ambience paintings—and you stick with them only so long as you're willing to linger in the everything's-a-game milieu. Dunham takes the past too seriously as style and not seriously enough as art. When he invokes Matta or Twombly or Hofmann, it's not so much as painters but as art-world icons—as symbols of a new, East-Village-style pop nostalgia. By now modern art

is so thoroughly assimilated in the mass-culture image bank that many younger artists think it's just another side of retro pop.

I've been emphasizing the lightness of retro style, but there's also a dark, ominous, almost pathological side to the retro craze. Ultimately we're discouraged—and turned off—by artists who frame their every feeling in terms of some outmoded style. One could say of Carroll Dunham's paintings, as Pauline Kael said of the French director Jean-Jacques Beineix's second movie, *The Moon in the Gutter*, "his material is so far removed from actual experience (and is so familiar) that it can't support the weight of his emotions." (In tone Dunham's paintings are halfway between the blue-tinted, punk-in-Paris dreaminess of Beineix's first movie, *Diva*, and the dissociated, overbearing stylization of his second.) Retro style is enjoyable enough when one encounters it on the street—in clothes, in advertisements, in "home furnishings"—but when it gets into the galleries and museums, the retro giggle has a way of turning into a retro grimace. As a high-art style, retro has a stale, slightly sordid flavor. It's rather a surprise that Americans—who tend to like their art fresh—should have taken to retro. (Maybe the old American taste for Gothic creepiness—as in Ivan Albright—is coming to the fore again.) But it's certainly no surprise that some of retro's most typical high-art products, such as the paintings of Sigmar Polke, originate in the Old World. Polke, the German whose name we were hearing flashed across the Atlantic from this summer's Venice Biennale, has a yeasty, desiccated view of the pop past that seems perfectly attuned to the I've-seen-it-all-before spirit of the day. Over the summer the Modern had a painting of his hanging in its contemporary gallery. Polke's *Mao* (which dates from 1972 and was acquired by MoMA four years ago) offers a portrait of the Chairman and some tacky Chinese figures painted on a surface collaged out of several different cotton fabrics. It's as dumb as those Andy Warhol Maos. It's an Andy Warhol that's been beaten black-and-blue and dumped in the East River to rot for a couple of years. Pop becomes Retro Pop.

The obsession with the styles of a decade ago or of a generation or two ago that floods through Polke's paintings—and through Dunham's, too—has a pedantic and also a slightly silly aspect. Polke—who was born in 1941 and began painting in the 1960s—comes to his Pop Art

consciousness at something like first-hand; by now he's a world-weary old master of the genre. What one wonders about a younger artist like Carroll Dunham (whose work has a likable brightness) is whether his taste has drawn him to the styles of the not-too-distant past, or if he's simply nostalgic about the idea of taste—any taste. When Dunham does an Abstract Expressionist routine, I wonder if he's trying to recapture *their* energy or just fantasizing about the funky fifties on Tenth Street. Retro chic is a very mixed-up business. At some level, painting has to feel authentic, and Dunham's saving grace may be that he knows this instinctively. Even as his nose for style is carrying him into the connoisseurship of artificiality, his painter's eye is bringing out a bit of the pure visual poetry of a walk down Kitsch Memory Lane. Possibly an abstract painter, because he can't use the crutch of immediately legible figurative references, has more of a shot at transforming retro chic into something that can stand on its own.

Still, there's a fundamental connection between what Dunham is doing and the work of artists like Sigmar Polke and the Americans Robert Longo and David Salle. (Salle included Dunham in a show he organized at the Donald Young Gallery in Chicago last May.) Like the others, Dunham is a sort of collagist, connecting autonomous elements to achieve a cool, layered effect. Whether they know it or not, David Salle (whose recent copies of Géricault's severed heads are bad painting without the quotation marks) and Robert Longo (whose new *Steel Angels* series ought to be dumped in the same trash bin where MTV is headed) traffic in incoherence because it passes more easily than their other option, which is failed coherence. But with Dunham, whose incidents have a real flavor, it's discouraging that the pieces are so insistently unconnected. Dunham may be doing exactly what he wants to do. In order to make a painting cohere, he'd have to reduce the number of variegated incidents that he stuck together in one piece—and this is probably something he's unwilling to attempt, since the atmosphere would immediately become less flighty. What I'd call a more coherent painting might well strike Dunham as a safer painting. He may not know how to achieve closure, but he also may not want to know.

What takes the place of closure in Dunham—as in Polke, Salle, and Longo—is an antipainting, guerrilla state of mind. Half the time, Dunham is building something we take in with our eyes; the other half of

the time, he's ripping it to shreds by the way he treats each part as a detachable gesture, a statement about some aspect of the past. The self-consciousness of the process—the overload of different materials—pushes us away. There's something corrosive about the ironist's stance that says everything is a gesture and the buck never ever stops. Dunham's unwillingness to let the pieces go together leaves us feeling out of sorts; he seems at war with himself. He's unwilling to believe in a painting as a world with its own internal logic. There's no spaciousness to his vision because he won't work out the relations between the parts. What he ends up with is a spacey painting, a work in which the pieces yank around, ricocheting off one another without rhyme or reason. However long Dunham may work on his paintings, they look unedited, unrevised. Dunham lets his ego show overly much. He loves to tell us what a knowing, retro-conscious New Yorker he is. You leave Carroll Dunham's shows with too strong an impression of the artist and not enough of an impression of the art.

October 1986

PICASSO'S SKETCHBOOKS

From art we want both quality and qualities. *Quality* depends on the harmony of the work as a whole; it results from the artist's overcoming of the personal, from his absorption in the disinterested (but also fluid) laws of a medium. *Qualities* are precisely personal; they're the products of a particular intelligence and sensibility as it makes its unique response to the blaze of everyday life. Art is propelled forward by a healthy rivalry between the two Qs.

Modern art has been said to favor quality over qualities; as a theory, "modernism" certainly does. And yet Picasso, who died thirteen years ago, now engages us especially through the proliferation of his qualities. One had always known of the ponderous neoclassical figure style of the early 1920s; of the swirly, psychedelic-colored Marie-Thérèses of the early 1930s. But how many of us, before the Museum of Modern Art retrospective in 1980 and the opening of the Musée Picasso in 1985, had been prepared for the fullness of these periods, for their elaboration of qualities? If 1900–1925 has been, for two generations, the essential quarter century of Picasso's career, we may now feel that 1915–1940— from Synthetic Cubism to Dora Maar—is the quarter century we want to look at the most. It's the period when the onslaught of qualities puts quality on the defensive.

Picasso's sketchbooks have only just come into public view, and they reveal the artist as (if possible) more than ever an inventor of new qualities. At the magnificent show of sketchbooks mounted by the Pace Gallery in New York this past summer (it's now on tour), one could feel humbled by the extraordinary bulk of the material. The plenitude of the sketchbooks—there are, apparently, 175 separate ones—introduces a whole new dimension into the already overfull career. The Pace

Gallery gave the show a clever title: "Je suis le cahier," a phrase which is inscribed on the cover of a notebook from 1906–7. But a cleverer title would have been: "Just when you thought you'd seen all of Picasso: The Sketchbooks." In time, one's initial unease gave way to something like relief: these crowded notebooks, with their many different formats, are a kind of confession, a testament to the plain hard work of the artist's life—to the trial and error, the false starts, the repetitions. These drawings occasionally achieve the grandeur that comes with taking the ultimate risk; they more often have the interest born of a willingness to make mistakes, to try something different ways.

A sketchbook seems to have been, for Picasso, the plotting out of a world. The sketchbooks from around 1900 describe a crowded scene based in equal parts on direct observation and the art of Steinlen and Toulouse-Lautrec. The figures take nervous, *fin-de-siècle* poses, which are softened by Picasso's black crayon lines. These singers, dancers, waiters, and bohemians pass their nights in the blurred atmosphere of cheap cabarets and their mornings in rooms where the wallpaper has probably gone gray from neglect. A half-decade later, in the *Saltimbanques Sketchbook* of 1905, the light has cleared. We are on the fringes of the circus, amidst the slender young men, pretty girls, fat jesters, lascivious nudes. In the *Demoiselles Sketchbook* of 1907, civilization has back-tracked to a forest of anonymous African goddesses, who practice a ritualistic form of dance that mainly consists of raising and lowering their monumental arms. And on and on: the sketchbooks take us through magic shows where cardboard clowns do disappearing acts amidst a polka-dot decor; an Olympus of blank-eyed Grecian goddesses and forty-pound babies; surreal beach-party shenanigans; wartime psycho-hysteria; pulchritudinous bobby-soxers; and, finally, in the 1960s, the somewhat impersonal couplings of pornographic bedroom farce.

Though the sketchbooks contain great individual sheets, their mood is essentially discursive. One might have expected the sketchbooks to underline the commonly held view of the post-Cubist Picasso as an idea man whose natural medium was drawing. (As the story goes, Picasso hardly cared what colors he used when he painted.) In fact, the sketchbooks give the opposite impression: they show us that Picasso's ideas found their fulfillment in oil paint. Nowhere at Pace was this so clear as in a 1922 drawing of an enormous, dewy-eyed mother and her equally

massive boy child. This dazzlingly virtuosic confection of spun silver tones is awash in neoclassic nostalgia—for Raphael, for Prud'hon. The monumental scale and treelike limbs of the figures (they swallow up the page) are somehow undercut by the technique; the draftsmanship is brilliant, but in a nineteenth-century academic sort of way. One misses the weight of oil paint, the density of surface which gives to the stylistically related *Large Bather* (in the Guillaume Collection; c. 1921–22) and *Pipes of Pan* (in the Musée Picasso; 1923) their peculiar modern force. At Pace the open-endedness of the sketches, with their almost nervous pursuit of contradictory effects, brought the profundity of the oils into ever higher relief.

Last winter, a sketchbook Picasso took with him to the beach at Dinard in Brittany in 1928 was the subject of a separate exhibition at William Beadleston Fine Art. The Beadleston show (which passed without receiving the attention it deserved) included all the sheets from the Dinard album (it has been disbound) as well as related paintings and sculptures, and gave an in-depth view of the sketcher at work. At Beadleston one saw a long, unwinding sequence of pages—a cinematographic effect. In one series of six drawings a woman tossing a ball is taken through a steeplechase of kaleidoscope variations; her body keeps resolving into new configurations, ever more surprising. This wild erotic fantasy is carried out with cold mathematical logic, as if Picasso were seeing exactly how many transformations he could wreak on a single female theme. It was particularly interesting at Beadleston to see a 1928–29 wire sculpture (which Picasso suggested as a monument to Apollinaire) surrounded by a series of preparatory drawings from the sketchbook. These drawings are meditations on the third dimension; they aren't just flat things, but are mappings of alternative courses through space, of routes going in various directions. Thoughts about form-in-space appear all through the sketchbooks: from the six separate studies that circle around the same seated boy in the *Saltimbanques* book of 1905 to the series of views of a woman's head, with the nose twisted every which way, in a 1964 book that happened to be the final work included in the Pace show. At Beadleston the suggestiveness of the sketchbooks—of, for example, a series of figurelike abstractions constructed of bone- and stone-shaped volumes—spilled over into the full-bodied emotion of

the sculptures and paintings. Against the modernist idea of the artist as absorbed with an immediate response to his materials, the sketchbooks offer *invention*.

Taken one by one, the books have about them an intimacy we rarely associate with the dimensions of Picasso's career. There are tiny notebooks: one from 1924 contains little still lifes in pencil and pastel that can only be described as adorable. All through the Pace show one was conscious of the pleasure to be derived from different formats and different types of paper. When Picasso sat down to invent the world, it was at a table well stocked with fine materials. The great pile of books—nearly three-quarters of a century worth—reveals Picasso as before all else a dedicated craftsman. This dedication is related to a training in traditional methods and a knowledge of the proper use of materials. The sketchbooks convey a comfortableness that grows out of loyalty, fondness, habit.

The Picasso of the sketchbooks can be a bit stuffy, overly preoccupied with showing off a command of the tools of the trade. Indeed, he may at times fail not through an excess of casualness, but through an excess of craft—by a too great insistence that everything be gotten down on paper, be made concrete. In 1960 as much as in 1900, he was the meticulous practitioner—trying the head a bit to the left, a bit to the right, from this angle, from that angle. The paintings that Picasso finished in a few hours, in a day, were the result of a long, apparently arduous preparation—the sketchbooks testify to this. Picasso's vision was, it turns out, learned, acquired. Which makes it, really, all the more miraculous.

In 1955, Picasso had this to say about the sixteenth-century German painter Albrecht Altdorfer: "I've been copying Altdorfer. It's really fine work. There's everything there—a little leaf on the ground, one cracked brick different from the others. There's a picture with a sort of little balcony—the closet, I call it. All the details are integrated. It's beautiful. We lost all that, later on. . . . These things ought to be copied, as they were in the past, but I know no one would understand." This isn't the ordinary voice we associate with Picasso; it's a side of his personality that the sketchbooks—long salted away, now an object of study and admiration—bring to the fore. That these books were hidden is interesting; they constitute a professional secret, a mystery of the trade.

Picasso had, after all, been the son of a teacher in a provincial art school: he'd worked from the casts; gone through (albeit very rapidly) the course of study of an academy; and done a large figure composition to signify the end of his apprenticeship—a deathbed scene, with a nun and a dedicated doctor, for whom his father had been the model. Afterward Picasso took up the bohemian life, left for Paris, and helped to invent the language of a new age; but the hard labor of a fitfully successful father in the dim academic backwaters of *fin-de-siècle* Europe—this was a lesson in the trials of craft that Picasso never forgot.

November 1986

WHAT I SAW
IN SEPTEMBER

On Fifty-seventh Street the male nude may be superseding his female counterpart as an object for casual erotic daydreams in art. Gay culture has its part in this, but the new male eroticism also has a transcultural appeal. Women's bodies no longer work so very well as decor. The public now spends its days dressed in his-and-her business suits and is bored by both the prefeminist view of woman as a tasty morsel in the boudoir and the feminist idea of a woman's body as a battlefield over which the sexual wars are waged. In two September shows—the paintings of Rainer Fetting at Marlborough and the photographs of Bruce Weber at Robert Miller—the male nude had the chic of a newly hatched subject.

Rainer Fetting's *Stunde der Rose* ("Hour of the Rose") shows a dark-haired boy lying in the buff on a couch, a glass of red wine in one hand, a red rose at his feet. In another Fetting a black boy, Desmond, stands with nothing on in a pose that reveals all at once his buttocks, his broad back, and a three-quarter view of his face. These young men also appear in groups, sometimes with women, on the New York tenement roofs and Hudson River piers where Fetting's crowd goes to sunbathe and party; the skyline is always there in the background, an emblem of the city. Fetting handles paint in a rough, casual manner; his abrupt light-into-dark chiaroscuro and straight-from-the-tube colors are reminiscent of the work of the 1950s Bay Area realist David Park. Fetting could have learned to draw from one of those correspondence courses that used to advertise on the covers of matchbooks: he jots down jaws and eye sockets and lips with diagrammatic casualness. His young men are a compendium of cliché attractions—comic-strip good looks, often revised to fit a negroid type. The high arch of a cheekbone and the straight

line of a nose recall the covers of romance novels, only Fetting gives the stereotypes a high-art twist with ideas borrowed from Ernst Kirchner and Edvard Munch.

The dramatic tingle in Fetting's show had something to do with the juxtaposition of an urban setting and the naked boys. The city is a strange, grimy, and garish backdrop for this new democracy of the undressed. Each of these young men—whether he stands bolt upright with his back to us on a Hudson River pier or turns to meet the artist's gaze in the studio—is transformed into a pop saint. Fetting's bust-length self-portrait, bare-chested, in a large hat, reveals him as another young man—one among equals. The boys come from abroad (Fetting is German-born); or from the provinces; or from the ghetto. They may well be Fetting's friends and lovers. But the salient fact is that they've got what Andy Warhol promised, their fifteen minutes of fame, in a once-upon-a-time story in which you undress and become a prince of the city, up there on the walls of the Marlborough Gallery.

Bruce Weber's photographs of young men have none of the headachy, expectant aura that's churned up by Fetting's brushwork; they're all the more the perfect eighties ingenues. In the travelogue world of Weber's recent book, *O Rio de Janeiro* (Knopf), and the accompanying exhibit at the Robert Miller Gallery, young men fill the decorative visual interlude that used to belong to women. Weber's style, which is rather Art Deco and cool and severe in the fashion pages he does for magazines like *GQ* and *Interview*, moves here in the direction of the informal snapshot and the randomly cropped tabloid image. While much of the story in *O Rio de Janeiro* involves the crowds of dark-eyed and dark-haired urchins on the beaches and the partying in local joints and a family of jujitsu wrestling champions, in the quieter moments back in the rooms at the hotel the lighting gets a little dim and what you see, just beyond a chair heaped with clothes or a table with the remains of a meal, is a young man in his brief swim trunks or underpants. Part of the effect of Weber's show, like Fetting's, has to do with the repetitiveness of the types. Not one but many of Weber's young men look like Greek gods. These are heroes for an Age of Mechanical Reproduction. The clonelike proliferation of Weber's blank Adonises and of Fetting's campy night people has a leveling effect.

Seven years ago, when Robert Mapplethorpe hung a series of pho-

tographs of homosexual sadomasochistic sex on the walls of the Robert
Miller Gallery, the pornographic imagination was supposed to give gal-
lery art a good kick in the pants. Pornography is still occasionally ex-
ploited for its shock value in the galleries downtown; but more often of
late there's an attempt to defuse the scandal of pornography and give
the male nude a broad—and commercial—appeal. Mapplethorpe's re-
cent shows have been pretty mild. Another artist who now exhibits at
Miller, Robert Greene, does romantic scenes of Central Park at twilight
in which, among the dog walkers, one encounters the little surprise of
a muscular, scantily dressed guy. The male nude has gone from hard-
core to soft-core in a matter of a couple of years. Stylishness, not sex,
is the ultimate aphrodisiac these days.

A peregrination through the galleries in September left one with
many thoughts, few of which were exactly about works of art. Some-
thing like the portrait of Adolf Hitler by Albert Oehlen, included in
the "What It Is" group show at the Tony Shafrazi Gallery in SoHo,
mostly raised the question of how one ought to respond to the damn
thing. Every reaction was too large or too small to fit this Andy Warhol-
style job, done in primary-school red, yellow, blue, and black. Shafrazi's
show was accompanied by a sixty-page, full-color catalogue, which was
conceived, edited, and designed by the curator of the exhibition, Wil-
fried Dickhoff. The catalogue contains photographic portraits of the
artists and a lot of creative layout work, but leaves one pretty much in
the dark as to what "What It Is" was about. The show's title derives
from an essay by Mayo Thompson which is printed next to a photograph
of Albert Oehlen. (The essay is called "Representation of Representation
of is not as easy as it looks like it looks.") Thompson begins:

> An interesting exchange was heard recently at an "opening" in an
> art gallery:
> Artist 1: Your work is shit.
> Artist 2: It is what it is.

From here Thompson goes on to explain that the phrase " 'It is what
it is' . . . reflects the effect of the hegemony of laissez-faire, pluralist
ideology—here expressed in the form of a classic zen-historicism—in
the productive sphere." (Does this reduce to "anything goes"?) The

particular flatulent stupidity of the entire catalogue and show is best expressed in the "Five questions" offered by the painter Donald Baech-ler, who in his photograph looks to be the age of a college freshman:

1 What are your favorite diseases?
2 Are your paintings answers or questions?
3 How often do you shave?
4 What photographs do you use for masturbation?
5 Are you religious, or in business?

Is Donald Baechler's quiz an example of "laissez-faire, pluralist ideol-ogy"—or of "classic zen-historicism"? Do we care?

The dozens of fall group shows, which are meant to tell us where the art scene is headed, are in fact a murky nightmare in the face of which one's powers of analysis feel cruelly tried. Fall group shows used to be a means by which galleries announced their season's lineup; but now they include more than just the artists to whom a gallery plans to give one-man shows. The goal is to suggest what will happen next, city-wide or even globally—and thereby get a jump on the zeitgeist. The individual artist is an element in an ensemble, and the more-than-the-sum-of-its-parts effect of these shows is underlined by the frequent practice of leaving the artists' names off the walls. The works seem to belong to the galleries rather than to their creators. This arrangement also encourages the carefully cultivated in-sy appeal of so many shows. You're supposed to recognize the work of all these young painters and sculptors without looking up their names on the typed sheet that's sitting at the reception desk. But you can know all the names only if you go to all the exhibits and read all the reviews and generally keep yourself attuned to the very new.

Who goes to see the group shows? Though artists, critics, collectors, and museum people do make the rounds, the shows are probably mounted with art consultants—the galleries' most important paying public—in mind. The consultants (who work free-lance or for corpo-rations) function as a liaison between the art world and the people with the money. Art consultants rationalize tastemaking, so that business and professional people with no immediate link to art can buy into art's prestige. In general consultants don't have strong personal taste; but they read the magazines and carefully watch what the galleries are

pushing, and on the basis of all this they figure out who will be reviewed in *Art in America* and *Artforum* nine months hence. They're the (perhaps) unwitting enemies of all true innovation, because they want art to proceed in a readily predictable fashion. The group shows are a clearing-house of artistic futures; artists earn points on the basis of how many important shows they get into in the course of a season. The galleries must have a kind of unwritten agreement with one other: you give my guy or gal a push, and I'll do the same for yours. The hope is that each gallery will end up with a couple of box-office stars.

This fall we're in a retro glut, and most galleries are slicing off a piece—or a couple of pieces—from the art-historical pie. Some galleries have new artists recycling old styles; others just recycle the old artists. Gary Indiana of the *Village Voice* calls it "Neatly Timed Flashback." In the East Village, Hal Bromm had a show called "Non Objective," which proposed a rerun of 1960s and 1970s Minimalism. One of Don Judd's multicolored metal boxes presided over a room full of objects which were attached to long-established names. One imagined the phone calls to the artists, most of whom have never really left the limelight, all of whom must have been pleased to be invited to exhibit at Avenue A and East Eleventh Street, in the neighborhood where it's at. Around the corner from Bromm, at Jack Shainman, the show was "The New Metaphysical Dream: Seven Italian Painters." The theme here was lost pastorals and collapsing classicism, and all interest focused on the flurry of rising reputations, hopeful initiates in the New York fraternity.

From the evidence of the group shows, Lydia Dona is a comer this year. Her abstractions, which consist of rectangular and circular forms rather ponderously inscribed all over a surface colored geranium red or mustard yellow, are crude cousins of the architectural fantasies of Vieira da Silva. Dona's work recapitulates, without much verve, the formulas of post-World War II European abstraction. Who would ever have dreamed her work would be fashionable in New York in 1986? But then the retro craze can make anything look new. Dona was in the group show at Luhring, Augustine & Hodes, a Fifty-seventh Street gallery that trades in East Village taste right down the hall from André Emmerich. At Luhring, Augustine & Hodes, Dona's work looked like a send-up of traditional abstraction; downtown at Rosa Esman, a gallery which does not go in for camp, there was perhaps an argument being

advanced that Dona was actually a good artist. Esman's show was called "Painting: Abstraction Rediscovered"—to which I say: "?!" The extraordinary badness and thinness of Dona's painting was nothing compared to the achievement of getting into two important autumn shows. But even when the painting itself is somewhat better, as is the case with the abstractions of Willy Heeks, which were also at Esman, the modicum of pleasure to be had from the artist's handling of a gritty paint surface and from the attractive combination of black and yellow ocher seemed irrelevant beside the larger fact that painterly abstraction was once again "in."

To look at painting as painting in these group shows is a labor; the surprise of what's-being-shown-now keeps shifting one's attention to the scorecard, the fashion forecast. The pressure must be exciting career-wise, but it has to be hell for any artist who wants to concentrate on painting or sculpture itself. In Heeks's case (he's in his mid-thirties), what talent the artist has may already have been put too far forward all at once—there's a straining to be liked. For something in the neighborhood of Abstract Expressionism, I prefer Harry Kramer's *Gull II*, which was in the group show at Gruenebaum. The Kramer—a maroon-gray surface which has been churned up all over—might not hold us for very long, but it has the authority of its sensibility. You feel something happening between the artist and the canvas. Some of the best things to be seen in September were at galleries, like Gruenebaum and Bowery, that stand outside the marketing marathon. At Bowery, I admired Temma Bell's trio of tiny, casually brushed apple-green views of upstate New York farmland. Also Barbara Goodstein's *Pietà*, a near-abstract meditation on a late painting by Botticelli, done in the artist's white-plaster-on-black-plywood relief technique. For Goodstein, who reduces figures to the most abbreviated calligraphic signs, the relation between nature and abstraction is apparently tenuous, poignant. There's passion in Goodstein's *Pietà*—but the passion has been tightly controlled, and it's turned melancholy and cool.

The fad for group shows suggests a fading of the cult of personality which peaked only a few years ago with the emergence of Julian Schnabel and David Salle. Today people wonder whether any artist or critic can achieve the authority that figures like de Kooning and Greenberg

achieved a generation ago. The scene now seems to defuse or dissolve the force of anyone with whom it comes into contact. It's hard to take a stand when what's beneath your feet and all around is quicksand. For anyone who says "yes" there's someone who will be glad to say "no" exactly as loud.

What's really new in the past year or two is the collapse of style as a means of self-definition and communal identification for the artist. Membership in the camp of the geometric or painterly or realist painters never assured the quality of one's work, but it used to signify a general attitude on the part of the artist, a sense of one's relation to the past. To say one was working out of Abstract Expressionism or Neoclassicism suggested a value system, a vantage point. You can't assume that anymore, now that style has become something in the nature of party dress, to be put on and taken off at will. It's as likely now that someone who works in an Abstract Expressionist vein is criticizing Abstract Expressionism as connecting with it. The thought that any style can signify anything may, on the face of it, seem exhilarating, but what it really creates is chaos.

Back in the 1970s, when easel painting and medium-sized sculpture were in critical disrepute, the gallery system faced an identity crisis. Fashionable art was either too ephemeral and inexpensive (mail art, photography) or too large and unsalable (earthworks) to be of much use to the well-heeled commercial dealer. In the 1980s, spurred on by economic improvement, the artists, the dealers, and the critics have achieved a new alliance. Ninety percent of the art that's touted today consists of variants on the antiobject—on the work of art that criticizes the idea of art. But these antiobjects are, at the same time, salable gallery objects. This is the main paradox that we confront today. Too much has been made of the distinction between hot and cool styles, between Expressionist painting and Minimalism of the Neo-Geo variety. (Neo-Geo is what geometric abstraction is called when it's exhibited on the Lower East Side.) Tony Shafrazi, whose "What It Is" group show had no stylistic coherence, probably understands more about the collapse of stylistic distinctions than any of the critics. If Mary Boone can sell both a 1960s Minimalist like Artschwager (whom she was showing in October) and an appropriationist like David Salle, we should accept the fact that her clients see as many connections between the two as dif-

ferences. To quote a broadside that was given out at "When Attitude Becomes Form," a show that was right across Mercer Street from Shafrazi at the Bess Cutler Gallery, "The work is a 'questioning object' that may reveal more about the viewer than it does about itself." The art world is (according to Bess Cutler's brochure) "some sort of magnificent, sprawling theme park."

In SoHo the life of the streets—especially during the weekdays, when it's mostly the local residents who are around—has some beauty to it. This is one area of New York where gentrification hasn't yet passed entirely into the hands of the big real-estate wheeler-dealers; you can still enjoy the love that's gone into the freshened-up facades of factory buildings, and appreciate the personal note in the decor of whatever first-generation food stores and galleries remain. At Paula Cooper's Donald Judd show, which opened at the beginning of October, it was cheering to be in the presence of an artist who's attuned to the scale and textures of SoHo—to the open, unadorned loft spaces and the unpretentious yet imaginative use of simple industrial materials. Judd's work always strikes me as pretty empty when I see it in group shows or museums; he's one of those artists who can't sustain his mood in mixed company. But in the exhibition he had at Leo Castelli in 1984, and in his new show at Paula Cooper (an old SoHo gallery which he's just joined), the work takes on an authority that comes from the artist's ties with the life of the community.

Cheap space first attracted artists to SoHo, and the high ceilings, large windows, and long perspectives can provide a serene, euphoric feeling that's very rare in the city. To these spaces artists brought a combination of do-it-yourself ingenuity and less-is-more idealism. A classic SoHo loft is the creation of a philosopher of the lumberyard and hardware store who dreams a bit even as he's scraping and sanding and painting and getting the shower installed. Don Judd's work, with its simple ideas and its surfaces of plywood and metal and concrete and plastic, comes right out of the sessions at the lumberyard and the browsings through the industrial materials catalogues. To the idea that an old factory could be a home, Judd added the idea that a crate of metal or plywood could be a sculpture. You can almost hear the artist, as he waits to be served at the hardware store, saying to himself, "Why

couldn't this be a work of art?" What's impressive about Judd's work is that he makes the transition from factory to gallery without irony and without making us feel that he's overplayed his hand. Don Judd is the Bernini of SoHo: as Bernini's fountains bring together two thousand years of Roman art and history, so Judd's boxes make a little essence of twenty years of life below Houston Street. Judd's work doesn't transcend its moment; but Lord knows there's little enough around that just epitomizes its moment, which Judd's work certainly does. Even the announcement for the Paula Cooper show—a rectangular card with the artist's name spelled out in tall, simple red letters—was in its own way an inspired thing.

December 1986

LETTER FROM PARIS:
WHOSE CENTURY WAS IT, ANYWAY?

The old train stations of Europe, no matter how grimy they may have become, retain a certain romantic aura, and that's probably what the French government was after when it transformed an abandoned station on the Left Bank, the Gare d'Orsay, into a new museum of nineteenth-century art. The Musée d'Orsay, with its elaborate iron and glass construction, is a highly theatrical space; the catwalks and ramps and multiple levels and sweeping views of the city create an effect akin to the great crystal palaces of the nineteenth century. This station, which was designed by Victor Laloux and opened in 1900, has been spruced up, as if it were going to be used as a movie set; and it's also been revamped and accessorized by the postmodern Italian designer Gae Aulenti, so that it has some of the gift-wrapped allure of a boutique or a nightclub. With its deep perspectives and rich details, it shows up beautifully in photographs. The Orsay is a gigantic curiosity, a surefire draw with the tourists. But all of this has the effect of competing with the paintings and sculptures that the museum contains. The age-of-railway metaphor, carrying as it does overtones of arrivals and departures and nostalgia, is all wrong for an art museum, where one wants to experience things in the here and now. At the Orsay you only really get in touch with the art once you've forgotten where the art happens to be hung.

On entering the Orsay, visitors are confronted with a grand alleyway, running from the front to the back of the vaulted central space where the trains once arrived. Everything flows off this main promenade, which Aulenti has designed in a pretentious neo-Egyptian style. This concourse was apparently arranged as a place to relax in between one's visits to the adjacent galleries. It's filled with academic sculpture, much

of it mediocre, which the curators may have seen as neutral, a mild amusement. The effect, though, is to place at the very center of the Orsay an aesthetic vacuum. And all around one sees a tangle of styles—competing, contentious, irreconcilable.

The Orsay is a clever renovation but not an inspired one—it's not comparable to the Musée Picasso, which was fit so snugly, so brilliantly into the seventeenth-century Hôtel Salé in the Marais. At the Orsay several of the old railroad station's reception rooms have been carefully restored, and though they're opulent in a rococo-revival, Third Republic way, they aren't used creatively: they've been filled with the dullest of period paintings and sculptures. Hasn't it occurred to anyone on the staff that if the mirrors in these rooms were covered over they'd make a ravishing space for *great* paintings? I'd love to see the late Renoirs—in which Renoir gives a Third Republic sensibility all the depth and radiance of Titian's Ovidian pastorals—exhibited in these elegant galleries.

The Orsay is the first museum to reflect the enormous upsurge in nineteenth-century studies that has overtaken art history in the past twenty years. Historians have been going through the storerooms and basements of museums and galleries, bringing back into the limelight the generations of academics and *pompiers*—and the many naturalists, too—who were buried in the triumph of modern art. It's all up on the walls of the Orsay—good, bad, atrocious together. Though painting and sculpture take a starring role, the museum also reflects a growing interest in the graphic and decorative arts. The old photographs have been taken out of the albums and portfolios in the libraries; the museum encompasses printmaking, architecture, furniture, design. It's honeycombed with little shows-within-shows: of Whistler's prints, of Atget's and P. H. Emerson's photographs; of the designs for the Opera House and its productions; of the nineteenth-century dictionary craze; of the early history of the movies.

In a way the Orsay is a reprise of all the interesting scholarly shows that have been mounted over the past fifteen years. What's missing is the adventuresome spirit of those years—the sense of discovery that accompanied, for example, the early days of the photography craze, when it seemed every antiquarian bookshop contained photographic rarities that you could pick up for a song. At the Orsay the excitement

of revaluation, and the accompanying shake-up of values, is solemnized. You're not supposed to enjoy the kitsch and the camp—you're supposed to learn something from it.

There's a subtle leveling process at work, too. Ultimately, the subject of the Orsay is the democratization of taste in nineteenth-century Europe. The Industrial Revolution had severed the old aristocratic ties between a cultural elite and a power elite and had eviscerated folk and ethnic traditions. What began to develop in the 1840s was a commercial culture that was neither popular nor elitist, but had elements of both. This new commercial culture dealt in prepackaged images and emotions; it was available to everybody. (Its descendants are the big studio movies and the Hallmark greeting cards.) The Orsay, which basically covers the years 1848 to 1914, describes a crisis of authenticity in nineteenth-century cultural life. For artists, it was join or be damned. Painters and sculptors could either feed bourgeois ambitions with outmoded aristocratic imagery (thus the glitzy revivalism of the second half of the century) or else turn their backs on all hope of vital connection with a consensus of educated taste.

At the Orsay, which includes collections brought together from a number of Parisian museums, the avant-garde from Courbet to Matisse is presented as one among many responses to this culture in crisis. Though Françoise Cachin (the director of the museum) and her curators haven't overturned received opinion on who's great and who's not in the nineteenth century, they have tossed Manet and the rest of the avant-garde back into the historical stew. This is meant to restore the reality of history. But whose reality? It is impossible to be true simultaneously to the academics who thought that Manet was a brilliant young man who never fulfilled his promise and to those who saw him as the most daring artist of his day. While these people lived at the same time— and sometimes knew one another—they were, mentally, worlds apart. The Orsay may be a museum that recaptures the confused hodgepodge that is lived experience. But because the curators at the Orsay are unwilling to make aesthetic judgments, the museum ultimately fails to express the real exhilaration of living in culture in time, which has to do with one's efforts to separate the good from the bad and respond to new forms of beauty when they're really new. A museum where Courbet's *Artist's Studio* (1855) and Couture's *Romans of the Decadence*

(1847) are given something like equal billing can't hold our confidence for long.

The painter Jean Hélion told me that almost everyone he'd spoken to was disappointed with the museum. "Historically it's correct," he said, "but artistically it is not." And in Le débat, Claude Lévi-Strauss said he got a migraine at the Orsay; an art museum, he observed, shouldn't try to teach sociology. The Louvre—which the French quite naturally take as their model for the encyclopedic museum—exhausts in an exhilarating way; it keeps heaping peak experiences on top of one another until we can hardly take it anymore. It's exquisite torture. The Orsay—another encyclopedic museum—has a very different effect. It's as if an extravagant but ill-planned feast has been hurled in our faces.

One of the opening galleries at the Orsay, devoted to Ingres and his circle in the 1840s and 1850s, gives a fair sense of how the museum's eclectic mix of classics, rediscoveries, and kitsch flattens everything out. The two good-sized Ingres here are The Source (1820–56), that iconic image of a standing female nude pouring water from a vase, and The Virgin with the Host (1854), a tondo of the virgin, eyes downcast, in a most pious mood. Along with these are works by Gérôme, including his polished essay in antiquarianism, Young Greeks Watching a Cock Fight (1846); an elegant portrait by Flandrin; and an annunciation by Amaury-Duval, which carries on its frame the inscription "Ecole d'Ingres." While all the work in this room is joined by its clear contours and smooth surfaces, the Ingres are the only paintings with elements of genius. From the candelabra and attendant angels in The Virgin, Ingres generates a dazzling succession of contrapuntal curves; and The Source, though her look is too goody-goody, is a voluptuously rhythmical piece of figure painting. Still, these are Ingres in which the second-rate sentiment isn't ever quite transcended; he's falling into some of the same kinds of clichés as Gérôme. It's interesting to see to what extent Ingres was a part of his age, and even, at certain points, a victim of the age's aesthetic malaise. What's lost at the Orsay, though, is the tension between a great artist's taste and a period's taste. Here the Ingres don't look like failed masterpieces—they're just period pieces. And when you move from the Ingres to Gérôme's Young Greeks, you suddenly feel a new equanimity about Gérôme and his banality—he's just another manufacturer of period

pieces. Ingres, Gérôme, Flandrin, and Amaury-Duval harmonize easily; they're passed off as members of the same close-knit family. And, of course, they are and they are not.

While the galleries at the Orsay devoted to the art of the 1840s and 1850s demonstrate a generally high level of technical accomplishment, the work of the academics of the 1880s and the 1890s looks every bit as bad as reproductions have led us to believe. Cormon's *Cain* (1880), in which a bedraggled band of half-naked savages out of some Road Warrior movie marches across a desert landscape, is too awful—and too enormous—even to be funny; the only rational reaction is to flee. Couture's *Decadence* and Cabanel's *Birth of Venus* have the interest of specimens from the history books—nothing more. Too much of the work on display calls forth at best a measured response—a response that makes it difficult, a moment or two later, to rise to the occasion of a Courbet, a Puvis de Chavannes, a van Gogh.

If the Orsay does offer a fresh insight into nineteenth-century art, it's through the suggestion, perhaps inadvertent, that the emotional decadence of official art had a deleterious effect on the avant-garde. At the Orsay the famous emotional ambiguity of Manet, as well as the neutral tone of the early work of Monet and Pissarro, looks like a defensive reaction to the orgy of false feeling amid which these artists came of age. Courbet and the Barbizon painters had been freer with their feelings. They were the products of an earlier period, the 1840s, when the art establishment was still somewhat isolated from commercial taste. In the 1860s the Salons were beginning to drown in kitsch; feeling—any kind of feeling—seemed dangerous.

By the time that we arrive at the early Impressionists, we've been zapped by schlock, as they probably had been, too. Those first, flat Impressionist paintings of gardens and country roads seem to say, "I'm just going to be direct and simple. Whatever I do, I'm not going to gush." The sentimentality of the potboilers in the Salons gave subject-matter painting a bad reputation among the avant-garde. Manet would start with a complicated narrative idea—and then leave the painting tentative, ambiguous, unfinished. The scientific ambitions of Impressionism are also related to this escape from sentiment. The 1860s and 1870s are an emotional cooling-off period. When emotion and grandeur of conception return to French painting in the 1880s and 1890s—with

Monet's ecstatic coloring, Renoir's dance hall scenes, van Gogh's brushwork, and the classicizing compositions of Seurat and Cézanne—the avant-garde has already gone through a period of purification and consolidation. The avant-garde is no longer afraid of its feelings, or of its longings for the grand styles of times past. A new age has begun.

During the past few years many of us have been bemoaning the resurgence of interest in the academics and the *pompiers*; we've believed that the battles of modernism would have to be fought all over again. But that is probably the wrong way to look at the current situation. The academic painters will never again have the prestige that they had a hundred years ago, and the fringe loonies who are claiming that Bouguereau is as great as Cézanne aren't setting policy at museums like the Orsay, and probably never will.

The biggest mistake that's been made in setting up the Orsay involves the transfer of the great Courbets from the Louvre. At the Louvre the *Burial at Ornans* (1849–50) and the *Artist's Studio*, which are the last of the mammoth nineteenth-century masterpieces, were in the galleries that still hold the Davids, Géricaults, Delacroixs, and Ingres; there was the blissful sense of seeing the dialectic of history as it worked itself through. At the Orsay, Courbet has beautiful natural light, but nothing connects with him. He's a giant, shunted off by himself. At the Orsay the sense of history as a succession of artists interacting with one another is lost. Even Manet is presented without drama. He becomes just another stopover along the way, a detour off that main sculpture promenade.

What's really happened at the Orsay is that the whole idea of believing passionately in one or another kind of art has fallen out of favor. The rule of thumb now isn't how a painting or a sculpture moves a viewer; it's how interesting it is. And art can be interesting aesthetically or historically or psychologically—or just to bounce one's sensibility off of. Tastes aren't changing; the very idea of taste is falling apart. In this respect the Orsay is very much of a piece with the contemporary art scene as a whole. The same taste—or lack thereof—that hangs Cormon's *Cain* on permanent display in an art museum is filling the pages of the art magazines (and the art pages of the *New York Times*) with articles and reviews in which every kind of art is given the same weight, the same attention.

Françoise Cachin and her curators are casting a cold eye on the ideological and aesthetic battles that were once the lifeblood of art. At the Orsay nineteenth-century culture, primarily French, is grist for the scholarly mills. The line between a historian's impartiality and a museum-goer's alienation has become very fine indeed. The view of the century offered at the Orsay is touristic. This is a railroad station that offers dozens of excursions but no destinations. Have the French forgotten that for 150 years, no matter where an artist happened to have been born, coming to Paris equaled coming home?

November 2, 1987

JOTTINGS
ALONG THE WAY

In 1982, the sculptor Anne Truitt published *Daybook*, an informal account of her work and life during a period of seven years, from 1974 through 1980. Truitt, who's now sixty-six years old, described her marriage and her divorce, her three grown kids, her house in the suburbs of Washington, D.C., her money worries, teaching jobs, and days in the studio, where she makes the slender, luxuriantly colored, four-sided columns that have been exhibited at the André Emmerich Gallery in New York and in one-person shows at the Whitney Museum and the Corcoran Gallery in Washington. To judge from *Daybook*, Truitt has led a more conventionally middle-class American life than most artists who have "serious" New York reputations; but then the interest of *Daybook*, which had a *succès d'estime* and meant something special to many artists, lies in Truitt's ability to show us just how strange and serendipitous a conjunction of bits and pieces an artist's life really is. Though Truitt's professional good fortune, much of which stems from the praise of Clement Greenberg, is more than most can ever hope for, her career *is* like many others—a combination of hard work, some deep kind of self-confidence, and a few interventions by the guardian angel.

Truitt has now published a second volume, *Turn* (Viking), which begins with her feelings upon the publication of *Daybook*. In tone it's much like the first book, but the diary entries, which cover a period of about two and a half years, carry a heavier psychological freight, because Truitt's ex-husband, James, has committed suicide. Though they'd been apart for many years, and he'd remarried, the news leaves Truitt unable to work for over a year and sends her into an uneasy period of introspection. The suicide—which she finds totally inexplicable—forces

Truitt to accept how little her present situation resembles that of the woman who married James and entered into what sounds like an intimate marriage, a kind of romantic meeting of minds, so cozy that it got stifling, until somebody had to break out for air. The divorces of Truitt's two daughters, mentioned here and there in *Turn*, echo her own shaken expectations, and Truitt begins to find herself frightened of her own limits—she experiences an anxiety attack while driving through a storm to pick up her son. But there's also a feeling of satisfaction in what she has—her solitude, which she finds she rather enjoys; her grown children and grandchildren, with whom she spends summer vacations and keeps up correspondence; and her work, which brings out into the open images she first sees in her mind's eye and provides a means of engagement with the world. At the beginning of *Turn*, when a bookshop in George-town gives a party for the publication of *Daybook*, Truitt describes seeing the copies of her book

> displayed in the front bay window to the right of the shop's narrow gray wooden doors, through which [my husband and I] used often to pass in the early days of our marriage. Perhaps it may have crossed James's mind then that he might one day see a book of his there (I wish he had), but never once did it cross mine that I would see one of my own.

In a way the whole book is about Truitt's acceptance of her own success in the wake of her ex-husband's—what to call suicide?—ultimate failure. By the end of her journal, Truitt is working again. She's come through something, and she's feeling pretty good.

Truitt grabs onto some great subjects (and when she lets go of one of them I feel annoyed). She remembers that

> when I was a child, I had to take a nap every afternoon and used to read surreptitiously the books exiled to the children's floor of our house in Easton, Maryland. One of these was a large edition, beau-tifully illustrated, of Swift's *Gulliver's Travels*. The text was in French, which I could not read, but I pored over the pictures, most often over the one in which Gulliver is tied down by the six-inch-high Lilliputians while he is asleep: there lay the immense Gulliver rendered helpless by countless tiny lines pegged to the ground.

I was interested to know why Truitt recalls this picture so clearly, because I also remember an illustration of that episode in *Gulliver's Travels*. But instead of talking about the memory Truitt closes it off with some fancy metaphor about how "every work of my life attaches me to that life." This makes no sense, and feels like a bit of a cheat, since of course what really attracts a child to that picture is its peculiar sadism—the triumph of the little guys over the grown-up. I'm not saying Truitt is prudish or that she's withholding her deeper feelings; she does, though, have a rather mannered idea of what writing ought to be, and she strains after "literary" effects. When she comes to her trip to Europe—her first, at the age of sixty-four—she has a fascinating subject, and we want to know as much as possible about what kept her from Europe all those years. She gives us *some* information, and the line on first entering the Louvre *is* brilliant: "The Louvre rolled up a lifetime's study of art into a pellet and spat it out in my ignorant face." But she never focuses on what Europe means to her. It feels like just a minute between the time when she's preparing her house for the house-sitters and her return, with its serene sorting out of memories. The writing of these two books seems to be the controlled act of a very controlled woman, and there's an interest—an extraliterary interest, one might say—in one's sense of a personality exposing itself, sometimes almost in spite of the elegant turns of the prose.

Truitt has taken on the major task of transforming a life into an open book, and if I closed each of her books with the feeling that these volumes aren't quite first-class literature, they are nevertheless very special: I can't get them out of my mind. Artists are drawn to Anne Truitt's books because she tells them what it feels like to work at the trade day by day. She speaks for all the artists who have ordinary lives— children, lovers, jobs; and she isn't mired in the same old gossip about the New York glamour world of Schnabel and Haring and Clemente. To Truitt those names obviously mean beans. Not that Truitt is unworldly! She wants to make it—she has made it—and she talks about it. She even takes legal action against the University of Maryland, where she teaches, because she's sick of being a woman who's the worst-paid professor in the department. (We have a hunch that she's both the best teacher and the best-known artist among her colleagues.)

To celebrate the publication of *Turn*, in November André Emmerich mounted a small show of Truitt's sculpture in his ninth-floor

gallery at 41 East Fifty-seventh Street. There was a bench where one could relax and watch these rectangles encased in skins of springtime pink and green, blood-thick red, dusky twilight blue. The Persian-miniature-bright colors bring to mind the author, who often writes of color effects—"the peach-colored blur of budding trees," or "blazing yellow maple leaves against an enamel-blue sky." The plywood columns are made by a carpenter, and then Truitt covers them with many coats of color, until each side shines hard and clear. There are basically two types of compositions. In one type, each side is a different color, and the viewer is pulled around to experience the shifting hues. In the other type, there are stripes at top and bottom that run round the four sides and draw one's eye to base and pinnacle, up and down. Truitt's sensibility connects with the extreme aestheticism of the Color-Field painters; but her forms, which are right-angled and severe, are more traditionally Constructivist. (Her columns recall in many respects those of the Neoplastic painter Ilya Bolotowsky.) Truitt's sculpture, with its dazzle of colors, is about a hedonism that's subdued and contained. Her books are about what she's left out of the sculpture—the big et cetera that for an artist is living, day by day.

————

Jonathan Silver, whose sculpture was at the Gruenebaum Gallery in November and December, is interested in the human form. His work, which is in cast and modeled plaster, and in bronze cast from plaster, presents the figure disfigured—fragmented, broken, rearranged. Silver (who's forty-nine) wants to give us the sense of an intelligence that's at home in the riches of history and religion and myth. His art invokes figure types and compositions from Ancient Greece, Baroque Rome, and twentieth-century Paris. Among his subjects are Jesus, Eve, Diana, Venus, and the Sun King. Silver obviously sees himself as an artist who's drunk on the whole glorious past of European art. But his sculptures abuse images of decrepitude and collapse in order to throw a murky film over a tradition Silver cannot really grasp.

There's a long and honorable list of artists who have taken up the pose of the heroic figure weeping at the Grave of Art: a few more tears can always be wrung from the Death of History or the End of Classicism. De Chirico sometimes catches the tone appropriate to a pallbearer for the ancient world; and at least one contemporary American painter, the

absurdly little-known Alfred Russell, has twisted classical culture into
a troubling contemporary dream. An artist, though, has to be up to the
old forms before he can get away with taking them apart. He's got to
give us a taste of the age-old perfection, show us what Greece and Rome
were, before he can excite us about what they no longer are. Silver's
view of the past isn't specific enough to convey a genuine obsession.
We can't really sympathize with him when he tries to convince us that
he's experienced a loss, because his hacked-up forms look like little more
than acts of random violence—an adolescent's rage.

Silver's work, with its slender, vertical configurations, is obviously
meant to invoke Giacometti. But Silver, whose every piece is an elab-
orate quasi-historical flight of fancy, has missed the very essence of
Giacometti, which is his simplicity. What are we to make of the missing
breasts in *Even with Eve* and *Small Venus?* Are they mastectomies? Or
the residue of some existential crisis in the studio? Silver will attach an
absolutely conventional face to a body that's splintered to shards, and
we don't know which came first, the chicken or the egg. Why is *Sun
King* covered with pustules and horrible growths? Why the faceless
Heads? And why, oh why, *The Barbarian Killing His Wife and Himself?*
Is it supposed to be a love poem to the Baroque? What it really looks
like is a Judy Pfaff plastic job covered in gray plaster glop. Silver's show
was full of ideas—some of his half-demolished sculptures looked like
ideas that had turned against themselves—but this artist can't sustain
anything, and he can't carry anything through. The show was a sketch
for the greatest one-man show in history, a show that would include
everything and that no artist in his right mind would attempt. It even
had a room-sized environment, called the *Chapel of Alexander Severus*,
which carried this classy quote from the *Scriptores Historicae Augustae*:
"In the sanctuary of his lares he kept statues of the deified emperors
and also of certain holy souls . . . Apollonius, Christ, Abraham, Or-
pheus. . . ." The *Chapel* was a gloomy room. The walls were streaked
with olive-drab paint; the floor was dusted with leaves and plaster muck.
This was the artist's studio as pagan shrine. Only the incense was
missing.

————

Louisa Matthiasdottir, who's seventy, has given about as much plea-
sure as any painter working today, and her 1980 show at the Robert

Schoelkopf Gallery—with its brilliant Icelandic cityscapes, complex still lifes, and enigmatic self-portraits—remains for me one of the radiant memories from fifteen years of gallery going. Matthiasdottir's big clean brushstrokes are the sort of thing one might expect from a brilliant student—they look that unpremeditated—but hers make space and color as no student's ever can, and there's an exhilarating shock in finding this most ingenuous of styles catapulted into paintings that aren't quite like anything you've seen before. Matthiasdottir has said that most of her paintings are done in one sitting. This is borne out in the freshness of the pictures, in their wonderfully unfussy surfaces. While Matthias-dottir's work has the glow of oil paint, her knack for thinking in terms of big simple areas recalls the old fresco masters, for whom painting was also a one-shot deal. There is, though, a danger in this uncompli-cated way of handling paint. When Matthiasdottir doesn't go all the way—and in her show last December at the Schoelkopf Gallery she mostly didn't—the work can look perfunctory, thrown off too fast.

Much of the problem with the recent show may have stemmed from its being so heavily tipped toward paintings of sheep and other farm animals, which are Matthiasdottir's most likable, but not necessarily her most satisfying, works. There were so many paintings of sheep in those gentle green Icelandic hills of hers that you could almost have been counting sheep. There was less of a sense in this show of an intelligence contemplating many different subjects, and the relative flatness of the landscapes wasn't enough counterbalanced, as it has been in other years, by the full volumetric space of the still lifes—which are landscapes on a tabletop—and of the self-portraits. Some of the major canvases, such as *Three Horses in Icelandic Landscape*, were too much a matter of sharply silhouetted forms. This painting looked like a series of pop-up pieces; it had no enfolding atmosphere, no weight.

In recent years Matthiasdottir, who's always had a strong following among a group of artists and critics, has gained something of a more public reputation for the Icelandic landscapes—they've become her sig-nature. I have the uncomfortable feeling that the preponderance of animal paintings in Matthiasdottir's recent show was a bow to this new, paying public—and who can blame her, after all those years of respect and few sales? But Matthiasdottir ought to know that the audience that's always treasured her shows counts on her variety.

The painting that held me the longest was *Sheep and Red Roofs*, with

its wide valley marked off at the front by a trio of small animals and in the background by a range of hills. Here Matthiasdottir trades her modern love of the surface for a powerful recession into depth; the painting recalls Dutch masters such as Ruisdael and Hobbema in its panoramic effect. Matthiasdottir gives her glowing, banner-brilliant color a more subdued, tonal mood, and there's an interesting new sense of scale—the tiny animals are overwhelmed by all that space. When one looks at *Sheep and Red Roofs* from a distance of eight or ten feet it's a complete success. But from close up, little things go wrong. The strokes of green and blue on the houses in the middle distance don't sit in space—they don't fit into the overall flow—they declare themselves too much as autonomous marks of the brush. You can't quite stay inside the painting, as you can in Matthiasdottir's best work. Passages keep slipping from their moorings and bobbing up to a surface that she's otherwise trying to disclaim.

Matthiasdottir's inability to bring off this super-deep space is probably due less to miscalculation than to a reluctance to let her painting go totally 3-D. (In her still lifes, where she's confronting a space that's in reality fairly shallow, she can fully model the forms without refuting that surface architecture she's learned from Cubism and abstract art.) For some years, Matthiasdottir has built naturalistic landscape effects from nearly abstract structures of color; now she's hovering on the edge of tonalism and depth.

———

Standing in front of Sigmar Polke's new abstract paintings (at Mary Boone in November)—with their curlicues and escutcheons floating on expanses of thinly poured or sponged paint—I found myself thinking of Miró, who was the first artist to mesh writing and painting into a style of flat, enigmatic signs. Miró's paintings are hymns to shallowness—and it's something of a miracle that this Spaniard, who died on Christmas Eve in 1983, squeezed a whole life of important art out of variations on this one deliciously decorative idea. Not surprisingly, when others take up Miró's method, the shallowness generally turns to emptiness. And yet artists keep being attracted to this shadow-play version of pictorial space, probably because it expresses so beautifully our feeling that we can't any longer sustain total illusions, that everything is running down and emptying out.

Polke, who as the German guru of the appropriationist and Neo-Expressionist movement led the world for several years in the piling up of ill-synchronized pictorial allusions, has gone Minimalist in these gray and brown and black compositions. The new abstractions take up a position at the exact point where Neo-Expressionism has thrown off its glamorous rags and turned fanatically pure. The critic John Zinsser recently commented in the *East Village Eye* that "The East Village, once the turf of Fun, is now home to no-Fun, the new abstractionist backlash." Polke has done no-Fun one better. Down in SoHo he's shown how you can have your no-Fun and still have Fun.

Polke's curls are derived from decorative designs in Dürer's *Prayer Book of Maximilian I* (1515). Like Kiefer, he's invoking the German past—only Polke's motifs, which are isolated from their Renaissance context, are so purely ornamental as to look rather French Rococo. Blown up into two- or three-foot-high enigmas and suspended over fields of snowy white and gray, Polke's images are beguiling in their shameless, empty elegance. The old-fashionedness of the curlicues is neatly undercut by the puzzling aura of the pictures as a whole, and by the ragged edges on some of the curls, which were obviously copied from slide projections of photomechanical reproductions. These are shallow paintings—and I sort of like their smart soullessness. Why, then, do they go so completely sour after I've looked at them for a time? Cocteau once observed of Miró that he "is saved by his living line. He only has to draw a cross in order to crucify." Those loops of Polke's couldn't strangle a fly.

——

The *New York Times* has been carrying reports of the trial (in State Supreme Court in Manhattan) at which Christie's, the auction house, is being sued by Cristallina, an investment concern that consigned eight paintings for sale in 1981, seven of which didn't reach their reserves and thus went unsold. Works that don't sell at auction are generally hard to move afterward—it's as if they've lost their luster by being rejected in the auction room—and Cristallina was understandably upset to take back most of its paintings. David Bathurst, the president of Christie's, ended up resigning over accusations that he lied about how many paintings actually sold (he told reporters three). Cristallina is claiming it was misled by Christie's as to what prices its pictures could make. Christie's is claiming that Cristallina knew just what it was getting into.

These days the auction business, with its wild prices and nonstop publicity, seems to be echoing the financial scene as a whole—that was what a lot of people felt about the auction action last fall, when a Jasper Johns went for $3.6 million and a Mondrian for $5 million. There was said to be a change in the atmosphere of the auction rooms: people were bidding who'd never bid before. These people have loads of money, very little taste, and treat picture purchases as if they were corporate takeovers. Capitalism is in one of its berserk moods, and works of art are being bought and sold like stocks and bonds. Not surprisingly, tempers have begun to flare. Tom Armstrong, the director of the Whitney, was peeved at being outbid for Rosenquist's *F-111* by Jeffrey Deitch, a vice-president in Citicorp's art advisory service—though what the Whitney needed *F-111* for, God only knows.

Most interesting are the complaints of the old-time dealers. Heinz Berggruen, who buys and sells classic moderns, said, "It's insane. It's a hyped market, overplayed. There are a lot of people involved with fresh money who don't know what this is all about." People like Berggruen represent the best side of the post-World War II art establishment, the establishment that believed in modernism, canonized its values, and made many fortunes in the process. Now these old-timers are upset, because the values they have lived by all these years are in collapse, and the market is being overrun by a new crop of buyers who don't give a hoot about the carefully worked out canons. Two million for a Rosenquist is regarded as a scandal because it places an incorrect value on the thing—a value, in other words, that's not supported by the opinions of the established dealers, curators, and critics. A Wall Street investor, Asher Edelman, was quoted as saying that the auctions are "a less pleasant place to be. But it's patronage. It creates an environment in which more art, and more good art, is created." This is one of the classic postmodern remarks. How is buying works by dead artists or older works by living artists patronage? How is five million for a Mondrian patronage? If sales had been what moved Mondrian to paint, he'd never have put brush to canvas.

March 1987

THE LELAND
BELL SHOW

The Phillips Collection in Washington, D.C., is home to some of the most beautiful nineteenth- and twentieth-century French paintings in America. From Renoir's *Luncheon of the Boating Party* through Matisse's *Studio, Quai St. Michel* to the room full of Bonnards, it's a place where the great transformations of French art—by which ordinary subjects are carried up to lyric heights—take place again and again. At the Phillips you can't help feeling wonderful about French art—the collection has an amazing coherence—and the curatorial staff likes to mount temporary shows that expand on the collection's essential themes. The Phillips organized the memorable "Braque: The Late Paintings" in 1982 and hosted the American side of the Bonnard retrospective of 1984. When the gallery exhibits living artists, an attempt is made to show things that Duncan and Marjorie Phillips, who built the collection that bears their name, might have liked. Two years ago there was a group of paintings by the English abstractionist Howard Hodgkin. This season's schedule includes shows of works by Elmer Bischoff, the Bay Area painter; Jacob Lawrence, who makes a patchwork-quilt-in-paint of black American history; and, now, the sixty-four-year-old New York painter Leland Bell.

As it happens, Bell had some of his earliest experiences with great paintings at the Phillips back in the thirties when he was a teenager living in Washington. It was also here that he encountered the work of Karl Knaths, an American painter who was a member of the pioneering American Abstract Artists group. Soon Bell got to know Knaths, who remains to this day the only teacher he will acknowledge. Knath's semi-Cubist compositions, with their constructions of black lines and their free planes of color, have a certain resemblance to Bell's work—though

Bell is undoubtedly the superior artist. Bell's pictures, with their matte surfaces and rich colors—midnight blue, dusky purple, burnished gold—looked at home at the Phillips. His way of giving the old subjects of still life and portrait and figure composition a twentieth-century beat found echoes at every turn.

While described as a retrospective, the Bell show was by and large a survey of the past fifteen years of his career, with a handful of works on view to give a sense of where he'd been before. The earliest pieces, a group of small biomorphic abstractions done in ink and gouache on paper, dated 1942–45, contain shapes derived from Jean Arp and Paul Klee. (One is titled *Homage to Klee*.) Each bean, amoeba, or sharp-angled form is painted in flat color and surrounded by black lines. Though some of Bell's abstract shapes are faintly humanoid, his work of the forties is more closely linked to the pure abstraction of the thirties than to the New York avant-garde of the war years, when Abstract Expressionism was rising out of Surrealism and automatism. Then (as now) Bell seemed to distance himself from contemporary trends and take a backward or sideward glance. Bell's abstractions are based on a pre-Abstract Expressionist belief that a painting ought to be totally clear. There are no mysterious depths, no fading edges. Bell likes everything to be unambiguously nailed down in space.

The Phillips show gave very little sense of Bell's work of the fifties and early sixties, when he had stopped painting abstractly and was doing what appears to be (from the few examples in the show and others I've seen in reproduction) his most impressionistic work. Back then, Bell used overlapping strokes of color (he probably had Giacometti in mind). The paintings had an informal demeanor they've lost as time has gone by. At the Phillips, the best of the early figure paintings was *Self-portrait at Easel* (1954), in which the artist, seen in three-quarter view, stares out at us from his chair. This also happened to be the first in the series of self-portraits that made up the most coherent room in the show. You could see Bell's face, with its prominent eyes and high dome of curly hair, changing as he went from early manhood to late middle age. In *Self-portrait at Easel*, the strokes of blue and brown and red, running over and under one another, build to a warm and even gentle mood. Some people have always regretted Bell's abandonment of a fluid way of painting—they believe his small, bust-length self-portraits are the best things he's ever done. Still, looking back at the paintings of the

fifties now—to these self-portraits, and to the painting of three nudes reproduced in *Arts Yearbook 3* (1959)—I realize how their energy derives from a desire to get beyond the maze of overlapping strokes and locate what's absolutely essential in the motif. When the black lines come back into the work (it seems to be in the mid-sixties, although it's hard to say, since many of the paintings have been reworked or lost), it's as if Bell has finally lassoed—conquered—an unruly world.

As a painter of reality Bell still values pictorial logic over naturalistic effect. He gives relatively little attention to the weather, the time of day, or the particular textures of cloth and metal and glass. He's miles away from the poetry of a painter like Fairfield Porter, who will capture with haikulike precision the feeling we have on a clear morning after a big snowstorm in Massachusetts, or on an ordinary afternoon in downtown New York. Flickering sunlight, chaotic plays of shadow: all this is too ineffable, too subject to change for Bell. The black lines that he ran around his abstractions in the early forties are there in much of the later work—as a way of containing and subduing reality, of turning it into *compositions*. When Bell does a self-portrait or a still life it's as if he's making an essence of everything he knows about the subject. (Maybe this is why he sometimes works on paintings for years—so that every chance impression can be modified.) The paintings place nature under a terrific pressure. Sometimes Bell leaves us feeling that he's pared down the motif too much; at other times he finds a way to incorporate its essential character into a design that reveals some hidden order in the world—an order built from the contrasts and correspondences of forms.

In the self-portraits of the late sixties and seventies the interwoven strokes of paint are overrun by a few relatively thick black lines that bring out the critical contours and turns of the form. Here the many tiny color shifts give a sense of the texture of flesh and the movement of the muscles. The black lines pull it all together, pin it down. Bell gives us the mess of nature with clarity laid on top. He'll finish off his head with a perfect little triangle of black—a memory trace of abstraction that also defines the tip of the nose. The self-portraitist is, by definition, a narcissist; but the painting process, which is intensely analytical, can occasionally transform self-absorption into revelation.

Bell always works in series. When he finds a subject he likes, he reworks it for years—even for decades. One canvas gives birth to an-

other, to a geometric increase of versions. There's the thirty-year-long series of self-portraits—small scale, close to the face—and two series dealing with the figure. In one of these (vertical in format, generally called *Morning*) we see a bedroom in which a standing female nude and a man who's still under the covers gesticulate at a cat that's just killed a bird. The other series (horizontal in format) involves three people around a table, pointing at a bird, a butterfly, or a moth. Bell has been quoted as referring to his subjects as prisons; he says he dreams of breaking out. But one rather feels that he likes being imprisoned, and the figure compositions have become, over the years, a set of self-imposed limitations. Bell may believe that by putting his whole being into one idea forever he'll ultimately achieve release. I wonder: as the years go by these variations on a couple of themes seem to be going around in circles.

The men and women in the paintings are exceptionally stylized. Bell turns arms and faces into single-colored, Arpish forms. Then he sets his figures to interacting in frenetic domestic ballets. The broad expanses of color are often set up in stunning juxtapositions. In one of the big groups of three figures there's a lovely, crazy clash of pink and orange—Bell's color in the recent versions has definitely lightened up. The close encounters of these streamlined bodies are a joy to behold. But the ordinary occasions (a cat caught killing a bird, a moth flying into a room) jibe rather oddly with Bell's impassioned rhetoric. This seems a hell of a lot of fuss over very little. There's a strange mismatch between the planes of flat, decorative color and the encasing black lines (all of which push so resolutely forward) and the complicated, inter-locking gestures (which move in and out and back and forth in space).

Bell's figure groups unite the rhythms of Baroque figure composi-tions with the planar architecture of Cubism. They're both old-fashioned and anti-old-fashioned, a last shot at narrative painting and a decon-struction of narrative. They have the brilliance of something carried on at the farthest edge; when you're in front of them, you may feel that Bell is doing the only kind of figure painting you can do in these modern times. You may feel that naturalism, whether of gesture or of drama, has been wiped out by Cubism and abstract art. But there's ultimately something unsatisfactory about an artist who invokes a psychologically charged situation and then refuses to clarify the story line or bring out

the dramatic nuances. Bell's figure compositions don't really deliver the goods. He sees figure composition all too much as a matter of pure expressive form: he gives too little weight to questions of meaning. When Léger does figure groups that are as flat and brilliantly decorative as Bell's, he doesn't attempt to express drama or movement—he makes his figures into benign dum-dums who go great with the bright modern space.

The ripest paintings in the Phillips show—the ones that held in my mind—all seem to break with the idea of a series and come out of a unique moment, an immediate necessity. These include the two *Standing Self-portraits* (1979 and 1980), in which we see the artist in the studio interior, surrounded by paintings and a set of drums (Bell is an amateur drummer and jazz aficionado); and a still life called *Rose and Cymbals (II)* (1979–82). The surfaces are the matte, dense ones Bell favors; but the odd intervals and juxtapositions—rose against cymbal, the head of the artist against a painting hanging on the wall—have a specificity we miss in many of Bell's paintings. The forms really build and pulse. In the two *Standing Self-portraits*, the artist himself becomes an explosive piece of modern sculpture—a composition of rocking convex and concave planes—and we're spun up to the face and outward, through the room. These self-portraits are great paintings.

For years now Leland Bell has cut something of a figure in New York, not only as a painter but also as a teacher and a lecturer. He's known as an odd man out, for his advocacy of unfashionable artists and causes—the later work of Derain and Rouault and the mature style of Dufy (which he praised long before Dufy became the chic thing). Like most people who've admired Bell's work for some time, I've found his lectures very moving and have come in the course of things to know him to some degree. As it happens, my name comes up in passing in the new book, *Leland Bell*, by Nicholas Fox Weber (Hudson Hills), the publication of which provided the occasion for the Phillips show. Bell mentions that I had asked him to give a talk at a symposium in Philadelphia on "Tradition and the Artist"—which he did, and it was a good talk, too.

Weber has composed his text in the form of a series of visits to the artist's studio, an approach reminiscent of a certain kind of *New Yorker*

profile. This is not a bad idea, and the extensive quotations from Bell are often very interesting—the artist can be a brilliant *poetic* talker. Weber, though, is too much in thrall to the artist, and his text has the cloying air of being written by a kid who's got his nose pressed against the window of a candy shop in which a painting by Leland Bell happens to be the prize bonbon. Weber is a fan—which in this case means that he tells us too many little details about the artist's life and pet peeves and can't locate them in any significant context. He wants to convey a sense of Bell's importance, but he goes haywire in his praise. Weber's comparisons to Matisse and Frank Lloyd Wright are distortions, not illuminations.

This book is special-case criticism. The writer senses an injustice in the art world and sets out to right it by giving the underdog the kid-glove treatment. "Don't knock a guy who's down," seems to be the idea. But Leland Bell is too important to be just patted on the back and told, "It's OK that you're not as famous as X or Y, because of course your work is perfect, anyway." I trust Bell has enough sense not to believe it. The real drama of Bell's situation is something Weber doesn't seem to understand. Bell has stood against fashion and yet managed to remain a part of things—which takes real courage. How rare he is: an idealist who's in touch with reality but won't let it destroy his dreams.

When Bell lectures today you can still feel the enthusiasm of the kid who had those first mind-expanding experiences with the paintings at the Phillips Collection almost fifty years ago. For students his energy is a sign of hope—he's an artist who influences the courses of young artists' lives. His message, moreover, transcends the advocacy of one or another sort of work—of late Derain, of Corot's gifts as a figure painter. Despite his deep commitment to reality, Bell is a formalist. He's in the tradition of the early moderns who saw the whole history of art as existing simultaneously, in a democracy of pure form. Unlike the Greenbergians, Bell refuses to read the history of art since the Renaissance as an irreversible progress toward abstraction. For Bell the meaning of all art—a Fayum portrait, a Rembrandt, a Picasso—is encompassed by the same simple truths: by the beauty with which lines and planes and colors are weighted and set in motion and brought into harmony. Many of the weak spots in Bell's work—and in his taste—no doubt derive from his excessive dependence on this idea of form. But

I know of no one today who has expressed the moral value of pure painting with as much lyric conviction as Leland Bell. "I want the shuffles and echoes," he says in the Weber book, "and a certain mysteriousness." And again: "Am I getting that crazy thing that happens, that movement between things, that rhythm that captures the essence of reality?"

Bell came to New York before World War II; he's been a vital part of the scene here since the late fifties. Vigorous, unsentimental, in some odd way all-American, he's inspired several generations who will never forget the first time they saw him flash a slide of a Matisse or a Dürer on the screen and start talking about "those great guys." For many of us, he's one of New York's precious natural resources. The art establishment here in New York, which keeps missing the boat, has missed it again. Bell's first big show looked lovely at the Phillips Collection in Washington, D.C. But how much more of an impact it would have had at the Whitney or Guggenheim, in the first city of contemporary art, which is where it really belonged.

April 1987

JASPER'S SEASONS

The Four Seasons is one of art's primal subjects. It has attracted painters ancient and modern, East and West; and as myths, poems, and stories have enriched it over the centuries, the Seasons theme has come to inspire some of the most deeply layered and urbane images in the history of art. But the appeal of the Seasons remains, at heart, very simple—something anyone can understand. The Seasons is about the changes that overtake the planet and all of us who live on it. It's about the leaden gray mood of the dead of winter; the first rush of warmth and expansiveness that arrives in February or March; the heavy luxuriance of high summer; and that clarifying of the sky to a clear, deep, flat blue that signals the coming of fall.

The first—and absolutely damning—thing to be said about Jasper Johns's new cycle of paintings called *The Seasons*, which was at Leo Castelli in February, is that Johns has been unable to evoke four (or even two) different moods. Johns's *Spring, Summer, Fall,* and *Winter* are covered in a bluish- or greenish-gray scum. They have the same rhythmic intervals; they all look and feel the same. And it's not as if Johns is trying to tell us something about the eradication of natural rhythms in the modern world. His four paintings are full of conventional seasonal signs—snow for winter, rain for spring, things like that. He wants to produce images of growth and death and change; but he seems reluctant to make any radical shifts in color or scale. His *Seasons* are muffled, well-mannered, self-consciously artistic.

The four paintings, each vertical and seventy-five by fifty inches, were hung together on the south wall of Castelli's West Broadway space. Johns's paintings weren't an aggressive presence in the gallery, the way some of David Salle's and Julian Schnabel's oversize paintings have been

in recent years. On the other hand, they didn't look provocatively small, the way Johns's paintings did in his last show, in 1984, in Castelli's barnlike Greene Street space. *The Seasons* had no presence at all. Each is just a jumble of tics and tricks, held together by the device of regular vertical divisions of the canvas. *Summer* and *Winter* are split into two equal sections; *Spring* and *Fall* in three, the two side ones each half the width of the central one. There may be an idea of moving from images that fit the frame in *Winter* and *Summer* to transitional images in *Spring* and *Fall*. It's like watching the segments of a filmstrip wind across the rectangle of the canvas. A shakily edged silhouette of the artist reappears from painting to painting, as do a black disk, a handprint, some pieces of pottery, a ladder, a rope, and excerpts from Johns's earlier work. The paintings are overcrowded, particularly in their lower halves, as if everything had sifted down through the force of gravity. There's no depth, just the overlapping of odds and ends on a pictorial bulletin board, presided over by the self-portrait of the artist as a faceless non-entity. In the early seventies, Leo Steinberg praised the space in the paintings of Johns and Rauschenberg with the altogether accurate (and to my mind devastating) term, "flatbed picture plane." Johns is still composing paintings on this plan, where "the surface stood for the mind itself—dump, reservoir, switching center." And he's still coming up with the kind of art-gallery smash hit that marked his debut, also at Castelli, back in 1958.

The appearance of the Johns *Seasons* was accompanied by a sort of instant iconographic key, in Judith Goldman's Castelli catalogue essay. She describes borrowings from Johns's own earlier work, as well as "the Isenheim Altarpiece [by Grünewald]; a Swiss road sign with a bilingual warning of falling ice; the *Mona Lisa*; George Ohr pots; and a trick English vase, the sides of which form profiles of Queen Elizabeth and Prince Philip." The biggest debt in *The Seasons*, though, is said to be to Picasso, and especially to *The Minotaur Moves His House*. Apparently Johns was attracted to this 1936 Picasso, in which the Minotaur pulls along his belongings in a down-at-the-heels cart, because Johns himself had just moved to a new home—a townhouse, on Manhattan's East Side.

The Minotaur series isn't totally satisfactory Picasso, but it does have a remarkable energy that derives from the way Picasso infuses

classical mythology with a kitschy sexual dimension. His macho minotaurs, often juxtaposed with languorous ladies, exist somewhere between the (perhaps inadvertently) uproarious Neoclassic pornography of Ingres's *Jupiter and Thetis* and the Tarzan-Jane pulp of Hollywood. *The Minotaur Moves His House* is classical myth with a cartoonish edge—it's a bit like a Picasso version of TV's Fred Flintstone leaving in a huff after a tiff with his wife. What Johns can't see in Picasso is the instinct for caricature that brings the classical imagery to life. Johns totally misses the pop zing of thirties Picasso. When Johns borrows the Minotaur's cart from Picasso but not the Minotaur himself, he's losing the human interest—and the life force—of the original.

Johns used to be a sanctimonious Pop Artist: he painted the beer cans and American flags and elementary-school maps in such a way that they looked like well-mannered lyrical abstractions. It was all so tasteful, so lily-white. Johns despised whatever vigor popular culture really had: why else did he strangle his flags with elegant brushwork? Now, in taking up a high-art theme, the Seasons, all Johns can think to do is be sanctimonious about the heartland of Western art. He's taken the life out of the Four Seasons; he's doing a Seasons for prestige. Johns wasn't passionate about pop Americana, and he isn't passionate about the turning of the seasons that the old masters took as one of their great themes. When Poussin painted his *Spring*, with Adam and Eve in the juiciest green garden of them all, he spoke for everyone who's ever fallen asleep in the grass on a gorgeous May afternoon and felt that they'd never get up again. Johns paints like a man who's never been outside his studio; he has the audacity (or is it stupidity?) to set a Seasons cycle indoors.

Johns's *Seasons* are an interesting episode in the history of Pop Art. Along with Warhol and Rauschenberg, Johns achieved fame very young. Since then one pressing question has been a career question: how to keep the public interested. It must be gratifying to find your own early work garnering record-breaking auction prices and becoming the subject of elaborate art-historical analyses, but everyone wants to feel that what he's doing now is important, too. Warhol solved the problem by more or less quitting art and becoming a gossip-page phenomenon of unprecedented proportions; Rauschenberg seems to have accepted the fact that no one takes anything he's done in the last twenty years seriously

and turned his energies to a cycle of international goodwill tours, the point of which is to bring Pop Art to every corner of the globe. Johns's stroke of genius has been to realize that rather than waiting for the march of time to turn your current work into history, you can just junk up your current work with so many art-historical references—including references to your own earlier work—that people will respond to the paintings as if they're art history already. Johns's *Seasons* show was a hit because it satisfied an audience that believes aesthetic experience is a form of historical experience. Johns is doing what the appropriationists do: he's quoting images from the recent and distant past, without really getting involved in them emotionally. He's even appropriated the idea of being an old master. The wunderkind of Pop has grown up—or so he wants us to believe.

These past few months have been thin, art-gallery-wise. Competence, intelligence, ingeniousness are much in evidence; but almost everywhere one feels the inability of the artist to really engage the audience. Artists aren't attuned either to a sense of the present (which is different from fashion) or to a sense of the past (which is different from academicism). Important new art comes about when a tradition reaches beyond itself, when a tradition begins to yearn toward and enter the present. It's the promise of that past-into-present leap that keeps us going to galleries. Johns seems to have many people convinced that he's made the leap. I say his feet are stuck to the ground.

June 1987

PAUL KLEE NOW

The Paul Klee retrospective at the Museum of Modern Art was the great museum show in New York this past season. It was a case of the Modern doing what it does best—delivering the classic modern goods. The museum staff was obviously in deep sympathy with the artist. How else could they have brought off this inspired installation, in which paintings we've known for years in Paris, Philadelphia, Washington, and New York found their perfect partners and places on the wall? The blessed absence of entry-point audio-tour salespeople and exit-point gift shops didn't prevent Paul Klee from being a hit with the crowd that goes to perhaps half a dozen exhibitions a year. And unlike some shows that have pulled in the museum-going public—unlike, for instance, the Modern's own those-were-the-days Vienna extravaganza and the Whitney's swashbuckling Sargent retrospective—Klee was an exhibit to which artists were also going, and going many times. For some younger painters it might turn out to be an it-changed-my-life experience.

The crabbed products of Klee's Symbolist and Art Nouveau youth were wisely kept in a kind of anteroom, so that his entry into the avant-garde at the beginning of World War I could hit viewers with full force in the show's first gallery. Here, in works done between 1914 and 1919, Klee is already in command of his singular synthesis of Cubist construction, Fauvist color, and a Da Vincean synthetic imagination. With the North African landscapes and such fantasies as *Genesis of the Stars* (1914), he offers us a view all his own, and we're hooked, and we stick right by him to the show's extraordinary close.

There are many modern European artists who've been interested in non-European art, but Klee is the only painter who found a way of building an entire world-class career outside of easel painting. Klee's

paintings don't act entirely unlike easel paintings: they do hang on the wall, so that we regard them from a certain judicious distance. But Klee's taste for narrative complexity and intricate internal scale tends to confound the expectations that we bring to his work from easel painting. In the first room of the MoMA show he pulls us into a Persian-miniature relationship to the image. You don't stand back and look at a painting, you draw close and *read* it: you read the movement of many small parts in relation to one another, the unpredictable mixing of media, the poetic titles. Later on, as Klee's scale expands, he lets you move back a bit and take a wider look, but you're still reading, still examining images piece by piece, clue by clue.

Klee, who was born in Switzerland in 1879, met Picasso and the Delaunays in Paris early on, was a close friend of Kandinsky's, participated in the Blaue Reiter group, and taught a famous series of courses at the Bauhaus. Nevertheless, he's one of those rare pictorial geniuses whose achievement stands somewhat outside the capitals of art. In an essay published in 1941, the year after Klee died, Clement Greenberg said that "Klee is to the modern painters of Paris somewhat as the school of Siena was to that of Florence in the early Renaissance." It's an attractive analogy, especially when Greenberg goes on to observe that Klee is "less realistic and at the same time more literary and sentimental [than the Parisians]. . . . Klee's [works] live in a more fictive medium and require of the spectator a greater dislocation, a greater shift." Still, it would be a mistake to see Klee's vision as hemmed in by a particular local history or geography, as the work of the Sienese masters was. He's more in the mold of the displaced European intellectual who feels drawn to several cultural traditions at once and uses his outsider's status as an asset. Klee doesn't suffer from a crippling sense of homelessness; he feels free. He makes us believe that the whole world of art and culture is his home.

You pick up a sort of meandering trail of thoughts and memories every time you look at a Klee. Take *Florentine Villa District* (1926). Into a pink- and mustard-toned stucco surface Klee has inscribed buildings, row upon row. Think of Florence: the city of frescoes and pinkish fresco color; but also of quiet quarters where cultivated foreigners visit and sometimes stay for a lifetime. Let the associations go: quattrocento revolutionaries; nineteenth-century poets; the graffiti on old walls; a painting as smudged and moldering as a medieval monument; the pile-up of

periods; all those who've passed by. Or look at *Ad marginem* (1930), that picture with the smooth surface of a vellum page. Begin with the Latin title, which makes us think of those medieval illuminated manuscripts where the artist's interest is often focused on the margins. Notice how the sun is at the center of the page, and the grass and plants and animals are sprouting from the four sides, all around. This is a landscape in which the edges of the rectangle are the soil—an idea only possible after Cubism has abolished gravity in painting, which in turn carries us back to the fourteenth century, to the Books of Hours and the beginnings of the naturalism that Cubism ultimately undid.

The secret of this stream-of-consciousness visual art style rests in line, which, as Klee explained in his "Creative Credo" of 1920, expresses movement, change. Line is a kind of seismographic emanation of the mind. "Art does not reproduce the visible but makes visible. The very nature of graphic art lures us to abstraction, readily and with reason. It gives the schematic fairy-tale quality of the imaginary and expresses it with great precision." Klee pulls in everything. What other artist did such a thorough ransacking of the Middle East, Africa, and the South Seas, as well as of the folk-art traditions of Europe? Klee even designs variations and improvisations on modern avant-garde styles: on the work of the Constructivists and, if I'm not mistaken, of the Surrealists (who'd originally been influenced by him). No one has made more profound art out of the layerings of memory in our image-besotted modern minds. In the pointillist paintings of 1931 and 1932 one is made conscious all at once of Seurat, Cézanne, and Roman mosaics—not to mention geology, atomic particles, and music theory. Klee draws on all we know about the present and the past. He's a wizard for the cognoscenti; he makes knowing things part of the fun—the more connections you can establish, the deeper in you can go. He makes us equate certain emotions with certain art memories, and he swishes those memories around together beautifully, lyrically.

Klee's work up to the early thirties is well represented in American collections; but the immense production of his final decade has remained in Europe—mostly in Switzerland, where he died in 1940 from a rare degenerative skin disease. The Modern show gives us our first opportunity, certainly in many years, to see what Klee did after he'd left

Germany under the pressure of the Nazis in 1933. There has always been a contingent that saw the late work as a falling off. I suspect this view is grounded in the belief that Klee was essentially a little artist, and that he betrayed his gifts when, during the thirties, in an effort to respond to the darkening European scene, he reached for a bolder, flatter, heavier kind of impact. I've always had questions about the late work, especially about the queer style of creased, deformed-looking figures. But at MoMA, where the key late paintings were all in place, this work felt like a logical, inevitable development—a heightening and intensification of ideas that had been in there all along.

The four- or five-foot-wide paintings of the late thirties are like scaled-down, portable murals. Here Klee's key borrowings are from Egyptian wall painting. In works such as *Legend of the Nile* (1937) and details such as the hieroglyph-eye in *Intention* (1938) the Egyptology is unabashed—Klee must have been fascinated by a funerary decor that had nothing to do with either Greece or Rome. But Egypt presented Klee with a structural idea as well: a way of floating graphic signs onto an expanded field. The surface becomes increasingly open; in the watery imagery of *Rusting Ships*, *Rich Harbor*, and *Insula Dulcamara* (all 1938), Klee is halfway between Egypt and the nineteenth-century seascape painters. After this come the fetus, cauliflower, and brain shapes— they're unnerving yet familiar, and may owe something to Picasso's scrambled figuration of the early thirties. Klee used Egyptian signs and biomorphic deformations to create the first late style in twentieth-century art. I suspect that this style had an impact on the subsequent development of Braque and Picasso, each of whom visited Klee in Switzerland toward the end of his life.

Klee's late style is based on transformations and metamorphoses. The beautiful, full-foliaged, gray-green *At the Hunter Tree* (1939) is like some spongy, scrunched-up giant; while the teapot and vases in the last *Untitled (Still Life)* (1940) use their handles and spouts as arms with which to wave farewell. Coming at the close of an unforgettable retrospective, these pictures have some of the same jittery drama that the last Picassos had at his MoMA retrospective in 1980. You arrive at these late works feeling full and overfull, and their intimations of darkness and panic send you over the top. Only Klee, in *O! These Rumors!* (1939) and *Death and Fire* and *The Cupboard* (both 1940), works on us with a

quiet intensity that may go deeper than Picasso's dazzling slob-genius shenanigans.

In recent years a great deal of scholarly attention has focused on Klee, probably because he's one of the few twentieth-century artists to whom the art historian's iconographic methodology can be readily applied. There have been some formidable art-historical essays written about Klee—the research has really panned out. But the study of iconography (which was developed in order to reclaim for the modern viewer a web of references and associations that would have been relatively obvious to the Renaissance or Baroque artist's cultivated contemporaries) isn't all that necessary for the museum-goer's understanding of Klee. Happily, we still share Klee's general cultural framework—the worlds of art, music, and science still look much the way they did to him.

But even if we have little trouble getting the general drift of Klee's thought, we may leave the retrospective awestruck at his ability to find a form to express his every thought. We're in the hands of an artist who's actually communicating with us through paint—and that's miraculous, coming at a time when most painters don't seem to know how to communicate and when the self-styled communicators in the art world don't know or care about painting. Klee puts it all together; he plants an idea within a painting, and we actually enter into that idea, and feel through it. You don't have to know that the paintings he called Magic Squares are based on music theory to enter into the discourses between different voices that go on in *Rhythmical* (1930) and *New Harmony* (1936). When there's a little figure walking through one of Klee's landscapes, it's a floating intelligence. Klee makes us think about how the weather, geography, terrain touch that little figure; he builds toward a fairly complicated sense of the world. Whether a Klee is totally abstract or rather figurative, the artist never lets us think *at* the painting. We're not theorizing; we're connecting to something that's built into the image; we're thinking *out of* the painting. He generates an unprecedented variety of thoughts from paint. It's in this sense that Klee is a far greater artist than Miró, whose work, both collectively and individually, has a more coherent look, for the simple reason that it's less richly generative of thought.

Of all the modern painters, none speaks more urgently to the present moment than Paul Klee. As time goes by Matisse and Picasso and even Mondrian look more and more like an integral part of the European easel-painting tradition, and that tradition looks more and more like something to which we'll never again have an uncomplicated connection. Klee is different. He conceived the studio as a laboratory and developed an elaborate methodology that recalls the approach of the scientific researcher. His lectures and notebooks—posthumously collected in two enormous volumes, *The Thinking Eye* and *The Nature of Nature*—come out of the same need to address epochal transitions that had earlier given birth to Da Vinci's writings. In Klee's thought there's an in-depth acceptance of how far we've traveled from the world that supported traditional art-gallery art. Unlike Mondrian and Kandinsky, though, he finds little consolation in spirituality or idealism. Klee studied the changes taking place in civilization—in art, music, science, mathematics, the state. He lived through the destabilization of culture that sent Duchamp and so many others into the no-man's-land of antiart, but he wouldn't turn his back on art. He had a courage—and a gift—that puts Duchamp and his progeny to shame. Klee is the outsider as modern hero; he's also the romantic comedian who sent up everything and yet won through to the heart of Western art in the end.

In his earliest images, especially those grotesque "Inventions" of 1905, Klee eulogized the dying graphic traditions of Middle Europe and the nasty, angular style of the Viennese Art Nouveau. The work of the twenty-six-year-old artist was like a dry riverbed, full of peculiar fossils and queer remnants of lost civilizations. It looked like a dead end, until, at the beginning of World War I, he found it within himself to flood that old riverbed with the pure waters of modern French art, and suddenly everything sprang to life—a new life, full of unforeseen evolutionary leaps. For Klee—and for us—painting is a river or an ocean on which we venture forth. Nothing is fixed or solid, and we can look up, down, to left and right, forward and back. Painting is the Mediterranean, with its classical traditions; the Rhine, with its fairy tales and Wagnerian myths; but also the Nile and the River Styx. In some of his last pictures, Klee is climbing into Charon's boat, for a visit to Hell.

June 1987

THE SHOWS
MUST GO ON

The one-man gallery show is a nineteenth-century invention that freed artists from the tyranny of the Salon and the official commission and provided a very personal form of communication with the audience. By filling several public rooms with a range of recent works, artists could bring off an act of aesthetic self-revelation; and they're still doing this today, and the one-man show remains the essential way we see contemporary art. But the very intimacy of the contemporary art gallery, which is, among other things, an exclusive retail shop, militates against the one-man show's achieving any large-scale audience. The general public is rather isolated from the gallery scene, and so there has grown up, parallel to this primary experience of contemporary art, a secondary experience, in the form of the museum show—whether an annual, biennial, theme show, ten-year survey, or mid-career retrospective. For the cognoscenti, all such museum shows are a recapitulation of what they've seen in the galleries already; for the rest of the public, they're the closest they'll probably ever get to the primary gallery experience.

Unfortunately, museum exhibitions of contemporary art obscure much more than they reveal. Shows like New York's Whitney Biennials falsify contemporary art by treating it as a panoramic spectacle—as something that can be taken in with a swivel of the head—when in truth art is now more than ever before powered by personal, idiosyncratic visions. Some curators have acknowledged the weakness of the smorgasbord-style exhibition by organizing big shows that are made up of many little solo shows. Examples include the "Individuals" exhibition currently at the Los Angeles Museum of Contemporary Art, which covers a quarter century, and this past summer's ten-year survey, "L'époque, la mode, la morale, la passion," at the Pompidou Center in

Paris. These shows are an improvement, but they still have the effect of giving to the individual statement that is the solo show an irrelevant curatorial sanction. The Whitney Biennials and the Pompidou survey don't only report on trends—they make them, they force contemporary art into an officially sanctioned historical frame, and in doing so they place an unhealthy pressure on a gallery scene that would be best off left to its own often questionable enough devices.

It was much noted last spring that the 1987 Whitney Biennial had a very different look from the one in 1985. Where the 1985 Biennial had been neon-bright and casually erotic, this one was tasteful, severe. The show looked to some like a return to seriousness; but this was true only in the sense that gray flannel is serious. The Whitney show certainly had a new decor; its personality had changed. But personality isn't character, and the character of the Biennial remains unchanged. This show is still smug and dogmatic. It's nothing more than the place where the permanent government of the New York art world announces what's in and what's out. And yet Arthur Danto, the art critic for the *Nation*, who rarely reviews anything but museum shows and has a big following among the New York intellectuals, could leave the Biennial and reassure his readers that although the art was terrible, "the problem this year is not with the Whitney but with the world of art. What is shown is what, alas, alas, alas, there is." This may assuage the guilt of some few readers who don't go to the galleries but think they should—now they know they aren't missing anything. But there is a lot more out there than meets the Biennial's eye. A Biennial that overlooked Gabriel Laderman's terrific *House of Death and Life*—the ripest figure composition we've seen since Balthus last showed in New York—is not a Biennial I can believe in.

————

Bill Jensen, a gifted abstract painter last featured at the Whitney in the "Five Painters in New York" show in 1984, is now doing fantastical landscapes. His show at the Washburn Gallery in April, which consisted of watercolors that were either studies for or studies after his oils, was his least satisfactory exhibition in recent years. The illusionistic and illustrative elements in Jensen's images are getting out of hand. Jensen isn't a bad watercolorist; he's reaching to respond to the delicacy of the medium. But the dryness of the works in this show had the effect of

highlighting the extent to which Jensen's success so far has been based on a sensuously visionary grasp of images (and one wonders how much further he can go with that). In the watercolors Jensen renders forms tightly, schematically; his magic is on the point of evaporating. Without the weight of an oil paint surface to hold down his biomorphic shapes and moonscape hills and dales the pictures become distractingly 3-D. In watercolor the storytelling aspect of his work comes all too much to the fore; everything becomes overly clear. One misses those overworked groundswells of paint, those scraped and troweled surfaces—and the sharpness of the burin line and the bite of the acid, which give his prints their distinction. Just now, too much of Jensen's work brings to mind the modeled biomorphic forms of academic Surrealism.

How illusionistic can abstraction be? This is a question that is raised by Jensen's new work. This is also probably the central question raised by Frank Stella's *Working Space* lectures, which were given at Harvard in 1983 and came out in book form a year ago (Harvard). For Stella the third dimension means Caravaggio; and it's symptomatic of how charged with implications illusionism has become that the third dimension seems to carry as a sort of payoff, in Stella's telling, the promise of a Caravaggesque dramaturgy. Through some audacity or wishful thinking, Stella hopes to convince us that we can have Caravaggio's theater without his leering boys or histrionic Biblical characters. This sounds pretty farfetched, and yet Stella isn't alone in reaching for a New (Abstract) Baroque. Jensen's taste is tending toward the curvilinear and spatially flamboyant—characteristics of the Baroque. And in Al Held's show at Emmerich in April, the work, which has been illusionistic for years, looked quite a bit like a series of Piranesiesque interiors waiting for the figures to appear. Held, who has been closely associated with the art school at Yale, where representational painting has its strong advocates, may have taken a serious look at the work of contemporary figure painters. His paintings are mildly enjoyable in a sci-fi kind of way. When abstraction goes baroque, science fiction can't be far behind. In May, at Paula Cooper's SoHo gallery, Elizabeth Murray broke out into a series of cartoonishly baroque forms that looked rather like those of the sci-fi graffiti artist Kenny Scharf, who was showing a block away at Shafrazi and being hailed, by Dan Cameron in a catalogue essay, as really an abstract painter after all.

Abstraction was in evidence at this year's Biennial, and of a variety—

teeming with incident—that might have seemed, a decade ago, the nec-
essary antidote to Minimalism. Yet the canvases of George Condo and
Lari Pittman, which are very busy works indeed, prove little except
that more can be a bore, too. These artists have a most debased sense
of the Surrealist imagery out of which they are working; for them,
symbolic abstraction is an idea with no grounding in the experience of
the medium. Condo and Pittman are being called post-Conceptual paint-
ers—and the tag fits, because they see painting from the outside, as if
one could lay claim to painting without accepting the demands that
painting makes upon the artist. The real movement within abstraction
is more interesting than the pseudo-avant-garde painters represented at
the Biennial could possibly imagine. The revolutionary mission of ab-
stract art is now spent, and so abstraction must succeed as a genre of
painting with no greater or more urgent hold on our imaginations than
any other. Perhaps it's this normalization of abstraction that makes its
relation to representation seem far less an adversarial one than here-
tofore.

We need only look to the Klee show last spring, or to the beautiful
Miró show that was at the Guggenheim over the summer, to see that
abstraction can be many things, and that it can be more or less abstract.
But to the extent that contemporary abstraction does become more
variously expressive, it will have to give up its post-World War II stance
as the supreme public decorative art. In *Working Space* Stella argues for
the importance of the arcane symbolic images of the later Kandinsky;
but as a painter Stella doesn't bring to mind those miniaturized universes
of Kandinsky's Parisian period, probably because they wouldn't, after
all, do anything for the lobbies of the corporate headquarters where
Stella has been apotheosized. Bill Jensen interests us because he wants
us to know about an experience—a revelation, a moment of insight—
that he's had while alone in his studio. For the catalogue of last summer's
Corcoran Biennial, to which some exhibitors were asked to contribute
a statement or some quotations, Jensen offered Georges Braque's beau-
tiful mystical words about painting being a process of impregnation,
hallucination, obsession.

———

Though the needlepoint pictures of Nicolas Moufarrege weren't
included in the 1985 Whitney Biennial, they epitomize that infamous

Biennial's mood—they epitomize it and they transcend it; they prove that low-culture images can be transformed into high-culture fun. Moufarrege, who died young in 1985, was the subject of a memorial exhibit at the Clocktower this past summer. His pictures are high-camp confections, but they're constructed with an elegance that holds you—and holds in your mind.

Born in Alexandria, Egypt, of Lebanese parents in 1947, Moufarrege came to the East Village via Beirut and Paris. According to Rene Ricard, in an obituary that was first published in the *Village Voice*, "He invented the Lower East Side. 'Nicolas Moufarrege made me,' Gracie Mansion [the art dealer] insists. Of course, she's right. But nothing was too big or too small to escape the scope of his enthusiasms and he could always see the future in things." We've heard a good deal about how hot the East Village scene was when it was really hot (it seems to be finished now); but Moufarrege may be the only artist who got some of that kitsch-without-end spirit into a form that has staying power on a gallery wall. Moufarrege seems—from the evidence of his art and his writings (in *Arts* and other magazines) and the comments of his friends (which have been collected in the Clocktower catalogue)—to have had some of the exotic charm and oracular charisma of an earlier emigré painter and author, John Graham.

Moufarrege began working in thread on needlepoint canvas while he lived in Paris in the seventies, but the architectural fantasies that he did back then, in which skyscrapers and fragments of classical architecture float around in an indeterminate tan- or rust-colored space, aren't anything much. They have a sort of Art Deco élan that may have passed for chic in Europe a decade ago; it looks pallid and artsy-craftsy today. Though Moufarrege is said to have been poor in Paris, he managed to have a show with Jacques Damaze, an elegant dealer associated with Sonia Delaunay and other School of Paris figures; perhaps the understated decorativeness of his Paris work was born of a misguided attempt to do something really classy. When Moufarrege arrived in New York in 1981—he became, almost immediately, a figure at P.S. 1, the alternative space in Long Island City—he was released from good taste into our Baghdad-by-the-Hudson, this democracy of trash.

In the four years he worked in New York, Moufarrege held onto his embroidery technique, and it's this anti-high-art technique that gives

his work its warmth and its insouciance, its blithe unwillingness to compete with the "grown-up" domain of paint on canvas. But if Moufarrege didn't put himself into competition with high art, he still kept broadening the range of his work: as time went on he switched to full color and made his references both more various and more specific. His first gallery show, at Gabrielle Bryers in 1983, consisted of long, scroll-shaped canvases, on which he unfurled a glittery array of comic-strip superheroes, warriors from nineteenth-century Japanese prints, fragments of Picasso, and Arabic words. Moufarrege worked on the see-through needlepoint canvas in colored and metallic threads, leaving some areas bare, painting on others, encrusting fake rhinestones and pieces of junk jewelry. He built up a lavishly tacky Arabian Nights surface— an overloaded surface, layered with outtakes from his image-saturated brain, where, as the artist remarked, "East and West, Michelangelo and the Sheik of Araby, Coca-Cola and the Eiffel Tower" mingled. The 1983 scrolls are small by the standards of today's art—a foot and a half high, four or five feet wide. They don't blow up all those pop images; they bring them into the artist's own microcosmic world.

One key work from 1983 has at its center a drawing of a wide-eyed, open-mouthed boy wearing a pair of big, old-fashioned earphones; he looks like something out of an illustration in an elementary-school textbook. This ham-radio kid may be a stand-in for Moufarrege; around him, to left and right, unfold the artist's rollicking cartoon imaginings, a stream of zips and zaps from comic books, *Guernica*, the nineteenth-century printmakers Kuniyoshi and Yoshitoshi. To the left, there's a greeting-card Santa Claus, who holds a gift list on which are inscribed the words Hiroshima, Nagasaki, Vietnam. Moufarrege doesn't force these names on us—he just drops them there and lets the horrific downside of modern life intermingle. The buccaneers of kids' TV aren't really anything I want to look at; but Moufarrege's juxtapositions keep me interested in these modern kiddie icons. In a painting where a superhero in green trunks is shown as responsible for the dismemberment of one of the figures in *Guernica*, the convergence of high and low sources really clicks.

The works from 1984 and 1985—they were shown at the FUN Gallery just after Moufarrege died—are very different in temper. The color tends to primaries or clear pastels; the mood isn't any longer

smarmy and overheated. Here Moufarrege is joining rectangles of pop or high art imagery into Constructivist designs. The combination of elegance and silliness is one we know from a great deal of mid-eighties art; but when Moufarrege combines a Roy Lichtenstein and a van Gogh, or a Fragonard and a Picasso, he's not doing it for free-floating ambiguity. Instead, Moufarrege builds a little story in each of his pictures. In one there's a cartoon of Donald and Mickey going fishing, and the balloon over their heads, with its exclamation "LOOK MICKEY . . . ," refers to the hunk of a male torso they've pulled in from the lower left. The silliness of the Disney image cuts the allure of the rippling muscles—it's a gentle joke on cruising. Moufarrege is a Roy Lichtenstein aficionado—which I'm not—but I like Moufarrege's Pop takeoffs anyway. When he redoes Lichtenstein in needlepoint he seems to me to (1) bring this Pop artist down to his real worth, as an amusing illustrator; and (2) extend the jokes. Moufarrege joins a Lichtenstein of a girl moaning, "OH JEFF . . . I LOVE YOU TOO . . . BUT . . ." with a half-filled-in paint-by-number landscape, which becomes a representation of her confused mind. The Lichtenstein woman who's drowning, exclaiming, "I DON'T CARE! I'D RATHER SINK—THAN CALL BRAD FOR HELP!" overlaps a detail of Hokusai's *Great Wave*; and the blonde, her hair blown by a city breeze, wondering, "M-MAYBE HE BECAME ILL AND COULDN'T LEAVE THE STUDIO!," is set beside a van Gogh self-portrait, with the bandaged ear. Some of these images are framed in rectangles of Mondrianish red, yellow, and blue; the pictures are like little skits, played out in the prop room of world art. And the needlepoint technique is quite interesting; Moufarrege works the thread in different directions and lengths for texture, for movement.

The more Moufarrege gets into high culture, the more interesting the work becomes. In some of his last works he combines needlepoint pictures, needlepoint canvases preprinted with images from Fragonard, Renoir, or Guido Reni, and inexpensive neo-Egyptian yard goods. When Moufarrege gives us two needlepoint canvases after a Fragonard next to each other, he reminds me of Joseph Cornell, who paid homage to Bronzino and other great artists by filling boxes with reproductions of their work. Cornell and Moufarrege don't use mechanical copies of masterpieces in order to devalue art; they mean to show us how the aura of a masterpiece survives even in these debased, ghostly forms.

There's humility in the references: these modern artists are confiding in us, telling us that they want to make their own private museums out of the art of the past. These miniaturized museums are an eccentric response to the flesh-and-blood museums that Cornell and Moufarrege probably found impersonal, overbearing. Cornell and Moufarrege are saying that reproductions are all they can take: confronted with the real thing, they'll OD.

One untitled painting from 1985 is about graffiti through the ages. A Lichtenstein-style hand holding a spray can is juxtaposed with two Fragonards of a girl carving on a tree trunk, over one of which Moufarrege has graffitied, in needlepoint, his own name, NICK. (This made a beautiful cover for the Clocktower catalogue.) In *Music*, a Renoir of two girls at the piano (partly needlepointed) is set into a larger rectangle of cotton fabric printed with Egyptian tomb paintings of women playing music. Joined to this is a Lichtenstein of a woman who hears bars of music coming through a window. The ensemble is seductively fey. It works because of the little flickers of embroidery, the amusing juxtapositions, the informality of it all. Moufarrege is making love to the whole image world of East Village New York—and he doesn't use his knowledge to aggrandize himself, or make it all seem more important than it really is.

The temper of Moufarrege's work reminds me in some general way of Frank O'Hara's poetry. There's the same supersophisticated appreciation of the surfaces of urban culture; there's the same faintly Dadaist lack of depth. I can imagine Moufarrege admiring the young man in the orange shirt who, in O'Hara's "Having a Coke with You," looks "like a better happier St. Sebastian." I can imagine Moufarrege, with O'Hara, waking up in the morning and exclaiming, "oh god it's wonderful / to get out of bed / and drink too much coffee / and smoke too many cigarettes." And surely Moufarrege would have told the "Mothers of America"—

> let your kids go to the movies!
> get them out of the house so they won't know what you're up to
> it's true that fresh air is good for the body
> but what about the soul
> that grows in darkness, embossed by silvery images.

The appeal of Moufarrege's work rests in its tomorrow-we-shall-die exuberance. It's an attitude that's knit into the fabric of a city like New York, where the line between art and fashion isn't always clear, and where both art and fashion can be seen as an affirmation of the present, an assertion of the marvelousness of the moment. Moufarrege catches something of this moment. His compositions are brilliant afterimages from the fast-track life of modern bohemian New York.

———

In May at Sperone Westwater, Carlo Maria Mariani showed a series of portraits of art-world luminaries—Jasper Johns, Julian Schnabel, and so on—done in a highly finished academic style. These were accompanied by some of the oversized portraits of thick-limbed, sentimentally Neoclassical boy-gods that Mariani, who was born in 1931, has been doing for a number of years. The show demonstrated a certain level of traditional technical proficiency wedded to a very mopey sensibility. This combination of conscientious manual labor and mental sloth is common among the many artists who have in recent years (in both Europe and the United States) taken up a Neoclassical style. In America the Neoclassical revival began as a humanistic critique of established modern values; as it has turned out, the work sells like hotcakes.

A show that included Mariani, called "Modern Myths/Classical Renewal," is touring around the country this fall, and though I haven't seen it, I've been pretty familiar over a period of years with the work of many of the artists included and have watched as their painting has gone from problematical to hopeless. Ten years ago Martha Mayer Erlebacher was struggling to achieve a Düreresque clarity of form and did some portraits and figures that had a blunt, simple dignity; but as she's begun to feel comfortable with her technique, her unpardonable bad taste, which runs to nudes surrounded by picnic debris, has taken over, and that technique of hers now looks as trite as Paul Cadmus's. Something similar has happened to Bruno Civitico, whose early nudes had a sort of primitive charm, but whose work is increasingly hard and unfeeling. Once certain technical matters have been mastered, these artists collapse into mannerisms. All along, no doubt, they've been trying to fit themselves into a fixed idea of what classicism is. They think there's one classicism, when of course classicism must be rein-

vented by every generation and is different for Phidias, Botticelli, Raphael, Poussin, David, Puvis. Like the Pre-Raphaelites, these current artists are in love with an idea that exists mostly in their own sentimental imaginings. They're totally uncritical about the draggy side of classicism. Poussin's second *Et in Arcadia ego* may be a masterpiece, but who wants more pictures of shepherds mooning over old tombs? No one since Puvis has used a tunic or a toga convincingly—and Puvis, though a great painter, is a great painter in spite of the sentimentality of his art.

Richard Piccolo, who had a show at the Robert Schoelkopf Gallery in May, has one foot in the Neoclassical thing. Since his first one-man exhibit at Schoelkopf in 1975, he's toyed with arcadian themes, but he's had the good sense to give his nostalgia a more pointed form. A longtime resident of Italy, Piccolo invites us into an eighteenth- or nineteenth-century Italian provincial world, where broken statuary and other reminiscences of classicism are found amidst the rustic furniture and earthenware jugs, and where the young women look to be the descendants of a Roman muse. In other words, Piccolo is up front about the romanticism of his classicism.

Piccolo's 1975 show, a virtuoso debut, consisted of brooding seventeenth-century-looking landscapes, in the foregrounds of which oversized vegetables loomed surrealistically. There were problems with those paintings. The foregrounds and backgrounds didn't go together, the compositions didn't exactly click; but the pictures had brilliance, and an enviable esprit. As time has gone on, Piccolo, unlike the other Neoclassicists, has held onto his esprit; but like the rest, he's gotten into a bind where his retrospective mood makes it impossible for him to break through. His eyes are focused on the past, and so there's something crotchety about his figure compositions, in which a young woman frequently sits near a table on which some interesting objects are arranged. The figure painting is stiff, but it's probably a difficulty not with knowing the anatomy so much as with finding a way to express that knowledge. What we miss is a guiding principle, a practical plan.

It's in the smaller paintings that Piccolo's beautiful feeling for grayed-over, pink-and-green color combinations, and for the way a brush can bring a surface to life, pulls him through. His small Italian landscapes—with their stormy weather and their mountains, roads,

houses, wee figures—are like essences of Mediterranean history. Two tiny still lifes in the recent show, representing the sculptor's and the writer's table, were the kind of deliciously deft pictures you might expect to find in a corner of an old museum and linger over. I wasn't quite clear on how the allegory in these two still lifes was supposed to go— I couldn't identify all the objects—but their nostalgia, for the days when an artist could work quietly in a rural hideaway perfecting his métier, had a certain urgency and carried me along. I didn't leave Piccolo's show with my back up, as I usually do when a contemporary painter seems intent on convincing us that they did everything better in the olden days. (What kind of an attitude is that for an artist who's painting *now?*) There's much that's experienced firsthand in Piccolo's painting; he's obviously exhilarated by what he's doing. He's a very odd phenomenon: a real artist caught in the grasp of an unreal idea.

———

Though Nell Blaine, who was born in 1922, began as an abstract painter back in the forties, you wouldn't know it from the cozily ebullient flower pieces and still lifes and landscapes she's been doing since the fifties. Seldom more than a couple of feet in any direction, and full of the kind of old-friends-in-combat clashes of alizarin and green or orange and blue that have been a staple of neo-Fauvist painting for seventy-five years, Blaine's canvases don't grab out at the viewer or make a dashing impression hanging on a wall. Each of her bouquets or unexceptional New England vistas appears self-involved. Her brushwork, which is made up of jots and flashes of oil paint, is like a kind of sloppy knitwork, pulling the surface together casually, erratically. Though Blaine is without a doubt the best flower painter at work today, her painting can sometimes seem a little dull, and though I've followed and admired her work for years, I've also missed a show here and there, because it didn't seem urgently necessary to go.

Blaine's exhibition at the Fischbach Gallery last April astonished me, and I'm not entirely sure why. It may be that I'd just come from that sullen Whitney Biennial and was itching for someone who knew how to paint. Or it may be that I'd forgotten to what a degree Blaine really inhabits that world of hers. Or it may be that this show really was a breakaway one for Blaine. Whatever the reason, the two rooms at Fischbach were dazzling: Blaine was going great guns, carrying all

before her. The show included the best Blaine landscape I've ever seen, *Gloucester Harbor from Banner Hill*, a horizontal, quivering vision in which the artist manages to be true to the bobbing boats of a small New England harbor and the dull vegetation on the nearby shore and also to fill it all with some personal warmth and intimacy—a sense that these things are seen through *her* eyes. Better yet was a still life called *Summer Interior with Open Book*, a view of an overloaded table, a set of sliding glass doors, and the garden outside. The scene itself is insistently unchic—everything crowded and ordinary, reflecting a messy summerhouse generosity. With its book and vase full of flowers and miscellaneous objects, this painting is shut up tight when you first look at it; but gradually it begins to break open, with rivulets of color slipping this way and that in space, carrying you over an object, out the window, around a shrub. Blaine's color is pretty, but with a tough edge. One could almost say that her toughness rests within her prettiness—an artist has to be rather tough to dare to paint pretty nowadays.

Fairfield Porter once wrote this in defense of Raoul Dufy's habit of painting the same subjects: "To ask why he did again and again what he had succeeded in once is to miss the importance of a pleasure repeated, like orange juice for breakfast every day." That's probably how Blaine feels about the repetition in her work, too. Her subject is the extraordinary lift one can receive from ordinary things. Several young artists I know who are attuned to the kind of work Blaine does didn't get much from her show, which makes me think that perhaps hers is an especially grown-up sensibility. Her work comes out of an acceptance that this-is-the-way-it-is. Her magic is in the way she takes you into a normal but beautiful world. She doesn't take a form and clarify it, as Louisa Matthiasdottir will do when she paints a still life or a bouquet. Matthiasdottir improves on nature—she almost geometricizes it. Blaine gives nature to us with all the messy bits intact. Blaine's bouquets, with their daffodils and anemones and roses, all very plain and very lovely, aren't arrangements. They flop around in a jar or a vase, or stand packed together in a clump, just as they came in from the garden or the florist's shop. These beautiful blazes of color are often plopped right in the middle of the canvas, like a centerpiece on a table. Half a dozen of the flower pieces in the recent show were extraordinary. Of *Carnival Bouquet* I can only say that it lives up to its altogether appropriate name.

Blaine is one of the valuable group of painterly realists who came

up in the early fifties. Along with Leland Bell and Louisa Matthiasdottir, she was a member of the Jane Street cooperative gallery; their work—like that of Jane Freilicher, Fairfield Porter, Robert De Niro, and some others—has for years now had a discerning and appreciative audience. Blaine has had forty-eight solo shows, and this amazing number speaks for a life of bouquets, landscapes, interiors—a life of experiences, re-corded in her no-nonsense style. Of course we can get worn out by the long line of her one-woman exhibitions, year upon year, each rather like the one before, a series of nearly like experiences. And yet when Nell Blaine's show was up in April, simultaneous with the Whitney Biennial, those two rooms at Fischbach on Fifty-seventh Street had an urgency and an immediacy that put everything else in New York to shame.

September 1987

WELCOME TO BERLIN

"Berlinart 1961–1987," at the Museum of Modern Art this past summer, was a show that wore its heart pinned ostentatiously on its sleeve. The galleries were lined with paintings done in a thumpingly Expressionist vein. Most of the remainder of the one hundred and fifty works by fifty-five artists were neo-Dadaist gimcrackery—assemblages, found objects, and the like. Though the paintings weren't especially large by contemporary standards, many of them were too big for the galleries. They loomed forward, overwhelming the glass-fronted cases full of artists' booklets and collagelets. Nothing harmonized; the galleries had a helter-skelter look. Kynaston McShine, senior curator in MoMA's department of painting and sculpture and the organizer of "Berlinart," had transformed the Modern's temporary exhibition spaces into a playground of the avant-garde. This playground—outfitted with the sights of West Berlin in the wake of the Cold War—was melancholy, run down. There was barbed wire, darkness, dirt. "Berlinart" was all sloppy surfaces and portentous undercurrents. The art may not have been anything much, but the subtexts —of East-West relations, war and peace, the Nazi past—were being played for everything they were worth.

Since the sixties a good deal of national and international money has been injected into the Western sector of Berlin in a largely successful effort to turn the city into West Germany's art center. The plentifulness of such artists' subsidies as the DAAD Fellowships (which brought Allan Kaprow and Edward Kienholz, among others, to the city), along with the city's tradition of cultural and sexual recklessness, has made West Berlin very popular among the contemporary international avant-garde. Eleven of the artists in "Berlinart"—including Christo, David Hockney,

and Malcolm Morley—have been visitors to Berlin from the West; others, such as Georg Baselitz, are refugees from the Eastern bloc. Artists come to Berlin, get caught up in the strange mood of the place, and stay. The American novelist Edmund White has said that visiting Berlin made him feel an anxiety "unlike anything I'd ever felt before in my travels. . . . In New York I feel overwrought but optimistic, in Paris sane if sad, but in Berlin I was *anxious* in both senses of the word—excited and uneasy."

White—and other admirers of the city—refers those of us who haven't experienced Berlin firsthand to Peter Schneider's short novel *The Wall Jumper*, published in Germany in 1982. Schneider summons up the Wall indirectly, through accounts of the famous or bizarre crossings that have taken place since the structure went up in 1961. The folklore of the Wall—brought into play by Schneider with a casualness that gives his novel its contemporary charm—is, of course, a metaphor for the things that divide us. But the image of the Wall is also the glue that holds together the narrator's fractured reminiscences of evenings in cafés, visits to the Eastern sector, life in an old apartment building, and a love affair gone bad. While the narrator—like, probably, most of West Berlin's bohemian populace—takes a certain leftism for granted, he's not attached to any particular political hopes or ideas. The conversations he has with his friend Pommerer, a dissident writer who lives in the Eastern sector of the city, are circular, dull, fatalistic. Everyone, it turns out, is more a prisoner of his national identity than one might wish to believe. In *The Wall Jumper* there isn't much free will. While Berliners resent the Wall, they also depend on it as a source of national definition—it tells them, East or West, who they really are.

The "Berlinart" show was full of the iconography of Schneider's novel. We saw the airplanes that take visitors in and out of the city; the dark streets; the interesting, squalid night life. To celebrate Berlin is to celebrate the artificiality of the place—an essence, perhaps, of modern urban experience, which no one, after all, ever claimed would be easy. At "Berlinart" the violent, ironic spirit of the city is invoked through a few stark oil-paint images: K. H. Hödicke's screeching black and yellow cat (called *Nocturne*); Helmut Middendorf's zany, break-dancing *Painter*. I say images advisedly—they hold you in the manner of emblems or

graphic signs; they don't come to life as paintings, as fulfilled works of art.

In modern art, Expressionism invariably spells dissent, from norms of behavior in the aesthetic, social, and political realms. It's a natural style to express disaffection and probably came easily to the German artists of the years after World War II, who had every reason to be cynical and pessimistic. Expressionism also attracted the postwar generation because it had a tradition in Germany—in the Weimar Republic and, some would say, in earlier centuries. (A number of survivors of the old guard, including Karl Schmidt-Rottluff, Max Pechstein, and Max Kaus, taught at Berlin's College of Visual Arts after the war.) While it's tempting to see the Expressionism of recent years as an extension of the work of the teens and twenties, the pre-Nazi heritage may actually have been something of a liability for artists coming up in the fifties and sixties. Much of post-World War II Expressionism has a dangerously parodistic element. Even Donald Kuspit, a supporter of the new Expressionism, has observed, "It is hard, today, to authentically strike the note of strangeness or estrangement that was so crucial to the original Expressionists." We're seeing the jagged figures and camp-fire-bright colors for a second time. The effects are leftover, reheated.

The great Expressionists—Grünewald, El Greco, Picasso in the thirties—distort nature so completely as to produce through their distortions a new kind of completeness. They may do violence to the traditions of figure composition, but they're in full command of those traditions, and so no matter how violent their manner becomes we aren't left confused—our trust is never violated. Max Beckmann is the only modern German who understands Expressionism in this positive sense. Kirchner, Kokoschka, and Schmidt-Rottluff may be living through an authentic existential crisis; they're full of rage, they're lashing out; but they don't have enough of a grasp of painting as an ongoing history. They're strongest in their graphic work, where undertones and resonances aren't essential. Their paintings have too much the air of random gestures—hasty, reactive, superficial. To the extent that post-World War II artists such as Baselitz, Middendorf, and Hödicke mean to return to an old modern standard of national style, they're confusing a non-repeatable aesthetic revolt with a usable past.

The best among the Expressionists in "Berlinart" have raw talent and little more. Certainly Rainer Fetting has it. Born in 1949, Fetting teamed up in 1977 with Middendorf, Salomé, and Bernd Zimmer to form the Galerie am Moritzplatz in Berlin, where much of the new Expressionism made its first appearance. Fetting's big, homoerotic *Large Shower* is a ripsnortingly flashy piece of painting. It's a sixteen-foot-long scrawl—black and blue profiles with slashes of red and yellow flesh. Fetting works like a stage designer, setting the mood. And he keeps the twists and turns of paint vague enough that we feel as detached from the *Large Shower* as we do from a theatrical backdrop. *Large Shower* is a painting to do something in front of; it's all premise with no development, no follow-through.

"Berlinart" brought the Museum of Modern Art back to a taste for sloppy, sensationalist figure painting last featured in the "New Images of Man" show of 1959. Salome, one of the younger painters in "Berlinart," was represented by a *Self-portrait* in clown makeup, red jockstrap, and barbed-wire-clad legs. Salome vacuum-packs a vertical shaft of Modern Man into a lot of flat, unembellished space. He plays the loneliness-of-humanity theme in rather the way Bay Area realists like Nathan Olivera did a quarter century ago. In both fifties California and contemporary Berlin, Modern Man is dragged, kicking and screaming, into the studio: only provincials try to express emotions so directly. The roomful of paintings at MoMA by Baselitz, who was born in 1938 and was a guru for the new German Expressionists, presented the artist as butcher, serving up pieces of human flesh. Baselitz doesn't construct the figure—he alludes to it, as a symbol charged with all kinds of inchoate but sinister implications. Picasso may disfigure nature; Baselitz and the other new German Expressionists disfigure art.

If the Expressionism of "Berlinart" is meant to add up to one of those end-of-formalism statements, it makes a very weak case. While the formalists of the sixties underestimated the range of experience that could be expressed in modern art, these Berlin Expressionists are all too caught up in the glamour of subject matter. There's a conventional and even gossipy attitude lurking behind their angst. The painting is illustrative in the worst sense of the word.

Life may be a hell of a lot more important than art—but who ever went to an art museum to find *that* out? The story told in "Berlinart"

is full of the politics of the sixties and seventies: the Wall, the antiwar protests, the ecology movement. The informative catalogue includes some photographs of the late Joseph Beuys, looking a bit Buster Keatonish as he presides over the youth revolt in his ubiquitous hat. As a member of that youth revolt who would do it all over again, I think I understand the mystique of a Beuys work such as *Sweep Up*, a plexiglass box full of some litter that was collected with a red broom after a 1972 May Day demonstration in Karl Marx Square in West Berlin. *Sweep Up* is a plea for litter-free cities, an archeological dig into the politics of protest, a nostalgic souvenir of a moment of solidarity. It's all of this— but it's meaningless as art. Who wants to look at some old trash and a wooden broom lying at the bottom of a plex box? As a museum piece *Sweep Up* was dead on arrival. Which, depending on your point of view, says something devastating about museums, or about Joseph Beuys.

The work of Beuys and the Fluxus group, who did performances and sent little art packages through the mail on both sides of the Atlantic for several decades, is praised for its wit, drama, magic, mystery. The engine that really drives all of it is something more like Fear of Cuteness. When you park a Volvo station wagon with shovels spilling out of its hatchback in an art gallery, as Beuys did in his 1983–85 piece *S.I.U. Dfesa Della Natura*, you're working out of no known pattern, you're trying to get from ground zero to something totally new, and you're liable to end up with something that's merely novel—the work is in danger of looking cute. Stripping down and scaling up kept cuteness at bay in Pop, Minimal, and Conceptual art. Beuys, with his more saturnine European sensibility, added to the anticuteness arsenal the grossout (as in a dead rabbit carried around a gallery) and (this is the ultimate) his own true-life tale of death and resurrection. Much of Beuys's work alludes to the central experience of his life—a close encounter with death that occurred during his stint as a German fighter pilot during World War II. His plane was shot down over the Crimea and he was saved from subzero temperatures by nomadic Tartars, who wrapped his freezing body in fat and felt. It's a great story, full of interesting implications, which engendered from the studio of Joseph Beuys many stupid-looking pieces of fat and felt that have ended up hanging, leaning, and lying in art galleries and museums around the world.

Though anything is possible in art, most things are impossible. And most things that are possible have been done, in one way or another.

Environmental art? Think of Bernini's fountains and the twisting paths
in the Boboli Gardens. Real creativity is in the slight variations—the
shifts in point of view, in the uses of technique—that add a degree or
two to our field of vision. At certain places, "Berlinart" looked like a
dumping ground for experiments gone awry. There were exhibition
cases full of collages and limited-edition books that had a wayward,
melancholy tone. These included many odd little bits of paper full of
private jokes, insider's information: papers that have been doodled on,
colored in, printed up, put in boxes, sold in galleries. This graphic work
is superficially hermetic. It lacks the decorative or typographical élan
that kept some of the original Dada pamphlets alive by turning antiart
propaganda into art.

For the Museum of Modern Art, "Berlinart" represented a bow to
Neo-Expressionism and the contemporary international avant-garde. As
a media event, however, it came some years too late. Opinion makers
in New York had long ago wearied of Neo-Expressionism, and the news
that there's news from Europe has been told too often to be even mod-
erately diverting. In trying to be with-it, MoMA seemed all the more
out-of-it; yet our premier modern-art museum will no doubt keep trying
to be with-it, because with-it is what the audience thinks it wants. No
one ever learns from the mistakes of the recent past—not from the
incoherent "International Survey of Recent Painting and Sculpture"
with which MoMA reopened in 1984 (organized, like "Berlinart," by
Kynaston McShine); not from the namby-pambiness of MoMA's re-
cently resuscitated "Projects" series, which features little solo shows of
contemporary art (it ought to be called the "Compromises" series).
MoMA's attempts to cover the contemporary scene are Band-Aid op-
erations. Worse yet—the museum passes off advocacy as history; it
grinds axes while pretending to build a consensus. Whatever one may
think of the taste represented by such relatively youthful New York
institutions as the New Museum, P.S. 1, and the Clocktower, they do
perform a community service. They make no bones about being in the
business of promoting certain ideas; they reflect the interests of a sub-
stantial segment of the New York art world (and they sometimes get to
artists before they've been had for lunch by the commercial galleries).
The Modern, the Guggenheim, and the Whitney ought to know by

now that they have a different role to play in this great center of art. They're the guardians of the past.

MoMA has always had an interest in historical shows—they were part of the museum's program from the first. Only recently, though, has MoMA become interested in apocalyptic shows. In a period of prosperity the middle class likes to titillate itself with fantasies of its own demise—preferably against some foreign backdrop and, if at all possible, *mit Schlag*. Such was the attraction of the "Vienna" show in the summer of 1986, an exhibition that was long on ambience and short on significant art. When you told people that Klimt (the main attraction at "Vienna") wasn't a great painter, they sometimes agreed, but they rushed to defend the show, saying something about Wittgenstein, Freud, Strauss, none of whom was included, all of whom were in the air. "Berlinart" was a Vienna show for the jet-lag generation. It was another look at the nerve ends of capitalist culture, only this time without the Wiener Werkstatte frills. Graffiti is the new ornamental style. "Berlinart" was a fantasy about the ultimate Cold War town, the town where the Cold War got hot and spewed forth its symbols: a Wall, a Gate. The art provided the props. You were supposed to provide the imagination that brought the fantasy to life. You were supposed to make believe you were knee-deep in the anxiety of Berlin, only not one of the one hundred and fifty works on display could make you believe. "Berlinart" was an embarrassment.

October 1987

SECOND SEASON: 1987–1988

POLLOCK AND COMPANY

There may be very little left to find out about the Abstract Expressionists, and yet some force keeps attracting writers to the old personalities and disputes, and it's not just publish-or-perish. Each author sets off into the New York of the forties and fifties, passes by the same galleries (Julien Levy, Peggy Guggenheim, Betty Parsons), the same critics (Robert Coates, Clement Greenberg, Harold Rosenberg), the same artists (Gorky, de Kooning, Pollock). One writer distinguishes himself from another by taking up a formalist or an anti-formalist line, by focusing on biographical facts or political events. Still, they all follow much the same path, and they all more or less end up with what Irving Sandler called, in the irresistible lingo of bestsellerdom, *The Triumph of American Painting*. Serge Guilbaut's recent academic best-seller, *How New York Stole the Idea of Modern Art*, may be wildly fantastical in its intermeshing of Cold War and avant-garde, but it also belongs to the literature of triumph, to which it offers a new type of hagiography, whereby the artist becomes a martyr to Pax Americana.

The catalogue of an important exhibition, "Abstract Expressionism: The Critical Developments," which has been mounted at the Albright-Knox Art Gallery in Buffalo this fall, is perhaps most memorable for giving Abstract Expressionism a sprinkling of fashionable French ideas. Whatever one may think about Foucault and structuralist terminology, this modern Continental thought is too elegant and self-consciously clinical to shed much light on the New York avant-garde of the forties, with its blunt directness in style, discourse, and ideas. In most of the eight essays in the Albright-Knox catalogue, theory is a dressing that smothers the raw ingredients of history. The terms in Richard Shiff's

essay, "Performing an Appearance: On the Surface of Abstract Expressionism," may be "indexical" and "iconicity," but they ultimately seem to refer to old reliables, such as abstract and representational. Why, in this case, all the bother? No doubt to convince us that the old dish of Abstract Expressionism has the allure of a newer nouvelle cuisine. At least Ann Gibson's essay, "The Rhetoric of Abstract Expressionism," has a surprise ending, where the reader who persists will meet this stunner: "One could, then, with hindsight, define the late procedures of certain Abstract Expressionists as postmodern." But perhaps this is only to heap Pollock and Newman with further praise, postmodern being a current euphemism for important, significant. And why not postmodern? Serge Guilbaut had already concluded his book by referring to Pollock as the granddaddy of the students who closed down the university at Nanterre in 1968 and scrawled on a wall the message, "The porridge you forced down my throat as a kid: I've come with it all over your wall."

The whole subject of Abstract Expressionism seems to wither beneath the mercilessness of the attention, or maybe all of this is a form of inattention. Surely there's too much busyness about the writing of essays, the gathering of bits of data. No one would dare doubt that Gorky, de Kooning, Pollock, Newman, and a few others are the foundation upon which the glorious edifice of American art has been built. Perhaps, unconsciously, there's a sense among those who labor in the field that one shouldn't look too carefully at the works themselves. After all, if Abstract Expressionism turned out to be not quite all that has been claimed—if Pollock isn't the heir to Picasso—then the whole edifice of Pop, Minimalism, Conceptual Art, and Neo-Expressionism might begin to tumble down. We need Abstract Expressionism; it's our birthright, the key to our legitimacy.

Certainly Deborah Solomon, in her new biography of Jackson Pollock (Simon & Schuster), takes as a given the centrality of her subject to the history of twentieth-century art. Solomon opens with Pollock exclaiming in 1946, a year after the end of World War II, "Everyone is going or gone to Paris. With the old shit (that you can't paint in America). Have an idea they will all be back." This is supposed to set an upbeat mood; but Solomon's book isn't in the triumphal mode. She

appears from her writing to be a perfectly nice and reasonable person, and I found myself wondering why she'd undertaken the biography of someone who was an alcoholic and given to self-destructive love affairs. Solomon doesn't seem to care all that much about Pollock's art. There's no energy to this book—no positive point of view. Whether this is because Solomon was trained as a journalist rather than as an art historian and can't quite grasp the art scene, or because she's temperamentally opposed to writing uplifting prose, or because she has doubts about Pollock's importance, I don't know. This biography has so little imaginative dimension that a couple of days after I'd finished reading it I couldn't exactly remember if I'd made it to the end. Solomon may have thought it was a good idea to take a singularly unromantic view of Pollock, and at first a reader will appreciate her clean-lined approach. But it rapidly becomes clear that Pollock's life makes no sense at all if it isn't given some romantic spin. If Solomon's point is to demythologize Pollock, then an article would have done.

The fascination of Jeffrey Potter's *To a Violent Grave*, the oral biography that came out in 1985 and from which Solomon has borrowed quite a few anecdotes, is in hearing the voices of the actual participants in Pollock's life as they talk on like a Greek chorus intoning the holy name—Jack, Jackson, Pollock, round and round. Potter's tape-recorded conversations don't exactly add up to a book, but they do give us the mood of the period, or at least of the period as seen through the retrospective gaze of those who were there. As the monologues proceed, you begin to imagine the ashtrays filling up with cigarette butts and the thick voices each stopping for a minute as one after the other of the survivors gets up to fix another drink. They're a circle of old-timers— adoring, envious, disgruntled, nostalgic, embittered—all weaving their stories around the golden boy from California. Solomon and other biographers reproduce a photograph taken when Pollock was sixteen, two years before he came to New York, in which he looks like a beautiful innocent angel. It's never quite clear if Pollock's story is about what he did to New York—or about what New York did to him.

The problem with Pollock as a subject for biography is that as a person he isn't especially interesting. The idea of his being a genius is something you submit to or reject. Elizabeth Frank, in a short monograph published in 1983, accused an earlier biographer, B. H. Friedman,

of sentimentality. But reading Friedman's *Jackson Pollock: Energy Made Visible* beside Solomon's new book, I rather felt the advantage was with Friedman, who'd packed his book with all the activity of the art world—controversies, gossip, interlocking friendships. Solomon, writing a popular biography, doesn't expect her readers to be terribly interested in the ins and outs of the art world (she may be right), and yet without the big supporting cast Pollock's story loses its modern urban pulse. He begins to sound like the hero of a very old-fashioned novel: a boy from the boonies with a gift and a tragic flaw who comes to the city, makes it, and is then destroyed.

Solomon describes the early scenes of Pollock's life at some length. The stalwart, artistic mother who gave birth to Pollock, her fifth and final son, in Cody, Wyoming, in 1912; the wayward, drunken father who was often away somewhere trying to earn a living; the parents' various attempts at setting up farms and other businesses in the scrappy, half-built towns of Southern California—all of this is mostly interesting as a case study in the awful poverty of rural America in the early part of the century, and how it broke families and ground down lives, and how people also managed to pull through. The Pollock family actually held together amazingly well. Mrs. Pollock was still around at the end of the forties and eager to praise her youngest son's drip paintings. There were regular family reunions, which Jackson seems to have hated and drunk his way through. Many attempts have been made to portray Pollock's Western youth as the rich soil out of which his genius arose, but his later interest in Indian sand paintings and symbols probably has more to do with what some French Surrealists were talking about in the thirties and forties than with anything a child saw along the way. After Pollock's arrival in New York in 1930 at the age of eighteen he seems to have mostly wanted to dissociate himself from his past. He's one of those artistic Americans for whom being born in the Midwest or the West is a kind of accident of fate and New York always remains the promised land.

Pollock spent most of the thirties as a disciple of Thomas Hart Benton, whose reputation was based on the wholesale rejection of modern art. In Benton's art and thought Pollock found a pop mythology that could romanticize the American hinterlands he'd known all too well. Perhaps even more important, in Benton's Greenwich Village

apartment and Martha's Vineyard summer place Pollock—who learned how to make spaghetti sauce from Benton's wife, Rita, baby-sat for their six-year-old son, T. P., and took part in folk-music evenings—found the ideal American family he'd never had. In later years this phase of Pollock's career was looked upon by all as an aberration, to be treated gently. Authors will find in Benton's looping baroque compositions some prediction of Pollock's drips; while the Bentons, though ideologically opposed to abstract art, made an exception for Pollock, and long after he'd gone his own way and gone to his grave they spoke to the interviewers about him as a nice, errant son.

Like many charismatic alcoholics, Pollock conveyed a sense of desperation that elicited from family and friends an active sympathy; people managed practical matters for him and got him back on track when he'd begun to get derailed. Pollock passed from a dependence on the Bentons and Charles and Frank Pollock, the brothers who were living in New York in the thirties, to a dependence on Lee Krasner, whom he met in 1940 and married five years later. In her ministrations Krasner was assisted, in degrees difficult to determine, by Peggy Guggenheim, Betty Parsons, Clement Greenberg, Tony Smith, and many others. In the fifties, when this crowd began to weary of shoring him up, Pollock turned to the Cedar Bar, where he could be a Hero. The Greek Chorus, however, had turned into a Mob.

The biographers all make much fuss about how hard things were for Pollock—but what avant-garde artist had it easy in the forties? Once the ball got rolling in mid-decade, Pollock's situation wasn't half bad. The complaints about lack of sales are understandable only by the absurdly overinflated expectations that were to come later on. Pollock had dealers who were willing to send him monthly checks; he had a run-down house and some land on Long Island, places to stay in the city—and this is all many would hope for even in the 1980s. As for the bills, those who go into the arts without independent incomes have to expect that they will never be paid on time.

The story ends in tragedy, but not really with any surprise. There was so much craziness in the years leading up to Pollock's death that it would perhaps have been more of a plot twist if things had evened out and Pollock were still around, enjoying the fruits of a ripe old age. In 1956, Lee went to Europe, with divorce on her mind. A few weeks

later Pollock, out in his car with two young women, killed himself and one of them, running the car into a tree. In the accounts of Pollock's end one's attention quickly goes from Jackson and the women to Lee in Paris, at Paul Jenkins's apartment, receiving the phone call, and Greenberg, when asked to speak at the funeral, refusing. "The reason I won't talk is because he got this girl killed and I want nothing to do with it." Everyone looked to Pollock, but many felt his great time was past, and perhaps some were glad he was gone. One has the impression, reading the many interviews that Lee Krasner gave in later years, that both she and Pollock, those two hardheaded, self-contained artists, never really had an idea of going through life *together*. "Much has been written about Pollock's difficulties in the last three years of his life, and more has been spoken." This is from Frank O'Hara's slim 1959 monograph. How much more has been written and spoken since 1959. But, again, to what effect?

The roomful of Pollocks in the "Abstract Expressionism" show currently at the Albright-Knox Gallery is perhaps a bit weak in the paintings of the 1948–49 period that everyone calls "classic." Still, this selection of eleven works captures Pollock's unique blend of bluntness and extravagance and makes a most satisfying circuit of the roughly ten years during which Pollock was an artist his contemporaries believed they had to reckon with. The Albright-Knox show (which is a part of the museum's 125th anniversary celebration) brings us as close as we'll probably ever come to a sense of how it felt to see the Pollocks—and the Gorkys and de Koonings and Hofmanns—as they were coming out of the studios and onto the walls of galleries such as Peggy Guggenheim and Betty Parsons in the forties and fifties. Michael Auping, a curator at the Albright-Knox, may have produced a catalogue that's insufferably chi-chi, but the show he's hung in Buffalo is another matter entirely— it's sanity itself. This exhibition actually gains from its having been mounted far away from the pressure points of the contemporary museum world. At the Albright-Knox, which is a great but slow-paced insti-tution, the galleries have a lived-in look, and the Abstract Expressionists don't seem to be straining for importance. You can get in touch with the artists' dark-toned, scowling, art-intoxicated mood. The museum, with its extraordinary permanent collection and its great riches in Ab-

stract Expressionism, has the clout to obtain major loans; yet there's no overkill, no pizzazz.

At the end of a seminal 1955 essay, " 'American-Type' Painting," Clement Greenberg comments that all pictures "stand or fall by their unity as taken in at a single glance." I believe that Greenberg is dead wrong about this. But I know why he says it: no other aesthetic position can support the exalted view of Abstract Expressionism that Greenberg holds. When you walk into the rooms full of de Koonings and Pollocks at the Albright-Knox the works have a masterpiece look. The surfaces are brilliantly agitated, the paintings attract you with their quirks of paint handling, with their confessional poetry of drips and smears and slashes and stains. I can see why people think these are great paintings. From twenty feet away de Kooning's *Gotham News*, with its reds running unpredictably into whites and blacks, is irresistible; and Pollock's *Convergence*, with its soft skeins of red, yellow, blue, and white, is a gorgeous hallucinogenic blur even from five feet away. Yet after one's initial glance, the Pollocks and de Koonings—and most of the other paintings in this show—just start to collapse. The artists seem to believe that emotion resides in the painting *taken in as a whole*. In the work of Rothko, Newman, and Still the parts are totally neglected; in de Kooning, Gorky, and Pollock the parts are looked upon as having no consequence beyond their relation to the whole. Abstract Expressionist paintings are mysterious, but there's no key, no clue, no way into the labyrinth. The viewer isn't enough engaged in making the whole out of the parts. I can admire a Pollock "at a single glance," but the canvases repel close attention, they don't engage my imagination. If you look at one part of a Pollock, it sluffs you off, it pushes you away. Most Abstract Expressionist paintings offer a generalized experience, an experience that has none of the counterpoint or development we associate with great works of art.

Hans Hofmann is the only Abstract Expressionist who makes it possible for us to enter into the painting, and his *Towering Spaciousness* is the one painting in the Albright-Knox show that challenges a viewer inch by inch. Here the clashes of high-keyed, summery colors and the alternating passages of flat and impasto paint are matters with which the eye can engage, out of which the imagination can make a logic. This is the single painting in Buffalo inside which I was happily lost, through

which I felt challenged to find my way. Hofmann draws viewers into a pictorial world. In a sense there's nothing more brashly American than Hofmann's paint handling. But of course, as Harold Rosenberg put it, Hofmann had been in Paris during "those ten overwhelming years in which Fauvism, Cubism, Expressionism, De Stijl, Futurism, had burst into view with barely enough time between to ensure their identification." The Abstract Expressionists understood a good deal less about the School of Paris and its traditions than is generally believed.

The Buffalo show is the first comprehensive survey of Abstract Expressionism to be attempted in over two decades, since the Los Angeles County Museum of Art mounted "The New York School, The First Generation: Paintings of the 1940s and 1950s" in 1965. As such this ought to be the occasion for a wholesale revaluation of the group of artists who first made New York a city to be reckoned with in art capitals around the world. In truth, though, if Michael Auping's catalogue is any indication of the range of currently acceptable ideas, the Abstract Expressionist painters are now receiving the same bloodless, unblinking veneration that Renaissance masters such as Raphael received in the academies of an earlier age. And academics aren't the only ones who are sticking to conventional wisdom. Painters such as Frank Stella (in *Working Space*) and Julian Schnabel (in his new memoir-cum-testament *C.V.J.*) talk on about the Abstract Expressionists, but without close attention, as if they were required stops on a tour, like the Arch in St. Louis and Mt. Rushmore on the way out West.

Those who were disappointed by the de Kooning retrospective at the Whitney in 1983 (many) and by the Rothko retrospective at the Guggenheim in 1978 (not a few) are rarely heard. And when a dissenting view does go public, it's quickly swallowed up in the generalized hum of received opinion. Perhaps we ought to be very interested now in finding ways to give dissent a more prominent, public role. In this context, it is interesting to read Sanford Schwartz's long, brilliant, and demanding essay, "Clement Greenberg—the Critic and His Artists," which is in the current issue of the *American Scholar*. In the midst of Schwartz's uncoiling appreciation of Greenberg lies a devastating attack on Pollock and the other Abstract Expressionists. Of Pollock he writes: "I believe we would prefer not to 'know' him fully, because we don't

want to risk being disappointed by him. I think we want to keep him a pure symbol—a symbol of epic striving and of vulnerability." And of the Abstract Expressionists in general:

> Looking at a couple of Barnett Newmans, say, or Mark Rothkos, we can be awed, but a full show is monotonous. It is all the same thing. The Ab Ex story is, in part, how the American artist was determined to join, by one colossal leap, the ranks of the great Europeans. The American achieved it, but he created a facade of greatness; the Europeans' ideas were rethought and turned into a single "sign" or "look" or way of painting. Rothko, Newman, and the rest shove their power to us all at once; there seems to be little in reserve. Their emotions always vibrate at the highest pitch. If we are not on their wavelength, we feel nothing.

"Nothing" was hanging on many walls at the Albright-Knox. Still and Kline struck me as unredeemable trash; Reinhardt and Newman as wildly overrated. Rothko and Gorky are both crippled by their tastefulness, by the overbearing elegance of their effects. Rothko confuses fuzziness with feeling; and he imagines that you make a cheerful painting by using bright colors, a depressing one by using dark ones. As for Gorky, I believe the early detractors who claimed he added nothing to Picasso and Miró were right. Gorky never got beyond the quasi still life and the quasi landscape; nor did he know how to get from the sketch to the finished painting. Either he smeared color over a drawing or he jotted in black line over smears of color.

The Albright-Knox, which has received munificent gifts from Clyfford Still, may be pardoned for giving this black-and-orange-fixated Halloween painter a room of his own. Less understandable are the elevation of the bombastic Kline to equal status with de Kooning and the demotion of Hofmann to a corner of a back room. For me Hofmann is the emotional center of the movement; but certainly the heart of this show is Pollock, and this jibes with history. As de Kooning said in the movement's most famous remark, "Pollock broke the ice." When Greenberg wrote of Pollock's *Number One* (1948) that "it is as well contained in its canvas as anything by a Quattrocento master," or Frank O'Hara wrote of Pollock's *The Deep* as "a scornful, technical masterpiece, like the *Olympia* of Manet," they may have been overreaching, but they were

also being carried aloft by their emotions. (Faked criticism doesn't read so well a generation later.) The passionateness of modern European art spilled over into the studios of New York, and the new American avant-garde had the idea that the revolution could be carried forward *here*, that one could extrapolate from the past into the present and so on.

It must have been extraordinarily exciting to see the work of Gorky and de Kooning and Pollock as it first appeared in the studios and galleries of New York. The Abstract Expressionist paintings—with their phlegmatic blacks and whites, their lowering grays and blues—represent the spirit of a city that no longer really exists: a city of workingmen and manufacturers, of row houses and tenements, a place of rough, brash emotions.

We all know what Clement Greenberg is talking about when he says in 1945 that "all profoundly original art looks ugly at first." The criticism reflects a time of change—of shifts, turns, transformations. "In this day and age," Greenberg writes, "the art of painting increasingly rejects the easel and yearns for the wall." The time is *now*. "At a certain moment," Harold Rosenberg writes, "the canvas began to appear to one American painter after another as an arena in which to act." This is the critic as reporter, a reporter privileged to witness the landmark events of his age. The ugliness of which Greenberg spoke was, of course, supposed to give way to the beauty of the masterpieces in the museum. A masterpiece holds its original alien spirit as a kind of secret that you can regain when you stand in front of the painting, when you take it apart and put it back together again with your eyes and your imagination. For the generation that came up in the thirties and forties it often seemed that the Abstract Expressionists had achieved that strange new poetry of the masterpiece. I think the early enthusiasts were confusing the strangeness of all masterpieces with something else—with the shock of the new.

And yet the Abstract Expressionists of the forties and early fifties, of the years when Pollock was alive, really earned the world's admiration. They knew that they and their friends were alive to what was alive in modern culture; they did everything in their power to fulfill themselves through their art. Their best work is about beginnings—about the first attack on the canvas, the sensuousness of materials, the possibilities that each brushstroke implies. What's missing is conclu-

sions—something beyond the rumpled overlaps, the jostling forms. The painting of the Abstract Expressionists is about the artist's studio as a new frontier. The austere masculine power of the work began to diffuse only in the fifties, when raw energy and simple courage could no longer carry the day. The rest is Fame—a long, dull, dishonest epilogue.

November 1987

PHOTOGRAPHY AND BEYOND

There isn't very much that's very interesting in the way of photography being done just now. This may be one of the reasons why the photography boom of the seventies, which had been focused on the achievements of the past, ultimately faded away. The young photographers never really demonstrated the relevance of the past to the present. And the dearth of engaging new talent left a vacuum that's been filled in the eighties by a group of artists who take as their subject the public's lust for photographs while at the same time making it clear that their work isn't really photography at all. Cindy Sherman and Sherrie Levine, as well as more recent entrants onto the scene like the Starn Twins and Clegg & Guttmann, are far more knowing about the needs of the audience than any photographer who has emerged in the past quarter century. Indeed, these artists seem to be onto everything about photography—its romance, its place in modern culture—except the internal possibilities of the medium they've taken up. They use and abuse photographs; but their work isn't really in the spirit of photography, which is ultimately concerned with a way of seeing the world.

Doug and Mike Starn, the twins born in New Jersey in 1961 who show their photographs as the Starn Twins, had their first New York show in 1986, when the Stux Gallery, which represented them in Boston, opened its New York quarters on the corner of West Broadway and Spring. Like their later exhibits, that show included collages and wall displays made up of the Starns' fuzzy, stained, and over- and underexposed photographic prints. These are the kinds of prints that others might think are best left on the darkroom floor; the photographic paper is often creased and torn—it looks like it's been stored underfoot.

The Starn Twins' photographs represent such unexceptional items as a modern side chair, a piece of classical sculpture, or, in their 1987 show, a silhouette of two horses. These are the raw materials for wall works that range from a single image presented in a heavy, pompous molding to groups of pictures that are scotch-taped and tacked together into flimsy, sprawling abstract collage designs. The Starns' enthusiastic supporters view their works as utopian meditations on the ruins of technology. And when you first see this run-down image world, where everything is faded and melancholy, it's fetching, it's clever. But then it's just obvious; there's no intermediate experience, you're never engaged. The subject is nostalgia; but the work is a cheat because the images don't really fulfill their elusive themes—there are no hidden depths, no secrets to reveal. To the theoretically minded, the Starn Twins' work may illustrate some lesson about the collapse of capitalism; for the ordinary gallery-goer these are fuzzy emblematic images that have a certain mysterious allure. Last spring, when the Starns were featured at the Whitney Biennial and one began to hear people singling them out for praise, it was probably simply because the work had the romantic seductiveness that soft-focus photography has had for a hundred years. This is a new type of gray and sepia decor, reminiscent of Deborah Turbeville's distressed photographs of fashion models in ruined palaces.

The Starn Twins are a perfect example of how artists nowadays achieve fame in New York. It seems to take approximately a year from initial exposure to major-museum apotheosis. Robert Pincus-Witten, an art critic who has the gossipy skills of an eighteenth-century courtier, has planned a monograph on the two twenty-six-year-olds. Is it wrong to be a success when you're still so young? No, not at all; but it doesn't prove anything, either.

In the face of a gallery scene saturated with photographic imagery, the persistence in the museums of separate departments of photography begins to seem like a holdover from an earlier age. By now most people have made up their minds about photography one way or the other, and the kind of special pleading for the significance of photographs that photography departments specialize in can be tedious. When Peter Galassi, the very sharp curator of photography at the Museum of Modern

Art, observes in the catalogue of the new show, "Henri Cartier-Bresson: The Early Years," that the Frenchman's work between 1932 and 1934 comprises "one of the great concentrated episodes in modern art," he sounds rather old-fashioned. Who wants to hear any more of those aggressive–defensive arguments for the importance of camera art?

The best section of Galassi's Cartier-Bresson essay is devoted to a biographical study of Cartier-Bresson's early years (he was born in 1908) —the years when he was just coming to photography and making his way through the international bohemia of Paris and New York. Here Galassi writes very much one-bright-young-man-to-another and catches something of the youthful amused inventiveness of the period when Cartier-Bresson met Harry and Caresse Crosby, Julien Levy, and Jean Renoir and ventured across three continents, snapping pictures along the way. Galassi believes that the photographs Cartier-Bresson took in the thirties are among the purest expressions of a Surrealist sensibility in photography, and Galassi wants to isolate Cartier-Bresson's early work from his later career as a sort of journalist. Galassi argues his case with considerable delicacy, but I can't believe that anyone who has thought very much about Cartier-Bresson ever imagined there wasn't a Surrealist element in the work of the man who invented "the decisive moment." Cartier-Bresson's immortal images are sprinkled throughout his career, early and late. Much of Galassi's essay seems to come down to an argument within the photography world—specifically, to a quarrel with the curators over at New York's International Center for Photography, who are very much photojournalism-oriented and mounted a large Cartier-Bresson show in 1979. Galassi may be more tied down than he himself imagines to the old closed world of photography, with its interminable arguments about journalism versus art and straight photography versus the manipulated image.

Though Galassi has gone to the trouble of including four of Cartier-Bresson's early paintings in the show, in the catalogue he makes short shrift of Cartier-Bresson's work as a moderate Cézannesque landscape painter and of his studies in the twenties with the academic Cubist André Lhote. From the two examples of paintings done under Lhote's influence that Galassi includes, Lhote's teachings seem to have had a deleterious effect on Cartier-Bresson's painting, at least in the short run—his work became less spontaneous, more schematic. Galassi knows

that Lhote wasn't taken seriously by his legendary contemporaries—they hated his academic formulas; but Galassi misses, I believe, the extent to which Lhote's post-Cubist gloss on traditional easel painting resounds through Cartier-Bresson's work. (Galassi is probably unaware that some contemporary artists still find Lhote's *Treatise on Landscape Painting* a good guide to the place of classic pictorial construction in a modern pictorial world.) Most of Cartier-Bresson's experimentation with the tiny Leica camera reflects a search for quirky variations on the old formulas of landscape art. Cartier-Bresson's odd croppings, overwhelming foregrounds, closed-up middle grounds, and flat, too-close backgrounds can be read as a series of tricks and surprising reversals played on the old normative sense of landscape space. Taken as a whole, Cartier-Bresson's work has a lofty, generalizing tone that separates it from the more picturesque effects of, say, André Kertesz, and this tone probably has something to do with a characteristically French taste for the well-constructed image. The point isn't that Cartier-Bresson was depending upon Lhote, any more than he was depending upon André Breton or Louis Aragon; it is only that in Cartier-Bresson the Surrealist taste for surprise is cut with something of French classicism. According to Galassi, Cartier-Bresson saw Lhote shortly before his old teacher's death in 1962. Cartier-Bresson recalls this comment of Lhote's: "Everything comes from your formation as a painter."

Given the close connection that Cartier-Bresson has always maintained with the past of landscape painting it's not really surprising that in the seventies, when he pretty much ceased taking photographs, he took to drawing in pencil and pen and to making paintings on paper in gouache. When the drawings were first shown at the Carlton Gallery in New York in 1975 the artist's old friend Julien Levy (who had first shown the photographs in New York in 1933) regarded Cartier-Bresson's drawings as another kind of approach to the artist's continuing exploration of the world *out there*. Levy said that Cartier-Bresson had moved from images that "stopped reality" (photographs) to images made of a "questing line." A selection of Cartier-Bresson's paintings and drawings was mounted at the Arnold Herstand Gallery on Fifty-seventh Street to coincide with the MoMA show this past fall; but the opportunity to compare the artist early and late, as photographer and "drawer," was one that few critics in New York seemed to want to take up. For those

anxious to demonstrate that Cartier-Bresson's early photographs are a high point of high modernism the nineteenth-century mood of his current work may have been an embarrassment.

Cartier-Bresson isn't a complete figure as a draftsman or a painter. His output seems to be that of a gifted amateur; it doesn't have a clear shape or direction; he isn't driven the way painters are. Still, the best of his drawings—which are the least worked up ones, the views of the Tuileries Gardens, where the thick and nobby pencil lines give substance to the bare branches of the chestnut trees—are understandable as products of the same voracious eye that gave us the photographs in Cartier-Bresson's famous picture books, *The Decisive Moment* (1952) and *The Europeans* (1955). The gouaches carry the sketchiness of the drawings into full color (and also bring Cartier-Bresson full circle to the intimacy of his first Cézannesque oils). One winter scene of the Tuileries recalls Marquet's great Parisian oils in its vision of urban architecture under a blanket of snow. When Cartier-Bresson's drawings are more fully worked up, with an increase in detail and middle tones, they begin to lose their overall force; his best drawings are "fast," like his photographs. The show at Herstand ranged from still lifes to figures and interiors and left one with the sense of a warm, unprepossessing intelligence. In his drawings and paintings, as in his photographs, Cartier-Bresson uses the medium transparently—as a window through which we see the world.

In returning to the plein-air painting past of French art, Cartier-Bresson is also in a way asserting a link to the nineteenth-century world out of which photography originally emerged. And as it happens, the show in New York early in the fall where one came closest to Cartier-Bresson's spirit of generous curiosity wasn't a photography exhibit at all; it was the show of landscape paintings and drawings (and a few sculptures) by the forty-six-year-old painter Stanley Lewis, at the Bowery Gallery in October. This was Lewis's first solo appearance in New York in six years. (In the past he's shown at the Green Mountain Gallery—and in its later incarnation, the Blue Mountain Gallery; he's also exhibited at Gross McCleaf in Philadelphia, and in Kansas City, where for many years he taught at the Art Institute.) Lewis handles the artist's materials as brilliantly as anyone working in America today. The

paint rises off the surface in thick strokes and gloppy coagulations; but amazingly the ultimate effect is light, elegant, clear. Lewis's landscapes, with their pearly grays and surprising range of greens, have a subtle, shining beauty. Like Cartier-Bresson, Lewis is attentive to the scrappy, surprising, and odd elements of the world around us. This artist, too, can make the ordinary extraordinary.

In at least one landscape of Northampton, Massachusetts (where Lewis now teaches at Smith College), a remarkable artist reaches the high point of his career so far. In this New England vista the snowy tracks of earth and the cozy familiarity of a little town become the raw ingredients for a precisely pitched lyric poem. The paint handling and general form-sense here—and in many of Lewis's paintings—may recall the work of the Englishman Frank Auerbach; but Lewis's landscapes are more fully realized than any of the three dozen or so Auerbachs I've seen in New York. Painting from an elevated viewpoint, scanning the scene below him, Lewis takes it all in with a serene yet passionate concentration. He knows his American buildings and trees and vistas as well as Morandi knew his Italian ones. And in this show he finally begins to resolve a problem that he's had over the years with his foregrounds. Too often the big close-up trees and bushes have been a blur in Lewis's paintings—a blur we rush around to get at the interesting details in the distance. I've heard artists say that Lewis's vague foregrounds are a reminiscence of the hours he and all the rest of us spend driving through the American landscape, with our eyes trained on the distance. This may explain the indecisive foreground as a motif. But structurally the foregrounds have weakened many of Lewis's finest paintings—up until this show, where in a number of canvases he at last knits the front together with all the rest.

Everything in Lewis's show was felt to the same high degree. If much of it didn't ultimately succeed, it was a question of a kind of large failure that we rarely encounter in the galleries nowadays, where "good" painting usually means "safe" painting. Lewis never plays it safe. Two mural-scale works (roughly eight by ten feet) are abstracted from a series of drawings of figures sitting in some sort of public place, perhaps a bus station. (The motif contains just the sort of interesting intermingling of figures and architecture that has caught Cartier-Bresson's attention from time to time.) These large works are related to the even bigger

painting based on the entrance to the Columbus Circle subway station that Lewis exhibited at the Green Mountain Gallery in 1976. Now, as then, what's missing is some fundamental idea of abstract structure that can replace the perspectival space which the artist loses as he flattens everything out. Lewis might seem to be moving in the direction of the jostling forms of Léger's *City*; but unlike Louisa Matthiasdottir, who in her great *Vesturgata* cityscape of 1980 managed to reconsider nature after Léger, Lewis makes flat painting the same as spaceless painting. When he abstracts a sky area, the amplitude of natural space is reduced to a wedge of color—an arbitrary design element. Lewis's big paintings are honest failures; but they're such exquisitely painted failures that some observers may think they're empty elegance and nothing more. I see in them a bumbling romance with the idea of abstract art. Something similar lies behind the four sculptures in the show, rather academic cubistic experiments in plaster, with a woman sitting amidst some sort of architecture. Lewis doesn't yet understand abstraction as a world unto itself—sometimes I doubt that he ever will—so when he wipes out all the interesting picturesque details of modern suburban America he has nothing to offer in their place.

Stanley Lewis's landscape paintings, which combine a nineteenth-century loyalty to perception with a twentieth-century reach toward abstraction, bring us back to the point around the turn of the century when landscape painting—at the hands of Monet and Cézanne and Matisse—was leading, almost in spite of itself, into abstraction. Cartier-Bresson's paintings and drawings are in part documents of a great Frenchman's continuing interest in the naturalistic impulse in nineteenth-century art, the impulse that did so much to create a climate receptive to the ultimate naturalism of photography. (As it happens, the first major exhibition that Peter Galassi organized at MoMA, the 1981 "Before Photography," examined exactly this relationship between painting and photography in early nineteenth-century Europe.) Both landscape photography and abstraction are in certain respects out-growths of the shattering of traditional compositional practices that was inaugurated by the early-nineteenth-century plein-air landscape paint-ers. And just as the idea of painting in the direct presence of nature had its origins in the radical Romanticism of the early nineteenth cen-

tury, so photography and abstraction were grounded in a revolutionary vision that no academy could accommodate.

When photography became central to the art scene of the 1970s, it was in part because photography was—and remains—an untraditional and even an antitraditional vehicle for high art. But the deeper appeal of photography has always rested in its being a visual medium through which our responses to the world can be expressed directly. Representational art, which was resurgent in the seventies, was a different kind of response to a similar need; and it wasn't uncommon for artists and collectors and dealers who were interested in photography also to be interested in the new representational painting. The excitement that gallery-goers felt in front of photographs suggested that aesthetic feeling might be closer to ordinary feeling than was often believed. And this in turn highlighted the extent to which a late modern aesthetic that denied the value of human feeling was insupportable. What's wrong with the Starn Twins is that in their work (to quote Marshall McLuhan's famous dictum) "the medium is the message." With the Starn Twins the tearing and defacing of photographs is an act committed against a medium that is basically viewed as inert, inexpressive. For Henri Cartier-Bresson, both as a photographer and as a painter and draftsman, the medium is, as I said earlier, transparent. So also with Stanley Lewis, whose brilliance as a paint handler has to do with his belief that the picture surface must be as natural as nature itself.

December 1987

O'KEEFFE
IN THE CAPITAL

Arriving in Washington today, we still see what Henry James saw at the beginning of the century, "a city of palaces and monuments and gardens, symmetries and circles and far radiations." Washington remains a mix of the democratic and the imperial, and if for James the capital was "the place of business, the estate-office" for "a huge flourishing Family," the family is now only larger and more contentious: it's the whole Western world.

James was back in the United States in 1904 after almost a lifetime passed in Europe, and what struck him in Washington was how little the handsome public buildings told a visitor about the life of the nation. At the Capitol he saw three American Indians, "arrayed in neat pothats, shoddy suits and light overcoats." They were a demonstration "of what the Government can do with people with whom it is supposed able to do nothing." And thinking back on James Fenimore Cooper and his Leatherstocking Tales, a favorite of his youth, James suddenly recognized in those Indians-turned-tourists "an image in itself immense, but foreshortened and simplified—reducing to a single smooth stride the bloody footsteps of time. One rubbed one's eyes, but there, at its highest polish, shining in the beautiful day, was the brazen face of history, and there, all about one, immaculate, the printless pavements of the State."

The stones of Washington still pretty much don't speak, and crisscrossing the Mall today (which may be the worst-kept ceremonial park in the West) we visitors still see vistas that are hard and clear, built up of "the printless pavements of the State." As a city that we take in with our eyes, Washington reveals a good deal less about the nation's history than New York or Boston or maybe even Santa Fe. Washington lacks

a settled history; it lacks a compelling aesthetic dimension. On both counts it's an unlikely center for the study and appreciation of art. Yet Washington has become in recent years a capital of American culture, a city second to none in its riches in painting, if not yet in sculpture and the decorative arts.

The painting collection at the National Gallery is now the best one-stop collection in the country, far broader in its range than that of New York's Metropolitan Museum of Art. Washington is also home to some of the great small museums of the world, including, right there on the crowd-congested Mall, the Freer Gallery, where the Oriental paintings on paper and silk are actually exhibited without a crowd-proof cover of plex or glass. As much as New York, Washington is shaping the American tourist's idea of what going to an art museum is all about. This is a development one could have probably predicted some decades ago: with the Mellon family and Samuel Kress behind the National Gallery, how could it fail to become a major-league museum? What no one could have counted on was the National Gallery's more than occasional willingness to challenge the average museum-goer with shows addressed to the connoisseur. This fall, along with the crowd-pleasing retrospectives of Georgia O'Keeffe and Berthe Morisot, the National Gallery was host to "The Art of Rosso Fiorentino," a large, intellectually demanding collection of Mannerist drawings, prints, ceramics, and tapestries.

Looking back over the past decade, it's the National Gallery that has sponsored not only the glitziest of the glitz shows, "Treasure Houses of Great Britain," but also some of the really unexpected and unforgettable exhibitions. While the Met has given us such major but mainstream events as Manet and van Gogh, the National has answered the cognoscenti's dreams with a Watteau retrospective (planned in conjunction with the Louvre) and the first-ever gathering of Matisse's work of the twenties (a National Gallery exclusive). If both exhibitions were marred by traces of the wrong kind of showmanship—those *House and Garden*-colored walls at Watteau, the mega-aura of Matisse, which was padded out with too much pre-Nice work—these were a very small price to pay for the kinds of shows that we still find ourselves talking about months and years after they've been taken down from the walls. Could it be that the National Gallery is actually less of a hostage to the box office and the marketplace than New York's Met? Could the Na-

tional Gallery turn out to be our elite art institution, a museum whose sense of quality has nothing to do with the politics of left, center, or right, but simply aims to offer us the highest aesthetic experience available in America today?

With the Georgia O'Keeffe retrospective, the National Gallery is very much in its crowd-pleasing mode. Visitors line up outside the entrance to the East Wing beneath a huge banner, and on the way up to the show they pass by photo blowups of Georgia O'Keeffe's beloved Southwestern landscape and of Georgia O'Keeffe herself. But this show isn't a crowd pleaser that plays down to the crowd. The National Gallery has somehow managed to give both the early modernist O'Keeffe and the later mythic O'Keeffe their due. Once you're in the galleries, the bare white walls and the uniform silver frames set a subdued, sensuously elegant mood. Though the selection of works is erratic and the semi-chronological arrangement of the galleries is a little bizarre, there are some inspired installations, some things that couldn't be bettered, such as the small room that contains a group of the pinkish, curvaceous abstractions of 1918–19. Meanwhile the catalogue that the National has produced, called *Georgia O'Keeffe: Art and Letters* and containing an album of reproductions and a group of 125 of O'Keeffe's own letters, gives the public something to take home and *read*, avoids the scholarly overkill of museum catalogues of recent years, and makes an honorable addition to the small but choice shelf of books by and about O'Keeffe. (Also out in time for the show is *Georgia O'Keeffe: One Hundred Flowers* [Knopf], a gift book if there ever was one, measuring 13½" × 16". *One Hundred Flowers*, in full color, may not be everybody's cup of tea, but it's like nothing else we've ever seen, a theme-and-variations extravaganza that's drop-dead chic, druggily hypnotic, and utterly weird. Talk about flower power!)

Born in 1887, O'Keeffe was a painter of consequence for about fifteen years, from the abstractions she did just before she turned thirty, partly inspired by Kandinsky's *On the Spiritual in Art*, through to the flowers and skyscrapers and skulls she had done by the early 1930s. O'Keeffe had the benefit of some of the most advanced art education that America had to offer early in the century (she studied with John Vanderpoel at the Art Institute of Chicago and with Arthur Wesley

Dow at Teacher's College in New York), and she was a sharp-eyed visitor to Alfred Stieglitz's galleries long before she became one of his star artists and his wife. Her best work would have been impossible without the new freedom that had been won for art by Europeans since the late nineteenth century. But if O'Keeffe adopted the imaginative liberty of a cosmopolitan modernism, her sui generis concoctions of flattened-out form and photographic modeling always bore the stamp of a fundamentally provincial sensibility. Despite the eerie voluptuousness of her subjects, there's nothing voluptuous about O'Keeffe the painter. Save in a few of the early works in watercolor, her paint handling is invariably dry, flat, almost perfunctory. When she announces, in the autobiographical fragments published in 1976, that her work "had nothing to do with Cézanne or anyone else," she's glorying in her insistence on following her own line—on not being seduced by the great European experiment.

The charcoal drawings of 1915, the mystical symmetries of *Series 1, No. 8* (1919) and *Pink Moon and Blue Lines* (1923), and all the unfolding petals may barely count as compositions, but they are the kind of personal icons that stop you dead in your tracks. The power of this work depends on the bold assertion of the strange and unexpected. Each small, intensely felt impression is insisted upon, is borne in upon the viewer. Composition in the traditional sense—composition as practiced by a John Marin or a Marsden Hartley—was probably way beyond O'Keeffe's capacities. It didn't matter. She made a virtue of her weaknesses, went her own way, and became our greatest painter-seer.

The difference between O'Keeffe and a Europe-oriented semi-abstractionist such as the early Hartley is that Hartley likes the high drama of modernism, the sense of being involved in a clash of traditions. With O'Keeffe, semiabstraction exists outside of history; it's forever and never-never. Semiabstraction is also a bit of a mesmerist's trick for her, with each side of the abstract-representational equation disguising the weaknesses of the other. O'Keeffe can't invent anything but the most elementary abstract structures, and she probably depends too much on naturalistic modeling to give the forms some bite, some immediacy. This is a delicate balancing act of a style, in which the inert, two-dimensional-design character of the images is all that prevents that super-real modeling from veering off into banality. When O'Keeffe goes

overboard with the three-dimensional element, she destroys our sense of the picture as something that's dreamed up, imagined. When she does standard modeling, as in the still life *Grapes on White Dish—Dark Rim* (1920), she's no better than Regionalists like Thomas Hart Benton—her technique is that academic. The Southwestern landscapes of the thirties reflect a genuine love of the earth, but as paintings they're unconvincing; here O'Keeffe's unwillingness to look into Cézanne really shows.

Oddly enough, when O'Keeffe's work plummets—this is in the thirties—one still doesn't exactly see her as a failure. There's no fury or energy to her bad paintings, perhaps because she'd never gone very deeply into the culture of painting to begin with. She's the opposite of an artist like Max Weber, who learned about painting straight from Matisse and lost what he'd known in a nightmare of miscalculations and overelaborated effects. O'Keeffe doesn't become a weak painter—she just loses her poetic impulse, her gleaming inspiration. Perhaps it was a question of having a small personal capital of ideas which she drew on for too long, until there was nothing left. By the forties she's producing the ghosts of O'Keeffes. There are semirecoveries, such as *It Was Red and Pink* (1959), but also outrageous howlers, such as the late *Sky above Clouds* series. At some point her writing is more effective than her painting. I'd rather read O'Keeffe's description of the famous door in the wall in the adobe house in Abiquiu than see the oils she did, which are so embarrassing in their greedy annexation of post-Abstract Expressionist painting ideas. *My Last Door* (1954), in the collection of the designer Calvin Klein, is all stark, handsome intervals; it might as well be the set for a Calvin Klein commercial.

And yet you don't leave the O'Keeffe show feeling let down. Her slow, deliberate sensuality is there to the end. To the end her mood is quasi-religious, romantic, reminiscent of Caspar David Friedrich, with whom she shared a taste for iconic crosses that refer to some ambiguous, anti-institutional idea of Christianity. O'Keeffe and Friedrich are middle-class mystics; they give their fantasies a crisp, concrete form. And just as Friedrich's Romanticism is knit inextricably into the Biedermeier sensibility of early-nineteenth-century Germany, O'Keeffe's Romanticism can't be separated from the Art Deco taste of the America of the twenties and thirties, the years when she achieved her great fame.

The public is going to the National Gallery to see O'Keeffe's paint-
ings, but it's also going to make contact with the woman herself. In her
journey from Wisconsin and Virginia and Texas to New York City and
Lake George and Abiquiu lies one of America's great true-adventure
tales. This is not to deny that we sometimes grow weary of the legend.
I for one find the alliance with Stieglitz somehow uninteresting, too
much a matter of two egoists on an ego trip together. And yet you
cannot deny that this is one of those marriages-within-modernism that
are so extraordinary a part of the art life of the beginning of the century.
Whatever the particulars of their life together, O'Keeffe and Stieglitz,
along with Robert and Sonia Delaunay and Jean Arp and Sophie
Taeuber-Arp in France, mark a new era in male–female relations. For
the first time in history a man and a woman are partners in art as well
as in love.

O'Keeffe was, and very definitely felt herself to be, a feminist, the
odd-woman-out of the Stieglitz circle. In her writings she liked to set
herself off from "the men" and suggest that some of her strength had
to do with her sex. At the same time she hated to have her work discussed
in terms of female imagery. (It's for this reason that she rejected Paul
Rosenfeld's wonderful O'Keeffe essay in *Port of New York*, with its
evocation of the slowly unfolding rhythm of her art.) I see a connection
between O'Keeffe's distaste for gender-linked interpretations of her work
and Balthus's equally virulent distaste for sexual interpretations of his.
Both artists recoil from the idea that something so deeply personal can
be labeled, given a tag. And what, really, is there to say about O'Keeffe's
female imagery except "Yes, of course"? It's obvious that her forms are
closely related to female anatomy (as well as to a culturally determined
female taste for flowers, for soft things), and it's natural that an artist
in the confessional mode would draw on these kinds of sources to some
degree. While painting by painting O'Keeffe is a less various artist than
that other mystic of the Stieglitz group, Arthur Dove, O'Keeffe's nar-
rower achievement surpasses Dove's by adding something stubbornly
original to the history of art.

If O'Keeffe spent a good deal of her life proving that she was some-
how more than human—a High Priestess of Sante Fe chic, and all of
that—she had good reason, because for a woman of her time and place
what passed as merely human often turned out to be considerably less

than human. I think Henry James would be interested by O'Keeffe's presence there on the Mall. She'd been a teenager when he made his last visit to America in 1904, and as an artist she'd had to make do with the dearth of fixed cultural institutions that James analyzed in his book on Hawthorne. O'Keeffe knew about nineteenth-century America, and as one who passed much of her life in the Southwest she knew about those "bloody footsteps of time." When Paul Rosenfeld, in 1924, predicted that the tide of art was beginning to flow toward America, O'Keeffe was the heroine of the story—a story told in *Port of New York* in cadences that were in part borrowed from the style of Henry James. O'Keeffe's life has many of the elements of the unending argument between convention and innovation that interested James in both his fiction and his nonfiction. She was absolutely a product of the American earth, and along with that she was an artist, a bohemian, a feminist, a great lady. She lived all these roles to the hilt, and had, from the evidence of her own writings, a subtle humor about her driving ambition and her iconoclastic independence. At the National Gallery, Georgia O'Keeffe gave the public what it had every right to demand: a story set firmly in the American landscape, in which individualism triumphs as a democratic ideal.

January 1988

FROM SEPTEMBER
TO DECEMBER

The Mary Boone Gallery arrived in SoHo a decade ago, along with Neo-Expressionism and a new bullish art market. Boone's artists, especially the two who would become most famous, Julian Schnabel and David Salle, had no inhibitions—about size, about subject matter, or about taking up a Macho Man pose that had gone out of fashion in the egalitarian atmosphere of the sixties and seventies. As a matter of fact, Mary Boone seemed to be almost proud that she didn't show any women artists; she obviously enjoyed bringing back, single-handedly, the image of the artist as a bad boy who'd been given permission to be bad forever. Schnabel, her baddest boy, resented media claims that he was Boone's creation and left a few years ago for the Pace Gallery, where his work has become either lazier or more subdued—one can't ever be quite sure. A new rabble-rousing recruit, Eric Fischl, was brought in; but the temperature at Boone has definitely dropped in recent years.

AIDS, and perhaps a sense, even before Black Monday, that bull would turn to bear, has made Boone's boys-will-be-boys act a little stale. Salle, after beginning as the smartest smart-ass of the decade, is now cultivating cultural credentials, making sure that his first encounter with a Balanchine ballet is noted in catalogue chronologies and confiding to an interviewer that his bedtime reading is Edmund Wilson's *The Fifties*. Boone has moved with the times, showing cooler, abstract art. If this is a gallery where one could always count on some male artist to kick up a rumpus, now that the moment has come for seriousness and sobriety the women have suddenly appeared: Barbara Kruger and Sherrie Levine, with their anticommercial message art. For Boone, who trades in gender clichés, Woman is Prophetess. Kruger and Levine are the Guard-

ians of the Mysteries. And the mysteries nowadays have much more to do with technological society than with the natural world. Boone, with Schnabel and Salle in tow, sponsored the rebirth of the original. She has now had the show-biz acumen to turn expectations inside out by sponsoring Sherrie Levine, one of the artists who popularized the death of the original as an art-world idea. Sherrie Levine's debut show at Boone—it opened the season in September—was an event that left the art world in a mixed-nuts mood.

Sherrie Levine's work is faceless, impersonal; but what many of us see as a lack points to Levine's essential idea. Levine's images aren't meant to have an aura; they're meant to tell us that there's no such thing as an original work of art anymore, that we live in a world of replicas and clones and shades. That's a position, no doubt about it, but if you're seeing Levine's work in a gallery, how are you supposed to respond? All one could do at Mary Boone in September was stroll through Levine's show, a spectator at the ultimate media event of the moment, and then perhaps stop to talk to a friend.

In the back room was a group of Levine's rephotographings of photographic reproductions—in this case black-and-white photographs of black-and-white reproductions of Russian Constructivist photographs by Rodchenko. This is the kind of "appropriation" that first made Levine famous among the people who read *October* magazine and think a lot about the death of the original. In the two front rooms were Levine's recent small-sized abstract paintings: plywood rectangles on which the plugs that lumberyards put in place of the knots have been painted gold; compositions of vertical stripes; checkerboards; others resembling backgammon boards. Some of the paintings are done on wood; some are on sheets of lead mounted on wood (lead is, God knows why, the material of the moment). In the recent work Levine is appropriating indirectly. She isn't making exact replicas of modern masters, as she did in her photographs and watercolors; she's taking the "look" of a recognized high-modern style as the starting point for a series of variants. Levine does variants on Gene Davis, much as Warhol did variants on Campbell's Soup cans. (Keep the basic image, change the size, change the colors.) What mild stuff these are, Levine's comments on post-fifties hard-edge stripe painting. Levine paints in an even, pleasant manner, with pretty pastelish colors and tasteful, slightly rumpled surfaces. She's the friendly appropriator; the work looks almost cute.

The crowds that were having their first close encounter with Sherrie Levine at Mary Boone in September must have felt bemused, unsure of why they'd been urged to come to SoHo in the first place to look at such small, undistinguished paintings. Only Levine's supporters knew exactly what the artist had risked by going into Mary Boone's pressure-cooker atmosphere, where all Levine's little ideological grace notes would count not at all. Since her early shows at Baskerville & Watson's closet-sized uptown gallery, Levine had expected gallery-goers to pay close attention to every shading of literary or political or aesthetic irony. To hard-core Levinites it matters that Levine's watercolors are done after art-book reproductions of Légers, not after the original Légers. At Baskerville & Watson the audience was hip to exactly what was being appropriated—they knew the difference between Stuart Davis and Léger, they understood that Davis is, intentionally, a bit "low," that Léger, a first-generation Cubist, is altogether "high." But what did the crowd at Boone know or care about any of the details? Donald Barthelme's catalogue essay made a brave attempt to keep the sugar-spun labyrinth of Levine's political analysis alive; but at Boone, Levine was being forced to stand or fall as a painter, and fall she did.

The Levine show caused chagrin among some of the artist's old supporters, who didn't know what to make of this icon of antiestablishment art going with a gallery that had possibly been antifeminist and was certainly pro-commercial success. The catalogue—with a pink cover, the artist photographed in Hollywood-star sunglasses, and the paintings illustrated in upscale downtown *Metropolitan Life*-style lofts—only added to the feeling that Levine was now a sellout, and proud of it. Some argued that Levine deserved success as much as anybody, but never before had the *October* magazine crowd been so cruelly confronted with the hard fact that to the American art market the leftist critique of the market is as easy to swallow as an after-dinner mint. Some left-wing critics were really demoralized, and I sympathize with their discomfort, just as I sympathize with the discomfort of those (often on the right) who believe government funding is bad for the arts but now begin to wonder if the private-money people know any better. Where do we turn?

Empirical experience shows that a gallery such as Boone—which was always obsessed with the market and is now, in showing Kruger and Levine, obsessed with the critique of the market—isn't a place where

vital art appears. (Barbara Kruger, in a *Vanity Fair* article about the scene, praised Mary Boone's gallery as a "charged site"—*October*-speak if ever there was such a thing.) Yet it all can't be blamed on the market; artists still do make the art. Sherrie Levine has never done anything I'd consider a good work of art, but she used to have a few shreds of moral authority—the authority of the quirky critic of art life. She might have had it in her to become a gadfly, a curmudgeon, one of those eccentrics who knows what's going on, points a finger, follows things moment by moment, glories in her own pessimism and despair. Instead, she's going to end up among the hordes of the famous ones; she'll probably soon be turning out lithographs in editions of a hundred. At least Marcel Duchamp knew the hand he was playing and played it to the bitter end. Sherrie Levine doesn't even have the guts to play by her own rules. The cash registers started ringing and she came running.*

———

The work in William Tucker's show at David McKee in September held you, but at a certain distance. Completed in 1985, this trio of bronze monoliths with Greek god names (*Ouranos, Gaia, Tethys*) followed hard on the group of *Gymnasts* that Tucker finished mostly in 1984 and showed at McKee in 1985. Like the *Gymnasts*, the Greek gods are casts after plaster models (they're roughly seven feet high) and have irregular, rumpled surfaces. In the *Gymnasts*, the basic shape was a slab that had been folded in one place to create a flexing, figural form, and all the surface activity seemed a bit of an afterthought. In the god sculptures the rough-hewn skins do make a convincing match with the hulking, bulging forms. One critic has compared the gods—which are like giants' body parts (an arm with a fist, a leg with a calf or an instep)—to the clunky figures in Philip Guston's late paintings. The gods have a slow, flexing power; Tucker's Rodinish aspirations come to the fore in the romantically twisting or up-reaching impulse of the forms. Like Guston, Tucker is interested in forms that come out of a mysterious, primitive world. There's also something tamped down, subdued about the gods.

* Postscript, 1991. In the fall of 1990, Crown Point Press released a series of five prints by Sherrie Levine, each in a limited edition of twenty-five. This *Barcham Green Portfolio*—it's named after the paper that the edition, which includes aquatints and combinations of aquatint and photogravure, is printed on—is a mini Levine retrospective that includes a Walker Evans appropriation, a stripe composition, and so on.

Tucker may want to convey the impersonality of archaic idols; he may also be trying to create an overall impression that is too elegant. In their weighty way, *Ouranos, Gaia*, and *Tethys* are oddly demure. For works about beginnings—about the Birth of Sculpture—there's an excessive concern with achieving a neat total effect, the aura of Art.

At fifty-two, William Tucker can look back on a quarter-century-long career during which he's both moved with the times and maintained a certain discriminating distance from the times. His sixties work, with its smooth, high-tech forms, comprised an intelligent man's guide to sixties style. The work had a Pop edge, but it was tempered by a strong grounding in the David Smith–Anthony Caro line. During the seventies, using industrial materials, Tucker looked like a more sensible Richard Serra, giving building materials a light, elegant, sketchlike feel. Nowadays, working in bronze, Tucker wants old-time solidity, but in a modern mood. If he was once a moderate who insisted on making objects rather than antiobjects, he's now a moderate who holds off from some of the extremely figural implications of bronze. With Tucker the sense of the present is always modified by a fixed idea of quality. He will never go for broke; he's obviously an artist who believes in generally accepted, gradually evolving values. He rejects all extreme positions—the extremely voguish, the extremely personal. He makes us believe that there's some ground that we're standing on together, and this is attractive. If you don't give yourself entirely to Tucker's work, it may be because he doesn't give himself entirely, either. He's lyrical but levelheaded; he draws us in with his intelligence, his refinement, his care.

Painting, one of the most solitary of occupations, goes on only so long as there's a community of artists that supports the individual's work; and when an artist who has meant something to other artists dies, the community gathers together to commiserate and commemorate. Although I didn't know Gretna Campbell, I know many of her friends, and agree with them that her death this past summer at the age of sixty-five was a considerable loss to the community—a loss that elicited too little attention in the press. Sixty-five isn't young; but for an artist it isn't old, either.

Campbell was the subject of two shows in New York during No-

vember, as well as a memorial service at a Quaker meetinghouse down-town. At the Ingber Gallery, with which Campbell had been associated for fifteen years, were gathered together the turbulently lyrical works (landscapes and studio nudes) of the last fifteen months of her life. At the New York Studio School, where Campbell had first taught in the school's halcyon days in the early seventies, a show called "Early and Late" juxtaposed this later work, full of agitated brushwork, with the delicate, more systematically abstracted landscapes of the fifties, the first decade of Campbell's career. The Studio School show, beautifully chosen by Louis Finkelstein (who was Campbell's husband and is a painter of kindred sensibility), gave a strong sense of the trajectory of the career. Among the very earliest works, from 1949–50, was a group of self-consciously antiquarian paintings, much influenced by the crisp form-sense of trecento painting, of women sitting in rural settings. These gave no hint of the changeableness of nature, which was to become one of Campbell's central ideas; but they were interesting nonetheless for establishing a motif—the figure in the landscape. Soon enough the figure itself was to disappear from Campbell's out-of-doors; and yet isn't the figure always there, as the intelligence of the artist who sees with us and guides us through the natural world?

At "Early and Late" the robustness of Campbell's later work was contrasted with the thinner, clearer manner of the landscape paintings of the mid-fifties, full of olive groves and, to quote the title of one painting, the *Remembrance of Provence*. The canvases of the fifties, quite rich in color, are often built up with a narrow, longish, rather regular brushstroke that Campbell certainly saw as an evocation of Cézanne. To us, though, these strokes, adding up to a delicate, mobile tracery, suggest not Cézanne but the mood of modern art in the years after World War II. There are connections between Campbell's style in this work and the hand in the abstract ink drawings of Nicolas de Staël, in the early Philip Guston abstractions, in the paintings of Joan Mitchell. Period style, when honestly achieved, can express a period mood. Of course this fifties style of Campbell's is connected to Cubism, but to a Cubism that's been released from Cubism's tight architectural structure. In Campbell's fifties landscapes there's a tendency to let things give way at the corners and the sides. She leaves the image a bit incomplete, as an Abstract Expressionist might, and the very irresolution of the pictures yields a melancholy dimension, perhaps because the artist is so conscious

of the completeness of nature, which she can neither encompass nor deny.

In the later work Campbell's technique is subtler, more richly nuanced. Also, as she becomes thoroughly loyal to nature—and therefore more involved with traditional questions of representation—she finds herself taking on a new, difficult relation to the history of modern art. If for Monet landscape painting, an improvisation before nature, signified the ultimate revolt against museum art, at the hand of an artist such as Campbell painting a landscape turns out to be an act committed within tradition and in confirmation of tradition. Campbell's squarish formats and her fondness for motifs that are boxed in by hedges, orchards, shrubs, streams—all this suggests a sense that options aren't infinite, that there are limits to what a person can comprehend. In a catalogue essay Finkelstein describes the working up of the paintings from squared-off drawings, how Campbell prepared herself for the ultimate assault of paint strokes, the creation of a rich, interesting, agitated surface. Campbell uses paint in a variety of ways—brushing, scraping, scratching, drawing. The focus and emphasis shift inch by inch. Campbell doesn't see the parts of the landscape as fitting neatly together, as they do in a Marquet or a Morandi. The odd, unbalanced relations that Campbell discovers between a tree and a house and a distant hill are closest in feeling to Constable and perhaps some other English landscape painters. There's also something English about Campbell's hedges, roses, twisting vines. In the shape of Campbell's career the late paintings are a triumph of honesty, of directness. Memorable are the wrenching, unbalanced interactions of green and purple; the turmoil of high-keyed colors resolving but never quite resolving into peculiar grays. Campbell's rhythm is uneven, romantically unpredictable, with large sweeping movements leading into quick, jumpy ones. For her nature is a drunken dance to music by Brahms, with dancers in costumes of rose and purple, olive and gray.

At Ingber, I was particularly interested in a painting of a rural cemetery. It was difficult not to feel in this choice of motif an uncharacteristically autobiographical or at least emblematic impulse. The light here—an eerie, tarnished golden yellow—is disarming and even tragic, with some of a seventeenth-century Dutchman's sense of landscape as a cosmic mood poem.

At Gretna Campbell's memorial service several of her ex-students

spoke of the artist as a teacher, of her influence. From the people I know who knew Campbell I've always had the sense of a person strong, intelligent, assertive. She was buried on the coast of Maine, near Cranberry Isle, where for years she'd had a summer home and gone out on her bicycle each day to look for the motif. Her intelligence, her vital place in the art life of the city, were all perfectly natural for a painter of landscape—which is historically the product of a highly sophisticated urban consciousness. In Finkelstein's catalogue essay there's a considerable effort to look clearly at the loss and to do justice to the work. (Writing his essay in the midst of the current art scene, Finkelstein would have had good cause to ask himself, "If I don't give Campbell her due, who will?") "Each year," he observes, "her language became more sure, more supple, more venturesome. Her color opened up, and also her space, pulling the viewer's attention from close at hand, the 'entry' into depth and back again to the surface. She was still discovering the resources of this taut space and newly vibrant color during her final illness." It's always so easy to talk about how bad the times are. Gretna Campbell is one of the ones we will think of when we think about how good the times have been.

———

At Sperone Westwater, during Susan Rothenberg's show in October and November, gallery-goers stepped carefully and spoke in hushed tones, just as they had at Jasper Johns's show at Leo Castelli last winter. They'd come to Sperone expecting serious work, and serious they would be. What they saw were figures somewhere between skeletons and ghosts, floating or swimming through a flickery, brushy space. Susan Rothenberg wants us to believe in a world of twilight, a world of afterimages. Many of her spectral forms are refracted, repeated, like passing figures in Futurist paintings. Rothenberg's canvases can be quite large—in the range of ten feet wide—and her brush strokes, which are more mechanical than lyrical, go around in circles, like benedictions to the void. The work is all void. The last thing a mystical artist can afford to be is vague, and yet vague Rothenberg will be. She's an inscrutable, uncertain guide to the world of dreams. Rothenberg denies us the pleasure of fantasy art, which is the pleasure of finding fleeting images given concrete form.

———

Though the Lucian Freud retrospective, which was at the Hirshhorn Museum in Washington, D.C., this fall, won't come to New York, Freud, an Englishman aged sixty-five, is a painter of whom New York is very much aware. When he first showed his tightly rendered, insistently unromantic figures and portraits in New York at Davis and Long (now Davis and Langdale) in 1978, people argued about them. Were they daring or academic? Since then a lot of good things have happened for Lucian Freud: a monograph by Lawrence Gowing has appeared; he's had the cover of *Artforum* magazine; and his *Large Interior W. 11 (After Watteau)* (1981–83) has been widely hailed as a masterpiece of modern figuration. Freud's show at the Hirshhorn was a sort of pendant to the "Representation Abroad" show that the Hirshhorn's former curator, Joe Shannon, organized in 1985. Like "Representation Abroad," the Freud retrospective highlighted a type of realist painting that hasn't garnered much museum attention in the United States since World War II. One wonders if the acceptance of these European paintings has something to do with their not being done by Americans. Is realism seen as an Old World sort of thing? At "Representation Abroad" the glamour of certain European associations—famous friends, distinguished themes—seemed to add a luster to many of the artists and much of the art. In Lucian Freud's case it certainly can't hurt to be a grandson of Sigmund Freud's. The audience's curiosity is piqued.

Freud sets most of his nudes and portraits in rather shabby bohemian surroundings. Occasionally he does a cityscape that continues the bleak mood. He invariably paints in gray and brown, and he doesn't give his tones any reach, any lyric surprise. The color is the flat, inexpressive color of magazine illustrations. Mostly Freud is interested in wrinkles and blotches and sags. He's unrelenting; what a literal rendering of flesh won't accomplish, paint handling will. Freud's faces, which are worked over for months and sometimes years, are full of ridges and creases of paint that don't follow the form and make the features appear worm-eaten, acid-etched. Freud brings us low, no question about it, but once he's got us there he just leaves us to fend for ourselves. There's no illumination; we don't ultimately see things clear.

Perhaps detail work has some a priori value, as a demonstration of

the artist's willingness to engage in a slow, incremental process. Certainly, detail work breeds respect in the audience. The audience goes to Freud because he tells the truth. People go in the same spirit as they go to Richard Avedon's photographs of old people—with a stiff upper lip, as if this must be good for them. Freud has the added feather in his cap that he actually manufactures every imperfection by hand. When Freud does his no-holds-barred renditions of male genitalia or a woman's breasts he's bearing witness—but to what? (It's the same question you may ask after going through a room full of Avedons.) Yes, Freud fills us in on a certain slice of post-empire England, where everybody is beyond hope. But all Freud gives us is surface; it's a Masterpiece Theater view of the English condition. Rendering is moralizing, details are insights, or so the logic of Freud's paintings goes.

Englishness has a certain cachet in these postmodern times, probably because English art has rarely been, properly speaking, modern art. A painter like Freud seems to be neither for nor against modern art, and his out-of-it-ness can appear chic. We're at a strange point in the history of taste when Balthus, an artist very much equal to the grand tradition, receives mixed reviews and a sort of academic novelty act like Freud is showered with praise. I can only guess that far too much is at stake in Balthus. If Balthus is the true heir of Courbet, Seurat, and Bonnard, then the history of modern art must be rewritten to include him. Freud can't claim to be the heir of anything, and therefore he can be admired without there being any dangerous implications. Freud's paintings are natural curiosities. We look at *The Artist's Mother Resting* and remark on how strangely the splotches on her face match the splotchy pattern on her dress.

———

It may be Neo-Geo that emboldened the Sidney Janis Gallery to mount its first Auguste Herbin show since 1974; but one could care not at all for most of the current geometric painting and still be grateful for a large gathering of works by one of the finest European abstractionists of the post-World War II period. Though Herbin was a part of the Constructivist scene in Paris in the thirties, it was only as geometric abstraction was fading from view after the war that he found his way to a style that had some of the assurance we associate with the artists of the Bauhaus, revolutionary Russia, and De Stijl. Herbin recalls the

Neoplastic painters in his devotion to a system that is both flexible and clearly defined, as well as in his adherence to strict frontality and his rejection of overlaps. Herbin's system, which permits the full range of hues, and circles and triangles as well as right-angled forms, has a special evocative power. Though Herbin was a fervent anti-Surrealist, there's something anthropomorphic, Kandinskyish, in the way his rows and stacks suggest the figural, the seasonal. Working within a limited system, Herbin achieves a wide range of effects and gives to his variously placed and grouped triangles, circles, and squares different qualities of movement and stress. (Sophie Taeuber-Arp must have been a major influence.) There are rising and falling compositions; works that oppose the tightly stacked to the loosely arrayed; and contrasts of sunnier and darker-toned hues. As in the mature work of the American Neoplastic painter Ilya Bolotowsky (another case of a Constructivist who really bloomed after World War II) the combination of unpainterly, hard-edged forms and ripe, throbbing color breaks new emotional ground.

Janis's Herbin show was only one of the exhibits this fall that added dimensions or shadings to our sense of modern art. (In an art capital we expect these backward glances, these studies in the way we were.) Grace Borgenicht's André Derain show was the best of several New York gallery exhibits that in the last fifteen years have been devoted to the post-Fauvist work of this important painter (he died in 1954). The still lifes, landscapes, and portraits in the Borgenicht show, mostly very small, had a beautiful clarity of purpose, the eloquence of challenges isolated and taken on one by one. You could move around a woman's face, enjoy the darkness of her hair against the lightness of her skin, appreciate how the eyes, nose, brow fit into the sphere of the head. Elsewhere a vase full of flowers sent its blossoms off in this and that direction, so that one zinnia seemed to confront us head on while another turned away, acted almost shy; and there was the greenness of a little park, with the luxuriant tree in the foreground, the picturesque bridge just behind. And there were lovely drawings, too—portraits and wonderful deep landscape views.

In the past few years Derain's work has become easier to see in France: the Guillaume Collection, recently installed at the Orangerie in Paris, contains some of the most famous works of the twenties; and the Museum of Modern Art in Troyes, consisting of the collection of the industrialist Pierre Lévy, has much of the most important work from

the thirties through the fifties. I must confess to being among those who
have come back from the Orangerie and Troyes feeling less ecstatic than
I'd hoped to feel based on the vigorous appreciations of the later Derain
we've had from Giacometti and Leland Bell. Borgenicht's show made
me think again. It had the not inconsiderable virtue of allowing us to
judge Derain's very elusive aesthetic on our own home ground.

Other shows of modern classics, major and minor, during the fall:
Cubist Picasso at the new Jan Krugier Gallery; "The Cologne Progres-
sives," a close-up look at German trends in the early decades of the
century, at Rachel Adler; André Masson at Marisa del Re; Richard
Stankiewicz at Zabriskie. The Léger retrospective at the Acquavella
Gallery was a stunner, in many respects superior to the retrospective
that was mounted at the Albright-Knox Gallery in 1982 to celebrate
the centenary of the artist's birth. And there were, as always, wonderful
School of Paris paintings to be seen along Madison Avenue, in the
windows of Davlyn and the front room of Perls.

———

Holt Quentel, who had her first show at the Stux Gallery in No-
vember, calls her works paintings, but they're really more like banners,
these blackish-gray emblems (one letter, one shape) inscribed on dis-
tressed, unraveled pieces of canvas that hang loose from the wall. Quen-
tel's pictures look like stone-washed, pre-torn Levi's that are meant to
decorate the home, and they automatically made me think of the rage
for distressed, very seriously torn jeans that hit New York last summer.
Nothing else came to mind. The catalogue (and what, this season, is a
show without a catalogue?) brought a perplexed gallery-goer the news
that the whole show was already in the hands of collectors, among them
Barbara and Eugene Schwartz, Emily and Jerry Spiegel, and . . . the
Saatchis. Things are definitely hopping at the Stux Gallery, for what
reason I can't begin to guess. Here the mysteries of art are overwhelmed
by the mysteries of commerce.

———

In 1986, David Salle received a Guggenheim Award to work on set
designs for the dancer and choreographer Karole Armitage and her
Armitage Ballet. The company came to the Brooklyn Academy of Mu-
sic's Next Wave Festival in November, bringing an evening made up

of two ballets. In *The Tarnished Angels*, to the music of Charlie Mingus, the dancers wear Christian Lacroix costumes and dance (in front of David Salle drops) in a style that telescopes Parisian café-concert and cabaret behavior from the nineties through the twenties. One of Salle's drops is of dead fish, perhaps a pun on the dancers' fishnet stockings. In *The Elizabethan Phrasing of the Late Albert Ayler* the David Salle sets dominate the ballet, with the dancing itself only one element in a collage of scrims and backdrops and elaborate stage props. Armitage has set *The Elizabethan Phrasing* to jive monologues by Lord Buckley, to Webern, Stravinsky, and the folk jazz of Albert Ayler. *The Elizabethan Phrasing* is a high-toned curio shop of a theater piece, with dribs and drabs of fifties aesthetics presented to the audience like knickknacks in an étagère. Karole Armitage isn't inside the spirit of the Graham and Balanchine ballets she has taken as her models for the occasion; and David Salle isn't inside the Noguchi, Picabia, and Pop Art he is spinning off of. Nor are Salle and Armitage exactly outside of their sources—camping, spoofing. One can see a theme in the unwinding of the decor's icon- ography, with its eyes and lights and light fixtures, but it is something to be contemplated as a mental construction, not an emotional one. *The Elizabethan Phrasing* is a parade of SoHo good taste—Balanchine, No- guchi, Lord Buckley, on and on. Salle's and Armitage's mandarin cool looks to me like the cool of those who haven't had to learn things for themselves, who take everything for granted. They're just taking up what others have already declared to be the best. If they'd found it on their own, maybe they wouldn't be so quick to mix and match, collage and juxtapose.

Paul Berman, in an interesting article on "The Face of Downtown" in *Dissent*'s special New York issue, has this to say about the work of David Salle: "Looking at his paintings, you can't help posing Big Ques- tions, to which come back dismissive answers in the vernacular. It puts you off balance. Being off balance makes the true downtowner feel more at ease, because off balance is how he feels inside." The concert-goers at the Armitage Ballet were definitely downtown, but they weren't acting as if Salle and Armitage were putting them off balance at all. They sat quietly, attentively, and left like people who'd gotten just what they'd expected. Paul Berman may be a few beats behind SoHo aes- thetics. Robert Pincus-Witten, who wrote an article on the Salle- Armitage collaboration for the November/December issue of *Artscribe*,

sees this pair as having gone way beyond off balance into something that sounds awfully like the balance of high classicism. "Irresolution and paradox, the bombardment of heterogeneous anachronism of dance, set and costumes, resolve into a new model of coherence. A perfectly credible world unfolds in community with the fantasy of transcendence, even as this latter credo, Modernism's underpinning, is arraigned." "Credible"? Incredible.

The Elizabethan Phrasing of the Late Albert Ayler is the creation of collectors, not of artists. Sources have been marshaled, but the transforming power of art doesn't come into it at all. Perhaps the schools are to be blamed for spawning a generation that knows art images but has no art fever. Whatever the reason, what generally passes for sophistication today is something more like anthologization. David Salle's sets are collections of fifties imagery. At Meyer Vaisman's show at Castelli in November the one painting that held me for a minute or two was a collection of thirty-two small oval canvases mounted together. All of these were printed with Vaisman's signature canvas pattern, and about half of them contained, in addition, profiles from coins and medals of ancient, Renaissance, and more recent times. The range of color in the Vaisman—black, white, blue, rust—and the slightly clunky photomechanical reproduction process brought to mind the Italian pottery of the fifties, Fornasetti ware, which was often decorated with photomechanical reproductions of interesting old things—including coins. Fornasetti is a hot collectible nowadays, and Vaisman obviously knows it; for all I know he doesn't know the difference between buying a Fornasetti ashtray decorated with photomechanical reproductions of Roman coins and hanging some photomechanical reproductions of Roman coins in a gallery. Collecting isn't making art, and although collecting is amusing, amazing, addictive, it becomes destructive when it's confused with making art.

The collecting sensibility as a gallery phenomenon peaked in early December with the show called "Fictions," organized by Douglas Blau, and consisting of "A Selection of Pictures from the 18th, 19th and 20th Centuries." A joint effort of Kent Fine Art and the Curt Marcus Gallery, "Fictions" featured landscapes and interiors, all related by a hyper-real, romantic sensibility and ranging from the nostalgic to the scientific to the futuristic. There were nineteenth-century landscape paintings,

movie stills, magazine illustrations. In part the show was meant to build a context for the work of such contemporary artists as Mark Tansey (who shows his Victorian-academicism-equals-postmodernism paintings at Curt Marcus) and Komar and Melamid (the Russian immigrants who were represented at "Fictions" by *Scenes from the Future: Museum of Modern Art*, in which the ruins of the museum fill the middle ground of a bucolic, post-Decline-and-Fall Manhattan).

Sundered from their narrative underpinnings, the images in "Fictions" became elements in curator Douglas Blau's free-floating fantasy, which was most interesting for a homoerotic undercurrent that ran through a good third of the selections. In the context of "Fictions," Charles H. Stephens's *Anatomical Lecture of Dr. William Williams Keen* (1879, oil on cardboard), with the doctor standing in front of a classroom talking about a young man on whose bare torso he rests his hand, suggested interests other than the scientific. The many pictures with groups of men (generals, scientists, artists) could be read as groups of good-looking guys doing mysterious things together. And the many landscapes with a man, generally youthful, looking off into the distance were erotic in a free-floating, voyeurism-becomes-narcissism way. (The catalogue, which contains reproductions of many works not included in the show, makes Blau's theme even more overt than the show itself.)

At "Fictions," a gallery-goer was encouraged to wonder if the lines of attraction and the relationships that he was seeing in the images were figments of his imagination or were actually lodged there by the artists. "Fictions" was about this kind of free-form thinking; it was about the out-of-controlness of images—that's what gave the show its campy element. The mood was muffled, unreal, and this heightened the drama of all these nice, clean-cut fellows who were engaged (or being engaged by us) in some obscure yet passionate kind of thing.

You weren't meant to regard those cool little rectangular pictures hanging on the walls as works of art—they were jokey vignettes, ironic mood poems. Douglas Blau exhibited some plain old-fashioned shlock (paintings by Joseph Hirsch and Maxfield Parrish), and it looked as elegant as anything else. And why not? When everything is presented as ambience, good and bad dissolve into one another.

February 1988

WORKING STELLA

The abstract relief constructions that Frank Stella has been producing during the past decade are chaotic and over-stuffed, but they're also terrifically swank. In the recent retrospective at the Museum of Modern Art of Stella's work from 1970 to 1987, one saw the fifty-one-year-old artist upping the ante—adding more and more elements, going into deeper and deeper space. Since the mid-seventies Stella has been turning out dozens of his ten- and twelve-foot works every year. He's gone from wood to aluminum and from straight forms to curving forms, and his changes of medium and style have been so rapid-fire that it's become rather difficult to relate to his vast output as something human-scaled. This recent work has an impacted, layered look. In some cases the individual metal shapes are kept tightly contained, in roughly rectangular configurations; in other cases the shapes break out of the rectangle, and the reliefs look like plants that are growing in two or three directions at once. Stella keeps adding more ingredients to his strange stew: metal tubing and wire mesh, graffiti-style paint handling, and gobs of glitter.

No expense has been spared on Stella's cacophonous assemblages; and the captains of industry who buy them for use as decorations at the office and in the home surely feel a more than passing sympathy with Stella's high-tech fun house sensibility. This artist is an intellectual who traces the lineage of his hulking parti-colored labyrinths back to the Baroque paintings of the seventeenth century. He's also a cigar-smoking celebrity, who likes to play squash and drive fast cars. Stella's constructions are like fantastical suits of armor designed to be worn at a Venetian masked ball. The designer is an impresario of fashion, culture, and aesthetic history; he's also the favorite son of the most powerful modern art institution in the world.

Stella was twenty-three when he made his debut at the Museum of Modern Art in the "Sixteen Americans" show of 1959. In the catalogue there's a photograph of Stella in a dark suit, looking very young and very sure of himself—like a kid who's just won the high school science prize. Abstract Expressionism's glorious decade was drawing to a close, and Stella was exhibiting a series of Minimalist black paintings, decorated with regular pin-striped divisions. It was a heady and controversial appearance for an artist who hadn't yet had a one-man show in New York: some people believed that the black Stellas brought modernism to a new peak of formalist restraint. To Stella, arriving at the Museum of Modern Art must have been like being admitted to the Academy of Modern Art. While Pop Art was on the verge of exploding the modern orthodoxies (Jasper Johns was also in "Sixteen Americans"), Stella knew that most contemporary artists would echo Flaubert's words about the French Academy when they talked about MoMA: "Disparage it, but try to become a member, if possible." Stella was in, and he's stayed in ever since.

A few artists have become more famous than Stella since the beginning of the sixties; Stella isn't exactly in the Warhol league. Still, amid the stylistic push-and-pull of the past three decades, no one has had quite Stella's high-visibility staying power. (Johns has had staying power of a more reclusive sort.) With the clout of the Modern and William Rubin, the director of the Department of Painting and Sculpture, squarely behind him, Stella has gone through a series of stylistic gyrations that epitomize the modernist establishment's response to the changing times. The sculptor Carl Andre, in a statement for the "Sixteen Americans" catalogue, said that "Frank Stella is not interested in expression or sensitivity. He is interested in the necessities of painting." In the ensuing decade "the necessities of painting" turned out to have an awful lot to do with adjusting one's horizons to the pressures of Pop and Color Field and Op. In 1970 Stella was still declaring that Flatness Lives. But he was just about to do his volte-face and go into 3-D and announce that Anti-Flatness Lives. Was this a response to "the necessities of painting" or to the necessities of the times? I think the latter. After all, by 1970 abstraction was looking anemic; site-specific work was making the gallery beside the point; and a resurgent representation was attacking orthodox modernism from without.

Some critics were wondering this past fall why Stella deserved a

second MoMA retrospective. The question was, "What is Stella to the Modern?" The answer is, "He's the Guardian of the Citadel." Like many aging institutions, the Modern is uncertain of its relation to a fluid situation and belligerently confident that it will always lead the pack. For the Modern and for Rubin, who organized Stella's 1970 and 1987 retrospectives, Stella is the artist who can most effectively mediate between the changing times and the Modern's unchanging orthodoxy. While the Whitney throws a new brand of postmodernism before a happy public every couple of months, the Modern keeps offering updates on its generic modern product. Rubin and Stella will tell you that Stella's reliefs aren't postmodern, but updated modern. The distinction may seem academic, but academic is what the Modern has been about for years. The SoHo crowd may find Stella old hat (they prefer to get their high-toned hipness at the Whitney and Mary Boone), and the independents may believe Stella's view of modernism is compromised by his grasping ambition and his forays into pop taste. But the whole world stands in awe of the one artist who can make graffiti, glitter, and Day-Glo acceptable at the Modern. The Stella show is MoMA's definition of the way we're living now.

I went to see the Stella retrospective three times and on each occasion found it impossible to connect with the work. Has there ever before in art been such a peculiar combination of hyperkinesis and impersonality? Stella's effects are relentless; his clashes of color and texture, his snaky rhythms and overlapping forms just go on and on. I'm not sure, though, how these hot tropical mazes are supposed to affect us. The reliefs present no point of entry; there's nothing that connects the fictive painted space and the real empty space, save for happenstance and sight gags.

Stella has been working toward the frenzied effects of his recent reliefs for years, and yet everything he's letting out of his studio looks uncertain, insecure. The constructions are assembled by a staff of assistants from squared-off drawings and maquettes, and when you're looking at the work it's hard to forget that the artist is manipulating large metal forms that he obviously didn't create single-handedly. This assembly-line method of production has implications that Stella hasn't ever really confronted. Doesn't he realize that the autograph quality so essential to the spirit of modern art is in danger of being lost? He may

want his works to look peppy, like improvisations; but his forms, which are clearly machine-tooled, trigger a different set of associations. A cool and complicated factory process comes between us and whatever inspiration the artist may originally have had.

Yet the idea of the artist as a master builder who has other people do much of the work apparently has a certain appeal for Stella. The Renaissance and Baroque painters used a great many studio assistants, and Stella, who in recent years has frequently expressed his admiration for Raphael and Rubens and Caravaggio, perhaps feels closer to those old masters than to modern artists such as Cézanne and Matisse, who worked alone. Stella's career has been conducted in public, and he revels in the high visibility of his art. When he talks about his constructions—something he's done quite frequently in recent years—he tends to explain them not in terms of personal need, but in terms of the needs of history. Surely Stella is not the first modern to claim history for his side; but there's quite a difference between the crazily visionary manifestos of a loner like Mondrian, who knew he was crying in the wilderness, and Stella, who has the big guns of MoMA with him every inch of the way.

Stella has no interest in the sort of fragmentary poetic observations that we often find in the writings of modern French artists such as Matisse, Picasso, and Braque. When Stella speaks out, it's in broad, general terms. He has a taste for old-fashioned Discourses, for laying down the law. And when Harvard University asked him to give the Norton Lectures in 1983–84, the occasion was a natural. It was the Academy of Modern Art meeting the Academy Itself. Stella stood up at Harvard and told the assembled Ivy League that the answer to modernism's travails was . . . academic Baroque art.

In *Working Space*, the published version of the lectures (Harvard), Stella is extraordinarily incurious about the Museum without Walls that has been inspiring painters since the latter part of the nineteenth century. It's not Stella's way to want to enrich Western art with the visions of Africa, Islam, Japan, folk art, early Christianity. In Stella's version of seriousness, anything that isn't European easel painting isn't really of use. To some observers Stella's recent work is the ultimate synthesis of the decorative and the abstract, but the fact is that by rejecting non-

European and pre-Renaissance art Stella has rejected the decoration of the East and the Middle East, the pattern and the ornament from which Matisse and others learned to organize their paintings in new ways. For Stella, decoration is surface interest—a colored skin stretched over a deep space that's derived from seventeenth-century figure composition. Right at the outset of *Working Space* Stella announces that "although we deeply appreciate art before the Renaissance, it remains qualified in our eyes." Picasso would have been shocked by this idea.

As has by now been pointed out many times, the unspoken presence in *Working Space* is Clement Greenberg, the critic who defined modern art as a struggle to isolate the essence of Western art. Actually the book tracks a love-hate relationship with Greenberg. Stella's lack of curiosity about non-Western art mirrors Greenberg's own; and the more one thinks about Stella's argument, the more it seems like an old-fashioned formalist discourse that's been given a postmodern twist. At the moment when Greenbergian modernism, with its lockstep march toward flatness, is being attacked on all sides, Stella is giving formalism radical surgery, explaining, We'll do this and this and this, and modernism will be able to carry on. Stella has a knack for picking up on a generally accepted sense of disaffection and dissatisfaction, but what he ultimately offers as an alternative isn't much more than a few scattered insights. People pick up Stella's book because they agree with him that something's awry; they read on because he doesn't paint too grim a picture.

When Stella says that "abstraction has to recognize that the coziness it has created with its sense of reduced, shallow illusionism is not going anywhere," he could be any eighties artist griping about the sorry state of art. Stella has a cure. He believes that the way for artists to bring the bloom of health back to abstract art is to make a close study of figure composition from Raphael (a painter Picasso and Braque detested) to Caravaggio (a renegade whose work founded an academy) and Rubens (whose *Maria de' Medici* cycle, which hangs in the Louvre, has impressed generations of artists as an unapproachable masterpiece of rhetorical style). Though Stella is too canny to acknowledge the influence of those less famous than he, I believe that part of what has turned his attention to the Baroque is the group of artists who, since the sixties, have returned to representation—and even, in some cases, to figure composition based on Renaissance and Baroque models. At the Modern, realism may re-

main the ultimate no-no; but Stella, a child of the zeitgeist, recognizes a challenge when he sees one. He understands that people are yearning for narrative, for storytelling, for legible spatial relationships.

"The aim of art," Stella says, "is to create space—space that is not compromised by decoration or illustration." This sounds pretty formalist—and many of us will wonder, "What about emotion, sensibility, metaphoric ideas?" Stella may not have a very good answer to our questions, but he knows that we're asking them. He explains that he wants a "space in which the subjects of painting can live." "Subject" is the wild card in the argument; it's the doppelgänger that Stella wants included but can't quite show us how to include. From the evidence of his extraordinarily prolific career, I'd say Stella confuses subject with style.

Greenberg made the modern artist's struggle to achieve purity—to eliminate narrative and representation—sound heroic, emotionally compelling. That's the genius of his criticism. Though Greenberg's intellectual clarity is way beyond Frank Stella, Stella, too, wants to give formalism a human face—that "subject." He somehow wants painting to be about space, but also about all the things that Caravaggio and Rubens put into that space. Stella says that Caravaggio "declares that pictorial drama is everything in art." In Caravaggio, Stella sees "the sense of a shaped spatial presence enveloping the action of the painting." Formalism again. But in the same pages Stella is praising Caravaggio's *Saint John* as "caressable, kissable." He says that "Caravaggio's boy has an aura that cannot be missed—this is the face that launched great painting. Beneath this self-satisfied, cheeky smile lies aggressive ambition, a feeling that this youthful success can rival Titian's glory." So the formalist is a romantic, explaining that this good-looking boy-saint is Caravaggio's stand-in. It's an odd two-step of a passage. Stella gets you from content to form without showing you the transition; there isn't any transition. Basically, Stella regards Caravaggio in the same light as the art historians who've called Caravaggio the first modern— not so much in a formal sense as in the romantic sense of the artist as a man possessed.

Stella skididdles from pictorial to extrapictorial concerns. In *Working Space* it's never explained how he will achieve Caravaggesque drama while painting paintings that are nonobjective, that have no human

drama. What is Caravaggio's drama, if not human drama? Looking from Stella's reliefs to the Caravaggios, you can see what Stella has taken from Caravaggio—the dramatic tilt or curving arabesques of space. But in place of the sensuous boy or biblical wise man or dirty servant in the Caravaggio, we get graffiti and glitter. In his lectures Stella invokes the later work of Kandinsky as a model; but he won't accept the fact that Kandinsky had a subject, which was derived from the life of plants, the mechanics of nature, Russian folk art. As an artist Stella has no subject to speak of (which is probably why those of us who write about him can find little to discuss other than Stella's theories and Stella's career).

Hovering around all of Stella's recent work is an age-old argument about the relative values of painting and sculpture, the pictorial and the sculptural, the optical and the tactile. Stella wants to make painting once again spacious, tactile, which he's done by making sculptures and calling them paintings. It's a gambit so flagrant one feels like a fool calling the bluff. What may ultimately be more interesting than Stella's invariable habit of referring to his reliefs as paintings is the desperation with which he and Rubin insist on this version of the Emperor's New Clothes.

There can be no question as to why Rubin and Stella are so concerned to prove that Stella is still a painter. Stella's first fame was based on Minimalist paintings; his lasting fame is as a painter who abandoned Minimalism. The dilemma for Stella has been to find a way to move away from the absolute flatness of his first decade without undoing the central assumptions of that work. I believe that the introduction of an illusion of depth into a two-dimensional surface was always a plain impossibility for Stella, because it would have called into question the flatness of everything he'd already done. Stella would agree with Gertrude Stein when she said that "anything in a painting that imitates air is illustration and not art." For Stella, going into a real third dimension was the only way to allow air into his paintings—thus the reliefs of the past fifteen years.

Stella's big relief constructions, with their Day-Glo colors and Graffiti-Art effects, are an attempt to graft the kitschy art fads of the past couple of decades onto a conservative modernist taste. Strip off the

razzmatazz surfaces and you find underneath some rather stodgy Constructivist sculpture. Stella is turning kitsch into—neo-kitsch? meta-kitsch? *Working Space* tells us that we can solve our problems and carry on. The metal constructions tell us that things have to change, but not too much. Stella is making an accommodation between the Academy and the hordes outside the gates. William Rubin, who compares Stella to Dante, Shakespeare, and Picasso, means to convince us that Stella's twirls and curls and curves are solid gold.

February 22, 1988

WHAT'S MAJOR?
WHAT'S MINOR?

Park Avenue and Forty-seventh Street isn't one of the places where gallery-goers usually make a stop; but it was worth the detour in December and early January, when the Banco di Napoli had up a display of the eighteenth-century Neapolitan Crib figures, which are called *pastori*. More than fifty examples, each between a foot and two high, all with elegantly carved heads and hands and elaborate costumes, were gathered together into a scene of the kind that some aristocratic Neapolitan families created in their homes two hundred years ago. In this Neapolitan Crib, called a *presepio*, the Nativity and Angels and Three Kings play a fairly small role, enveloped as they are by a panorama of figures representing the local low life and tradespeople as well as the exotic types who were described in the travel literature of the time. According to a catalogue privately printed by the Banco di Napoli, no complete *presepio* has come down to our day. The bank's holdings of figures were brilliantly united by Marisa Piccoli Catello and Silvana Piccoli of Naples into a dramatic series of scenes ranged over a picturesque mountain landscape. This was a crowded little planet, all salmon, green, scarlet, and gold, naturalistic in detail, fantastical in effect.

In spite of its tantalizing mix of theater, sculpture, and decor, the *presepio* looked clear, lucid, logically consistent. And in the midst of a season that has already brought us the religious kitsch of Julian Schnabel, the dime-store baroque of Frank Stella, and the pop-up world of Red Grooms, anything that mixed media but remained coherent held a viewer's attention. Viewed diorama style, as they were at the Banco di Napoli, the groups of Crib figures were like paintings exploded into three dimensions; they formed the kinds of picturesque and ribald scenes

one knows from the genre paintings of the seventeenth and eighteenth centuries. The scenes of a kitchen and of a group of people seated around a table looked like Annibale Carracci and Louis Le Nain paintings come to life. Contemporary artists who paint groups of figures might want to sketch from a *presepio*; they could learn much about how gestures and dramatic juxtapositions build a narrative. As a tableau vivant the *presepio* also ties into the confusion many are feeling of late about the place of spatial illusion within painting. For those who agree or half agree with Gertrude Stein's dictum that "anything in a painting that imitates air is illustration and not art," the *presepio* presents a way out in some respects not unlike Frank Stella's way out. If an artist is unwilling to paint air, he can put painted figures into real air. But the difficulties of working in bastard forms, which confound many of our contemporary artists, don't really hold with the art of the *presepio*. The mixed-media idea is inherent in a Christmas dollhouse scene designed for domestic consumption, and the social situation of the eighteenth century apparently had ways of accommodating both the sophisticated sculptors who did the heads and hands and the amateur enthusiasts among the aristocrats who worked on sewing costumes and painting scenery.

The Crib figures, with their beautifully carved and painted terracotta heads and wooden hands and flexible bodies, are conventional types; and yet the virtuoso execution and the lovely detailing of the costumes give the best of them a theatrical presence that draws you in. These ruffians and country beauties, knife sharpeners and shepherds, are like courtiers at a masked ball acting their respective roles to the hilt. They twist their little fingers, screw up their tan and pink faces. The *pastori* are elegant; but the vigor of the street is a part of them as well. Among the finest figures are the Feasting Shepherd, with his bald cranium, mouthful of broken teeth, and enormous, comically ornamental ears; the Poor Shepherd, with his addled blue eyes and lank black hair; and a sleeping male figure that looks like a down-at-the-heels relative of Bernini's *Blessed Ludovica Albertoni*. The *presepio* even includes miniature vegetables, among them a bunch of delicately curling, amusingly Rococo broccoli.

Something like the *presepio*'s charm—the charm of a mature intelligence at play—is to be found in the work of Alexander Calder. Calder's

Circus, on permanent display at the Whitney Museum of American Art, was a plaything of twenties Paris, and a delight in miniaturization and bold fantasy is also at the heart of Calder's wire and wood sculpture of the thirties, a selection of which was featured at the Whitney this winter. The work in "Alexander Calder: Sculpture of the Nineteen Thirties" takes the visionary impracticalities of Miró's Surrealism and the pure idealism of Mondrian's Neoplasticism into sculptures that are like absurdist toys for adults. With their slender wire trajectories leading to and from planets carved of wood and sometimes painted in red and white, these sculptures look good surrounded by a lot of bare wall and clear light. Calder is experimenting with dimension and direction— shooting straight lines and arcs and circles into uncharted space, creating his own idiosyncratic three-dimensional astronomical models. The work is sly and delicate in its effects; it's brilliant bantamweight sculpture. Fifty years ago these constructions, some of which are set in motion by motors or by wind, must have looked startlingly modern; now they're more like skeletal mementos—the pressed-flower souvenirs of an American who was in Paris during one of the great moments of European art.

When I first heard that the Whitney was organizing this little show, it sounded like exactly the kind of thing that our museum of American art ought to be doing; but after seeing fourteen sculptures presented like historical curiosities on a low platform in the Whitney's main-floor exhibition space, I wonder whether the Whitney can provide a friendly atmosphere for anything at all. Richard Marshall, who organized the Calder show and wrote the catalogue, is one of the group of curators responsible for the Whitney Biennials, and gathered together at the Whitney these Calders looked hard and cold, almost like something you'd see at a recent Biennial. In the catalogue of the show, Marshall reproduces a photograph of a Calder exhibition at the Galerie Percier in Paris in 1931. Clearly this vintage installation, in which the sculptures were lined up on a low shelf that circled the room, inspired the Whitney's wraparound platform. The improvisatory informality of that 1931 show cannot, of course, be regained. It would be an affectation to use white-painted wooden crates as bases for the work in a Calder show at the Whitney. But in trying to update the original setting the Whitney is both too close to thirties Paris and too far away. I know that the in-

stallation can't entirely be blamed on the curator, but it's a responsibility of the curator to preserve and even bring to the fore the texture of a work of art. What's missing at the Whitney Calder show is the delicate aura that ought to cling to the originals, their unique combination of folk-art fantasy and new-age idealism. Jammed together in 1931, the Calders may have looked like the component parts of a new universe. Jammed together now, they're turned from metaphors into designs. Metaphors need to be able to expand; at the Whitney the Calders have been depersonalized, flattened out.

And who, really, can be surprised, when so much of the Whitney's energy is spent glorifying contemporary art in which structure and sensibility count for nothing at all? How can a museum rise to the occasion of the Calder of the thirties when upstairs it's presenting Julian Schnabel, an artist with no quality, no feeling, as one of the masters of our time? Schnabel's mid-career retrospective, covering the years 1975 to 1987, is full of work that comes out of nowhere. It's just one hulking, overbearing gesture after another. Here are the paintings mosaiced with shattered plates; the anthologies of vignettes from high and low art scrawled on wood or velvet; and the washy reprises of Abstract Expressionism. The new paintings—grayed banners inscribed with a word or two, often in Latin—give us nothing to look at. I suppose they're meant to be taken on faith. The whole career is supposed to be taken on faith— which leads some people to the odd conclusion that Schnabel's subject is faith. (A painting inscribed with the name of Pope Pius IX could be about conversion or kitsch—or both.) Schnabel is presented as this humongous, out-of-reach figure. In a 1981 statement he remarked: "The true subject is meaning." This is the literary equivalent of Schnabel's painting: portentous baloney.

It's possible to compare Calder's work to that of Arp or Miró or Mondrian by analyzing the sculpture in very specific ways. If Calder's whimsy doesn't have quite the weight of Arp's, one can grasp why that is. And if Arp's humor doesn't have quite the weight of Brancusi's, one can grasp why that might be, too. Works of genius are not the products of inexplicable artistic operations; they're the products of explicable operations that most of us can't pull off. Masterpieces may have mystery, but there are ways to describe the distance between the minor–minor and the major–minor and the minor–major and the major–major. Schna-

bel is off the charts; but it's not because he's topped the charts. It's because he's not even in contention. He's a zero—an artist who doesn't know the rudimentary moves and is somehow mistaken for an artist who's beyond the moves. And here we have the Whitney exhibiting Schnabel, who isn't even minor–minor, and calling him major–major. Is it any wonder that the curators at the Whitney are blind to the refinements of taste and technique that give a Calder of the thirties its particularity?

"The Push and Pull of Cubism," the latest in the series of Hans Hofmann exhibitions that the André Emmerich Gallery has culled from the artist's estate, is all about painting as a process, as a series of steps. It's about an artist who went from major–minor to minor–major. The nine compositions, all painted between 1949 and 1951, and mostly small by contemporary standards (four or five feet), are clear, cheerful, unprepossessing. There are ruled lines, rectangular and triangular forms, and bright, straight-from-the-tube color. These Hofmanns have neither the moody exuberance of the forties works nor the effulgence of the big canvases of the later fifties and sixties. Hofmann fills the rectangle, extends trajectories from edge to edge, but the intimations of still life and interior space don't ever quite take hold. In this series of works he's knocking out solid, slightly perfunctory compositions. The show gave us a look at the pedagogical Hofmann: the professor who believed in mastering the basics.

You have to believe in the basics to be a great teacher—and Hofmann was the greatest teacher of painting in America from the thirties through the fifties. He began to teach Cubism in New York at a time when it was known only in the most watered-down versions; he also taught artists how to trust their own intuition, how to improvise. For Hofmann the essential models were the Matisses and Picassos that he'd first seen in Paris when he was a young man; his immense value as a teacher rested in the way he could demystify those models. Coming into one of Hans Hofmann's classes, a student learned to set goals, pursue objectives, develop. For generations of American artists, Hofmann put Matisse and Picasso within the realm of the possible. He gave artists a way to approach the masterpieces, and it's amazing how many of his students rose to the occasion. Even many of the Hofmann students whom "nobody ever heard of" did remarkable things.

Emmerich's "Push and Pull" show was a small essay in demystification. What you saw was what you got; the paintings left me feeling clear in the head. These Hofmanns aren't major art; but they're the product of a sensibility that knows what major is. As a painter who gained his first fame as a teacher, Hofmann knew what it meant to watch and wait. Perhaps he wasn't afraid of appearing minor; certainly he did a great deal of frankly experimental work. In Clement Greenberg's little monograph on Hofmann, published in 1961 when the artist was past eighty, there are allusions to matters other than the aesthetic. "Hofmann," Greenberg writes, "offers a lesson in patience. That lesson, from him and from others, I shall never finish learning. It includes one's own mistakes. One is also reminded of how in art the tortoise so often overtakes the hare." The Hofmanns from the years around 1950 that were at Emmerich in January are tortoise paintings. They define a procedure. When in the later fifties and early sixties Hofmann began to do work that struck many of his contemporaries as truly major, it was a vindication of the step-by-step idea.

March 1988

YES!

When an artist makes radical innovations in a familiar medium, or combines several familiar media in a radically original way, it takes a while for the rest of us to catch on. Barbara Goodstein's relief sculptures, which are done in plaster and modeling paste on rectangular pieces of plywood, may not startle us, but they're just about the only works to have emerged in this decade that can be said to add something new to sculpture. All European relief sculpture since Donatello has in some respect been an extension of painting; Goodstein is the first artist to evolve a relief sculpture style out of an aesthetic derived from painterly painting. Even when her reliefs don't look like painterly paintings, she's deriving her rhythms and inflections from them. In her third solo show at the Bowery Gallery in January there were some very high points and some very low points; there wasn't the across-the-board clarity of thought that the finest pieces in the show might have led one to expect. The Barbara Goodstein who can pull off a work of the caliber of *Resurrection (1)* can't yet sustain that level of accomplishment; still, she's one of the few artists around who has a level of accomplishment to fall off from.

There's no way of knowing for sure if the three faceless white figures in Goodstein's *Resurrection (1)* are male or female. Ambiguity is integral to the coolly impassioned mood Goodstein spins. In *Resurrection (1)* all we can be sure of is that three figures are locked in a pitch-black place; a place that—judging from their tensed-up, straining gestures—they would like to leave. Working with the most modest of materials, Goodstein transforms human anatomy into a series of expressionist graphic signs. She simplifies people, but she also brings us close to them—she shows us their experience. Goodstein's subject here is striving; and, perhaps, the something we strive toward. The central figure, with the

broad shoulders and the substantial upper arms, is helping the other two. The figure at left is just a few looping lines; the one at right is made of some scrabbles of plaster. These two look toward the stronger one, and the stronger one—a bulky torso on sturdy legs—faces forward and prepares to hoist them all, together, up on high.

The inspiration for *Resurrection (1)* was a fourteenth-century Turkish fresco of the Anastasis (a scene actually preceding the Resurrection) in which Christ raises Adam and Eve from the dead. This late Byzantine composition presented Goodstein with a store of concrete information off which she bounced her own less-is-more sensibility. Goodstein has done much of her most forceful work—including the *Pieta* in this show and the series of *Three Graces* in her last show—in response to models in older art. At forty-two, she's one of the most intelligent of the art-besotted artists of her generation; few are quite so alive to the possibility of making something really new out of the pieces of the past. Goodstein is liberated through her attachment to tradition. Models such as the Byzantine Anastasis give her a world that's preabstracted. She doesn't have to wonder how to turn an area of sky or floor or earth into a flat shape—it's already done. She's free to pursue her quirky figuration without the constant question, "How does this size up to reality?" The flat black space of *Resurrection (1)* has no relation to "real" space—it's the space of memory, and of art.

Mostly, though, the black-painted rectangles on which Goodstein does her sculptures don't have that metaphoric resonance. In her recent show Goodstein was using relief sculpture as a medium through which to develop thematic and structural ideas we generally encounter in the work of painters. It's an audacious program, difficult to bring off, and in many of the landscapes and single figures in this show the beautiful modeling in plaster ended up looking landlocked. Goodstein's pats of plaster are an analogy to the loose brush stroke of nineteenth- and twentieth-century French painting; the winning eccentricity of her work rests in her attempt to re-create sculpture within a painterly, expressionist sensibility that is, broadly speaking, antisculptural. The danger is that as Goodstein goes into three dimensions she calls into question the very essence of French modernism: the idea of the picture surface as a discrete world. When she reduces a landscape of trees to a few strokes of plaster, or puts a seated studio nude in the midst of a black space, the pictorialism of the reliefs begins to backfire—the black space

can seem like an afterthought. The white plaster signs don't always activate the rectangle. Two treescapes looked too much like Ab Ex explosions by Franz Kline or the Frenchman Georges Mathieu. Even the very beautiful *Mountain Landscape*, in which a great ribbon of mountain rises maybe two inches off the surface, has its problems: where in this landscape space is one supposed to locate the blank space below the hills?

In her recent show Goodstein wasn't standing still; she was trying different things. But the two most daring pieces were also the weakest ones. How Goodstein cooked up the idea of doing polychrome reliefs on a base of styrofoam packing materials covered in wire mesh and modeling paste I have no idea; in any event, the results are unpleasantly bizarre, like a hardened version of soft sculpture. In *Five Figures in a Landscape* Goodstein is working to activate the surface by filling it with colored shapes. Some of the nude women here, reminiscent of Matisse's sculpture, are magnificent pieces of plaster modeling; but by setting them amidst areas of blue stream and green grass and mustard sky, she banalizes them. In *Four of Iris*, several views of a woman's back, marvelously worked, are arranged amidst fragments of interiors that look like bad geometric painting. More interesting as a solution to the problem of activating the surface overall is the substitution of dark blue or green for black on the boards; or the use of plaster thinned to a gray tone.

Still, I don't know why Goodstein hasn't extended the implications of *Resurrection (1)* into more of her work. She is an extraordinary figure sculptor. Here, as in her last show, she turns out standing and seated figures in which the wonderful simplifications, derived from a close study of the model in the studio, rival Alexander Archipenko and Henri Laurens at their very best. Why, then, does some of the work seem unfulfilled? A larger version of *Resurrection*, three by five feet, was too loose, a bag of scraps. Goodstein hadn't filled the space; it was as if she'd just fizzled. And two small, very fine studio nudes, seated on chairs, would have been better yet if they'd been two or three times bigger. Sometimes Goodstein seems to want to be the Corot of relief sculpture: a miniaturist. It's a mistake. Her real affinity is with French painting that's more idiosyncratic and monumental: the tile decorations in Matisse's Chapel at Vence, the final black and white figure compositions of André Derain, the late street scenes of Jean Hélion.

Goodstein's work, with its arresting simplifications, suggests a devastating critique of contemporary taste in representational art, which runs to nit-picking demonstrations of naturalistic virtuosity. And yet the only community that has ever given Goodstein any support is the community of representational painters that has been an important part of the New York art scene since the fifties. Thus does one of the wisest members of the community revolt against communal pieties. Goodstein's art, which has really taken off only since she reached her late thirties, also exemplifies what I see as a new calendar in artistic life. It now seems to take a serious artist most of his or her thirties to develop the inner strength to make peace with the art world and go it alone.

Yet the painful sense of isolation from the larger world that all serious artists now feel has its dangers. Working, as Goodstein does, for a small group of artists and connoisseurs, she may feel that it's enough to maintain a holding operation. How much can you risk doubting yourself when the wide world gives you no support? And how much can an artist risk reaching out—enlarging art—when chances are that few will be there to respond? A certain diffidence could be felt in ways both large and small in Goodstein's show. A small but important matter was the sloppiness of the presentation—the messy wall labels, the inelegant nails that held the work to the wall, the sometimes warped and roughly cut boards. I think I understand Goodstein's diffidence. It's as if she's saying that if the wide world won't care about her, then she can't be bothered with the niceties of presentation that the wide world demands. But Goodstein is too important to overlook these things. Someday the wide world will pay attention. She must be ready.

All art today is created under conditions inhospitable to art. Goodstein's purest works are a response to a situation in extremis; she creates compositions in black and white. In *Resurrection (1)* she speaks not only for herself but also for the hopes of her friends—for a generation of artists that wakes up every morning to the terror that it's going to be buried alive.

———

Milan Kunc, a Czech artist now living in New York, works out of the same fund of Soviet kitsch images that are the sources for the Russian exiles Komar and Melamid. He's Komar and Melamid minus the pom-

posity. Kunc's photocollages, which were at Robert Miller in February, are based on three-by-four-foot photo blowups of cliché images of happy citizens under socialism—women working in kitchens; men standing in fields of wheat or sitting down for a meal. When Kunc paints on the photographs in powdery blues and pinks and yellows, the effect is akin to the hand-painted postcards of the turn of the century, only Kunc's work is wryly purposeful in ways those postcards never were. Kunc takes two photographs of women ironing and swishes some blue clouds under their feet and yellow halos around their heads—and makes them into domestic saints. One woman holds up a towel on which Kunc has painted a little Neoplastic composition. It's Veronica's veil as an art world icon. Kunc swirls around the fantasy of a good life under Communist-bloc socialism, and the little touches he adds to the photographs are enough to keep the comedy light. Looming just beneath the surface of these throwaway compositions is the hard fact that you have to leave the place that the jokes are about in order to make the jokes. A better comedian would have something to say about that. But then Kunc's work does convey the pop joy of freedom. This is the right fluff.

————

Picasso died in 1973, but as a creative force many believed he had died several decades before. His later work, much of which is by any standard weak or simply undistinguished, made him easy to overlook, and at a time when modern art was often seen as an art of young men, Picasso was without much ado retired to the old age home of reputations. The only late modern style that found wide acceptance in the fifties and sixties was Matisse's in his paper cutouts; and even then, Matisse's work between 1918 and 1940 was held in low esteem—the paper cutouts were an exception to the rule. For a long time modern art was thought to be about aesthetic breakthroughs, not aesthetic consolidations, and so the very concept of a late style—a style of subtleties based on long experience—fell out of favor.

In the early seventies few people were interested in Picasso's late work: only some of his old friends in France (Michel and Louise Leiris, Hélène Parmelin, André Malraux) and some art historians in America. I believe the upsurge of sympathy for the late Picasso that we've seen in the past ten years—it has now reached a culmination with "Le Dernier

Picasso," the big event at the Pompidou Center in Paris this spring—marks a genuine sea change in taste and consciousness. It's not just vain curiosity to want to contemplate the end of a great career; our new interest in Picasso's conclusions, which he was drawing at the century's three-quarter mark, are part of a more general effort to see the trajectory of our century as a whole.

In the exhibit of drawings from the last decade of Picasso's career that was at Hirschl & Adler in February, the Maestro keeps his figures—which are the usual roundup of grand ladies, nudes, courtiers, and musketeers—very close to the viewer. The four edges of the paper define a shallow stage. This holds true for the chiaroscuro drawings, in which Picasso does his version of Rembrandtesque lighting, as well as for the drawings in more or less unornamented line. In general I have problems with the shaded drawings. There's something softly seductive, but also a little vague and shoddy, about the way Picasso develops an illusion of depth. The gray washes have too much of Manet's slipperiness for my taste; Picasso is looking for easy effects. The line drawings are another matter, especially those from around 1970. In the pen and ink of *Le Peintre et son Modèle* (May 24, 1970) and the soft pencil of *Homme et Femme Nus* (August 2, 1970), Picasso is rehabilitating the Neoclassical line of the drawings of the twenties. His strokes separate form from form with the same decisiveness that they did forty years earlier; but in place of Picasso's old nostalgia for Ingres and Flaxman there's a fresh self-sufficiency in the way a line sets out into the emptiness of a page. Spreading out into a bulbous thigh, or resolving into a tiny pinpoint of a neck, these lines are comic without ever being cartoonish. The thin, scratchy pen lines in the 1970 drawing are like the dry voice of an old man. Eroticism and asceticism meet.

Jeffrey Hoffeld, a member of the staff of Hirschl & Adler, has written an essay for the catalogue that's characteristic of current commentary on Picasso: much is made of Picasso's debts to the old masters and Spanish literature, as well as of his waning sexual powers. Yeats's "Sailing to Byzantium" is quoted. All of this is no doubt relevant; and yet I'm mistrustful of the tendency to cloak Picasso in grand allusions, in some sort of Shakespearean tragedy of old age. Is it by accident that André Malraux's magisterial study of the late Picasso, *Picasso's Mask*, isn't in Hoffeld's bibliography? Malraux saw Picasso as an artist who

was simply trying to resolve the artistic problems that had obsessed him for half a century. An old man himself, Malraux didn't romanticize old age. Malraux also made a connection between Picasso's final works and the period when they were done—the late sixties, when the Maestro's rebellious hedonism found many echoes in the youth culture. At Hirschl & Adler, where the dark velvet walls have rarely done much for the work on display, Picasso's drawings labored under the added liability of the kind of overframing that galleries use to justify very high prices. (Louise Leiris, the first dealer to show the late drawings, frames them in plain wood.) At Hirschl & Adler one saw East Side gallery-goers who fit right in with velvet and period frames. But there were also young art students at the show, and it was their faces that mirrored Picasso's passion. There's a vigor to the very late Picasso—and it's not entirely unlike the vigor of youth.

Using different thicknesses and lengths of steel wire, and pieces of pinkish granite, the Japanese artist Tamotsu Shiihara turned the front gallery of 55 Mercer into an arresting, lightly surreal environment this past February. Shiihara welds the wire into delicate zigzags and networks that rest on the floor or project off the wall. Sometimes a little piece of granite perches amidst the steel rods, like a bird's nest in a tree. Running all around the room, from floor to ceiling, Shiihara's traceries suggest a plan for some sort of futuristic universe. But there's also a pleasing literalness to his effects: you're always conscious that he's decorating a room. It's a little like a new version of a Japanese rock garden—a garden of granite and steel. Yet Shiihara doesn't play the update-of-tradition for corny effect. He recalls the best side of Noguchi—the side that makes vivid contemporary theater out of a mix of Western modern and Eastern classical techniques. This is Shiihara's first show in America, and what impresses a viewer is the fun he's having with materials. Shiihara has the wit to turn a SoHo gallery into a garden that's halfway between the earth and the moon.

In the sixties, at a time when painters both representational and abstract were reacting against what was seen as the excessive subjectivity

of Abstract Expressionism, the strictly ordered Italian art of the fifteenth century had a special appeal. Richard Chiriani, who was a student at Pratt Institute in Brooklyn in the mid-sixties, became caught up in this fascination with the quattrocento. In the five shows he's had (four at Tibor de Nagy and a fifth at Robert Schoelkopf in January), he's remained true to the taste for crisp form and clearly designed spaces that first seized him all those years ago. The paintings in his first show at Tibor de Nagy in 1978 were like beautifully thought through science fiction visions: giant cubic structures rose out of parched landscapes full of trees shaped like crystals. Chiriani was linking up a fantasy of the past and a fantasy of the future. For this artist, and for some of his friends back in Brooklyn in the late sixties, quattrocento perspective was an intellectual head trip—a discipline you could get stoned on. (Remember Vasari's comment about Uccello's having gone mad on perspective?) Chiriani's early compositions, with their precise yet peculiar forms, were trippy paintings; they could have been dreamed up by a pothead who was reading the *Dune* books—those sci-fi works that are the literary equivalent of turning on and tuning out.

But the obsessive spirit that once drove Chiriani to dream up *Creation*, the twenty-five-by-fifty-foot mural a section of which was exhibited in that first Tibor de Nagy show, has since then driven him into obsessive schemes that are less successful. In the early eighties, Chiriani exhibited a series of four paintings of a rural marsh viewed at various times of the year. The composition was nothing much—just a flat expanse of weedy water, edged with bits of undistinguished landscape. Chiriani went at his marsh with a verve that was astounding but also ultimately somehow out of scale with the modesty of the subject. Lavishing all of his representational skills on marsh grass, he came up with images that had the sharp-focus banality of mid-nineteenth-century English painting. I don't think Chiriani ever intentionally goes for cheap effects. In the marsh series his plodding skillfulness was interesting; but this was low-level pleasure, and carried through four paintings it was too, too much. Chiriani's shows have been full of misbegotten ideas: some landscape paintings on supports with curving edges have recalled (one hopes inadvertently) television screens. On the other hand, he has had his real winners, generally when he returned to his earliest ideas, as in *C.E.I. on the Lake*, a scene of people at ease in a suburban park,

in which man and nature are transformed into similar geometric forms. The effect of the regular, faceted forms that Chiriani uses here parallels the effect of Seurat's dots in *Sunday Afternoon on the Grand Jatte*: the faceting is a way of abstracting nature, of giving nature a cerebral urban lyricism.

The main attraction at Chiriani's recent show at Robert Schoelkopf was a cycle of paintings done from New York bridges. Chiriani began the project in 1982 on a grant from the Ingram Merrill Foundation, and I must admit that when I originally learned of Chiriani's plan, I was skeptical. It sounded like an even more obsessive version of that marsh project. And it was going to be harder to carry out, since Chiriani was planning to paint bridges (and the city) from vantage points on other bridges, sitting hour by hour, week by week, in tight spots high above the water. (At Schoelkopf there was a photograph of the artist, wearing his hard hat, perched on one of the bridges, painting. This is a new twist in the plein-air tradition.) As it turns out, *View from the Manhattan Bridge* (43¾" × 80") is one of the best things Chiriani has ever done. Working in gouache on paper, he transforms the Brooklyn Bridge and lower Manhattan into a geometric fantasy. He sees the skyscrapers as a child's building blocks, and he knows which details to include and which to exclude. It's the Manhattan of dreams (no dirt, no poverty), the New York City one saw in the elementary-school textbooks of several generations ago. Here Chiriani's obsessiveness catches us up; we can study the off ramps of the bridge descending into the dark of lower Manhattan, and we can admire the cunning with which the bridge is constructed. (You feel sure that Chiriani has become an expert on bridge construction.) He knows how to point up the fantasy; a little blimp, floating high up in the sky, is straight out of the world of Le Douanier Rousseau.

The mystery of Chiriani at this point is why, if he's capable of a work of the caliber of *View from the Manhattan Bridge*, he gets bogged down in the dutiful, banal views that fill the rest of his show. What's magical in *View from the Manhattan Bridge* becomes dogged elsewhere. The beautifully clear, spare sense of color and paint handling too often turns cold or mushy. (I also fail to see the point of a 56" × 95" pastel.) It's difficult to escape a sense that the obsessive fantasist of Chiriani's best work fears his own penchant for fantasy, wants to prove to us that

he has his feet planted firmly on the ground. In the smaller room at Schoelkopf there were some landscape paintings done with a light Impressionist brush stroke that's completely out of Chiriani's range. Why is he doing this pastoral bilge? When people reach their forties (Chiriani is forty-five), they sometimes get the idea that it's time to be sensible, to settle down. But for an artist becoming sensible may be tantamount to going insane. When Chiriani is really clicking, he shows us how a dreamer's sensibility can merge realism with surrealism. There's room for enormous growth here—for more complex structural geometries, for a more thoroughgoing fantasy of topology as a way of seeing the world. Perhaps with the completion of the New York bridge series Chiriani will feel he's done his bit for reality. I just hope he still has it in him to be crazy after all these years.

————

In Stephen Taylor Woodrow's "Living Paintings," which were at the New Museum for twelve days in February, three young men, dressed in suits and overcoats with wide, nineteenth-century-looking lapels, were suspended for seven hours a day from three panels that hung on the wall. Each figure was spray-painted the same color as the panel in low relief representing a corner of an interior; the three compositions made up a triptych in somber, Brice Mardenish hues. Hanging in the main gallery at the New Museum, before a crowd that even on a weekday afternoon numbered about fifty people, the three actors looked like a cross between young punks and nineteenth-century dignitaries. The New Museum press release said something about "the vague and ambiguous interrelationships of reality and illusion," but the actual event was, thank goodness, humorous. (On the floor beneath each "painting" was a little heap of litter, the leftovers from the food the actors ate during their daily stints.) Looking at the three duded-up fellas hanging there—taking off a pair of shades, running a hand through a clump of hair, recrossing a leg, taking a little stretch—we were only being carried into a more extreme state of the see-and-be-seen mentality that's a cornerstone of downtown life. Woodrow's "Living Paintings" come out of a world where almost every man is to some degree a dandy, and the "Living Paintings" are just the narcissism of the dandy carried to an extreme: they pose, you contemplate, and nothing much else goes

on. The humor of the seduction was obviously on the actors' minds. One, who was eating a banana while I was there, offered a bite from it to a woman in the audience. She accepted. The Living Paintings were on television and National Public Radio and were treated as a news story in the *New York Times*. The New Museum had an avant-garde hit. The message was that the avant-garde can be fun (and you didn't have to stay any longer than you pleased).

————

For the past five years David McDermott and Peter McGough, who are in their thirties, have been collaborating on paintings that are self-consciously—clunkily—primitive. Some of these, such as a quartet of landscapes illustrating the seasons, look like conventional paint-by-number jobs that have been subjected to Dadaist alterations. In the case of the landscapes, each one has been inscribed with a message that reads, "I WAS BORN IN THE WINTER [or spring or summer or fall] OF THE 21ST CENTURY." Others of their paintings, such as one of a man and two boys (father and sons? lovers?) naked in a bathroom, look like they might be by an eccentric Sunday painter of the 1890s or 1920s. The nostalgia element in McDermott and McGough's work is under-lined by their habit of conspicuously double-dating the paintings, so that a canvas will bear an inscription like 1887–1987. There is something amusing, but also overly contrived, about these paintings. The tech-nique isn't even competent; the sophistication is all in the ironic attitude that McDermott and McGough are taking toward their kitschy material. What's new (slightly new) is the friendliness of the irony. The pictures have a bright, guileless look—they're cheerfully sophisticated. But the sophistication of the connoisseur who presents amusing yet mediocre images for our inspection doesn't hold our attention for very long. McDermott and McGough don't do anything much with the material that they quote and paraphrase. Their sophistication is a form of opacity: they show off their cleverness, but they reveal nothing about themselves.

That would have been my assessment of McDermott and McGough had I been writing this six months ago. But they've made an artistic breakthrough in the cycle of autobiographical drawings that was shown at Massimo Audiello in February, and there's now something more to say. Working in colored crayon on twenty-five-inch squares of brown

paper, McDermott and McGough have illustrated their life stories in thirty scenes that recall the graphic styles of George Grosz and Florine Stettheimer. Here the duo's taste for the charming and the amusing has been released: they're reinventing their own lives as a modern picaresque adventure. Their technique is still primitive; but the blocky shapes and rigid contours add something to the story—they give it a spare, unsentimental clarity.

We see the suburban houses McDermott and McGough grew up in and vignettes of the unforgotten images of childhood: David's grandmother, a busty woman standing very straight, as if ready to be photographed; the funky lady in the harlequin glasses who drove the Holy Family School bus. They're humorous about the painful and wistful memories of childhood and adolescence: the alienation of a boy who spent his time off in a corner drawing while his friends played ball; a Lawrentian first sexual encounter in a secluded forest pond. In the New York scenes the drama heats up. It's an update on the stories of hayseeds who arrive in the Big City and become bohemians—the kind of people that Dawn Powell described in her novels of the forties. There are chaotic, come-as-you-are parties; mornings in Bowery lofts where the young artists camped out under leaky ceilings; an argument with Keith Haring and Kenny Scharf, whose Hawaii-funk garb makes quite a contrast to the Edwardian getup of McDermott and McGough. In one of the best scenes there's been some sort of disaster in their apartment—things are broken all over—and one of the duo sits weeping in a chair.

McDermott and McGough cut quite a figure on the downtown scene. By going everywhere in nineteenth-century clothes, they've transformed themselves into a work of retro performance art: their very life style is double-dated, 1888–1988. And it's no doubt the duo's flare for self-publicity that accounts for a good deal of the attention that their work has received. This would have nothing to do with the work, except that in the neo-Dadaist universe through which McDermott and McGough have made their way, all gestures are equal, and it is taken for granted that a retro life style and a retro painting style can have a similar hold on our attention. I have a horror of the life-equals-art gestures that are McDermott and McGough's stock in trade: such gestures generally end up turning works of art into life style accessories. Certainly, nothing in the previous work (or reputation) of McDermott

and McGough has prepared us for the comic distance that they've achieved in their new drawings. Who imagined that McDermott and McGough would send up—lovingly, clarifyingly—the rise of the East Village? These drawings comprise the best "novelistic" treatment of downtown life we have yet seen. McDermott and McGough have the equanimity to step back and see themselves and their world clear. In the new work they transcend irony and go into humor. And their humor has some detail to it. We might just be witnessing the debut of a powerful graphic imagination. Or, considering that this is a duo, should I say imaginations?

————

The announcement of a historical retrospective can be an occasion for trepidation, because we've learned by now that there's such a thing as seeing more of an artist than we ever wanted to see. Some shows even offer more than we imagine the artist himself might want to see in one place at one time. It's a conundrum that a man of the caliber of Pierre Rosenberg, who organized the gigantic Fragonard show that's currently at the Metropolitan, should have so little sense of proportion. Two hundred and twenty Fragonards? Perhaps the matter is out of his hands; perhaps the only way to get funding is by doing the definitive show. Nowadays, with rising insurance premiums and serious doubts about the safety of moving works of art, every show is accompanied by a warning that it's going to be the last of its kind. The 1980s may turn out to be the Götterdämmerung of Big Museum Shows.

Fragonard survives the mega-retrospective treatment as the peculiarly unresolved artist one always knew him to be. Admiring the sketchy calligraphy of his smaller paintings in museums around the world, one sometimes imagines that there's another, more complete side to Fragonard. But one also knows from experience that, save for the cycle in the Frick, which is a masterpiece of decorative painting, Fragonard has no large synthetic vision. The retrospective only confirms this. In the catalogue, Pierre Rosenberg observes that the *Fête at St. Cloud*, a much-heralded loan from the Banque de France, has been judged by some art historians to be on a level with Watteau's *Shopsign*. My own reaction was exactly the opposite. The only way I could believe for one minute in this fête, with its Naugahyde trees and fashion-illustration figures, was by keeping Watteau out of my mind.

The greatest Fragonards are the ones that the Goncourt Brothers and Fragonard's other nineteenth-century admirers prized: the boudoir scenes, which are graphically and yet somehow also delicately erotic, and the landscape drawings from Fragonard's two trips to Italy. It's one of the paradoxes of Fragonard's art that these drawings are more specific and satisfactorily finished than most of his paintings. With the great red chalk drawings of Tivoli from the first Italian stay of 1756–61, Fragonard takes his place at the beginning of the Romantic age. In the ancient gardens of Italy the artifice of a man-made setting is giving way to something wild, beyond man's control. The overarching trees, the moss-covered ruins, the tiny figures have a romantic power that goes way beyond literary conceit. Nature is exploding the garden. The Renaissance has come to a close.

Fragonard is one of those eighteenth-century artists (Chardin is another) whose art had gone out of fashion even before the artist had died. The whole century—with its tremendous social changes signaling the collapse of the patronage system that had supported painting and sculpture for centuries—was in some ways inimical to art. Surely the eighteenth century is less rich in painting than either the seventeenth or the nineteenth. Going through the Fragonard retrospective, one had the sense of an artist who didn't quite understand his own gifts—who didn't always know quite what he ought to do with them. He did a great many figure paintings; and yet even when they're beautifully worked up, they're facades, with nobody home.

Ultimately the mega-retrospective may tell us less about the artist than about the organizers. Rare is the artist whose every scrap we want to see. Fragonard *is* a great painter. It's only our ridiculously overblown expectations that can make him seem small.

April 1988

LETTER FROM PARIS:
OBITUARIES AND RETROSPECTIVES

With a bit of falling snow, the Seine looks exactly like a winter scene by Albert Marquet. But it didn't snow for very long in Paris when I was there this past February, temperatures were good enough for aimless strolling, and the sky was as marvelously changeable as in May, going in a moment from oyster gray to delicate smoky blue.

I arrived in Paris a week after "Le Dernier Picasso" had opened at the Pompidou Center and went over to the museum on my first evening—it stays open until ten. A good-sized crowd was moving slowly through the big show of work from Picasso's last twenty years, and there was drama to the occasion. Only now, fifteen years after Picasso's death, has his late work finally arrived in strength in the city he came to nearly ninety years ago. I was glad to be in Paris for the occasion. I'd been in Europe in the summer of 1970, when the late Picasso paintings were first shown at the Palais des Papes in Avignon, but had been too much the self-absorbed eighteen-year-old to know or care. It was a decade before I got back to France—older and, I hope, better able to seize what came my way. There were still opportunities for contact with the generations that had made Paris the first city of twentieth-century art. My wife, the painter Deborah Rosenthal, admires André Masson's work enormously, and in 1980 she managed to arrange a visit with him, and I got to sit there and listen, despite my inadequate French, to a conversation that Deborah had been led to expect might last an hour but which actually stretched through an afternoon. That visit remains vivid in the imagination—a thimbleful of real time passed with a figure out of history. When, a few years later, Deborah and I met Jean Hélion, he seemed like an old friend from the moment we said

hello to him, probably because we'd already heard so much about him from his old friends in New York. In the eighties, Hélion was battling failing health and (the artist's ultimate nightmare) failing eyesight; but there was still his warmth and eloquence and generosity, and the hours spent with him will remain forever bright.

Now Masson and Hélion are gone. They died in Paris late in October, within a day of one another. At the time this coincidence struck many of their friends and admirers as strange and perhaps even unfortunate. Surely Masson and Hélion each deserved to have the obituary page to himself—two such important deaths were more than many of us could take in. Since the fifties, Masson and Hélion had seen something of one another and had had a number of friends in common; yet temperamentally they were very, very different. No neat message could be extracted from their deaths just hours apart; still, there we were, confronting all at once the ends of the last great representatives of not one but two periods—the twenties and the thirties. Their obituaries are part of the history of the past half century. André Masson: 1896, born near Senlis in the Île-de-France; 1924–28, plays a central role in the early years of Surrealism as the inventor of automatic drawing; 1929, defects from the circle of arch-Surrealist André Breton to the renegade camp of Georges Bataille; during World War II, lives in exile in America, where his calligraphic style makes a deep impression on the young American painters; 1945, returns to France, takes up residence in Provence, and begins a reinvestigation of Impressionism. Jean Hélion: 1904, born in the Norman village of Couterne; 1930–31, joins forces with Van Doesburg, Arp, and others to form the Abstraction-Création group; in the mid-1930s, gains a reputation among the international avant-garde with his geometric compositions; 1936, takes up residence in the United States; returns to France in 1940 to fight with the French, is taken prisoner, spends almost two years in German prison camps, escapes in 1942 and returns to America, where he writes a best-seller about his experiences, *They Shall Not Have Me*; 1945–50, makes a famous stylistic about-face and emerges in postwar Paris at the forefront of the return to realism.

In Paris in February modern art seemed old, and also unsure of itself. The last of Picasso—the work that had been a giant question mark when he died—filled the top floor of the Pompidou Center, and

people were still laughing in surprise and embarrassment at the por-
nographic plates of *Suite 347*, his enormous print cycle from 1968. On
the floor below, the curators in charge of the permanent collection of
France's Museum of Modern Art had given over one room each to
Masson and Hélion. The selections were spotty. I cringed at the thought
that anyone might judge these artists on the basis of what was hanging
here. Masson and Hélion, two of the least-understood figures of the
century, departed this earth with their reputations still unresolved. And
Picasso remains a controversial figure.

"Le Dernier Picasso" is the third major museum show to be devoted
to Picasso's final phase. This show—which is a joint effort of Pompidou,
the Musée Picasso, and the Tate Gallery in London—departs from the
format that was used at the Kunstmuseum in Basel (1981) and at the
Guggenheim in New York (1984) in that it surveys not the last ten but
the last twenty years of Picasso's life. I believe that there remains much
in Picasso's output between the end of World War II and 1965 that
hasn't yet been properly appreciated, and so the prospect of the first
half of "Le Dernier Picasso" was interesting to me. Unfortunately, the
curators—Marie-Laure Bernadac, Isabelle Monod-Fontaine, and David
Sylvester—haven't really taken up the challenge of the fifties; the lion's
share of the work on view dates from after 1965. The show pretty much
follows the idea of John Richardson—who is working on a comprehen-
sive biography of Picasso—that Picasso's two decades with Jacqueline
Roque form a distinct period in his life. This period is seen as culmi-
nating in the explosion of work that extends from *Suite 347* in 1968
through the paintings of 1971. We still need a major show that focuses
on Picasso's development between 1945 and 1960. The opening galleries
at Pompidou give some sense of how rewarding the postwar Picasso can
be; they also suggest why this phase of Picasso's development poses a
challenge to establishment taste.

Picasso's very late work has gained broad acceptance in recent years
because its rambunctiousness looks avant-garde. There's a growing
transatlantic consensus that Picasso remained to the end an artist who
knew exactly what he was up to. Contemporary taste has turned the
Expressionist of 1970 into an acceptable figure: "Le Dernier Picasso"
demonstrates how Picasso arrived at his final, antiarchitectonic style by

systematically dismantling the late-Cubist style he'd been committed to in the early fifties. But the orthodox Cubist of 1955 remains little re- marked or understood. Beware of those who believe in one "real" Pi- casso: if we've learned anything by now, it's that Picasso's reality lies in the way he becomes himself in the process of taking on a variety of stylistic disguises. If Picasso was knowingly defying all the conventions when he created such rhapsodic scrawls as the *Maternité* of 1971, he was knowingly accepting all the conventions when he painted a long series of Cubist interiors in the fifties.

These interiors are a shock when you come on them in the first room at the Pompidou Center. Particularly in *Nu dans l'atelier* (1953), Picasso is taking upon himself the congested, academic structure we know from the work of André Lhote and Marcel Gromaire. Academic Cubism has a way of dealing with the world. Every time a form turns or two forms overlap, the design is forced to the surface—and Picasso's surface, like those of Gromaire and Lhote, is a tight, congested grid. If I read the oil paintings of the period 1950–1960 correctly, Picasso is saying, "Maybe there's some life left in academic Cubism." One must remember that Picasso, unlike Braque, hadn't consistently designed pictures in an overall Cubist manner: the portraits of the thirties and the forties are extensions of *Les Demoiselles d'Avignon*'s distorted figures, not of *Ma Jolie*'s wholesale reorganization of space. But for the spectacle of the South of France—the gardens and salons of La Californie (his villa in Cannes) and the Riviera landscape beyond—a canonical Cubism seemed appropriate. And Picasso found much life left within a mode of construction that by the fifties reeked of musty "School of Paris" perfume. In *Nu dans l'atelier* and the La Californie interiors of 1956 the tightness of the space is inventively and surprisingly established. The shuttling back and forth between highly abstracted and highly natur- alistic details—which Lhote had turned into a cold mannerism—is re- newed. The exotic brazier on the floor, the seductive nude reclining on the couch, add piquancy to the overall design.

"Le Dernier Picasso" hints, in its first galleries, at a lyric side of the fifties Picasso that has yet to be fully revealed. In these paintings we encounter aspects of the world that Picasso isn't supposed to know about: dark shadows in the crowded atelier; doves nestling on a wrought-iron balcony; stucco houses built like tiny fortresses on sun-drenched hills.

It's inevitable that our museum curators, who are insensitive to much of the lyricism of modern French art—for example, the paintings of Dufy and Marquet—should be reluctant to exhibit the smaller Picassos of the fifties. Yet there's surely more of quality in these cabinet-sized Picassos—with their reminiscences of Renoir and the trecento—than in the dry, overcalculated variations on Delacroix's *Women of Algiers* that are always trotted out when something of Picasso's from the mid-fifties is felt to be needed. (They're included in "Le Dernier Picasso.") Too little is made of Picasso's gentleness—the gentleness that we encounter in the Rose period, and in the neoclassicism of the years around World War I, and again in the fifties.

An output with the vast dimensions of Picasso's can easily swamp us; selections must be made. But sometimes selections are made and they turn out to be the wrong ones. Two of the largest paintings in "Le Dernier Picasso"—*Femme nue sous un pin* and *Le Buffet de Vauvenargues*, both 1959–60—are monumental bores. This pair of behemoths, a reclining nude and a domestic interior, have no intrinsic interest, nor do they hint at where Picasso is going. When we're unsure of Picasso's intentions, one useful guide is the paintings that the artist or those close to him believed had a special significance. As a guide to the artist's development between the fifties and the *Suite 347* in 1968, the paintings in the collection of Michel and Louise Leiris are especially revealing. (They were given to the French state in 1984.) Louise Leiris (Picasso's dealer for decades) and Michel Leiris (the celebrated anthropologist and Surrealist writer) probably knew Picasso as well as anybody, and two works from their collection in "Le Dernier Picasso"—*Femme couchée sur un divan bleu* (1960) and *Le Peintre et son modèle dans l'atelier* (1963)—show Picasso discovering, in his late seventies and early eighties, new forms of spontaneity. In *Femme couchée*, Picasso takes command of the rectangle with a casual confidence that he isn't always capable of in those years; the figure unfolds out of the lines of the brush, prefiguring the sketchlike lucidity of the 1968–71 period. *Le Peintre et son modèle dans l'atelier*, in hot pink and spring green, also conveys a new freedom, a foretaste of things to come. This little studio interior, one of a long line of interiors from the sixties, is a masterpiece of the postwar period. The artist, seated at the left behind an easel, is fixated on the model who reclines on a divan all the way to the right. Here Picasso's whiplash brush strokes

fling us from left to right and back again. The space is tight yet elastic, as if everything were attached to everything else by gigantic rubber bands. That rubbery line of Picasso's is a comic line—it constructs both the artist's bulbous profile and the teeny-weeny reclining model; but there's also something metaphysical to the comedy, because the same line that makes form breaks form. In spite of the unnatural, zany color Picasso employs here, the artist's workroom is ominously shadowy.

Le Peintre et son modèle dans l'atelier is Picasso in full control of his powers; Picasso does keep hitting it until the end. But of course there are also plenty of clinkers. With late Picasso, one can either take the worst paintings as a baseline and dare the artist to do better, or grant him the best ones and see the others as a falling off. At one time or another I've taken both approaches; at "Le Dernier Picasso" I was on Picasso's side—the rhythm of the latter part of the show put me there. Several small rooms packed with the marvelous erotic contortions of his prints led into two large, squarish galleries tightly hung with a selection of the paintings that were first shown at the Palais des Papes in Avignon in 1970 and 1973. There are prints and paintings in which Picasso's controlled excess brings forth a new electricity, as well as works that are vague or spotty, dashed off too fast. Yet it's by no means easy to say when too little is too little. *Personnage rembranesque et amour* (1969), with a blurred effect that may derive from Picasso's experiments with aquatint, gives us very little to grab onto and yet is wonderful, delicately hallucinogenic. The sea-green *Maternité* (1971), from the Musée Picasso, is another great painting. At Pompidou, *Maternité* was joined by a few more amazing sea-green visions: *Homme à la flûte et enfant*, done the day before *Maternité* (they made a pair at Avignon in 1973); a melancholy, bust-length *Femme au repos* (1971); and *Homme écrivant* (1971), a head of a man drawn in jumpy calligraphic strokes that seem to be derived from Carolingian manuscript painting. When one is in these last rooms at Pompidou the effect of the ensemble can be overwhelming: gathered together, Picasso's gaping faces have an aura that gives even the lesser works a lift. Is it romantic to feel generous toward Picasso's failures? Perhaps, but I don't imagine that our experience of these late paintings can be separated from a certain mood of romance.

The curators of "Le Dernier Picasso" have produced a riveting finale. In the three ink drawings of reclining nudes from August 18, October

3, and October 5, 1972, all the voluptuous curves of the year before are gone. For once Picasso is drawing like an old man, with uncertain, broken strokes. The anatomy has sunk into itself. You can barely tell an arm from a leg in the shriveled remains of the female figure; these women look like the discarded carcasses of Victorian easy chairs. In doing his final nudes, Picasso may have been thinking of the erotic fantasies that Masson included in his album *Anatomy of My Universe* in 1938—it wouldn't surprise me if Picasso, at the very end, was still cannibalizing others to enrich his expressive range. It doesn't surprise me, either, that at the end Picasso finds something new. And that his wit—reflected in the way he turns the top of the "2" in 1972 into a tightly wound spiral—is there to give a comic twist to the baffled bitterness.

Each encounter we have with a painting is self-contained; returning to the same work a week or a month or a year later, something that moved us may not move us, or may move us more. With artists such as André Masson and Jean Hélion, whose work we can't be sure of seeing regularly, we're very much dependent on the slow accretion of experiences: the gallery show of such-and-such a year, the selection of works that hung in a museum at such-and-such a time. You have to contend with spotty and poor showings. You have to have the courage to trust in the impressions you've built up over the years.

Nothing in the climate of the past twenty—no, forty—years has really helped us to respond to André Masson. Though he died with his name firmly established in the history books, the image of a pioneering Surrealist or a guru to the Abstract Expressionists fits imperfectly with a body of work that consists mostly of smallish, complexly colored paintings that encompass a vast range of themes, motifs, and ideas. Masson, who came from Brussels to Paris in 1912 at the age of sixteen, saw Cubism as a permission to do all kinds of things. Even his essential Surrealist paintings of the twenties—the sand paintings, with their bare canvas and straggling red, blue, and black lines—are related to the idea of a painting as a literary emblem, an idea which had been rather rare in twentieth-century French art. (The literary side of Masson's work is what first endeared him to the Surrealists.) In a sense we ought to be ready for Masson, because we're in a period that's eager to question the

idea that less is more in modern art; but Masson's work is both so various and so self-contained as to repel casual curiosity. It takes a considerable effort to untangle his complex relations with Symbolism and Impressionism, with Greek mythology and Japanese religion.

My own introduction to Masson came at the shows at the Lerner-Heller Gallery on Madison Avenue in 1972 and 1973. The works I remember best are the wonderful, unexpected Massons: the 1939 *Hôtel des Oiseaux*, in delicate blue-gray washes, with strange birdlike creatures playing out some murderous narrative in a seedy French hotel; the 1955 *Migration*, with tiny calligraphic forms, emblems of the shifting populations of wartime, flung across a dark ground; the 1972–73 *Le vainqueur de Méduse*, in lurid red and blue, a blood-dripping classical hero with a hand in the place of his head and a face in the place of his genitals. Looking at the Lerner-Heller catalogue today, I realize that part of the excitement of *Le vainqueur de Méduse* was in thinking, "My goodness, he's still at work."

Unfortunately, the selection of Massons on view at Pompidou in February made the variety of his work look like incoherence. One of the most important paintings on display was *La Résistance* (1944), a dark, swirling labyrinth of separate yet interrelated spaces that clearly deserved better than the catch-as-catch-can installation it received. In *La Résistance* Masson represents the struggles of World War II as if they were episodes in a strange storybook: the secret meetings, the telegraph messages, the heroes, and, at the center, Notre Dame, symbol of France. No single view is enough to establish a judgment on such a painting, because its method, a semiabstract narrative combining elements of fantasy and current events, is so unfamiliar. The mood of this painting—and of almost all Massons—is melancholic, saturnine. The artist's shining intelligence—his great stock of ideas—can seem a terrible tragic burden when he's living through a period of skepticism about the painting of ideas. I don't know if I believe in *La Résistance*; but I do believe in the career that produced it. When one enters Masson's imagination, there's much that's delicate and gentle to be found. Masson, in the urban-apocalyptic works of the thirties and forties, as well as in the nostalgic pastoral works of the fifties and sixties, is the most Blakean of modern painters.

The Masson retrospective organized by William Rubin at the Mu-

seum of Modern Art in 1976 was a noble attempt to bring this com-
plicated career before American audiences. That the show failed to
register in New York is testimony to the difficulty of implanting an
alien sensibility on these shores. Mounted in one large room at the east
end of the museum (a room that was swept away in the 1983–84 building
program), the retrospective was too various for American audiences.
When an artist has as many periods and as many manners as Masson,
it's perhaps ultimately impossible to take them all in in one swallow.
What is actually an evolution over time can seem congested, confused.
This is, I believe, one of the difficulties in presenting Masson—and also
Hélion—to American audiences. The irony here is that both Masson
and Hélion spent time in America around World War II and had an
effect on American artists. But perhaps by now their American con-
nection works against them, because we think we understand them,
when in fact vast tracts of their work remain unknown.

The career of Jean Hélion is seen only in bits in America—and
usually the bits are minor or inferior. From the various shows mounted
in New York City during the past fifteen years one can gather that
Hélion began as a geometric abstractionist in the thirties, that he moved
through a period of abstracted figuration in the forties to the detailed
realism of the fifties, and that in the sixties and seventies this gave way
to the telegraphic, brightly colored manner of the figure compositions
and still lifes of his final years. In discussing his own work, Hélion often
spoke of its extraordinary range in terms of an effort to embrace the full
spectrum of human experience; he was fond of saying that reality con-
tains abstraction—and vice versa. I suppose I used to find Hélion's
statements a little incredible. From the perspective of contemporary
New York, where all serious art is terribly embattled and where we
can scarcely imagine anything but the most highly focused efforts as
succeeding, this Frenchman can seem crazily optimistic. And yet it's
Hélion's marvelous optimism that ties together everything he ever did,
from the first abstractions—full of an idealist's hope for a bright, clear,
new world—to the scenes of parks and city streets, in which Hélion's
fascination with all the details carries an it's-wonderful-to-be-alive mes-
sage. A long journey separates *Circular Tensions* (1931–32), with its rather
severe curving forms poised against a flat white ground, from *La Grande*

Mannequinerie (1951), with its bedraggled poet asleep in the gutter; but for the artist whom one visited in Paris in the eighties, all styles existed simultaneously within the dream logic of the imagination. In some of Hélion's very last paintings men of flesh and blood collide with the geometric solids of abstract art.

The Hélions on display at the Pompidou Center in February included a wonderful painting from 1979–80 entitled *The Exhibition of 1934*. Here the old artist recalls a vernissage of his youth: seven figures, some carrying flowers that they probably mean to give to the artist, fill a smallish room hung with Hélion's abstract compositions. The high-keyed greens that Hélion favored in his later work bounce across the surface, lending this intricate painting the loose-limbed rhythm of a musical-comedy number. A few galleries away at Pompidou, a series of exhibition cases was devoted to *Abstraction-Création*, the avant-garde magazine of which Hélion was an editor in the thirties. The curators at the Pompidou didn't make a connection between the two displays, but at least Hélion, early and late, was represented in Paris's premier showcase of modern art. Over on the Left Bank, at a small new gallery called Art of This Century, there was a modest but impressive memorial show. This brought to mind Hélion's Peggy Guggenheim connection: the gallery is run by Nicolas Hélion, one of the sons Hélion had with Peggy Guggenheim's daughter Pegeen, and is of course named after her mother's legendary New York gallery, where Hélion, among others, exhibited. At the new Art of This Century one could revisit the motifs and obsessions of a magnificent artist: the open windows, nudes, pumpkins, top hats, umbrellas, and street scenes that had enriched Hélion's art for half a century. Just outside the door of the little space on the rue Visconti the life of Paris that had nourished Hélion went on. Among those of us in America who admire Hélion there is now only one question: when will he be granted the major museum retrospective that his career so richly deserves?

In a 1980 tribute to Hélion the poet Francis Ponge actually linked Hélion and Masson when he commented that "Hélion's powerful personality, his passionate eloquence, his way of explaining himself in front of his pictures, is comparable, all other things being equal, to André Masson." The ebullience of Hélion's art is worlds removed from Masson's introspective mood, and yet their lives, ending so close together,

do raise similar challenges for interpretation. Both lived a long time and weren't afraid to go off in different directions, employ different manners. They enjoyed being involved in what was going on in literature and politics. They're among the fortunate ones—the ones who've had it all. And this can be held against an artist in a period such as ours, which celebrates the truncated biography of a Gorky or a Pollock. Heroes are supposed to be simple—and if they're complex, at least they ought to die young. Even Picasso is begrudged his paradoxes. In addition, both Masson and Hélion were great intellectuals, which no doubt discomforts art critics who like to imagine that they know more than the artist about something. I expect that Masson and Hélion would be more highly regarded today if they had accomplished considerably less.

The theory of modernism, especially in America, encourages us to believe that in modern art literalness is all (paint as paint, canvas as canvas). Masson and Hélion and Picasso in his post-World War II work insisted on the figurativeness of paint (paint as a symbol or metaphor, paint as a description of a person, a space, a world). Yet each of them also believed after his own fashion in the literalness of paint. Thus they were caught betwixt and between—neither exactly "modernist" nor exactly "antimodernist." It's just this betwixt-and-betweenness that now interests a new generation—my generation. And to an American in Paris in February it seemed clear that a final judgment on the late Picasso or on Masson or Hélion can hardly be attempted until we know something more about who we are and where we're headed.

Despite the considerable fame they achieved, both Masson and Hélion always believed that their art was undervalued. They were right, and they were also right to look to succeeding generations for a broader appreciation of their work. Perhaps this is part of why they were inclined to give a warm welcome to the young. Many of us benefited. God bless you, Jean Hélion and André Masson. The risks you took, the many new paths you explored, the inveterate outsider status you came to take for granted—all of this seems more relevant with each passing day.

May 1988

IN THE GALLERIES

The only way to see contemporary art is by going to galleries, and the number of galleries that compete for the attention of a fairly limited number of gallery-goers is bewildering. Every month, hundreds of shows make an appeal to us by virtue of the reputation either of the artist or of the gallery or of both. And even with these swollen numbers, many of our most gifted artists are denied the distinguished presentation that their work deserves. In the last couple of weeks of March, I must have seen a hundred shows in SoHo alone; what I culled from that number as being possibly worth writing about is less than a handful. I wouldn't necessarily conclude from this that art has gone to hell; it may just be that the scene is now so crowded with frauds, clones, and mediocrities that it's become a test of patience and willpower to find the genuine article. The bulk of the bad work is daunting; the variety of types of bad work is utterly confounding. Go to five shows and you may think you have a theory to explain it all. Go to twenty or thirty shows and you find your explanations falling away. In the end, a gallery-goer has only his eyes and his heart to guide him, and all he cares about is finding something to respond to.

On a particular day the real thing can be nowhere in sight; but one can never be sure where the real thing will turn up. That's why one has to go everywhere. My list of worthwhile exhibitions in late March would include Joan Snyder's show uptown at Hirschl & Adler Modern, one of the most deluxe (and beautifully appointed) galleries in New York, and Ned Small's show downtown at First Street, a modest establishment that's regularly ignored in *Art in America* and other top-of-the-line publications. I can't link these two shows together, except to say that both of them were a reach for me. I'm made uneasy by an

artist—Snyder in this case—who takes on explosive public subjects; and I'm inclined to see waffling in the soft-focus brand of realism that Ned Small makes his own. What holds me in both of these shows isn't the style so much as the feeling that informs the style.

Joan Snyder handles oil paint in a great variety of ways: with brush or palette knife, building it up or scraping it down, emphasizing the separateness of each stroke, or working layer into layer. She's in love with the possibilities of paint, and her shifts of approach, both within a single painting and from painting to painting, suggest an intelligent sensualist—an artist who wants to find out exactly how many kinds of rapture paint can convey. When Snyder works twigs or nails or pieces of fabric into her paintings, these collage elements are an extension of the painter's craft. The best moments in Snyder's work are expansive; the centerpiece of her show, the twenty-four-foot-long *Morning Requiem (For the Children)*, is hot and brassy, almost histrionic. All Snyder's work, including the serene landscape images of a couple of years ago, is dramatic; now, weeping for humanity, she's edging into melodrama. And yet when Snyder invokes strife in Central America, or makes little shrines out of news photographs of malnourished children, she manages to bring her mega-themes down to a painter's human scale.

Snyder's ripe colors and primal pastoral imagery of fields and skies often recall van Gogh. (She may have felt the impact of the duet of van Gogh exhibitions mounted at the Metropolitan Museum of Art in 1984 and 1986–87.) Her connection to van Gogh has as much to do with his aestheticism as with his agonized consciousness. When Snyder builds a little epiphany by working together burning hot orange and cool lemon yellow, she's emoting, but she's also making a bridge to the art-for-art's-sake tradition. (Painting in "van Gogh" colors, Snyder echoes the late pastoral works of Braque, who gave us the greatest "aestheticization" of van Gogh we've ever seen.) In a catalogue note, Snyder describes the origins of *Morning Requiem*: "The pain and suffering that our children are experiencing has obsessed me. I can no longer find words that explain the sickness, the insanity that abounds in our world and so I paint and paint. . . . I began *Morning Requiem* with the barren vineyards of April and ended it with a field of sunrises for the children. With paint I can only be an optimist." In the paintings Snyder seems to be making a connection between her beautiful brush strokes and all those beautiful

defenseless children. Snyder makes politics personal—and what else can an artist do? She tells us how the world has changed her.

Ned Small's show at the First Street Gallery contained some largish, very ambitious paintings; a few of them had public themes. I couldn't make much sense of *Soldiers and Heroes*, an indefinite gray-brown-black composition. A faceless crowd moves to and fro in a damp fog; it's like an Isabel Bishop canvas that's been left out in the rain. When it comes to Small's figure compositions, the less said the better. Small really finds himself only when he works on a restricted format (a couple of feet at most); his best works are the two self-portraits (14″ × 18″). These heads—in which the face looms out of a muffling blanket of greenish-reddish color—are as self-absorbed and unworldly as Snyder's big collage compositions are extroverted and with-it. Small, who was born in 1949, studied in the early seventies at the Swain School in New Bedford, Massachusetts, and he has the fondness for old-fashioned pictorial values that's a hallmark of Swain graduates. What Small brings to his two self-portraits is a psychological acumen that registers in the shifts in and out of focus and in the movement from paint-as-flesh to paint-as-paint and back. When Small shows an eye dimmed by the shadow of a cap's brim, it's just a smear of dark, as if he's avoiding our (and his own) gaze. When the paint gives out before it reaches the edge of the piece of masonite on which he's working, Small is telling us that he can't sustain the illusion. His self-portraits place him in the line of New York's eccentric realists, the painters who are brokenhearted as they contemplate the wreckage of the academic tradition. These two paintings are as good as many by Edwin Dickinson and Earl Kerkam (that's damn good). Two other portraits, a studio nude, a landscape called *Ruins*, a flower piece, and a still life sustain the richly melancholy mood.

Going through the galleries is like going through an enormous bazaar in which everything is for sale, and what interests and delights, such as the paintings of Joan Snyder and Ned Small, is jumbled up with all the rest. Artists can, to some degree, avoid gallery going and discover a usable aesthetic in the privacy of the studio. But for the rest of us the only place to develop an aesthetic is in the galleries, and any aesthetic will have to be hearty enough to develop amidst conditions bordering on anarchy. If we can't find our liberation within or in spite of anarchy,

we're dead. And if the gallery-goer can't formulate an aesthetic, the artists may all ultimately be dead, too: after all, works of art are completed in the eye of a beholder. When artists start to anticipate a viewer response, they end up with the overfinished, sepulchral mood that dominated Bill Jensen's show at the Washburn Gallery in April. Perhaps Jensen's best self is now stymied by the knowledge that the public that carried him to a deserved fame is an uncomprehending public. An aesthetic may be born in isolation or amidst confusion, but will it grow?

For those of us whose gallery-going days date back only as far as the early seventies, the end of orthodoxy is a primal condition—a fact of life. No one style, no one view of history offers the promise of salvation. This is our reality, and we must extrapolate from it. It's natural that we should look back and see a history without orthodoxies or clear traditions. It's also natural for us to believe that the only relevant tradition is the tradition that an artist makes for himself. The entire history of art is now an Arabian bazaar—an archetypal eighties institution like the Musée d'Orsay presents the whole unsorted heap—and our only defense against the dishonest and the second-rate is our freedom to choose. It's not that all history has become postmodern so much as that all history, including the history of modern art, has become premodern. The past has yet to be judged, and we can walk through the galleries (where past becomes present) in a condition of freedom—as free as the wanderer in an Arabian bazaar.

The only way to explain the crisis of the present is this: the more freedom is thrust upon us, the more gallery-goers (and artists, too) run for the cover of the unfreedom of theories and ideas. Only a public scared out of its wits by the possibility of freedom could have been so utterly bamboozled by George Condo's show at the Pace Gallery in March. Condo is one of the young painters (age thirty) who galloped out of the East Village at the beginning of the eighties. His paintings, which are knockoffs of Picasso, Gorky, and others, come in both abstract and representational flavors; they have topics (Edith Piaf in the nude, the Ascension), but no subjects. Condo is the artistic equivalent of a rapist: he's violating the Abstract Expressionists, the Picasso of the twenties, thirties, and forties, and the styles of any number of Surrealists. No gallery show this season brought me quite so low, probably because I adore many of the styles Condo has done violence to. Condo

doesn't understand that the closer you work to someone else's style, the more imperative it is that you be clear about who you are. He doesn't know the difference between influence and impersonation—he doesn't know anything, least of all who he is in all of this. Yet clarity of thought or feeling isn't expected. Not knowing who you are is the basic pluralist condition. And there's always now the escape hatch of appropriation: if Condo's work doesn't succeed as painting, then it will succeed as some sort of comment on painting. Condo's surfaces are congested, closed down. He's a parodist of freedom, painting icons for the unfree. And it's on exactly these terms that his work is accepted at the Pace Gallery and accorded adulatory reviews in the *New York Times* and the *Village Voice*. The people who hype art are relatively easy to ignore. It's the artists and critics who hate art but make it their business anyway who pose the greatest threat just now.

June 1988

KING OF
DROPOUTS

Everyone who visits the monumental Gauguin retrospective currently at the National Gallery of Art in Washington, D.C., is drawn to the artist's dramatic self-portraits. Gauguin—who had the reputation for being quite a character, charismatic and also a little repellent—wants to attract our attention, and he does, with his olive complexion, slightly hooked nose, and slanting eyes. Gauguin's earliest self-portrait dates from 1885, when he was thirty-seven, with a career as a stockbroker behind him, a wife and five children to support, and little prospect of making a living by his art. Painted from time to time over a period of almost twenty years, the self-portraits show a man who looks us in the eye and gives very little away. His is a striking, but not exactly a handsome, face. The luxuriant mustache falling over the sensual lips suggests a hedonism that's at war with the hardness of the large, dark, utterly unrevealing eyes.

Even if you didn't know this man's life story, it would be possible to recognize in his face the curious mixture of toughness and self-indulgence we know from the faces of middle-aged friends and acquaintances who've chucked families and conventional careers in order to go off on their own. These renegades' stories often seem to have a clear—too clear—shape: that great break has been quite carefully arranged. (It's only the twenty-year-old dropouts who don't know where they're headed.) The middle-aged folks who've done the things others only dream of doing are driven like the rest of us—with the difference that they're driven to run away from their own drives. In Gauguin's face we recognize the origin of their look, which is blissed out but also more than a little calculating. Gauguin is the first of a breed; he takes his fantasy into reality and sees, like it or not, how the two measure

up. This artist who was obsessed with myths of origin and sin has been to Paradise, met Eve, tasted the apple. He's an original—the King of Middle-aged Dropouts.

It's not just Gauguin's face that connects with a modern restlessness. His art is blissed out but calculating, too. The power of his work is in its sensuously off-balance color combinations: yellow and mauve; green and purple and orange. In his unconventional harmonies—which are heavenly, pure magic—Gauguin takes the instinctiveness of color about as far as it can go. This really is the kind of color that Gauguin saw in the South Seas, where he spent most of his life from 1891 to his death in 1903. But from the vantage point of Western art—which is, after all, his vantage point—Gauguin's electric color is iconoclastic, willfully arbitrary.

One of the most beautiful paintings in the show is the forty-five-inch-high *Matamoe* (1892). The young man chopping wood amid this overarching landscape is a distant cousin of the figures in the late Poussin landscapes—a tiny being swamped by the immensity of nature. Taken as a whole, *Matamoe*'s broad view of trees, thatched hut, figures, birds, and distant hills is like an outline of a Poussin that's been screwed up with crazy colors. This is a marvelously colored-in design; but the very designiness of the painting holds the color in too tightly. Once the initial impression has spent itself—an impression of a landscape like a gigantic yellow and green and pink bouquet—I find it difficult to engage with the painting piece by piece. The big impact doesn't carry through into a series of smaller interactions that are capable of holding my attention. Gauguin's paintings are one-shot experiences. I find I rapidly lose interest in a painting by Gauguin.

The show at the National Gallery starts slow, with Gauguin's fairly conventional Impressionist paintings of the early 1880s. But as visitors move on to the work of the early 1890s, in which Gauguin began to work with big flat shapes and odd color combinations and snaking rhythms, they relax into the artist's sleepily overheated mood. Gauguin's beaten-bronze harmonies are seen to advantage in a large retrospective. His flamboyance, which can put him at a disadvantage within a single canvas, where every little thing counts, expands into lyricism when the paintings are seen in profusion. Gauguin must have known this about his work: he tended to think in series. His 1898 show at the Galerie

Ambroise Vollard in Paris was, according to one of the curators of the current exhibition, Richard Brettell, "conceived as a total work of art." The woodcut decorations for Gauguin's last home, the House of Pleasure on the Marquesan island of Hiva Oa, as well as some of the late panoramic woodcut cycles, point toward the idea of an all-embracing work of art.

Gauguin's sculptures and woodcuts have received a good deal of attention in recent years. They define the outer perimeters of his experimentation and connect with a renewed interest in Expressionism that has characterized the most highly publicized art of the early 1980s. (If the Gauguin retrospective isn't a show that artists care deeply about, it may be because Expressionism isn't as much on people's minds as we've been led to believe. For many artists, the it-changed-my-life show of the decade will remain the National Gallery's Watteau retrospective in 1984, with its cooler and deeper emotions.) While many of Gauguin's early ceramics suggest the wilting prettiness of Art Nouveau, the later carvings are totally original: their broad, sometimes even gross, effects obliterate the fussy aestheticism that cripples so many European encounters with exotic styles. Hacking at a piece of wood, creating woodcut illustrations for his own weird mythic writings, Gauguin is an eccentric inventing a bold new primitivist world. The relief carvings and colored prints bring something new into French art: an unembarrassed love affair with popular vernacular sources.

Who can say how much of the charming awkwardness of Gauguin's style is self-conscious primitivism, how much is failed sophistication? The very instability of Gauguin's effects (and our uncertainty as to his intentions) frequently works in his favor. If his influential mix of the South Seas and the Japanese, the Early Greek and the Early Renaissance never quite jells, this may be because irresolution is the ultimate expression of the man's restlessness. If Gauguin saw the perfected world of a masterpiece as a trap, it's a trap he never fell into.

Gauguin's athletic girl-goddesses form the emotional center of the National Gallery show. People stop and stare at the adolescent in *Manao tupapau* (1892), her skin the color of greenish-tinged coffee beans. She reclines on her stomach on a white sheet, her buttocks up in the air, her hands flat beside her, her face staring out at us. Behind her is a

spirit person, one of Gauguin's enigmatic death figures; but the danger is built into the girl herself, whose slim, muscular body—like something out of Early Greek sculpture—offers a resounding "Enough!" to all the pale curving ladies of nineteenth-century French art.

In a sense Gauguin, who'd done a detailed copy of Manet's *Olympia*, was just continuing Manet's example, creating an antimyth within the myth of Woman in French art. But the girl in *Manao tupapau*, with her straight, boyish body, also marks the point where the taste for exoticism in nineteenth-century art resolves into something wilder, beyond the control of civilization. Gauguin writes that the Tahitian women are "not very pretty really, according to European standards, yet beautiful." That beauty confuses Gauguin, and inspires him, too.

In *Noa Noa*, the most famous text relating to the Tahitian adventure, Gauguin tells the story of a hike he takes with a young Tahitian man to a place where he can obtain rosewood for carving. The dreamy eroticism of this account carries over into many of the Tahitian nudes. "There we two were," Gauguin writes, "two friends, he a very young man and I almost an old one, in both body and soul, made old by the vices of civilization, and lost illusions. His supple animal body was gracefully shaped, he walked ahead of me sexless." This boy may have inspired the young male figure chopping wood in *Matamoe*. And on a deeper level, the arresting sexlessness of the back view Gauguin describes in *Noa Noa* may help us understand something about the women we see from behind in some of the paintings—in *Manao tupapau*, and also in *Pape moe* (1893), where the female figure drinking from a waterfall is actually based on a photograph of a man.

Gauguin's description of his day with the Tahitian boy is like a journey into the mysteries:

> From all his youthfulness, from this perfect harmony with the natural surroundings, emanated a beauty, a perfume (*noa noa*) which enchanted my artistic soul. From this friendship, which was so well cemented by the mutual attraction between the simple and the compound, love was blossoming within me.
>
> And there were only the two of us.
>
> I had a sort of presentiment of crime, desire for the unknown, awakening of evil. Then too, a weariness of the role of the male who

must always be strong, the protector having to bear the weight of his own heavy shoulders. To be for one minute the weaker being, who loves and obeys.

I drew nearer, unafraid of laws, my temples pounding.

The path had come to an end, we had to cross the river; my companion turned just then, his chest facing me.

The hermaphrodite had disappeared; this was definitely a young man; his innocent eyes were as limpid as clear waters. Suddenly my soul was calm again.

The South Seas are a place where desire and lawbreaking and freedom intermingle. No doubt part of the attraction of Tahiti for Gauguin was that here he could be the stronger one, the charismatic foreigner with young native women at his beck and call. But of course he'd also gone to the South Seas to lose himself, and like so many dropouts he was caught in the odd situation of needing to control the out-of-control. (When Tahiti seemed too civilized, he fled to smaller and smaller islands.) The Gauguin show is about letting go; and Gauguin's importance for European art rests in how he transformed the idea of letting go into new forms of beauty: mahogany skin, women with the muscular bodies of boys, a natural landscape composed of colors we Westerners know only from hothouse blooms.

Gauguin died in the Marquesas Islands in 1903. His influence would probably never again be as great as it was in the couple of years right after his death, when Picasso and Matisse and many others first saw his work in all of its profusion. Gauguin's heedlessness set Matisse and Picasso on fire; he inspired their climb-any-mountain bravura.

If Gauguin's work feels a bit remote from us today, it could be because so much of his own achievement has been dissolved into the masterpieces of those who followed him. Gauguin invented primitivism—and where would Picasso have been without that? Gauguin's taste for sun and sea and overheated colors encouraged Matisse and Bonnard to discover a domesticated Tahiti on the Côte d'Azur in the years after World War I. There are moments in Gauguin's landscapes, with their epiphanies of purple-yellow-red-green, that seem like a first glimmer of the incandescent effects that Bonnard achieves in his paintings of the

1930s and 1940s. At the National Gallery, where the Gauguin retro-
spective occupies the same galleries that held the great "Matisse in Nice"
show less than two years ago, Gauguin's strange combination of cold
egotism and sensual abandon offers a new key to Matisse, the coldest
sensualist of them all. Matisse had a taste for the trappings of bourgeois
life; but those apartments he lived in during his later years were also a
dropout's escapist fantasy, full of the huge green plants and gorgeous
models that Gauguin had crossed oceans to see.

The organizers of the Gauguin retrospective have brought together
a staggering array of material. It is probably inevitable that such a large,
scholarly exhibition should at certain points seem to be working at cross-
purposes with the artist. When I left the show, I was anxious to dig
into the catalogue, but when I sat down with it at the airport while I
waited for a flight back to New York, it took only a few minutes to
realize that this was going to be duty reading. Right at the outset of the
text the organizers state their "opposition to an exhibition centering on
the artist's life." This is amazing. If ever there were a case in which the
art flows straight out of the life, it's the case of Gauguin. The curators
aren't in sync with the artist. How could a curator describe *Manao
tupapau* as "a brilliant résumé of all the formal and theoretical progress
[Gauguin] had made since his arrival in the South Seas"? How on earth
could anyone call a Gauguin painting a résumé?

But Gauguin is there in Washington, and he is interesting in his
profusion. He personifies a kind of to-hell-with-convention idealism that
we could use more of. He was a fool and a bully and a rat; but it's not
clear you can do what he did without being all of those things, too.
Writing to Emile Bernard in 1890, before he'd left France, he dreamed
of founding "the Studio of the Tropics. Anyone who wants to may
come and join me. . . . Life doesn't cost a thing for a person who wants
to live like the natives. Hunting suffices to supply you easily with food.
Consequently, if I can close a deal, I am going to found what I have
just said and live free and create art." There's ballyhoo to this, but guts
as well. Of course, those dreams had a dark side. Gauguin might be
ensnared in the complexities of colonial life; but this was nothing to the
tragedy of a native population that could no longer control its destiny.
Though Matisse and Bonnard went further than Gauguin by bringing
it all back home, they wouldn't have been able even to begin their

experiments with anti-European color if it hadn't been for him. This King of Dropouts speaks for the bit of a dropout in every one of us. At the end of the National Gallery show there's a painting of men riding horses along a bright pink beach. Here Gauguin's figures have become papery thin. The warm sensuality is gone. A quiet kind of pleasure emanates from this new world that Gauguin has, if only tenuously, achieved. The painting is stately and airy—a cool, almost toylike vision of paradise.

June 13, 1988

ALL AROUND
THE TOWN

At the intersection of Broadway and Prince Street rundown office space is turning into slick gallery space at a fast clip. Those of us who spent last season listening to power saws and getting lost in half-wired hallways at 560 Broadway, where the post-modern appointments are only now falling into place, will probably spend the coming season rubbing elbows with the same construction workers up the street or around the corner. Boom time on the east edge of SoHo is partly a result of the migration of galleries that opened in the East Village in the early eighties but could never draw in the crowds; and the concentration of galleries in high rises does make it easier for all of us to get to a range of shows. But the use of office space as gallery space—long a fact of life on Fifty-seventh Street—also lends a dangerously homogenized tone in a city where as it is every streetscape is coming to resemble every other one. Though there is much that can be done to give a gallery in an office space a distinctive look (the Diane Brown Gallery at 560 Broadway has attempted to retain the storefront style of its earlier SoHo quarters), nothing can be done about the approach, which will inevitably be down a generic high-rise-building hallway. SoHo's rickety staircases, tin ceilings, and broad dimensions are the new victims of "economic prosperity," which has already turned the domestic-scale galleries of the Upper East Side, with their elegant fireplaces and drawing-room ambience, into wisps of memory. Uptown and downtown, what's involved isn't merely a loss of charm. Space, texture, color, and light are the lifeblood of art, and as those precious elements are sucked out of the gallery scene, we all lose. I find that shows in office-building spaces rarely hold in the imagination the way shows in more idiosyncratic spaces do. Generic spaces beget generic experiences.

When David Beitzel moved his gallery into the street-level location at 113 Greene Street that had been the downtown outpost of the Washburn Gallery for several years, he inherited a situation that was anything but generic. The space has weird proportions: overly high and deep in relation to its skimpy width, and narrower at the front than at the back. It's a space in which normal-sized paintings have never really looked at home (the proportions make your eyes move up, over, away), but of course the weirdness of the shape is what makes you remember the space and want it to work for art. Washburn's most successful installation was probably Ilya Bolotowsky's reconstructions of his WPA murals, two large horizontal compositions that were originally conceived as accompaniments to architecture and nearly filled those long walls. Another Washburn artist, the sculptor Ronald Bladen, put a skinny relief made of wood and sheets of aluminum along one wall; but Bladen's work, which was terribly self-conscious in its use of industrial materials, fit all too neatly in. It was a solution to a problem all right, but there was no enchantment, no surprise.

There hasn't been much surprise in Beitzel's installations, either, until the arrival of Christopher Macdonald, who makes trains, cars, and trucks out of scrap wood and nuts and bolts and responds to that impossibly shaped interior like a pool shark going for the shot that will win him the game. Macdonald answers the off-balance proportions of the room with the off-balance proportions and jumps-in-scale of his own work. He contrasts a choo-choo train that's fifty feet long and not two feet high with a sort of truck whose wheels are maybe twelve times as large as those of the train. *Zug*, the long, low train, comes practically to the front door of the gallery; you almost trip over it as you walk in. By juxtaposing sculptures that vary radically in size and scale, Macdonald takes the oddity of the Beitzel space to its logical conclusion; he makes it feel odder, more disquieting. Much of the work is crammed together in the middle of the room, and this forces us toward the walls, so that our standard viewing point (in the middle looking out) is reversed. We're on the outside, looking in.

Macdonald's sculpture is Constructivist ballyhoo. He mixes ideas borrowed from the models in children's woodworking books with a taste for Cubist form that recalls the projects of the early Russian modernists. There's no particular refinement to his big, disklike wheels and clunky

cabins. I suspect that if one or another of these constructions was ex-
hibited in isolation, it would look fairly inert and overly clever. But his
show—which ranged from the tiny trucks on the window ledge at the
front of the gallery to the vehicle with a crank that climbed toward the
ceiling—made a beguiling assemblage. (If only Macdonald knew how
to incorporate those shifts of scale into the individual works . . .) When
he puts it all together in a room, Macdonald proves that he knows
something about form-in-space. He reveals an artist's eye. In a sense,
he tells us what we already knew: that this space has possibilities. He
actualizes them, as a sharp-eyed decorator would. (Decorator isn't an
insult. What are Michelangelo's Laurentian Library and Bernini's Scala
Regia but divine decoration?) Macdonald points up the possibilities with
a clunky grace—a downtowner's grace. He takes nuts, bolts, hunks of
wood—and—voila!

———

Doug and Mike Starn's contribution to the end-of-season show at
the Stux Gallery in June, *Double Mona Lisa*, is poetic in ways the Starns'
work hasn't been before. At roughly nine by thirteen feet, it's one of
their bigger pieces, and the size may be good for them. This is the first
time they've actually achieved a little of the lyrical mystery their fans
have been reading into their photography from the start. The basic
image here is a shot of Da Vinci's *Mona Lisa* in her glass box in the
Italian Gallery at the Louvre. We see the painting itself, and around it
and over it, reflected in the glass, the museum-goers who are looking
at it, and the other paintings that are hung around the room. Pieced
together out of sepia-toned photographic enlargements, and doubled so
that there are two *Mona Lisa*s adjacent to one another, the composition
is a romanticized souvenir of a modern-day Grand Tour. Much of the
magic comes from the *Mona Lisa* herself. Her smile is the real thing,
but of course she's also a pop icon who's been replicated ad infinitum.
She's the perfect subject for the Starns' techy nostalgia. And yet they
really seem to be responding to her dreamy allure. The Starn Twins'
romanticism is heating up here, gaining some weight and dimension.
For once they aren't dealing with blank classical images but with the
seduction of a great image. They may believe that they're basically
seeing the *Mona Lisa* in Duchamp's Dadaist terms; but their faded pho-

tographs can't help evoking the glories of the Louvre—the *Mona Lisa*, and all the other Leonardos, and the Raphaels, and Titian's *Concert Champêtre*.

———

No contemporary painter knows more about the messy bountifulness of family life than the immensely gifted Temma Bell. In the series of still lifes, interiors, portraits, and landscapes that she showed at the Bowery Gallery last April, genres intermingle and blend. A table crammed with vegetables leads our eye to a landscape out the window; a self-portrait becomes a double portrait when a child turns up in a corner. All the paintings revolve around the life Bell has been living with her husband and three daughters on a farm in upstate New York; and the range of images that the show includes—landscapes in autumn, spring, and winter; girls at sleep and at play; the artist as mother, with an infant or growing girl—suggests a long novel's entangled plots. There are always a lot of things to look at in Bell's paintings: fruits and vegetables, vases with flowers, jars and bottles, pictures, mirrors, farm animals, towheaded children. Each element is a part of the domestic story; but each element also suggests a painting problem, and though it would be too much to say that Bell resolves every challenge she sets for herself, she responds to each of them with an intelligence and a generosity that lift the everyday up pretty high. Bell paints it all, and her brush strokes thrive on subject matter in much the way a novelist's sentences do. Her technique is derived from nineteenth- and twentieth-century French painting; at one point or another the scribbled surfaces, the underlining of a form with a black line, the bright light colors and the soupy darker ones recall moments from Corot, Derain, Bonnard, and a host of others. Bell isn't dampeningly reverent about those masters of the past; it's their gift for embracing life that comes through in the contemporary mood of her work.

Temma Bell makes us feel that painting culture is part of the natural order of things. Both her parents—Louisa Matthiasdottir and Leland Bell—are painters; for the daughter, tradition is virtually a family affair. Is it any wonder that Temma Bell, who's forty-three, is now painting her daughters and her husband? Family ties have always been at the center of her art. (Back in 1973 the Canton Art Institute in Canton,

Ohio, mounted a show called "A Family of Painters," which included Leland Bell, Louisa Matthiasdottir, and Temma Bell.) Among the priceless gifts the younger Bell has received from her parents are a knack for uncovering pictorial structures in the natural world and an unfailing sense of how a composition fits into a rectangle. Weaving her way between Matthiasdottir's brilliantly colored landscapes, portraits, and still lifes and Leland Bell's darker ones, Temma Bell has never been a slavish imitator; but in the past her work was often too much *in the manner of*. For years it seemed that the better a Temma Bell was, the more it resembled a Matthiasdottir or a Leland Bell. This is an untenable position for an artist. Only now is Temma Bell coming into her own; and not the least of her accomplishments is to show us some of the ways in which her parents' considerable and still growing achievements add up to a legacy that a younger artist can use.

For Leland Bell and Louisa Matthiasdottir, who came of age in the forties, at a time when the strict beauty of classic European abstraction was still something new, the onslaught of nature has always been subdued by a certain asceticism, a certain severity. (The fact that Matthiasdottir has never painted abstractly doesn't lessen the impact that abstraction has had on her work.) In the art of Bell and Matthiasdottir it often seems as if abstraction signifies restraint, nature signifies release, and abstraction and nature play an unending cat-and-mouse game. Temma Bell feels no particular attachment to classical abstraction, and so the restraint side of her parents' equation doesn't really hold. Her work has a dense literalness that brings it closer than either of her parents' painting has ever been to the overload of images we know from, say, Bonnard. She's also closer to the spirit of André Derain than her father, who has been, in lectures and articles, such an eloquent spokesman for the great ex-Fauve. A number of her self-portraits and still lifes are practically glosses on Derains; her naturalism has a vulgar streak (I mean this in a positive sense) that recaptures some of Derain's verismo excitement. Temma Bell's cornucopia of imagery casts her parents' spartan elegance in a new and clarifying light.

But if formally Temma Bell's work is as much an extension of Leland Bell's as of Louisa Matthiasdottir's, the particular sensibility that she brings to the traditions of Bonnard and Derain is much closer to her mother's than to her father's. In the French tradition women have gen-

erally been viewed as the other—as wives, or servants, or the flowers of high society, or erotic playthings in the boudoir. Part of the excitement of Louisa Matthiasdottir's rather imperious self-portraits has always had to do with our sense that a woman has never looked out of a painting with such self-confidence before. When Matthiasdottir, in a 1982 pastel, wore a cap with a brim like the brim in Chardin's famous pastel self-portrait, she seemed to be saying, "Move over, men, the women are coming in!" (And Matthiasdottir is a good enough pastel artist to take on Chardin without looking like a fool.) To the old artists, who let their wives or servants cook the dinner they painted, Matthiasdottir says, "I'll cook it, but I'll paint it, too." In Temma Bell's work the takeover continues.

Bell makes the link to her mother's work very clear in several small paintings of her sleeping daughters; they are virtual recapitulations of the paintings Matthiasdottir did of the young Temma a quarter century ago. And in Bell's recent self-portraits, the mature artist looks out at us with the straight-backed pride we know from her mother's work. There was a self-portrait on the announcement for Bell's recent show. It was called *The Farmer's Wife*; but this refined lady hardly looked like a farmer's wife, and once you'd explored the show, where that whole farmer's-wife life was taken in by a razor-sharp pictorial intelligence, that title couldn't but seem a bit ironic. Has any farmer's wife ever painted like this? And how many farmers have?

I don't want to exaggerate the extent to which Bell's work is fulfilled. While the first time I saw her show I was elated, the second time around I noticed all the things that hadn't come off, and felt grumpy. It's probably inevitable that an artist who's busting out in several directions at once will have trouble with follow-through. There are places in the work where Bell seems on the verge of solving a problem—of finding a way to turn a corner or open up the distance—but can't quite realize her idea. Still, there's always an idea. And even when Bell's paintings don't add up, I find that I can respond to the boldness of her attack. She's gutsy but lucid; this is a rare combination.

In the show, one didn't know quite where to look first: at one of the (too) many rural landscapes, with their fields and lines of trees and horses standing in profile, like tiny Etruscan bronzes; or at a still life with pumpkins and squash; or at a study of napping kids. To that awful

old cliché that women don't have to do creative work because they create children, Temma Bell—following in her mother's footsteps—has the most marvelous response. She's telling us that she can make terrific kids (hers are blond-haired beauties) and that she can make terrific paintings, too.

———

Careening teacups, lopsided exclamation points, and Formica-covered kitchen tables are among the elements that Elizabeth Murray stirs into the semiabstract canvases that dominated her mid-career retrospective at the Whitney in May and June. Murray's admirers read these paintings as unruly little domestic dramas that boil over into a big sensational love-hate relationship with the history of modern art. But it's difficult for me to see where the hate part ends and the love part begins.

In a catalogue essay, the critic Roberta Smith relates Murray's canvases and career to the rising fortunes of women in the art scene of the eighties. (Murray is forty-eight.) Smith says that "Murray's art has evolved a distinctly feminist character" and that "Murray is part of what might be called the degenderization of art." According to Smith, Murray is a formalist who uses classic modern techniques to bring into contemporary art "a kind of craziness which has conventionally been thought of as 'female.' " Smith is writing about levels of experience—aesthetic and otherwise—that are damn hard to deal with. I don't think her reasoning is uninteresting. I'm sympathetic to Smith's analysis as theory. But when she asserts that "Murray has developed an uncanny ability to convert emotional pressures into formal ones," I can't follow . . . because the work leaves me cold. I can accept the idea that Murray's work is a dissent from tradition and that this dissent is feminist; but how interesting will the dissent be if one hasn't been inspired by the painting as painting? (And if anyone wants to rule me a biased observer because I'm male, I know plenty of women who don't like the work, either.)

The first commandment of painting is that the support should be a stable, symmetrical shape. The point of commandment one is to create a foil for the tensions within the painting. Like all rules in art, this one can be broken if there's something to be gained; but when a canvas has

as many sides and curves and angles as one of Murray's, we're no longer seeing exceptions to rules—we're seeing exceptions to exceptions. Murray overlaps her strangely shaped supports into multicanvas configurations and sometimes allows them to twist up into Rococoish curls at the corners. There's a lot going on here. Forms jump around and nuzzle and interpenetrate. Big things gobble up little things. Representation segues into abstraction.

In the catalogue of the Murray show, the reproductions are accompanied by quotations from Murray herself, and these glosses on the paintings have a friendly, matter-of-fact tone. Of *Sail Baby*, a painting composed of three overlapping canvases that make up a gigantic yellow teacup, Murray says: "*Sail Baby* is about my family. It's about myself and my brother and my sister and, I think, it's also about my own three children, even though Daisy wasn't born yet. It's about childhood and using yellow." This is the kind of explanation that explains nothing—as if saying "It's about . . ." and connecting the three panels to three children gave us a handle on the painting. But Murray's simplistic readings obviously touch something in the audience. The artist's commentary on the paintings (like the audio tour that David Hockney narrated for the retrospective of his work, which was at the Metropolitan Museum over the summer) turns the paintings into illustrations in a storybook. Like Hockney, Murray is fond of telling us what happened while she was working on the painting—as if that has anything to do with the results. Of *More Than You Know*, she says: "I kept trying to turn the table into a figure and it wouldn't do it. The room just happened; it reminds me of the place where I sat with my mother when she was ill. Once I put the little rectangular shape on top of the green head, it made me think of a book; it was like trompe l'oeil. I was thinking of van Gogh, of *memento mori* subject matter, and the paintings by Vermeer of women reading letters which express simultaneously such serenity and anxiety." The paintings look the way the descriptions sound: flat-footed, blandly additive. What's missing is the poetic glue that would unite all Murray's odds and ends into an imaginative whole.

Because Murray is playing around with a wide variety of elements, the paintings catch up many viewers in a gosh-what's-that game—a game to which Murray's descriptions offer the key. I think people are impressed by a composition that at first appears to be abstract and then,

as they look at it, turns out to contain ordinary objects—the teacup, the exclamation point, the kitchen table. Murray's work jibes neatly with the middlebrow view that abstraction is a puzzle and that the puzzle will turn out to have a simple (and representational) solution if only you can find the key. What Roberta Smith presents as a feminist critique of modern values is really only a new version of the old critique of the difficulty of modern art. Murray is presented as offering modernism with a human—a female human—face.

The paintings are programmatically antiprogrammatic, and so motifs don't develop or evolve. An evolution has to have a starting point; Murray's early work of the seventies, in a ditsy mood that relates to the Chicago Funk style of Roger Brown and others, suggests that there was no starting point to speak of. (It's easy to turn the grand manner into a big joke when you began without any feeling for the grand manner.) Nowadays, Murray's color consists of harsh complementaries colliding into edges and planes of blueish or brownish muck. The overlaps and modeled forms are straight out of the academic abstract Surrealism of the forties. There's no rhythm to these paintings: they're all starts and stops, ruptures and collisions. The work is hideous—tastefully hideous.

————

In David La Chapelle's oversized cibachrome photographs, which were at the 56 Bleecker Gallery in May, the old Catholic-kitsch-as-sexual-turn-on routine is run through once more, *and with feeling*. The adolescent boys with the brown Michelangelesque curls, who play at being saints and angels, are perfect physical specimens, and the fakey-theatrical backdrops of technicolor clouds glorify them even as they send them up. In *Nativity*, a triptych, the side panels are occupied by shots of the same boy, doing a slow disco dance in a pair of white feathered wings. In the central panel he presides over the Christ Child and a blue-eyed, flaxen-haired Madonna who's as perfect in her female line as he is in his male one. The sight of this pair, with their god-given attractions, playing at Western civilization's great roles, has overtones of Cocteau, Buñuel, and the contemporary Spanish movie director Pedro Almodóvar (among his films are *Matador*, 1986, and *Law of Desire*, 1987). The actors bring a certain seriousness to their roles; as in some of Cocteau's work, there's seriousness in the silliness of the conceits. La

Chapelle's whole show is composed of visual clichés; but for La Chapelle, who's twenty-six, these are obviously beloved clichés, and he communicates the love, and sometimes, as in *Birth of Adam*, where the first man stifles a punkish yawn, he's ahead of the clichés.

The style of La Chapelle's work is a sort of cross between Cindy Sherman and Gilbert and George. I find the medium of the large-scaled color photograph as slickly uninviting in La Chapelle as in those other artists. Nevertheless, a straightforward prankishness breaks through here. La Chapelle isn't deconstructing photography or critiquing kitsch; he leaves all that to an avant-garde obscurantist like Cindy Sherman. Nor is he coy about his relation to pictorial theatricality. He knows that surface effects are surface effects, to be enjoyed. And he knows how to bring out the beauty in the planes of a face the way a good cinematographer does. He has a feeling for pictorial values. Using young flesh and new technology, he sends an alluring *fin-de-siècle* perfume through the gallery air. We're approaching the end of another century. La Chapelle wants us to make ourselves comfortable in his postmodern bordello.

———

The three-artist team called General Idea created a stir at the Koury Wingate Gallery in May with a show devoted to the AIDS epidemic. General Idea has turned Robert Indiana's famous LOVE logo of the sixties into an AIDS logo for the eighties, and though this wasn't the first time General Idea's insignia had been shown in New York, it was the first time there had been a gallery full of AIDS logos. At Koury Wingate five large AIDS canvases hung on one wall, ten smaller ones on the opposite wall. With the letters and intervals between the letters painted in a series of flat, posterish hues, the overall impression was one of cheerful emptiness. The transformation of LOVE into AIDS was a simple equation—an equation so blunt it mocked all the this-is-what-the-sexual-revolution-has-come-to commentaries. Art is by no means equal to the overwhelming impact of immediate experience; and if there wasn't artistry in General Idea's show, there was artfulness—the artfulness that comes from leaving the unsayable unsaid. Responding to tragedy with a barrage of bright colors, General Idea was refusing to drape an entire generation in funerary black.

———

William Wegman, who's best known for photographic portraits of his dog decked out in a variety of odd outfits, now also does paintings, in a quirky mix of oil and acrylic. The canvases that Wegman showed at Holly Solomon in May have dark, mottled surfaces, upon which Wegman inscribes odd little scenes of, for example, jungle animals, or a Middle American farm, or a romantic Greek isle. The work has a perky charm—although some of it looks a little too much like the kind of amateurish stuff you'd see on the walls of a pizzeria. The best painting in the show was *Irrigation*, a fantasy of sprinklers and water towers that's like a Sunday painter's reprise of selected motifs from Raoul Dufy's great *La Fée Electricité*. The easy, almost sloppy rhythm of the show, which was full of figures that might have escaped from forties cartoons and advertisements, amused gallery-goers who were weary of the formalities of the midtown art scene. Critics, in a rare show of near unanimity, were happy. The show had its teasing playfulness, but not much else. People were there because Wegman is a star. They stayed to have some fun with a star who's not afraid to let his hair down. I wonder if he can do more. The best thing on display was a tiny drawing in colored ink. Called *Life Aboard a Ship*, it consists of a few whimsical lines outlining a boat, with, overlapping it, a champagne bottle, some bars of music—emblems of the pleasures of a cruise.

———

West Twenty-second Street between Tenth and Eleventh avenues, where the Dia Foundation opened its latest exhibition space last season, is a picture-perfect holdover from the industrial New York of the early twentieth century. The cobblestone street is still lined with small factories and repair plants, and in June, when the first round of Dia shows (of work by Joseph Beuys and two of his students, Ima Knoebel and Blinky Palermo) was going down, activity across the street at the Alcamo Marble Works spilled out onto the curb beneath a blue sky that was as lovely and opaque as a theatrical backdrop. The Dia Foundation, which has been collecting and supporting a great deal of environmental and site-specific art since the seventies, wanted a space that would give large-scale works room to breathe, and they've got it. The three floors of exhibition space at 548 West Twenty-second Street have the austere opulence that only the very rich can achieve. (De Menil money is behind Dia.) Some of the doors and window frames in the former factory have

been taken down to the original metal, and they have a wonderful distressed look, like a postindustrial version of patinated wood. Through the freshly washed windows of the upper floors one looks at a view in which nineteenth-century brick buildings intermingle with Deco facades. This is the New York we all dream of living in; it's as if Donald Trump's city had never happened.

At Dia the setting almost makes love to the art. The stacks and heaps of industrial materials that Beuys and Knoebel employ fit into the space gently, beguilingly. There's a pleasing frank dignity to Beuys's piles of felt and copper, and to Knoebel's piles of lumber and prefab doors. These assemblages are exactly as beautiful as the metal window frames and concrete floors of the galleries, the cobblestone street outside, and the rusty radiator I saw halfway up the block. This art, which aestheticizes industrial materials, has no oomph to it. It blends right in with the beautiful industrial setting. Where the work approaches more conventional modes, its impact is shadowy. A roomful of Beuys's drawings consists of vague, slightly dotty doodlings—words, crazy maps, faint profiles. The sketches—which may have been inspired by early Klee and may remind some viewers of the drawings of John Graham— are pleasant but forgettable. *To the People of New York City*, Blinky Palermo's last effort (he died in 1977 at the age of thirty-three), consists of a series of forty rather staid geometric abstractions. The aluminum panels on which Palermo painted are divided into rectangular areas of red, yellow, and black, but the yellow has so much orange in it that there's no tension, no dialectic.

At Dia the setting carries all before it; it's certainly a setting to see. Around the corner, on Twenty-third Street, is the Gagosian Gallery, a space with the impressive dimensions of Mary Boone's West Broadway digs (at, no doubt, considerably less rent). Gagosian has gained a following with a series of shows of post-World War II "classics": Andy Warhol's paintings based on FBI wanted posters were featured in May. Lunch can be had at the corner of Tenth Avenue and Twenty-second Street at the nifty Empire Diner, a piece of gentrified Americana where those who've beat the nine-to-five rap pass the time.

————

I went by Eric Fischl's show at the Mary Boone Gallery to see if there was life after the mid-career retrospective (Fischl had his at the

Whitney in 1986). Fischl is still pulling in the crowds, and his painting has continued its evolution from the enigmatic but charged narrative episodes of the early eighties toward increasingly diffuse exercises in mood painting. At the same time the color has gone from the fairly even gray-greens of a couple of years ago to a sharper chiaroscuro. Here some commentators may see an increase in painting craft, and if painting craft rests in flinging brush strokes around in a prettily insouciant way, maybe Fischl has made some advance. But he's light-years away from John Singer Sargent's talents in this line, and Sargent can in any event only be a model for mini-minds. Fischl was always a lousy artist. Now he's a smugly lousy artist. No one ever called him an innovative painter, and there's nothing innovative about his recent habit of doing some of the paintings on several canvases. One canvas hangs on the wall, and the image extends onto a couple of smaller canvases that rest on the floor. The multicanvas arrangements are a diversionary tactic and an irrelevance.

Fischl's attitude toward his Middle American subject matter is distanced and vaguely disapproving. (Do the people in Fischl's paintings ever have fun?) Philip Roth, the latest writer to do one of Mary Boone's celebrity catalogue essays, has something to say about the bathroom being the last closed room in American life; but Eric Fischl isn't really the artist for people who want that door opened (whoever they might be). In spite of the sex-shock angle in some of Fischl's earlier paintings, his subjects are basically familiar ones: the self-indulgence of the affluently middle-aged and the embarrassing amusements of the very young. Fischl's churning, twilight mood is familiar, too. His recent work looks an awful lot like the American realism of the forties and fifties: the sort of thing Harvey Dinnerstein and Joseph Hirsch did, the sort of thing that's still shown at the Midtown and Grand Central galleries, the sort of thing that was featured in the show "Realism and Realities: The Other Side of American Painting, 1940–1960" that Greta Berman and Jeffrey Wechsler organized at Rutgers in 1982. Looking through the catalogue of that Rutgers show, I found some pretty close parallels to Fischl. Dinnerstein's *Brownstone* (1958–60) has Fischl's dark, dissociated mood. Meanwhile, Fischl's recent paintings of naked women silhouetted against a backdrop of beach, water, and sky look a lot like some of Walter Stuempfig's work (note *Lifeguards*, 1954, and *Two Houses*, 1946). I don't know if these connections are something Fischl is aware of; it's

a possibility. Joseph Hirsch was included in the "Fictions" show at Curt Marcus last season, and I wouldn't be surprised if that "other side of American painting" were being studied pretty closely in some SoHo studios these days.

Let's keep one thing straight. Fischl does the sort of painting that sophisticated New Yorkers would have laughed at a decade ago. Shadowy parties, mysterious encounters at the end of long summer afternoons—these melodramatic subjects aren't new. Nor is the way that Fischl seeks to express emotional instability through formal instability. There's murderous cleverness in the artist who uses a compositional rupture to express an emotional rupture. Cleverness is all.

Everybody knows that the media and the marketplace are responsible for the yawning gap that now separates the actual achievement of an artist like Eric Fischl from his spectacular reputation. But few are willing to admit to what extent the sort of fame Fischl has achieved influences people. In the past couple of years we've heard critics explaining to one another and to everyone else that we must be careful to be fair to the famous—not hate them for their fame. No need to worry. The fact of the matter is that fame is really all that matters to ninety-five percent of the educated public and that even those who ought to know better take the famous far more seriously than the unfamous. *Scarsdale*, Fischl's painting of a middle-aged woman slumped in a chair in an evening gown that looks a lot like a wedding dress, arrives on the gallery wall with, as the saying goes, every advantage: the average gallery-goer will take it as great painterly painting, and those who know better will look for irony, for a complex metaphor. As for this reviewer, I expect that most people are going to finish my gallery roundup with the clear recollection of a thumbs down on Eric Fischl and not the slightest memory of the thumbs up on a painter named Temma Bell.

September 1988

HOCKNEY'S
PEOPLE

Summer, 1988. New York City is sweltering. Many of the beaches in Brooklyn and on Long Island are closed as sewage and hospital wastes mysteriously wash ashore. Ecosystems are collapsing. In the art world as well, trash keeps rising to the surface. *Art in America* publishes a special issue, titled "Art and Money," in order to describe the many ways in which the art market is running out of control. The tone approaches celebration: one man's calamity is another man's triumph. Meanwhile, at the Metropolitan Museum of Art, David Hockney, who knows something about sunbathing and something about art-and-money, is the subject of a retrospective that opened in June, before people had begun leaving town. If New Yorkers stuck in the city opt for Hockney on one of those weekends when the beaches are closed, they'll probably look a little unkindly on his idyllic scenes of Los Angeles backyards and swimming pools. Hockney's subjects are leisure-time fun, modern relationships, and the buyables with which we all want to surround ourselves. Slipping into his show is like opening the *New York Times* to the "Home" section: you're avoiding the real stuff. His art, which is about life styles, aims for the same lowest common denominator that we encounter on the life-style pages of the newspapers. Hockney is an obvious right choice for a summer show, because so much of his work deals with vacation pleasures. But in New York in the summer, when everything is going to extremes, the mild, a-little-of-this-a-little-of-that rhythm of his enormous retrospective wilts pretty quick.

Hockney gives us pleasure without obsession, pleasure in little doses. His shifts of manner and medium—from loose painting to tight painting and then back; or from painting to printmaking to photography

and back to printmaking—lend the exhibition a provisional, easygoing mood. When contemporary artists are working deep inside painting the very intensity of their engagement tends to isolate them from the general public. People know that there's a limit to how much art obsession they can deal with, and they're confident that Hockney won't overburden them. Hockney's work brings inside the museum's walls the mood of casual pleasure that the audience pursues outside.

The couples and sunbathers and swimming pools and patios are what we leave the Hockney show remembering. Through these subjects, Hockney proves to us that he knows something about life. The 1968 double portrait of Christopher Isherwood and Don Bachardy, in which the compact, hawklike Isherwood turns to look at his lover, is answered, fifteen years later, by the photocollage of Isherwood and Bachardy—in which Bachardy, gray-haired and still extremely handsome, returns the gaze. There's a rightness in that exchange of glances: it tells us something about the affection and dependency that goes into a long-term relationship. Seeing the double portrait of Fred and Marcia Weisman (1968), you learn something about them, too—about the well-padded style of upper-class life in Southern California and how it lends marriages a certain calm surface. Hockney knows that we want to feel comfortable in the world. Just look at Ossie Clark, sinking his bare feet into the deep white shag carpet in the portrait of *Mr. and Mrs. Clark and Percy* (a cat). The carpet and the bare feet are souvenirs of the London that Michelangelo Antonioni brought to America in his movie *Blow-Up. Mr. and Mrs. Clark* is Hockney's synthesis of Mod London and a Neoclassical mise-en-scène. "This is our life," the artist seems to say. And for all the museum-goers who feel they've missed out on the fun, there's the titillation of the famous friends, the easy sex, the no-fault bohemia. But Hockney is a responsible fellow, too. He likes to go back to his hometown, Bradford, and paint portraits of Mom and Dad. Those disinclined to forgive him for the Boyfriend will surely do so after they've seen the Mother.

On the Acoustiguide tape that the artist, in a characteristically audience-friendly gesture, has narrated himself, Hockney comments that the three cities the show is visiting—Los Angeles, New York, and London—are the three cities that have been essential to his art. Watching Hockney go from Swinging London through Laid-back L.A. to some

recent essays in East Village Primitive is a little like watching the Audrey Hepburn–Albert Finney marriage go through changes of costume in Stanley Donen's *Two for the Road*. The period scenery is brought off with comic panache. But the amusing, style-is-all message keeps getting derailed in the reach for something else—in Hockney's case, in the reach for deep structure, deep content. On the audio tour, which is probably the closest many viewers will ever come to listening one on one to an artist talking, Hockney discusses isometric and reverse perspective and describes his "struggle to make a very clear space." He relates bits of information about his studio procedures. In *A Bigger Splash* (1967), the flat surface of a backyard swimming pool is disturbed by a spritz of white foam—the aftershock of a diver who has just disappeared beneath the surface. Of this painting Hockney observes that "something that lasts fractions of a second took me two weeks to paint. There's a kind of contradiction in this that interested me." Hockney narrates in friendly, even tones, as if the struggles were all behind him.

Trained at London's Royal College of Art as fifties turned to sixties, Hockney quickly gained a reputation as one of the young whipper-snappers of English art. But even the cartoonish paintings he did in the sixties with more than a nod to Dubuffet have a staidly intellectual aroma. In spite of the many years he's lived in America, Hockney remains an archetypal English artist; he watches the great events of European pictorial art from a balcony seat in London town. Hockney always paints with an eye trained on French hedonism (and he's made some insightful remarks about Raoul Dufy and the later Picasso). All in all, though, his is a rather academic, Bloomsburyish view of Paris. When Matisse or Bonnard or Dufy (all artists Hockney admires) moves his colors into a composition that clicks and sends us swooning, he allows us, at the same time, to see things utterly clear. Hockney is more like Duncan Grant or Vanessa Bell (though he's never done anything that's as unaffected as a few of the early Bell still lifes). He wants the ecstasy without the murderous hard work—and the result is obfuscation. There's a moral dimension to French hedonism that eludes this Englishman. When Hockney paints in happy colors the result isn't happiness, it's cheerfulness.

In the antipainting seventies Hockney maintained a commitment to

old-fashioned painting that has given him a bit of an I-told-you-so status in the propainting eighties. But if Hockney has managed to give the impression of being on the welcoming committee when everybody else returned to tradition, he's also taken pretty extensive vacations himself. Hockney's inveterate snapshot photography originated in the homosexual culture of the early sixties, when commercial pornography was hard to come by and everybody had a collection of homemade shots secreted in an album. As his snapshots and the related drawings and prints of California blonds lying between rumpled sheets began to be widely circulated in the late sixties, what caught people's attention wasn't the newness of the imagery so much as the move of a porn aesthetic into mainstream venues. Hockney is a popularizer. His big pressed-paper-pulp prints of the seventies carried the high tide of the printmaking boom into neo-Matissean, billboard-bright images that captivated an audience way beyond the art world. (Like almost everything Hockney does, the paper-pulp prints were turned into a best-selling art book.) The Polaroids of the seventies were a response to the photography boom; and the recent prints made on Xerox machines bring the kind of experimentation that has been featured for years at downtown outposts such as Printed Matter onto Fifty-seventh Street, where André Emmerich showed what Hockney calls his "Home Made Prints" in December 1986, at prices ranging from sixteen hundred to thirty-six hundred dollars. Doing Cubism with a Polaroid camera, or claiming the Xerox machine as a vehicle for high art, Hockney is never less than a quick study. He tickles the public with the thought that anybody who has a Polaroid camera or an office copier can do something artistic. Or maybe the appeal is the reverse, and people see Hockney as a genius who can do creative things that are beyond mere mortals, using the ordinary machines we have at home and in the office.

By the time you read this, the Hockney retrospective will be hanging in the Tate Gallery in London, and the other hot contemporary art ticket of 1988, the Anselm Kiefer retrospective, will have opened at New York's Museum of Modern Art. That neither show originated in New York tells us something about the state of the contemporary museum world: arts institutions are decentralizing in an effort to tap new sources of public and private funds. That both shows have been cele-

brated mostly for their subject matter tells us much more. Hockney is
the fantasy of everything we want life to be, and Kiefer, with his
overtones of Nazi disasters, is the nightmare of what the world became
and could again become. As Hilton Kramer commented in the *New York
Observer*, only a very small percentage of the museum-going public will
realize that Hockney can't do anything much with colors and with paint.
I don't think Kiefer can do more. We have, among our contemporary
artists, better hedonists than Hockney and better Expressionists than
Kiefer. But no topflight contemporary has Kiefer's or Hockney's mass
appeal. Kiefer likes to invoke Richard Wagner, an artist who merged
popular feeling and elevated taste into a new art form. Hockney, who
recently did sets for a production of *Tristan und Isolde* in Los Angeles,
has scored some honorable successes in theatrical design, where his
desire to please can be a strength. Nonetheless, the popularity of the
Hockney and Kiefer retrospectives has to do with a mistaken idea that
the visual arts can, in a very direct way, tell us who we are. Painting
resists easy revelations. In the long run, that's its strength, its staying
power. People who go to museums now are looking for the punch line
they can blow up into a moral. Hockney equals pleasure, Kiefer equals
pain. Together, they're as neatly balanced as yin and yang. Inside the
upscale packaging, kitsch lives.

October 1988

THIRD SEASON: 1988–1989

ANNOUNCEMENTS

Like the montages of newspaper headlines that the old Hollywood directors employed to suggest a leap forward in the narrative, the piles of gallery announcements that flood our mailboxes in the early fall are a sure sign that things are going to start happening very fast. The variety of sizes and styles in announcements is fairly large and in a state of constant flux; raining down on us from the hundreds of galleries that crowd the metropolis, they form an information blizzard that is both exciting and disorienting. There's nothing new about the appeal of a beautifully designed announcement or catalogue—standards set in the thirties and forties by the galleries of Julien Levy, Pierre Matisse, and Curt Valentin can be matched but scarcely excelled—and yet in the current period of unprecedented expansion what is chosen in the way of typography and design may be the result of calculations way beyond the imaginings of the dealers of a generation or two ago.

The color postcard announcing a show of paintings or sculptures is now pretty much out of favor, no doubt because the artist who presents his work directly and without guile risks appearing naively sincere. Full color reproduction is so ubiquitous as to strike many as banal. And who trusts a medium that has time and again drawn us to galleries where the art fails to live up to even the slim promise of the announcement? The color reproduction asks too much of a harassed and harried public, a public ill equipped to make the imaginative leap into a world only the artist really understands.

Some galleries and museums are turning from a straight photograph of the work to a photograph that spins a little story about the artist or the exhibition. This is the idea behind the announcement that the Anne

Plumb Gallery sent out for a show of David Hacker's sculpture in September and October. The color postcard takes us into what appears to be Hacker's studio—a dark, industrial-looking space with one of his big loud painted-metal constructions looming out of the dark. We see the art, but it's really treated here as ambience, a setting against which to glimpse a back view of the artist, who turns out to be a hunk in regulation white T-shirt and black jeans. The place, the pose, all spell excitement. The same is true of the black-and-white snapshot that's on the announcement for the preview of British punk-rock impresario Malcolm McLaren's show at the New Museum. McLaren—an entrepreneur's entrepreneur who prompted *Village Voice* columnist C. Carr to observe, "in the age of consumption, revolutions begin in the stores"— looks thin and a bit wan. He's sandwiched between two British cops who, according to a caption, are arresting him "during the Queen's Jubilee celebration, London, 1977." What can be the point here except to suggest that danger is in the air and that the preview might turn out to be a great party, a real smash?

It's but a quick jump from the announcement that presents the gallery as a theater of social unrest (the Starn Twins sent out the catalogue for their double show this fall at Stux and Castelli in an envelope imprinted with newspaper reports about last summer's Tompkins Square Park melee) to the announcement that pitches the gallery as a spiritual sanctuary. The exhibition space empty of visitors can be quite seductive, as in the photograph that alerts us to Minimalist Peter Joseph's show at Kent Fine Art. Here we see a corner of the gallery, with several paintings on adjacent walls and light streaming in through a strip of window. Printed on matte stock in pale tones of yellow, blue, and pink, the scene takes on a Photo-Secessionist softness that's mightily beguiling. The light of Fifty-seventh Street streams across the stone floor, creating a veritable annunciation in an art gallery and bestowing limpidity on paintings that are in reality closed and dry.

Gone forever are the days of the little printer who could turn out something lovely for a song. Going through the daily mail, which is full of pieces of heavy card stock, sometimes double-faced in contrasting colors, has become as much of a deluxe sensuous experience as going through the racks in the chic clothing stores. From the Washburn Gallery to the Stux Gallery, transparent papers are immensely popular.

These are evanescent signs of conspicuous luxury, tickling the imagination like some of the new gallery decor that you see around SoHo, where walls of thick blocks or thin frosted sheets of glass create a sense of looking through, of mysteries in inner offices. The announcement for "Transcendent," a group show at the David Beitzel Gallery, is printed in pale gray on strong, translucent, vellumlike paper. It's an announcement that one studies: holding it up to the light, turning it this way and that, wondering whether the vague shapes over which the typography is imprinted are body parts or folded cloth.

While paper, in its texture and color, can be luxuriantly avant-garde, typography has gone into a period of retrenchment and conservatism. Bauhaus asymmetry is little used, replaced by an insistent symmetry; many prominent galleries are sending out announcements that recall typography in the business world, with its serif types and raised lettering. Only the dusky colors—deep forest greens, brick reds—suggest something hedonistic or artistic and make a light joke of designs that might otherwise appear more appropriate to a Park Avenue wedding than a SoHo gallery. Surely this recent style in announcements is a response to the taste of the paying public, another sign that if the current art world was ushered in by radical chic, its values have been institutionalized by nearly eight years of Reagan-style prosperity.

The announcement for the show of work by Thomas Lanigan Schmidt at the Holly Solomon Gallery can be interpreted as a send-up of the conservative style in announcements. A cream-colored rectangle, the size of a business card and bearing the relevant dates and times, arrives wrapped in a mocking blue foil package. The foil is lined with pink paper, on which is scrawled a flaky, one-page short story. There's sub–Ronald Firbank humor to the story, which opens, "Filthy! Disgusting! Get your hands out of there! His lips said 'Stop.' His eyes said 'Go!' " The best of Schmidt's staple-and-tinfoil constructions, such as *Noli Me Tangere*, where Hollywood kitsch is the subject, continue in this giggly, adolescent vein; Schmidt is on far less firm ground when he seriously invokes the reliquaries and icons of Byzantium, those works that trigger ecstatic feeling through a formal inventiveness way beyond his amusing capacities.

If Schmidt makes a little joke on the business-style announcement, the card for the show of work by Italian Minimalist Jannis Kounellis at

Mary Boone apotheosizes it. Out of Boone's envelope comes a five-and-three-quarter by eight-inch rectangle of what looks like handmade paper—thick, white, finished with beautifully uneven edges. Kounellis, an artist whose arrangements of rough-hewn bits of wood and dusky sheets of steel are much in demand this season, needs no photograph as an introduction to Boone's audience. His show, which consisted of a wall relief of rock and burlap sacks bolted to metal panels, had a certain grim authority. The announcement, adorned with nothing but the artist's name, the show dates, and the gallery's name and address, all in heavily embossed letters, is by contrast an object of delectation—an elegant paper tombstone.

Along with the flood of announcements comes the only slightly smaller flood of catalogues. These range in extent from a little brochure for Alan Johnston's show of monochromatic abstractions at the Jack Tilton Gallery—which includes a few paragraphs of introduction to the work ("They are songs, they are monuments") and a sheet of onionskin giving the show dates and the hours of the opening—to a full-color job for the show of three-dimensional paintings by Rodney Ripps at Marisa del Re. This catalogue contains four slam-bang pages of text by Donald Kuspit, the Rambo of art writers, who pumps the word processor the way others pump iron.

The author of the catalogue essay is, willy-nilly, the artist's advocate. Strict minds may disapprove of this style in art writing, but friendly enthusiasm isn't necessarily any more of a deterrent to discrimination than the professional dispassion that all too often masks indifference. There are ways to write out of affection or sympathy and still say something that's valuable and even critical, *if* one knows the meaning of silences, of the evasive comment that conveys what's left unsaid. But the line between discriminating friendliness and a new laid-back style of agitprop isn't always clear, a case in point being the essay that Joseph Masheck has contributed to the catalogue of Doug Anderson's show at the Stux Gallery. This catalogue is a design doozy: cover in dusky rose with dots printed in green and name printed in black; interior pages for type in another green, flecked with darker bits; while the illustrations of Anderson's romantic images of flowers floating on a chiaroscuro of old-fashioned decorative fabrics are reproduced in tones of sepia and

purple. Masheck introduces the artist as a character he meets at some event. Anderson, Masheck writes, "did not perform the trick, so common in these parts, of seconding a motion he happened not to comprehend; but from what he did say he had evidently caught my drift." Clearly, the critic is putting himself up; but we were already on notice about this, from the tony excerpt from *The Education of Henry Adams* that introduces the little essay. The excuse for the Adams quotation may be that Anderson, like Adams, comes from Boston; but the intellectual overkill—which includes in two quick pages references to Adams, Rousseau, Henry James, Winckelmann, and half a dozen artists—lends a sour edge to Masheck's interesting picture of the art-world mentality today.

Collins and Milazzo, the curatorial team who pioneered the devilishly inscrutable catalogue essay about half a decade ago, weigh in this fall with another green-covered catalogue, for "Primary Forms, Mediated Structures," at the Massimo Audiello Gallery. The cover is in a mossy hue, with a light weave to the paper that's reminiscent of the letter paper on which elegant relatives wrote their thank-you notes a couple of decades ago. Collins and Milazzo have come a long way since the mid-eighties, when their essays tended to be disseminated in plebeian Xerox form: their success mirrors the success of an entire up-from-the-East Village generation. What is most interesting in the text for the Audiello catalogue is the duo's tendency to quote obsessively from their own earlier essays, some of which may by now be out of print and even collectible. Collins and Milazzo are anxious to assert their precedence, and their particular view of a period a few years ago when, to quote a text that's like the higher junk food, "cooption was culturally bumped-up to reification." Many of the Collins and Milazzo group shows have been preoccupied with the romance of the past and the romance of the future, or of both simultaneously, as in "The Antique Future," mounted at Audiello's old East Village space in 1987. Now, fearing that their own period of influence has come to a close, Collins and Milazzo are anxious to secure their little place in history as they prepare for a future that even they, heaven help us, can't any longer predict.

Look at gallery ephemera and you see, first, the velvet glove of a privileged world and, a little later on, the iron fist that lurks within. We all know that art cannot exist except in an economy that deflects

money from basic needs to luxury consumption—this is true of all periods, from medieval Florence to modern New York—and few would argue for bringing justice to an unjust world by going after the wealthy person who really loves art and has the wherewithal to live with, say, a Bonnard. But more and more of the money that is being interjected into the art world is something sinister—a violent assertion of power, unrelated to anything we can associate with taste, discrimination, or love. Gallery giveaways are one of the lightest and on the face of it least egregious assertions of the power of money. Still, anyone who has seen a printer's bill knows that mere cleverness or taste won't get one very far; which is not to say that those who don't have the money can be let off the hook. While the artist who takes fashion into account when at work in the studio is most likely a charlatan, the artist who refuses to consider fashion when presenting the work to the world is probably a fool. The current scene twists even the noblest soul into a desperado, and may end up bringing out the Dadaist in each one of us. It was Marcel Duchamp who made the ultimate statement about gallery give-aways in 1953, when he designed the catalogue for "Dada 1916–1923" at the Sidney Janis Gallery as a sheet of tissue paper that was wadded up into a ball and left for gallery-goers to pull out of a trash can.

November 1988

A DISSENT
ON KIEFER

Half a century after Kristallnacht, the Holocaust is a treasure trove of superstrength imagery that artists are inclined to adapt with little apparent hesitation. In some cases, there's an honest if dangerous effort to bring the unimaginable into line with the needs of the contemporary imagination; elsewhere images are presented in such a way that their precise relation to Hitler's Final Solution is veiled, even obfuscated. The Anselm Kiefer retrospective, currently at the Museum of Modern Art on the final leg of a four-city, nationwide tour, is a phenomenon that has brought an aestheticized fascination with Nazi Germany to the attention of an enormous public. Kiefer's mammoth images of charred tracks of earth are if nothing else a tabula rasa upon which many critics have inscribed their own overheated associations. And these associations have been abetted by curator Mark Rosenthal's text for the catalogue, which marshals the forces of art-historical scholarship to lend Kiefer's jazzy reputation as a contemporary tragic hero some weight, some dignity, some mythic resonance. Meanwhile, for those of us who are disinclined to take our zeitgeist readings from the media or the Museum of Modern Art, the appearance of the Holocaust as a motif in half a dozen shows by contemporary Americans suggests that Kiefer is hardly alone as he stirs the once irreducible facts of annihilation into a modern artist's metaphorical stew.

Despite all the attention that's been focused on Anselm Kiefer, people remain uncertain about how to react to his use of modern German—and modern Jewish—history. Because he's creating Art, people assume they have to suspend all (or at least most) reservations. Jews seem to feel almost guilty about their discomfort, as if they would expose a lack of cultural refinement by concluding that the obliteration of their

not-too-distant ancestors was a dubious occasion for exercises in the Beautiful or the Sublime. Moreover, art critics, unlike literary critics, have rarely tackled the many aesthetic and extra-aesthetic questions that bear on the Holocaust.

Perhaps the best place to look for some insight into the contemporary fascination with fascist history and ideology is Saul Friedländer's extraordinary book *Reflections of Nazism: An Essay on Kitsch and Death* (published in France in 1982 and in the United States by Harper & Row two years later). Friedländer is a Jew who spent his childhood hidden in Nazi-occupied France (this part of his life is related in a widely acclaimed book of reminiscences, *When Memory Comes*); he has also published a number of scholarly works on the Holocaust. In *Reflections of Nazism* he brings to a very difficult subject an impassioned yet somehow cool intelligence. The book is rather unusual in the literature that deals with artistic responses to the Final Solution in that, unlike most studies, which analyze works created by survivors, *Reflections of Nazism* focuses on the image of the Holocaust in literature and movies since the sixties. Though Kiefer isn't mentioned, many of Friedländer's observations throw light on Kiefer's art and reputation.

"Attention," Friedländer writes, "has gradually shifted from the reevocation of Nazism as such, from the horror and the pain—even if muted by time and transformed into subdued grief and endless meditation—to voluptuous anguish and ravishing images, images one would like to see going on forever. . . . In the midst of meditation rises a suspicion of complacency. Some kind of limit has been overstepped and uneasiness appears: It is a sign of the new discourse." *Reflections of Nazism* is difficult to summarize, probably because much of the beauty of this brief book rests in the elusive, circuitous manner of Friedländer's reasoning, his unwillingness to simplify or to tie together ends better left loose. It's the very porousness of his effects that enables him to suggest some of the strange ways in which "the endless stream of words and images becomes an ever more effective screen hiding the past." Through quotations from Joachim Fest's biography of Hitler and the memoirs of Nazi architect Albert Speer, Friedländer demonstrates how Hitler succeeded in projecting himself as a German hero and his cause as a German cause by swathing Nazi ideals in a kitsch imagery that had a strong hold on the middle-class imagination. Kitsch—which Friedländer, quot-

ing Abraham Moles, calls that "pinnacle of good taste in the absence of taste, of art in ugliness"—still appeals; and Friedländer's central insight is that the contemporary avant-garde's fascination with Nazi images echoes the original appeal of the Nazi mystique. The contemporary artist's response to the symbolic power of Nazism may not be so different from the response of the German of fifty years ago. About this mirroring of the past in the present Friedländer is obviously ambivalent: it's dangerous, but at the same time certain contemporary works may help us to understand something about the overwhelming attraction of a hideous ideology. "In effect," Friedländer writes, "by granting a certain freedom to what is imagined, by accentuating the selection that is exercised by memory, a contemporary re-elaboration presents the reality of the past in a way that sometimes reveals previously unsuspected aspects."

Over and over again Friedländer emphasizes how ambiguous a role Hitler has in contemporary art. Hans-Jürgen Syberberg's movie *Hitler, a Film from Germany* is perhaps the central piece of evidence—a movie that intermingles fascist kitsch, as in the sentimental memoirs of Hitler's valet, with the avant-garde infatuation with kitsch. Of Syberberg's effort, Friedländer writes, "It may result in a masterpiece, but a masterpiece that, one may feel, is tuned to the wrong key." "In facing this past today," Friedländer says later on, "we have come back to words, to images, to phantasms. They billow in serried waves, sometimes covering the black rock that one sees from all sides off the shores of our common history." Aestheticism, he says, is a defense against reality. This, it seems to me, is a perfect description of the appeal of Anselm Kiefer. In Kiefer's work, as in many of the works Friedländer discusses, the Nazi past has become a potent but also elusive presence—a sort of texture, made up of the burnt grays and blacks that evoke charred bodies, a sensuous texture, a texture that seduces more than it illuminates. This seduction serves to divert our attention from the hard facts.

Mark Rosenthal, the curator at the Philadelphia Museum of Art who wrote the catalogue for the Kiefer retrospective, isn't unaware of some of the problems that Saul Friedländer raises. Rosenthal's essay, however, grows out of a desire to operate in sync with Kiefer, and this ultimately amounts to something like collusion. The Holocaust is barely mentioned; and so the central fact of modern German history, the fact

that makes it qualitatively distinct from all other histories, is lost in the misty art-historical analysis.

Kiefer's *March Heath* (1974) depicts the wide-open perspectives and dappled birch trees of an area southeast of Berlin that's long been admired by Germans for its natural beauty. Rosenthal tells us that "the area is happily recalled for many Germans in Theodor Fontane's *Walking-Tours through the Brandenburg March*, written in the nineteenth century"; but this wistful, rather literary nostalgia is hardly the point when, as Rosenthal explains, the March Heath that Kiefer presents is layered with meanings. According to Rosenthal, this is an area "which in this century was lost first to Russia and later to East Germany." And "adding to the multiple associations of the painting is [the fact] that 'Märkischer Heide, märkischer Sand,' an old patriotic tune of the region, becomes a marching song for Hitler's army." To say, as Rosenthal does, that the territory depicted in *March Heath* "has become a sad memento mori of the Nazi experience and the separation of Germany" is both to aggrandize the meaning of a fairly ordinary landscape and to engage in Holocaust control. "Sad memento mori" softens the past, pretties it up; and the equation of "the Nazi experience" with "the separation of Germany" suggests a capitulation to the idea that the Holocaust is merely one calamity among others. Elsewhere, Rosenthal speaks of "the more difficult aspects of [Kiefer's] German heritage"—again, a euphemism. And of how Kiefer "drifted further back in German history"—again, calamity as an atmosphere one floats through.

Also disturbing are some comparisons that Rosenthal makes between Kiefer and other modern or contemporary artists. These art-historical sallies have the effect of deflecting attention from the uniqueness of Kiefer's situation. "In *Cockchafer Fly*," Rosenthal observes, "Kiefer became a kind of war poet, and the blackened, scorched earth his central motif, his Mont Sainte-Victoire, as it were, showing the province of the landscape to be human suffering, not the glory of nature." "A kind of war poet" is again a case of prettying things up. The comparison to Cézanne casts Kiefer in a cleansed, elevated, modern-masterish context. To say that Kiefer makes the landscape "the province of . . . human suffering" only points up the way he sanitizes suffering. After all, how much easier it is to imagine a landscape "suffering" than to imagine a person suffering.

Another comparison, this one to Warhol. Speaking of Kiefer's *Ways of Worldly Wisdom*—a painting that includes portraits of figures out of German history "taken from either dictionaries or books about the Third Reich"—Rosenthal says, "Kiefer's depictions recall Gerhard Richter's '48 Portraits' series of 1971–72 and Andy Warhol's many celebrity portraits from the 1960s onward. Like the American artist, Kiefer looks at the heroes of his country in a deadpan way. . . ." No, no. To associate the tongue-in-cheek glamour of Warhol's high-society gang with Kiefer's origins-of-totalitarianism motifs is to make a muddle, and finally to reassure viewers that all subject matter is equal. Here aestheticism is a leveler. And so, a couple of pages later, we're informed that "Kiefer offers art as a theoretical antidote for the terror of human history and the failure of mythic figures." Art as a theoretical antidote to the Holocaust?

In the past few years, Kiefer has visited Israel and begun to take some of his subjects from Old Testament history; he seems to have a particular fondness for Moses and the story of the crossing of the Red Sea. Perhaps some will see in this new twist of Kiefer's career a desire to escape the chronology of modern European history. But his tendency to mythologize everything (and Mark Rosenthal's tendency to use art-historical references to further muddy the waters) denies us exactly what we need when we confront Hitler—which is absolute, total clarity. The Kiefer who now memorializes ancient Jewish history was, twenty years ago, going around Europe taking photographs of himself dressed up in Nazi-style gear while giving the Nazi salute. These photographs were put together in a suite called "Occupations," which was published in the magazine *Interfunktionen* in Cologne in 1975. It's the nadir of neo-Nazi campiness. "I do not identify with Nero or Hitler," Kiefer is quoted by Rosenthal as saying, "but I have to re-enact what they did just a little bit in order to understand the madness. That is why I make these attempts to become a fascist." Rosenthal underlines this. "He assumed the identity of the conquering National Socialist. . . . In the flamboyance [!] of the Nazi *Sieg heil* he spares neither the viewer nor himself since he serves as the model for the saluting figure." And: "Kiefer tries on the pose of inhuman cruelty, plunging into a state of spiritual darkness in which he can coolly and almost dispassionately ponder one of the

most . . ." It's amazing that this museum catalogue has been greeted with such mildness, with such appreciation.

I very much doubt that Kiefer's early conceptual "Sieg heil" works would have earned him a show at the Modern; voices might have been raised. And yet it's exactly the same love–hate relation to the German past that's earned him his retrospective; only now the same attitudes have been packaged as high modernist art. As Rosenthal puts it, by 1980 "Kiefer had, in effect, integrated his ongoing thematic concerns with the outsize proportions of Abstract Expressionism and the modernist insistence on the literal qualities of the object." The secret of Kiefer's fame is that a sensational and even I would say pornographic obsession with Nazi atrocities is wedded to a mainstream modernist aesthetic.

Kiefer's paint is said to evoke rock and earth, the soil of Germany; and Kiefer tries to heighten our sense of earthiness through the inclusion of handfuls of straw, or the thickening of the paint with sand. This surface is the alpha and omega of Kiefer's art, and yet it's hardly the metaphoric miracle it's been claimed to be. Kiefer treats the canvas as if it were an upended track of land; he wants to imbue the flatness of the support with the lyric physicality of a nature poem. But his strong formalist leanings—and his infatuation with Abstract Expressionism— are in collision with what may or may not be a genuine gift for lyric evocation. Rosenthal has compared Kiefer to Pollock; he sees echoes of Pollock's *Blue Poles* in *The Mastersinger* and *Margarete*. This is Pollock with metaphysical and metaphorical trimmings, and the trimmings seem to come unglued as easily as Kiefer's hunks of straw. Strip away the fancy titles and the little representational doodles and you find paintings that look uncannily like post-Pollock formalist abstraction—especially the recent sensuous yet austere work of Olitski and Poons, both of whom, like Kiefer, paint with acrylic and like to build up the surface until it projects fairly far off the wall. In Kiefer's *The Book*, the surface is thickened with acrylic; and the translucent acrylic, after it has dried, is dusted with a dark tone. The effect is Olitski-ish—a kind of optical shimmer. Precisely what the painting lacks is the tactile gravity that we would expect in a painting that invokes earth—the weight that we know from some of the great modern Expressionist landscapes, from certain Soutines and de Staëls, the late landscapes of Georges Braque, and the canvases of the English contemporary Leon Kossoff.

Kiefer is easy for current taste to assimilate because his sensibility is, at heart, a postwar American sensibility. His sizes are Ab Ex sizes; and, like an Abstract Expressionist, he articulates the surface only insofar as articulation reinforces homogeneity. The perfunctory lines of perspective that Kiefer inscribes here and there do little to create dynamism or variety or surprise. There's really next to nothing in these vast paintings. (Some of the smaller ones are more nearly credible.) This is metaphysical formalism, and I don't think the artist I went to the opening with was far from the truth when she commented, "Six million Jews had to die so all these people could wear black tie." To claim for a reductive pictorial structure all the meanings that have been claimed for the Kiefers is to conflate the old formalism and the new taste for narrative in the most extreme and disastrous manner. It's fifty years ago that Clement Greenberg declared the absolute separation of high and low taste in his essay "Avant-Garde and Kitsch." Now, with Kiefer, the sort of optically alluring surface that characterizes what has been called Greenbergian abstraction is joined to a voyeuristic sentimentalization of Jewish history we'd normally expect to encounter in a TV miniseries or a trashy novel. The end result of Greenbergian taste—the heavily impastoed acrylic surfaces of Olitski and Poons—has been joined to a romantic infatuation with Nazi kitsch.

Just after I saw the Kiefer retrospective, I read *The Drowned and the Saved*, the book Primo Levi completed before his suicide in 1987. It's quite different in tone from Levi's earlier memoirs in that he has now left behind the narrative made up of anecdotes and portraits-in-miniature in favor of a severe essay style. Gone for the most part is the comfortable, consoling effect of painted scenes; here there are only a few hard facts, presented without halftones. It's a purified, skeletal book; and after I'd started it, I couldn't put it down and found myself staying up late, both hands clutching the pages very tight, until I'd gotten to the end. In the closing chapter, "Letters from Germans," Levi describes some of the correspondence he received after *Survival in Auschwitz* was published in Germany. In particular, he details a long exchange of letters with a woman, Mrs. Hety S. of Wiesbaden, who came from a family of leftists, had kept clear of the Nazis, and was, as he says, of all his correspondents "the only German 'with clean credentials' and therefore not entangled with guilt feelings." In one of the letters that Levi quotes, Mrs. S.

writes, "For many among us words like 'Germany' and 'Fatherland'
have forever lost the meaning they once had: the concept of the 'Fa-
therland' has been obliterated for us." It's exactly this concept that Kiefer
is trying to reinstate.

But if Kiefer's staggering success tells us something about Germany
today, it may tell us even more about how desperately people in the art
world want to believe that art has content, always more content, and
how willing they are to believe that content exists not so much within
the work as in a drama that's grafted onto the work. It's an overpowering
sense that the Holocaust is the ultimate *event* of modern history that
attracts artists now. Robert Morris, for instance, used photographs of
piles of corpses in the concentration camps as one of the elements in a
series of mixed-media wallworks on apocalyptic themes that were shown
at the Castelli and Sonnabend galleries last season. Almost fifteen years
ago, in her essay "Fascinating Fascism," Susan Sontag observed: "The
poster Robert Morris made for his recent show at the Castelli Gallery
is a photograph of the artist, naked to the waist, wearing dark glasses,
what appears to be a Nazi helmet, and a spiked steel collar, attached to
which is a stout chain which he holds in his manacled, uplifted hands.
Morris is said to have considered this to be the only image that still has
any power to shock." Now, using photographs of the death camps,
Morris has topped himself.

Within a few months of Morris's show, there was a painting in
Jerome Witkin's show at the Sherry French Gallery called *Terminal*,
which represented a young Jewish man, a huge Star of David on his
lapel, sitting in a cattle car; and there was a collage in Joan Snyder's
show at Hirschl & Adler Modern called *Women in Camps*, which included
photographs of Jewish women, also wearing the Jewish star. This fall
the Starn Twins have weighed in with Holocaust imagery. The *Lack of
Compassion Series*, in the Castelli Gallery half of their two-part show,
centered on a photograph of concentration-camp dead mounted on a
large piece of pale blond wood. Ranged around this were narrower
planks of wood, each bearing a black-and-white photograph of the face
of a martyred hero—from Gandhi to J.F.K. to Steve Biko. The
Lack of Compassion Series had a cool, knowingly Age-of-Mechanical-
Reproduction look: perhaps the Starns thought it would be as easy to
illuminate the Holocaust as to flick on a light switch upon entering a

darkened room. And if all this hadn't been enough, in October the abstract painter Gary Stephan included in his show, at Hirschl & Adler Modern, paintings entitled *The Stacks* and *Ashes*, and let it be known, via Lisa Liebmann's catalogue essay, that "they have to do with the Holocaust."

Relative to the size of the New York art world, something like half a dozen shows may not seem very many; but the range and diversity of artists apparently drawn to similar themes—from an academic realist such as Jerome Witkin to the internationally acclaimed subject of a MoMA retrospective such as Kiefer to darlings of the next wave such as the Starns—is pretty impressive. Witkin's brand of narrative painting (which is finicky about naturalistic detail and attuned to spectacle as sentiment) may have no connection whatsoever to Joan Snyder's experiments in collage (which walk a tightrope between the aestheticizing and the politicizing) except that there seems to be, all over town, this reach into the central catastrophe of modern European history. In the spectral bodies of concentration camp victims some will see resemblances to the contemporary ravages of AIDS; while others, especially Jews approaching middle age, may believe the time has come to confront the most essential and painful aspects of their communal past. Trying to hold in one's mind such diverse impulses expressed at such different levels of artistic seriousness is difficult, perhaps impossible . . .

Recently, in the catalogue of Judy Rifka's show at the Brooke Alexander Gallery, Robert Pincus-Witten observed that many artists want to restore "our strained belief in transcendence." Nothing strains the belief in transcendence quite like the Holocaust. And, perhaps, no event bears so immediately on the possibility for transcendence. To admit the Holocaust into contemporary art is to admit experience in its most extreme, uncontrollable, and incomprehensible form. It's a subject no artist may be equal to; certainly most who attempt it will be defeated even before they begin.

As for Anselm Kiefer, we can say for sure that no artist has gambled more on the appeal of the Holocaust as a symbol. I would argue that Kiefer's troubles begin right there, because to treat the Holocaust as a symbol is to belittle it, to make it bearable. Maybe that's what people really like about his work. The advertisements that the Museum of Modern Art is running for the Kiefer show present the artist as a special

case, an *interesting* case. "Something big," the headline informs us, "is happening at the Museum of Modern Art." Kiefer, we're told, "paints public memories mixed with private dreams—as he shuns the comfort of custom and fashion. Only 43 years old, he has already challenged the traditional ideas of what an artist is and does. . . . Kiefer's work demonstrates that boundaries of time and place need not be barriers to creativity." I'm not exactly clear on what all this means, except that the Modern knows it has a-hit-that's-much-more-than-an-art-show on its hands and feels no compunction about milking it for all it's worth. One thing is for sure: new-style content has never had so sweet a revenge on old-style formalism as right now, when they're hyping the Holocaust at, of all places, the Museum of Modern Art.

December 1988

NOTES ON ART
AND POLITICS

Art and politics is a now-you-see-it-now-you-don't topic. If you believe that art ought to address political and social concerns, you may be inclined to see political content everywhere. But if you're not tuned to the art-as-politics wavelength, a Barbara Kruger, even a Hans Haacke or a Leon Golub, may look like another idiosyncratic personal statement, one of hundreds that compete for your attention as you go from gallery to gallery.

Many artists have at one time or another felt like Anna, the heroine of Doris Lessing's novel *The Golden Notebook*, who sits down to write and imagines the downtrodden of the earth asking her, "Why aren't you doing something for us, instead of wasting your time scribbling?" This, however, isn't a thought that occurs only to artists; it's a thought (with "scribbling" replaced by some other action) that could equally occur to a lawyer, a truckdriver, or a chemist.

Political art per se has no style; it runs the gamut from humanistic dramatics to high-tech cool. The desire to make art address social or economic concerns can be applied to a given style, or it can, presumably, act as the catalyst for a new style. Theoretically, artists can agree politically, disagree aesthetically; or agree aesthetically and disagree politically.

The feminist critic Lucy Lippard has written an essay called "Trojan Horse: Activist Art and Power," in which she discusses the kind of political art that takes the artist beyond the gallery context. What's most striking in Lippard's essay is how the activist gesture is given a particular

artistic value. Lippard writes that "activist art is, above all, process oriented. It has to take into consideration not only the formal mechanisms within art itself, but also how it will reach its context and audience and *why*." Lippard's "process-oriented art" is an aesthetic idea, grounded in a rejection of the self-sufficiency of the work of art. Presumably, the artist who rules out process-oriented art on aesthetic grounds—who believes that art's ability to affect us must be embedded in its fixed formal dimensions—is in danger of being judged politically retrogressive. Where does aesthetic correctness end and political correctness begin? Even an artist such as Leon Golub—whose work is fairly traditional—seems intent on giving his paintings a process-oriented spin: he presents them as unstretched banners that hang loose from the wall. In rejecting the rigid rectangular support, Golub moves the work ever so slightly out of the art gallery context—he gives it a let's-break-camp informality. The painting becomes, in its bannerlike form, an indirect endorsement of protest marches and antiestablishment gestures. But what of the artist who believes in protest marches and antiestablishment gestures, but also believes in the rectangle? Can you reject the unstretched canvas and still be a political radical? I would say yes; Lucy Lippard might say yes, too. But given the way lines are drawn in the art world, it would be—is—a difficult position to maintain.

I admire political activists. Sometimes I admire them even when I don't exactly agree with them. I can't be indifferent to the let's-change-the-world drive of artists who band together with community leaders to paint murals and set up a soup kitchen in an abandoned lot at Eighth Street and Avenue C. And though I don't care for the collages that Tim Rollins and the Kids of Survival make out of pages extracted from classic literary texts, I say that if Rollins, who runs after-school art classes up in the Bronx, can help even a handful of adolescents get a lift out of the underclass, more power to him.

Tim Rollins, the East Village activists who mounted "The Real Estate Show" in an abandoned building on Delancey Street on New Year's Day 1980, and a host of others, were represented in "Committed to Print," the big exhibition of posters and broadsides that the Museum of Modern Art organized last spring. The MoMA show took as its subject all the artists who, at various times since the sixties, have left

the studio for the street. And there was true feeling—and even a little
rapture—in the way our reactions to events in Southeast Asia, South
Africa, and our own backyards vibrated through the slogans and car-
toons and tabloid images that were hung on West Fifty-third Street.
Who could forget the Art Workers' Coalition's 1970 My Lai poster,
with its color photograph of carnage and its question/answer format of
"And babies? And babies"? Or Andy Warhol's spiffy silk screen for the
McGovern campaign, featuring a sickly green Dick Nixon?

"Committed to Print" was a double eulogy—to the sixties and to
the activist spirit that had energized the East Village in the early eighties.
For left-wing critics of the contemporary museum world, who have long
believed that art institutions aren't sensitive enough to political concerns,
the show was a strategic victory. It also represented the high-water mark
of art world reaction to the Reagan years, which, with their mix of
upscale consumerism and right-wing politics, have made some artists
reject the whole idea of the art object as a luxury commodity. Yet at
MoMA, where the activists were detached from the activities and could
only be artists, the social dynamism dissipated—the work was aesthe-
ticized. Radical politics turned into radical chic.

Nowadays, the entire topic of political art sometimes feels like a
subheading of a bigger topic: the sixties. Neoconservatives aren't the
only people who are heard groaning, "Here we go again." Meanwhile,
those of us with good memories of the marches and rallies and be-ins
will wince at the way the past is being packaged, forced into one or
another rigid frame. Exhibitions such as "The Turning Point: Art and
Politics in 1968," at Lehman College in New York City this winter,
attempt to use the methods of academic scholarship to clarify recent
history; but such efforts invariably end up by reinforcing the kitsch-
nostalgia factor already at work in the newsweekly reprises of "The
Spirit of Haight-Ashbury" or "The Vietnam Years."

In the sixties, artists could believe they were part of a groundswell
of national consciousness. And, in the effervescent air of those years,
it was possible to make analogies between the political and the aesthetic.
It didn't seem to matter that some of the logical steps were missing—
the analogies were inspiring, anyway. Artists interested in a revival of
figure composition were saying, "Maybe we can find a way to make art

connect to politics, just as David did around the time of the French Revolution." It was an idea tossed around at a moment when a lot of ideas were being tossed around—not as dogmas, but as possibilities. But in retrospect, the original loopy logic gets lost.

Artists who find that they are out of sync with the go-go art world of the 1980s may be attracted to the *idea* of politics. Thus many artists who sit in the studio day by day, clutching the cooling cup of coffee under the grisaille of northern light, have become nostalgic for moments in the modern period when artistic and social radicalism converged. At no other time in the past fifty years has there been so much curiosity about the Russian Constructivist period just after World War I, about the works by Malevich, Tatlin, and El Lissitzky in which a yearning for social justice was united with a taste for immaculate abstract structures. Russian Constructivism exerts a powerful hold on trendies and antitrendies alike. It's the Brave New World for which everybody is now old enough to be nostalgic.

In a democratic society artists can't afford to be totally insulated from life-in-general; that way lies preciosity, decadence. But the line between rejecting art as a luxury commodity and rejecting art as a non-utilitarian but nonetheless life-illuminating necessity is something left-wing critics tend to (willfully) confuse. Hans Haacke, one of the most influential political artists of the past decade, has called museums "managers of consciousness"—as if the Metropolitan and the Museum of Modern Art were the ultimate consumer centers and anyone who wanted to spend a few quiet minutes with a Vermeer or a Matisse was in danger of being brainwashed. (But by whom?)

I rather like the flat honesty of Haacke's own work. The main attraction in his show last spring at the John Weber Gallery in SoHo was a striking pop eulogy to the Sandinista revolution. Beneath a movie marquee emblazoned with the message "The Freedom Fighters Were Here" was a back-lit photograph of three bedraggled Nicaraguan peasants holding a coffin and a cross amidst the lush green Central American hills. What Haacke does isn't exactly antiart; it's really political poster art—clear-headed, straight-to-the-point.

Haacke—who sent visitors to the Weber Gallery away with a sheaf

of Xeroxed pages outlining how the internationally renowned advertising executive and art collector Charles Saatchi helped sweep Britain's Margaret Thatcher to power—is speaking to a liberal audience troubled by what's happening in Nicaragua, South Africa, and our cities. He wants people to get more upset—he wants to get people to do something. But he may be falling into the very political naiveté he criticizes in others if he believes that a Haacke hanging in the Metropolitan or the Modern can influence political consciousness.

Part of what the political artists are up against is the pervasiveness of the mass media in our lives. In a world where we're all movie, TV, and newspaper junkies, the visual arts have an ambiguous, outsider status that may stymie Haacke more than he even knows. *Under Fire*, the 1983 Nicaragua movie starring Nick Nolte, had a better chance of changing people's minds about Central America than any work by Haacke could ever have (though Haacke would probably argue that director Roger Spottiswoode is too much in thrall to Hollywood values).

Political art made a bow to presidential politics in a cycle of events that the collaborative called Group Material mounted this past fall through the auspices of the Dia Foundation. Under the general rubric of "Democracy," Group Material—which has three members, Doug Ashford, Julie Ault, and Felix González-Torres—put together salon-style shows (and round-table discussions) that were meant to focus on the state of the Union at the end of the Reagan era. The tenor of the group's shows, which were held at Dia's gallery at 77 Wooster Street, was postmodern eclectic: some Pop Art, some Conceptual Art, some low-culture found objects (redwood picnic tables, bags of snack food), all crammed together into installations that made a conscious break with the minimalist presentations that art galleries generally favor nowadays.

In a sense, the mood of the shows, which was impersonal and hyper media conscious, mirrored the mood of the Bush-Dukakis presidential race. While big things were at stake in the presidential elections and important matters were alluded to in the art in the Group Material shows, what was actually put before our eyes—*those* candidates, *those* works of art—didn't bring the issues to life or tell us anything we didn't already know. If the candidates didn't seem to believe that eloquence could inspire us, the artists—who presented, to give a couple of ex-

amples, color photographs of upscale consumer products from Bloom-
ingdale's and computerized mock-ups of the ideal male movie stars—
didn't seem to believe that artistry could fire our imaginations. Tele-
vision had sucked the life out of presidential politics—which couldn't
surprise the postmoderns of Group Material, who accept the standard
eighties leftist belief that all visual media are forms of brainwashing,
scrims set up to close us off from reality. But did Group Material actually
mean for postmodern political art to be as banal as the electronic
presidency?

Part of the appeal of political art has to do with the if-it's-hard-to-
take-it-must-be-good-for-me syndrome. We've all seen gallery-goers
standing in front of the latest political art with pained looks on their
faces, like kids taking their medicine.

On close examination, a lot of the connections that are drawn be-
tween art and politics look forced if not downright wrong; nevertheless,
the idea of the engaged artist cannot be casually thrust aside. When
subject matter is unconventional or in some way a shock to sensibilities,
the personal and the political may of necessity begin to merge. To the
artist, politics can symbolize a yearning for something beyond the pri-
vacy of art. More important, art itself can offer ways to transcend the
here-and-now that have political overtones. Joan Snyder, whose luxu-
riantly colored paintings allude to human tragedies that no degree of
middle-class privilege can make her forget, has written about the rela-
tionship of art and politics. In a catalogue note to her show last spring
at Hirschl & Adler Modern, she spoke for the many artists who, baffled
and enraged, close the pages of the newspaper each morning before
setting off to the studio to work. "I can no longer find words that explain
the sickness, the insanity that abound in our world and so I paint and
paint. . . . With paint I can only be an optimist." Some will call this
late-eighties pessimism with a dash of sixties optimism, which probably
describes how many of us are living now.

January 1989

INTERNATIONAL EPISODE

The international art caravan unpacked its tents in Pittsburgh for a couple of days last November. Jet-lagged and bleary-eyed curators, dealers, artists, collectors, and critics from the United States and Europe toured the 1988 Carnegie International, a gathering of one hundred works by thirty-nine artists, which was presented in a stately progression of galleries at the Carnegie Museum of Art. The spaces for temporary exhibitions at the Carnegie, opened in 1974, are light-filled and lavishly scaled. Though not everything in the show was especially big, the many large-sized works by Julian Schnabel, Anselm Kiefer, Jannis Kounellis, Meyer Vaisman, and others didn't look hemmed in, the way they often do in New York. In fact, some of the largest exhibits were eaten up by the space. Wolfgang Laib's stucco building lined in fragrant beeswax looked becalmed—like a Quonset hut somebody had parked there by mistake. And smaller things—the Joel Shapiro sculptures, for instance—looked ill at ease. Shapiro's semi-abstract figures might have been on the verge of an acute case of agoraphobia.

The Carnegie International was a show that pretty much kept to the sort of work any assiduous visitor to New York's galleries would already know. (Thirteen artists included in the 1988 show were also featured in 1985, the last installment of what is now a triennial event.) Yet I was surprised, stopping to talk to people in the galleries, at how many New Yorkers had come in search of fresh impressions. Some art-world insiders are flying in to see these big group shows because they expect the curators to do the work of filtering and weighing the con-temporary scene for them. And when a new name appears—the newest one in Pittsburgh seemed to be that of Anna and Bernhard Blume, a

pair of fifty-one-year-old German artists who work with photographs—they put a little mark in their notebooks and go home feeling that their horizons have been expanded.

In the catalogue, critic Thomas McEvilley, no stranger to the international show circuit, hits the nail right on the head when he compares these exhibitions to "primitive rites or feudal religious festivals." "Large groups of humans," he explains, "gather to perform a bonding rite in the presence of art works which symbolically define and ratify the characteristics of the group." After a day spent viewing the show, everybody took a seat alongside Pittsburgh society in the gold and marble splendor of the foyer of the Carnegie Music Hall for a black-tie dinner. Six hundred and fifty people were at dinner, including more than half of the artists in the show. Wolfgang Laib was among a number of artists who dissented from formal dress. A student of Eastern religions who sports a monkishly shorn head, Laib appeared in a waist-length jacket of what looked like matted orange terry cloth. Julian Schnabel, outfitted in a big splendid waistcoat and cravat, with his young daughter in tow, had a seat in the balcony, a balcony out of some Tiepolo fantasy of a Venetian costume ball.

While the jury was closeted in the afternoon, picking a prizewinner, an important dealer went through the galleries grumbling to anyone who would listen about how poorly her artist's work was being displayed. She got the work moved before nightfall. Many kinds of power were being wielded, including the power of language. At a press luncheon, the curator of the exhibition, John Caldwell, emphasized the predominance of German artists in the show (nearly a third) and offered, perhaps by way of explanation, the stunning remark that "the German rubble is our rubble, too." As the day went on, leitmotifs reappeared, the rubble being right there in the centerpieces on the tables at dinner, in the form of little decorative heaps of shattered windshield glass.

The complaints one heard at dinner about the tough lamb chops and the soggy tart crusts were complaints about a rite that (to go back to McEvilley's description) could have been better performed. But they also reflected something else—a general sense among the visitors that Pittsburgh could never repay them enough for having come. True, Pittsburgh had on its side the historic allure of a show that included among its First Prize winners Picasso and among its judges Matisse; but the visitors had on their side the cachet of the moment, they control

the names that make the art market hot. At dinner, many found them-
selves seated next to "the others"—and how could an art-world celeb
and a wealthy local industrialist or lawyer possibly ever bridge the gap?
Incomprehension is a law of such encounters; hostility, too.

It was a week before the presidential election. When Henry Hillman
got up to make some remarks—he'd paid for the dinner, and his business,
the Hillman Company, was the major corporate sponsor—he said some-
thing to the effect that his wife would be up in the galleries after dinner
pressing George Bush buttons on everyone. This comment was met
with a storm of applause (mostly, one assumes, from the locals), out of
which, a few moments later, rose a chorus of boos (mostly, one assumes,
from the art-world visitors). A New York editor who booed was told
by her Pittsburgh dinner partner that he'd never encountered such bad
manners. But what about the manners of Mr. Hillman? He had brought
up the whole thing in the first place and then went on to joke that those
who'd booed would find a bill for dinner at their places. Then again,
one could imagine reasons why Mr. Hillman might have been feeling
a bit hostile toward some of the assembled guests, after he'd spent the
day sitting, as a Carnegie trustee, on a jury that had ended up by giving
the big prize to an artist who, one felt fairly certain, would look to him
like a "rad." (Mr. Hillman, someone hastened to assure all of us in the
minivan on the way back to the hotel, was the nicest—and most apol-
itical—guy in Pittsburgh.)

During dessert there was a roll call of the participating artists, and
those seated up in the balcony definitely had a theatrical advantage when
it came their turn to take a bow. After that, it was time for the awarding
of the Carnegie Prize, which went to Rebecca Horn, a forty-four-year-
old German conceptual artist whose entry, an installation called *The
Hydra-Forest/performing: Oscar Wilde*, memorialized Wilde with some ear-
splitting sound effects and fairly dangerous-looking bursts of spark. By
the time Horn took the podium to accept—she's the first woman to win
the prize since 1899, when it went to the American portrait painter
Cecilia Beaux—the hour was late, and people were eager to move on.
After midnight, there were impromptu parties in some of the downtown
hotels.

The Carnegie International is the second oldest international show
in the world, founded in 1896, a year after the Venice Biennale. And

if there are few people at least on this side of the Atlantic who would take a trip to Pittsburgh over a trip to Venice, the International, carrying on amid the dramatic ravines and now picturesque industrial architecture of Rustbelt, U.S.A., has a far from inconsiderable place in the history of the reception of modern art.

Some art lovers still speak fondly of Gordon Bailey Washburn, the director of the Carnegie after World War II, who made one of what were perennial efforts to bring the International in line with sophisticated national and international taste. Washburn in Pittsburgh—a patrician with a twinkle in his handsome eyes—was, like the trendier "Chick" Austin at the Wadsworth Atheneum in Hartford, Connecticut, one of those elegant men of taste who somehow managed to deal with the boards and the hordes. Washburn must have been a proselytizer, a persuader. A well-mannered and charismatic persuader—no other kind survives in places like Pittsburgh. In the catalogue of the 1955 International he wrote of visiting artists in "their poor roof-top studios," where "many artists and their families live within a borderland of insecurity." "Could more of us visit them," he told his Pittsburgh public, "fewer exhibition visitors would be inclined to question their seriousness or their probity."

But if good things have happened at the International over the past ninety-plus years, the triumphant moments have always been intermingled with less glorious periods. Like all the institutions devoted to the exhibition of new art, the International must be judged by the extent to which its official selections jibe with some standard of excellence that we discover beyond officialdom. (The true measure of value is always one that is evolving among artists and the small groups of collectors, dealers, and writers who are closely aligned with the taste of the artists.) By this test, the record of the Carnegie International—like the record of the French Salons and the Venice Biennales—is far from superb without being absolutely atrocious. What we have is an essentially stolid taste that from time to time has made certain adjustments in response to the forces of excellence and the forces of the new. (The two aren't always the same.)

As the chroniclers of Pittsburgh history always like to point out, for a provincial American city Pittsburgh has done pretty well. True, the International never showed Mondrian or Gris; and Klee and Kan-

dinsky each appeared only once, in 1939. But by the twenties Matisse, Braque, and Picasso were featured on a fairly regular basis. That was, of course, late; but an argument can be made that World War I, which interrupted the shows for six years, slowed the process of assimilation. On the other hand, when the School of Paris was shown, it was in its "antiabstract" phase. Picasso won First Prize in 1930 with an Ingresque portrait of Olga; Braque's *Yellow Cloth*, which won First Prize in 1937, was regarded as a rather daring choice. In short, the argument goes back and forth, and the bottom line is always that we judge the International's taste by some noninstitutional standard that we all agree is more important.

The real question, then, is why one should support shows such as the Carnegie International that everyone agrees have a hit-or-miss relation to quality. The strong argument for support is that, from time to time, such shows can have a positive effect on the public, by bringing better rather than worse examples of contemporary art into the limelight. Still, I think everyone who came to Pittsburgh for the International would have agreed that the top priority here wasn't an adventure in aesthetic experience but a summary of recent trends. Rather than expanding the number of artists or styles included to reflect the expanding number of artists currently at work, the International has in recent years become increasingly restrictive, so that it now deals with only a tiny group of artists who happen to exhibit at certain top-of-the-line galleries and receive a great deal of publicity. In 1955, three hundred and twenty-eight artists exhibited; in 1988, we're down to thirty-nine. As the art scene has become a jet-set scene, its horizons appear to have dropped. In the 1920s, when Charlotte Weidler was the International's German representative, she brought to Pittsburgh work by artists who were little known in America, such as Kirchner, Pechstein, Munch, and Nolde. Fifty years later, could we have expected a fresh view of Europe from Saskia Bos, the woman who runs De Appel cultural center in Amsterdam and advised the 1985 International on what critical writings and artists' statements should represent Europe in the catalogue? Considering that what you see at De Appel looks a lot like what you see at P.S. 1 in New York, wasn't it fair to assume that the writings Bos would deem worthy of export from the Netherlands and the rest of Europe would tell us little that we didn't already know?

In the antiauthoritarian seventies shows such as the International were tinkered with almost to the point of extinction. But in the eighties we've seen an upsurge of interest in exactly this kind of institutionally sanctioned art event. The authority—and relative homogeneity—of such shows becomes a hedge against the runaway eclecticism of the scene. In this context, the pomp and circumstance really matters: it's a form of institutional self-validation. Nothing highlights this new hunger for authoritative gestures so much as the revival of the Carnegie Prize, which was abolished in 1970 and reinstated only in 1985, when it was split between Anselm Kiefer (a painter who's nostalgic for older forms of order) and Richard Serra (a sculptor who insists in any public forum available that the public doesn't know what it really wants or needs). The renewal of the Carnegie International and the Carnegie Prize are last-ditch exercises in the legitimization of institutional authority.

Curator John Caldwell went straight to the question of authority when he gave a room of their own to Joseph Beuys and Andy Warhol, two putative father figures who'd died since the 1985 International. Situated at the end of the first suite of galleries, Beuys's stone floor piece, called *The End of the Twentieth Century*, was some sort of essentialist statement—rock as the alpha and the omega. Meanwhile, the quartet of late Warhol self-portraits—Andy as a ghoul in a white fright wig— offered a last, rather Holy Ghostish view of the original postmodern cynic. Each generation likes to pay its own form of respect to the dead. Still, there has to be considerable strain involved in turning these particular artists into kingpins in the line of succession of late-twentieth-century art: Beuys's and Warhol's entire careers were based on the idea of debunking artistic succession.

If Beuys and Warhol were obsessed with their authority—and they were—it was only in the sense that each wanted to insure that his own brand of ahistoricism would prevail. Yet here they were, not presented as artistic eccentrics or as voices of dissent, but as the lawgivers. If this is a paradox, it's one that the postmodern theorists will iron out lickety-split. When bad boys such as Beuys and Warhol become figures of authority, it gives renewed authority to a generation that once defined itself through a spirit of protest but is now for the most part eager to put on traditional formal dress. What no one should underestimate is how important the legitimization—and institutionalization—of Joseph

Beuys and Andy Warhol is to the part of the art world that believes in events such as the Carnegie International. The trendies believe in a mainstream, in lawgivers. Only, the lawgivers they believe in lay down a law of lawlessness.

If the people at the Carnegie had asked me how to honor the dead, I would have told them to hang some work by Jean Hélion, a painter who died a year ago and who has had a profound impact on much of the contemporary art I care the most about—works by artists in their thirties, forties, fifties, and sixties. But in all honesty I don't think I'd want to present anything as a response to John Caldwell's choice of Beuys and Warhol. Having seen all the disasters that have been brought down upon art in recent decades by one or another concept of artistic succession, I think it best to reject any such concept of succession. Each artist makes sense of the past in his or her own way; an original artist invents a lineage of his or her own. Sometimes it's healthy to break up the familiar lines of succession and perhaps say that Redon (never shown in Pittsburgh) is more essential than Monet, or that Earl Kerkam is more essential than Willem de Kooning. To hell with the canons—with John Caldwell's, and with anybody else's, too.

In 1898, Camille Pissarro was invited to be a member of the jury of the Carnegie International. We know his thoughts on the matter from a letter to his son Lucien. "My dear Lucien," he wrote, "I am sending two paintings to America, to the exhibition in Pittsburgh. I was invited by the director, a charming man. He also invited me to be a member of this year's jury, with travelling expenses paid both ways, and for the best hotels, by the Pittsburgh Museum. I would stay for fifteen days. Naturally I declined, out of principle." What were those "principles"? No doubt they had something to do with an absolute rejection of the jury systems that had, by the 1880s, turned the French Salons into showplaces for mediocrity. We live at a moment when the institutions have failed the real—the really serious—artists as grievously as they had in Pissarro's time, a hundred years ago. And yet how few, now as then, would follow Pissarro's example and decline "out of principle."

January 1989

MASTER COURBET

In a letter written to a friend in 1850, Gustave Courbet announced that "in our so very civilized society it is necessary for me to live the life of a savage. I must be free even of governments. The people have my sympathies, I must address myself to them directly." These words shed considerable light on Courbet's art—and not just because Courbet's subjects aren't always the predictable, socially acceptable ones. There's something direct and even savage (if by that we mean unconventional) in the way Courbet attacks the canvas: in the way he sponges or scrapes the paint, juxtaposes areas that are more or less realistically handled, and frames or arranges figures and objects in unexpected ways.

The risk factor in Courbet's work is, aesthetically speaking, very high. And the high-wire excitement of all those risks being taken all at once was a part—a big part—of what held us in the Courbet retrospective that was at the Brooklyn Museum earlier this winter. It was exciting to try to figure out how Courbet achieved some of his effects—how he worked the paint to get those textures of water or snow; how he orchestrated his colors to create those mysteriously beautiful flesh tones or those lowering gray-day-at-the-beach skies. And what pulled us deeper and deeper into the work was the extent to which, more times than we would imagine, the gambles panned out, and the crazy paint handling, the odd perspectives, the idiosyncratic color combinations coalesced into masterpiece-level paintings. There were many, many points in the show where Courbet seemed to be telling us, "To hell with convention." Still, the Brooklyn retrospective was one of the most totally civilized art experiences that we've had in New York in a very long time. Courbet challenges—and defies—our expectations; but he

does so in the name of preservation and continuation. The approach to painting is radical; but—in the sense that Courbet is trying to find new ways to attain the heights he recognizes in Rembrandt and Chardin—it's conservative, too.

First honors must go to Robert Buck, the director of the Brooklyn Museum since 1983, who set the planning for the show in motion. Organized by art historians Linda Nochlin and Sarah Faunce, this is the only major survey of Courbet's work to be seen in this country in nearly thirty years. The Brooklyn Museum has always had great collections; it now reclaims its place as one of the major centers of art activity in New York City. Eighty-seven paintings and twelve drawings in five light-filled, gently colored galleries made for a dream-perfect experience. (True, the video show shouldn't have been stuck in the second gallery in the midst of the paintings; but after the bread and circuses that we've been put through in recent years, this hardly gave offense.) The main point was that viewing conditions were optimal. While I'm told that there were big crowds on weekends, when I went on a Friday morning there were less than fifty people in the show. This may not have been good news for IBM, the major corporate sponsor, but for the rest of us it made the difference between going to an art show and going to a freak show. (Up at the Metropolitan Museum, having a ticket to Degas on a Friday morning was like having a ticket to Armageddon.)

In Brooklyn, Courbet's paintings were hung intelligently, in thematic groupings that extended their meanings. Despite regrettable absences, there was a sense that the works had been chosen in order to illuminate one another. There was no overkill—there was just enough to take in during a reasonably long visit. This was a show to put alongside the Chardin retrospective held at the Boston Museum of Fine Arts in 1979 and the Watteau retrospective held at the National Gallery in Washington in 1984. Taken together, these shows form a triumvirate that presents French easel painting in all its unbeatable glory. In French painting, paint *is* emotion, the manipulation of materials *is* the expression of feelings. Sitting on the bench in the last gallery of the Courbet retrospective, surrounded by the tragic *Self-portrait at Ste.-Pélagie* (c. 1872), in which Courbet shows himself in prison following his involvement with the Commune of 1871; by a host of nudes, including the

famous study of lesbians, *The Sleepers* (1866); and by the still lifes of apples, which look back to Chardin and forward to Cézanne—surrounded by all of this a museum-goer felt happily overwhelmed, but also happily clear in the head.

Because of the impossibility of obtaining the loan of certain major paintings that are in France, the Brooklyn show couldn't give a particularly clear picture of the days in the early 1850s when Courbet, who was in his early thirties (his dates are 1819–1877), was making his most audacious assaults on conventional taste. Without the two oversized compositions of the 1850s, *The Burial at Ornans* (1850) and *The Painter's Studio* (1855), and some of the studies of peasant life, *The Stone Breakers* (1850) and *The Peasants of Flagey Returning from the Fair* (1850–55), Courbet was made to appear a more private personality than he obviously actually was. And yet the very absence of *The Burial at Ornans* and *The Painter's Studio* had the effect of highlighting what many of us already believed, which is that Courbet's greatness is not really based on a few large, invented figure compositions but on the high level of originality that he brought to a wide range of subjects, generally treated in easel-painting sizes.

The Burial at Ornans isn't really top-notch Courbet; the downbeat mood of the story is carried over too much into a pictorial dullness—that dark frieze of figures just goes on and on, uninteresting, uneventful. And while *The Studio* is, area by area, a succession of little masterpieces, it never really adds up to a masterful whole. (Linda Nochlin points out in her catalogue essay that *The Studio* is unfinished.) In the context of the galleries of the Louvre, where *The Burial* and *The Studio* hung before their transfer to the Musée d'Orsay, it was quite clear that Delacroix, not Courbet, was the final artist to feel at ease when working on a monumental scale. Tackling a ten- or fifteen-foot canvas in *The Death of Sardanapalus* (1827) and *The Massacre at Chios* (1823), Delacroix is totally in control—his arabesques and twisting rhythms expand to fill the space. Courbet's grasp of composition is more episodic and eccentric; his finest paintings have an effect of strangeness and surprise that's probably irreconcilable with the idea of the wall-sized masterpiece.

Courbet painted landscapes, portraits, nudes, and still lifes off and on all through his life. And from the very start of the show, where we see a wall of youthful self-portraits, to the very end, where we see the

paintings of heaps of apples, he manages to give each subject a unique, freestanding value. Even when he's working on various versions of a single motif—as in the seascapes—he avoids formulaic solutions. He certainly never expects the kinds of techniques or structural ideas that work in a seascape to work in a landscape or a still life. He puts us in touch with the strangely awkward beauty of the landscape where he grew up—the Jura plateau in eastern France, through which the Doubs River winds, creating dramatic gorges and waterfalls. And he brings an equally deep but different sensitivity to the misty immensities of the Atlantic Ocean, which he visited as a tourist. Everywhere, one feels his supreme sense of scale, how the relation of tiny boats to enormous cloud formations in the seascapes is every bit as exact and poetically right as the relation of trees, towns, and rock formations in the paintings of the Jura plateau. Courbet responds as completely to the frozen loneliness of an animal foraging in winter—in *The Snowy Landscape with Boar* (1866–67)—as he does to the little fishing boats at the Cliffs of Etretat, just after a storm.

In a sense, Courbet is a promiscuous artist: he likes to imagine himself in the landscape of childhood, or in the hostile world of winter, or at the seashore. And this promiscuity jibes with the largeness of the personality that we know from the history books—of the man who got involved and messed up in political developments around the Commune, and who made dramatic gestures, as when, in anger over the rejection of some paintings from the Universal Exposition of 1855, he opened his own pavilion. But what the public histories don't really tell us is the extent to which the man could be authentic in different situations. That's what the paintings tell us. The bravado of the paint handling resolves into a perfect transparency of expression.

Courbet's sympathy shines forth in his portraits. Take, for example, the portraits of two brothers, the Nodlers, that Courbet painted in 1865. Courbet met the Nodlers—who were, apparently, in their twenties—at Trouville, a seaside resort on the English Channel where he'd gone in search of clients. These two young men are paragons of self-assurance—and of Second Empire elegance—and Courbet zeros in on their similarities and their dissimilarities. (It's the sort of union of social and psychological insight one expects from Ingres.) The older brother is a bit restrained and conservative looking, what with his neat,

shortish hair and quiet brown clothes. Courbet paints him in front of the ocean; and the pale tones of the beach, water, and sky give a moderate, pleasingly serene mood to the portrait of a man who seems to fit easily into the wide world. The younger brother, no less confident, is a flashier type—as Rae Becker says in the exhibition catalogue, he's a "young bourgeois with romantic yearnings." Courbet sets his more dramatic getup (a big red tie, a cape over one shoulder) against a deep green, this-could-be-anywhere backdrop. With a bold look in his dark eyes and his carefully unruly hair falling around his face, this younger M. Nodler looks like our contemporary—a guy standing at the espresso bar in the new Dean & DeLuca on the corner of Broadway and Prince. Courbet shows these brothers as they are—but what a presentation it is, in which the little details all build and add up to two discrete personalities. We see these men in their social milieu, and we understand the extent to which their individuality is defined by that milieu. Courbet has no axe to grind; he just wants to tell us who the Nodlers are.

Readers who haven't yet heard about the catalogue of the Courbet show ought to know that a good deal of controversy has been kicked off by a pair of essays by Linda Nochlin and Michael Fried that focus on Courbet's relations with women. This is the first time that the kind of gender studies now popular in the universities has dominated the text of a major museum catalogue; and a lot of people in art-historical and art-critical circles—including many feminists—are dismayed and have been throwing the catalogue down with cries of "Enough!"

In a long study of *The Painter's Studio*, Nochlin opposes what she calls "the 'normal' voice and position of the art historian" with what she calls "reading as a woman" and then arrives at a sort of fantasy version of *The Studio*, in which the nineteenth-century animal painter Rosa Bonheur has taken Courbet's place and "Courbet, nude, or rather partly draped, stands modestly behind her." Michael Fried follows this with an essay called "Courbet's 'Femininity.' " Courbet, Fried argues, didn't exactly look on women as strange, alien creatures; in fact, Courbet established a sympathetic complicity with women—thus his "feminine" side. Both Nochlin and Fried are at the top of their profession, and their essays are by no means lightweight stuff. When Nochlin marshals texts from Walter Benjamin and Fredric Jameson, she does it with the

kind of intellectual panache that earns people the top professorships at the top universities. Nochlin and Fried are capable of getting excited about paintings—both have written distinguished criticism of contemporary art; they describe with an immediacy that can't be faked. Some of Nochlin's catalogue entries—particularly the one for *Dressing the Dead Girl* (c. 1850)—are lucid and elegant; she tells us everything that we want to know. And so when she comes out with something as banal as the statement that Courbet in *The Painter's Studio* is "unequivocally male, unambiguously active," while the model standing behind him is "equally unambiguously female, and passive," you wonder what's gotten into her. Likewise, when Fried goes on and on about Courbet's sympathy for women, you wonder why he doesn't discuss Courbet's sympathy for his other subjects—for trees, wild animals, and men, too. In both of these essays there's a point where the intellectual playfulness is interesting, engaging; and then there's a point beyond that, where the postmodern theories and the scholarly flourishes only make a muddle. By dividing her essay into virtually freestanding parts, Nochlin acknowledges that her ideas don't really coalesce. She won't—and, I expect, can't—give up her passion for Courbet's art. And yet, when she looks back at the nineteenth century she's horrified by how circumscribed a role women had in social and intellectual life, by how men lorded it over them. She's right to love Courbet; and she's also right not to love the situation of women in the nineteenth century. It's a past many women understandably want no part of. (It's difficult to imagine any woman artist feeling nostalgic for the nineteenth century.) But what has this got to do with Courbet?

What is sure is that we have Courbet's paintings and that the paintings of women—of women in various stages of undress, and of women asleep—speak to us with as much urgency as any works of the nineteenth century. (Nochlin wouldn't be writing about them if they didn't speak to her.) Courbet's paintings of women disturb us in ways and to degrees unknown in Ingres, Delacroix, Corot, and Renoir. Even Manet, who shared Courbet's power to create imagery that shocked his contemporaries, can't shock us anymore, because he lacks Courbet's imaginative gifts, Courbet's ability to realize his ideas. There's always something brilliantly, unforgettably awry in Courbet's paintings of women. In *The Young Ladies on the Banks of the Seine* (1856–57) it's the gesture of the

woman in the foreground—the arms circling the head, the hands half open, unused, helpless—which makes her look like an awkward heap, a broken doll. In *The Sleepers* what holds us is the harshly clinical yet beautiful whiteness, and the sharp-focus attention that Courbet gives to every twist and turn of flesh. And then there are all of those cascades of women's hair—red, black, blond—that comprise a fetishist's capriccios, each different, each brilliant. And then there is the painting that has never been shown in public before, Courbet's close-up view between a woman's legs, *The Origin of the World* (1866). It's a shocker; but it's also a painting, a *real* painting. Even here, we feel that Courbet wants to take the subject seriously, to compose the elements. Courbet's paintings of women aren't acts perpetrated upon women; they're informed by all the freedom from open-and-shut motivations that the artistic endeavor implies. And the more dangerous and difficult the subject, the higher Courbet seems to go. *The Sleepers* is among the most eerily decadent images in Western art; but the harmonies of whites and tans and pale mauves, set against the dreamlike Prussian blue of the wallpaper, purify the decadence by giving an exact value to untoward tastes.

The title of the Brooklyn show was "Courbet Reconsidered"—as if appreciating Courbet were a two-step process, consideration and reconsideration. Some of the reconsideration in the catalogue was outstanding, especially Petra Ten-Doesschate Chu's essay on the landscapes, in which Courbet's fascination with the Jura plateau is revealed in all its richness of aspects—scientific, historic, sentimental. And while one may reject Nochlin's catalogue essay, it's important to remember that she did, together with Sarah Faunce, organize a great show. Still, the direction of Nochlin's thinking these days—and she is a bellwether of where art history is going—is toward increasingly forced forms of reconsideration. Thinking about Courbet is really a perpetual and unpredictable process, one that began when the artist first exhibited one of his canvases and will end only when there's no one left to look at the paintings. These paintings probably have more meanings than we'll ever be able to unlock. Just when we think we've grasped the one essential meaning, Courbet pulls the rug out from under us, and we're swept up, higher and higher, to a place beyond meaning.

February 1989

AUTUMN ALPHABET

Avigdor Arikha. There were a couple of richly evocative interiors in Avigdor Arikha's show at the Marlborough Gallery last October. They were works in which this Israeli artist (who's a longtime resident of Paris) turns his attention to the casual jumble of posters and reproductions that covers a wall of his atelier, a wall near a staircase that ascends to one of those typically Parisian balconies. Arikha doesn't give us a tightly realistic rendering of this wall full of printed matter; he draws everything with feathery strokes of the brush or pastel stick, so that we can make out some of the reproductions, but vaguely—a Poussin, for instance, or the edge of a poster for one of Arikha's own shows. The effect is of an assortment of images caught quickly yet concisely, the way you catch sight of things when you walk into your own home. *Up to the Loggia* (a pastel) and *Studio Wall* (an oil) are in tones of gray and brown and tan; they bring to mind the intimism of the turn-of-the-century English painter Walter Sickert. Arikha makes the sleepy Parisian studio look like the nicest place on earth, a snug retreat where models doze, interesting books sit in mild disorder on the shelves, and the pleasures of Europe are just beyond the tall, old-fashioned windows any time the artist wants to take a break. These studio views give us a peek into the pleasantly bohemian mores of the international art-and-literature set.

Though Arikha's paintings and pastels are all done directly from life, *Up to the Loggia* and *Studio Wall* are the only couple of his works that have ever struck me as being emotionally direct. Arikha, who writes occasionally for the *New York Review of Books* and other publications, is here being direct about his intellectuality; the Poussin poster recalls a show devoted to Poussin's *Rape of the Sabines* for which Arikha wrote a

catalogue in 1979. These are quiet, unprepossessing pictures—they don't carry you very far. But on their own anecdotal terms they're infinitely more successful than the Arikha paintings that aim to be deep, to show us a man's uncomfortable, Beckettish relations with the world. What grabs viewers in most of Arikha's works, including most of the work in this Marlborough show, is the peculiar mix of coziness and alienation. The coziness is in the swift brush and pastel strokes that Arikha uses to paint his unexceptional still-life objects, his models in rumpled clothes, his nudes with pale flesh and dark hair. The alienation is in the coldly formal compositions that isolate bizarrely cropped figures and objects against expanses of white wall. Arikha's equation of coziness and alienation never really computes. His compositions are unresolved (and often appear unresolvable): this is his (rather obvious) statement about how we're living now.

In a note for the catalogue of the show at Marlborough, Arikha defines his position as a realist by attacking the idea of "schemata" in art—that is, norms of representation. He speaks somewhat disparagingly of those, "like Gian-Pietro Bellori in the seventeenth century or Wilhelm Worringer in the twentieth, [who] believed in fixed rules preceding qualitative judgment. Did it occur to their followers that true art takes the pulse of its epoch at its inception and has a chance of remaining 'modern' to future generations when drawn from life, not from precept?" Arikha says he believes in direct perception. This *is* an intellectual position, only Arikha's paintings don't really bear it out. First: the way Arikha isolates objects and flattens them out close to the surface is a modernist schemata if ever there was one. Second: exactly what he fails to show us is what we perceive directly, such as the particular color and texture of an object. Arikha's peppers, onions, books, and clothing are all painted the same. He doesn't make (or even attempt to make) the variety of the world convincing in pictorial terms. Rather than giving himself over to nature, Arikha imposes an idea upon nature. This would be okay, except that Arikha claims not to impose. Immodesty in the guise of modesty is a very dangerous thing. In those pictures of the studio wall Arikha *is* a modest artist, telling us quiet little anecdotes about his life, and his work takes on a new interest and liveliness.

———

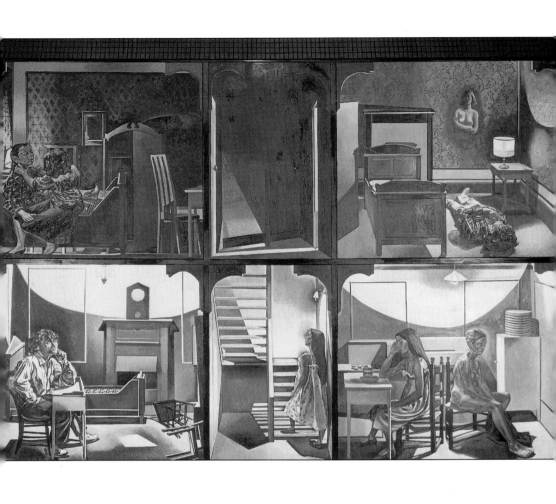

Gabriel Laderman, *The House of Death and Life*, 1984–85, oil on canvas, 93″ x 135″. Courtesy Robert Schoelkopf Gallery, New York.

Carroll Dunham, *Migration*, 1985–86, mixed media on wood veneer on panel, 85″ x 47″.
Courtesy Sonnabend Gallery, New York. (Photo: Pelka/Noble)

Nicolas Moufarrege, *Music*, 1985, thread and pigment on needlepoint canvas, 40″ x 51″. Courtesy Institute for Contemporary Art, New York. (Photo: Nicholas Walster)

Gretna Campbell, *Wild Wheat Field*, 1982, oil on canvas, 66″ x 73″. Courtesy the estate of the artist. (Photo: eeva-inkeri)

Barbara Goodstein, *Resurrection (1)*, 1987, plaster on board, 24″ x 33½″. Private collection, New York.

Richard Chiriani, *View from the Brooklyn Bridge*, 1987, gouache on paper, 46″ x 82″. Courtesy Robert Schoelkopf Gallery, New York.

Temma Bell, *Keith's Pumpkins*, 1987, oil on canvas, 37″ x 53″. Courtesy Bowery Gallery, New York.

David La Chapelle, *Nativity* (central panel of three), 1987, cibachrome, 58″ x 48″. Courtesy the artist.

Leon Kossoff, *Booking Hall, Kilburn*, 1987, oil on board, 78″ x 72″. Courtesy Robert Miller Gallery, New York. (Photo: Zindman/Fremont)

Faith Ringgold, *The Bitter Nest Part II: Harlem Renaissance Party*, 1988, acrylic on canvas, painted, tie-dyed, and pieced fabric, 94″ x 82″. Courtesy Bernice Steinbaum Gallery, New York.

Louisa Matthiasdottir, *Squash with Blue Cloth*, 1987, oil on canvas, 36″ x 62″. Courtesy Robert Schoelkopf Gallery, New York. (Photo: Adam Reich)

Trevor Winkfield, *Banishing Bricks and Pills,* 1987, acrylic on canvas, $30\frac{1}{4}''$ x 49″. Courtesy Edward Thorp Gallery, New York. (Photo: Dorothy Zeidman)

Joan Mitchell, *South*, 1989, oil on canvas, $102\frac{1}{2}''$ x $157\frac{1}{2}''$. Courtesy Robert Miller Gallery, New York. (Photo: Phillips/Schwab)

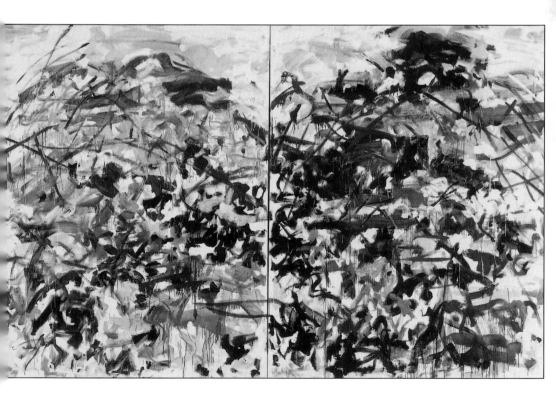

Shirley Jaffe, *West Point*, 1987–88, oil on canvas, 59″ x 51″. Collection Ileane and Bruce E. Thal. Courtesy Holly Solomon Gallery, New York. (Photo: Adam Reich)

Joan Snyder, *My Endangered Field*, 1989, mixed media on wood, $30\frac{1}{8}''$ x 72''. Courtesy Hirschl and Adler Modern, New York. (Photo: Steven Sloman)

Leland Bell, *Butterfly Group*, 1986–90, acrylic on canvas, 60″ x 106″. Courtesy Robert Schoelkopf Gallery, New York. (Photo: Adam Reich)

Bill Barrell. Grown-up artists who take their inspiration from children's drawings annoy us at least as often as they delight us. The representational shorthand that a child uses in a spirit of absolute sincerity can look thin and false in the adult's rehash, and as a sentimental view of childhood replaces the thing itself, the diabolism of the child's imagination gets lost, or bleached out. Paul Klee is the only artist who ever really topped the children; he gave a child's inspiration the depth and resonance of a grown-up's inspiration. Elsewhere, adults turn the child's ingenuousness into disingenuousness; or—maybe even worse—the ingenuousness is maintained but somehow trivialized. Crossing the mine field of the faux naïf, almost no artist comes out unscathed. Bill Barrell, who showed his paintings at Ingber in October, does better than most. The gentle whimsicality of his childish figures carries through into the gently ramshackle style of his semiabstract compositions.

In Barrell's most enjoyable compositions (*A Burst of Ideas* and *Heart Makers*) scrabbly caricature people are involved in cheerfully absurdist activities—making hearts, tossing off ideas (i.e., little bits of abstracted imagery). The pleasure of the work is in its scattershot inventiveness. Barrell uses conceits such as the blue-blob person in *Heart Makers* only once or twice and thereby avoids the predictability of much child-inspired art. One never knows what's going to turn up in these paintings: the amusing incidents in *A Burst of Ideas* include a blue handprint against a maroon backdrop and a ladder made of lines of blue, orange, and lime green. The little coloristic events can be very good (Barrell was a Hofmann student years ago). Sometimes, Barrell presents an American, Rube Goldberg–style version of Miró's chromatic elegance.

Barrell's paintings are best viewed from close up, so that his gaggle of abstract and representational forms overwhelms us and becomes our entire frame of reference. His paintings are like images seen in a kaleidoscope where abstract forms jostle representational ones, with each little fragmentary bit standing at an odd angle in relation to the next fragmentary bit. You enter these paintings the way you'd enter a funhouse—step by step, taking nothing for granted. Weakest are Barrell's attempts at resolving his compositions. The corners in *A Burst of Ideas*, for instance, where squarish forms are marshaled to stabilize the structure, end up looking contrived. Barrell's desire to give the paintings formal coherence sits uneasily with compositions that by their very

nature seem to elude coherence. At fifty-six, Barrell remains an inter-
estingly unresolved artist.

Barrell's flaky style will remind some viewers of the work of Jean-
Michel Basquiat, the artist whose death last summer of a drug overdose
set off a storm of end-of-the-eighties-art-world articles. Annina Nosei
(Basquiat's first dealer) had a memorial show in December. Basquiat—
who, like Barrell, looked at the paintings of Dubuffet and the Dutch
Cobra group—was far from being the worst artist of the 1980s. His
work, full of naively cartoonish characters, may actually be better com-
posed than Barrell's. Basquiat's figures, with their squarish heads and
bodies and angular gestures, fit neatly into the rectangle of the canvas.
But there's something dull about the very competence of Basquiat's
work; his juxtapositions of colors, his riffs, don't offer much surprise.
In a sense Barrell's work is less secure stylistically than Basquiat's, but
Barrell's lack of security is the source of his pictorial whimsy, his ability
to keep us amused.

There were a number of smaller paintings in Barrell's show that
took off on tangents—delightful tangents. One of the loveliest was *The
Green Cat*, a bluish painting in which the artist, standing at right, points
a long paintbrush toward a model, who stands with her back to him at
the left. Here Barrell is working out of Picasso's Artist and Model series
of the 1960s and achieving an original variation: Barrell's scrawled rem-
iniscences of Picasso. The nude is just a few smears of paint surrounded
by an outline; but the blue color here creates a palpably erotic atmo-
sphere. Barrell's work has been compared to Robert Beauchamp's and
George McNeil's. He's infinitely superior to Beauchamp, whose work
is always gross and overheated. What Barrell is doing now recalls the
excitement that George McNeil generated a decade and more ago with
the first of his cartoonish pictures. Only Barrell's work is gentler than
McNeil's. Barrell is a little like one of the goofy figures in his paintings—
an addled nudnik, trying this, trying that. He's like Charlie Chaplin in
the assembly-line scene from *Modern Times*—a man caught in the midst
of things that are bigger than he is.

————

Ross Bleckner. For the past few years Ross Bleckner has been working
on a series of deep blue and black paintings that memorialize victims of

the AIDS epidemic. And, as he has worked on this series, he has become a more substantial artist: Bleckner's imagery is more pointed now, more clearly inflected. The disembodied little white hands that reach out toward us from the gloom of many of the new paintings are *chilling*. The spectacle of a postmodern artist imagining his dead friends—or, as in the title of one painting, a *Friend of a Friend*—in a heavenly outer space is something you can't quite get out of your head. These paintings, which were at Mary Boone in October and November, seem to be the product of necessity. They feel authentic, and yet they illustrate a mystery rather than ever creating one. The shining lights floating toward us through the darkness are a deft, poetic idea; but the way Bleckner carries out the idea, with the points of light represented by blobs of white paint dabbed atop the surface, isn't visually compelling. There's nothing mysterious about Bleckner's technique.

The mood here is one of overcultivated fantasy—a *fin-de-siècle* mood. The lights that shimmer out from the gloom recall Gustave Moreau's jewel-box atmosphere. That connection may suggest a certain problem with Bleckner's work. Moreau, like Bleckner, is an artist whose effects are episodic and overly literary. Moreau's mood painting was to find its fulfillment in artists who made the medium itself magical—in Redon's dreamy pastels and the heavily impastoed oil paintings of Moreau's student Rouault. An artist who invokes Moreau today is invoking the weakest, most literary side of symbolism—a dusty symbolism. I expect this is part of Bleckner's idea; he wants to recall the brittle aestheticism of an earlier age, with its ghostly birds and icy diadems. But nostalgia is effective in painting only when an artist gives the old material a new shape. While Bleckner's paintings are dated 1987 and 1988, the dust seems to have settled over them a very long time ago.

———

Peggy Cyphers. Styles don't die, they just go underground for a while. That, at least, would seem to be a moral of the 1980s. Take biomorphic abstraction, a style that Clement Greenberg hoped to lay to rest more than forty years ago when he bemoaned a "return of elements of representation, smudged contour lines, and the third dimension. Images, no longer locked to the surface in a flat profile, reappear against indeterminate, atmospheric depths." He associated this painting with a "re-

turn to the human-all-too-human, too obvious emotion, and academic subterfuges." His review of a show called "A Problem for Critics," organized by Howard Putzel in 1945, still raises hackles among old-timers who like biomorphism. Now, biomorphism is back . . . and Greenberg still has a point, and his detractors still have a point, too. The time, indeed, has come to sharpen up some of the old arguments, because one problem with much of the new biomorphism is that the painters want to have it both ways: they want symbols, but they want pure form, too. Terry Winters, for one, dribbles biomorphic forms across Abstract Expressionist spaces and comes up with paintings that are tasteful and flavorless—biomorphism lite.

What I like about the work of the thirty-four-year-old painter Peggy Cyphers (who had a show at E. M. Donahue in October) is that it's unabashedly, one might almost say shamelessly, biomorphic. Cyphers does all the Greenberg no-nos (she even gives her show a literary title, "Biomorphic Impressionism") and comes up with something that's obvious but also poetic. Working on tall slender surfaces made of aluminum (the top quarter or so) and wood (the bottom three-quarters), she paints dreamily unfolding shell-like and snakelike and flowerlike forms that bring O'Keeffe and Baziotes to mind.

The gimmick in Cyphers's paintings is that each one consists of a sharply rendered part (the part painted on aluminum) that's reflected in a grainier, softer version (the part painted on wood). The lower section is like a romantic recollection of the original motif. Repeated in painting after painting in hues that encompass an entire rainbow of Kleenex-box pastels, Cyphers's unfolding images, with their faintly anthropomorphic configurations, are hypnotic. The dreamy precision of the shapes suggests an artist for whom painting is a form of meditation (as one suspects it was for O'Keeffe). The way the upper part of the painting is reflected and transformed in the lower part engages us, holds our attention as the patterns and variations in a Persian carpet sometimes will.

These paintings are eccentric sci-fi dreams. From the statements that Cyphers has made in the brochure for her show and in an interview in *Cover* magazine, I gather that she's into some half-crazy variety of sociobiology. "Nature," she writes, "in this present biological and chemically fractured society looms sinister in its altered and artificial state. Meanwhile we confront root nature as a precious holy specimen—reac-

quainting ourselves with the truth bearer of our being and conscious-
ness." Cyphers's paintings are illustrations of this nutty metaphysics.
It's the sort of stuff that drives the Clement Greenbergs of this world
to distraction—and, of course, they're right; but, well, only up to a
point.

———

Richard Diebenkorn. There were lovely moments in Richard Dieben-
korn's drawing retrospective at the Museum of Modern Art: a loopy,
casual charcoal drawing, *Seated Woman, Reaching Down* (1960); an ink
wash and charcoal drawing with velvety dark depths, *Seated Woman,
Tennis Sweater* (1960); a broad, horizontal abstraction full of mazy gray
lines, *Untitled (Ocean Park)* (1976); and another mazy abstraction, this
one vertical, from 1977. But mostly the work looked overrefined and
underdeveloped: Diebenkorn playing with the same predictable themes
in the same predictable ways. Over a forty-year career, Diebenkorn has
raised graphic delicacy to an aesthetic principle. What he calls the cre-
ative process, I'd call noodling around in the studio—self-indulgence.

The Modern show was organized by John Elderfield, who's divided
Diebenkorn's career into three phases: Early Abstract Period (1948–55);
Representational Period (1956–67); Ocean Park Period (1967–88). The
show was big, approximately 180 works, and clearly Elderfield believed
that Diebenkorn's work would look good in bulk. The first, and worst,
section surveyed Diebenkorn's unknowledgeable knockoffs of de
Kooning-type Abstract Expressionism. This kind of thing was a dime
a dozen in the fifties. You wouldn't think it would be that difficult to
understand what de Kooning did with Cubism; but Diebenkorn seems
unaware that the whole point is to compose *across* the surface, end to
end. Instead, he wanders aimlessly, inscribing the first zillion or so of
those pointlessly sensitive lines that are still wandering aimlessly through
his work thirty years later.

The level of the show does rise considerably when Diebenkorn turns
to drawing from life, mostly the female figure, in the late fifties. Nature
gives his work a sense of order. Real space is a set of coordinates that
can be related to the coordinates of the page. Reduction from a known
quantity works better for Diebenkorn than pure invention à la Abstract
Expressionism. (As an Abstract Expressionist, Diebenkorn was a naïf—

a provincial art school product.) Still, Diebenkorn never brings his women to life. For him the human figure is little more than an abstraction, a form from which to abstract. Diebenkorn's women are nobodies, and I expect he believes their blankness is inspired and justified by the blankness of some of Matisse's women.

Diebenkorn has taken an aspect of Matisse, his virtually abstract side, for the essence of Matisse. By overlooking the dialectical nature of the Frenchman's art—especially the dialectic between anatomy and abstraction—Diebenkorn misses the emotional force of Matisse's simplifications. At times, in the teens and in the charcoal drawings of the late 1930s and 1940s, Matisse does take the risk of anonymity; but his abstractions are based on a study of the emotional and erotic implications of anatomy. I believe that Pierre Schneider was correct when, in his book on Matisse, he explained the extreme simplifications in some portraits of Madame Matisse as attempts to turn a French housewife into an icon. Like the icon-makers of Christianity, Matisse is stripping away the veil of nature to reveal an essence—a human essence. Some of Matisse's later abstracted figures are erotic icons, sexual essences. Diebenkorn's simplifications work in reverse, against the figure, and thus distance us from exactly what might interest us. For Diebenkorn figure drawing isn't something that takes place between the artist and the model; it's something that takes place between the artist and the paper. This is academicized Matisse. What's lost is the life force. What's left are Matissean mannerisms, mostly the erased lines, which even Matisse himself at times overdid.

It's also from Matisse that Diebenkorn picked up the signals that sent him back into nonfigurative work in the late sixties. We're so used to considering Matisse's *Piano Lesson* and some other semiabstract paintings of the teens as seminal masterpieces that we tend to forget how very idiosyncratic they are. This is Matisse's personal version of Cubism—a version that gives Cubism a blunt and (considering the absence of Cubist chiaroscuro) almost naive power. Matisse doesn't break nature up, he pares it down. This is Cubism without Cubist theory; and let us not forget that by 1915 Cubism had become an orthodoxy among the avant-garde. I suspect that for Diebenkorn—who is an art-world outsider by virtue of being a California artist—the outsider aspect of Matisse's Cubism holds a considerable appeal. By working out of Ma-

tisse's nature abstraction, Diebenkorn believes he can become a seminal but unorthodox abstractionist.

The problem for Diebenkorn is that *The Piano Lesson* is one of those paintings in which Matisse constructed an endpoint—a point of reduction beyond which he was unwilling or unable to go. And Diebenkorn has taken this as his starting point. He's eliminated the boy and the piano and all the other realistic elements, but he hasn't gotten beyond them. He's just mooned over *The Piano Lesson* for twenty years, serving up an endless series of variations on those verticals and horizontals as well as on those orchestrations of gray and blue and green. *The Piano Lesson* isn't my favorite Matisse. I get a bit bored with Matisse's let's-see-how-little-we-can-make-do-with routine. But maybe it would look more interesting today if Diebenkorn hadn't been reprising it for so many years in his paintings and drawings. Diebenkorn carries reduction into illegibility.

I know that the generally attentive audiences at the Diebenkorn show didn't feel the way I did. I think I understand what they felt. Diebenkorn gives people something to look at. These are drawings that you can look at and say, "Now, why did he do that in that corner?" Or, "Why did he use that red there?" Diebenkorn is maneuvering compositional elements; that's about it. The translucent overlaps and smudged lines that many take for Diebenkorn's poetry look to me like a lot of fuss about very little. What *are* all those lines in the Ocean Park drawings? Where do they lead? Will Diebenkorn ever emerge from that gray-blue fog of his?

———

Paul Georges. Paul Georges—who's sixty-five—has never had a show that was all of a piece, logically consistent, or totally satisfying; he's probably never intended to. While his most assured works are generally landscapes, still lifes, or figures in which his virtuoso brushwork gives the world a clear yet lush beauty, his most ambitious works are often mythological fantasies in which America's youth fly through the air as if Tiepolo had met the Spirit of the Sixties. Georges's show in December at the Anne Plumb Gallery contained, as usual, both kinds of paintings; only for once everything seemed to be clicking, and the show elicited the kind of response Georges probably wants from us—a "Wow!"

The show was built around the chastity-and-death story of Diana and Actaeon, which is told by Ovid in the *Metamorphoses*. The hunter Actaeon accidentally comes upon Diana bathing with her nymphs; in revenge for his having seen the chaste Diana naked, the goddess turns Actaeon into a stag, and he's devoured by his own hounds. For a painter, part of the appeal of the story lies in the role silence plays: Diana says to Actaeon, who's on the verge of becoming a stag: "Now tell that you have seen me naked—provided you are able to tell." And he's unable to explain to his own hounds who he is. In the story the coldness of Diana contrasts with Actaeon's bloody end: "Not till he had died from his many wounds was the wrath of quiver-bearing Diana assuaged." A paperback copy of Ovid sat on the desk at Anne Plumb while the show was up. I felt that Georges's inspiration must also have come from Titian's paintings on the theme (*Diana Surprised by Actaeon* and *The Death of Actaeon*) and, perhaps, from the discussion and various illustrations of the theme in Erwin Panofsky's marvelous chapter on Ovid in his *Problems in Titian*.

Dry renderings of mythological themes have made fairly frequent appearances in the galleries in recent years, but dull pedantry has nothing to do with Georges. He recycles Ovid and Titian in his own haywire terms. His brushwork—loose, but at its best deftly descriptive—conveys a modern artist's giddy enthusiasm for the Venetians. Georges sees the myth as a conflict between deep greens (the forest where Diana bathes and Actaeon dies) and deep red (the color of Actaeon's blood, of his "many wounds"). In Georges's paintings, Actaeon is shown with a stag's head and a man's body—in the midst of the transformation, exactly where Titian shows him. Diana, however, isn't the sophisticated Mannerist beauty of Titian's compositions; she's more like a nubile adolescent. In *Diana and Actaeon—River/Sky* (79½" × 142¼"), Actaeon flees from Diana toward us and almost lunges out of the painting at us. Meanwhile, Diana stands off in the middle distance, a cheerful menace with a bow and arrow—a Nabokovish goddess. If there are unfinished or unresolved bits in the Actaeon figure, it is nevertheless the best painted of Georges's mythological subjects. The head and the arms of this half-stag–half-man are dashed in with brilliantly muscular strokes. The stag's head seems to shatter the picture plane. The larger *Red Diana and Actaeon* (153" × 137") sets the dying Actaeon in a beautiful broad green landscape based on the Norman countryside where Georges has

lived in recent years. Characteristically, he gives this landscape an eccentric twist, by letting the composition slough off at the edges, so that large swaths of red underpainting press into the green idyll.

Downstairs at Anne Plumb Gallery there were some smaller versions of the Diana and Actaeon theme, together with miscellaneous landscapes and a double portrait. Everywhere that high-keyed red-red kept reappearing: as the red floral border around a palm tree, as the dress and tricycle in a portrait of Georges's daughter and granddaughter. The palm tree painting and another landscape featuring a massive tree trunk were broadly treated, richly felt. The portrait of Georges's daughter and granddaughter is the best of his attempts at classical portraiture that I've seen: an orchestration of grays, with the red dress and red trike creating a powerful counterweight. This is Georges in a Velázquez mood—and it comes off amazingly well. The faces (which look like faces in a Derain) are convincing; the reds keep the old-fashioned grays from banality. And Georges himself makes a brilliant surprise appearance, in the form of an eerie self-portrait that hangs on the wall behind his progeny.

Georges has for years been a presence in New York as a teacher and proselytizer for figurative art. In some respects he's been a dangerous influence, leading young artists to paroxysms of ambitiousness that their meager technique can't support. With his gonzo painterly virtuosity, he may be one of those artists who turn their own disdain of the academic into a new kind of academy. Yet from the years when I first saw his paintings at the Green Mountain Gallery to the present there have been occasions when his extravagant conceits rang true. The Diana and Actaeon theme may be a reach for Georges, a healthy reach. For a male artist, Diana and Actaeon is a theme of self-exposure: man as the one who's vulnerable, changed, silenced, killed. Maybe a sense of danger is good for Georges—it gives an edge to his macho self-assurance. Certainly, he is closer to putting it all together here than he ever has been before. There are rhapsodically beautiful passages in the big *Red Diana and Actaeon*. The middle distance, with its rolling Norman hills and toylike church steeple, stopped me in my tracks.

———

Jean-Auguste-Dominique Ingres. "The Presence of Ingres," a study of Ingres's influence mounted at the Jan Krugier Gallery in November and

December, was a delight. (And the catalogue, a cache of pamphlets and reproductions tucked into a deep blue paper folder, was adorable.) Though works by Chassériau, Degas, and Balthus were included, the real subject here was the relationship between Ingres on the one hand and Matisse and Picasso on the other. Presented catty-corner were a large study in oil for Ingres's *Portrait of the Comtesse d'Haussonville* and an oil by Picasso of his wife Olga, from 1917, in which Olga's head, arms, and torso roughly duplicate the pose of the Ingres. Turning from the Ingres to the Picasso we saw Picasso underlining elements, extending implications. Picasso is fascinated by Ingres's sensuous curves and ripely sculptural modeling; he's also fascinated by the way the woman's sensual beauty is encased in the image of a conventional bourgeois. With Ingres, the eroticism of the image is held in check—not conventionalized, but restrained—by a recognition that conventions exist; and Picasso seems to be learning from this. So does Matisse, in *The Plumed Hat*, one of a series of drawings and paintings from 1919 in which the accoutrements of dress form a touchingly elegant frame for the model's quiet beauty. All in all, the show suggested the million ways in which the twin stars of Parisian modernism ransacked Ingres. To everything they took from him, they gave a personal, twentieth-century twist: what's flattened out in Ingres is flatter in Matisse and Picasso; what's erotic in Ingres can become virtually pornographic in these later artists. I think it was Virgil Thomson who called Stravinsky's *The Rake's Progress* supercharged Mozart; Matisse and Picasso do supercharged Ingres.

I was a bit disheartened by the mood at the Krugier show. People were so damned sober as they moved around the room, from gem to gem. To me, the show was a binge: Picasso and Matisse as two intoxicated geniuses, getting high on a genius who himself had an intoxicated side but wanted people to believe he was the epitome of responsibility—an academician. The show made one suspect that Picasso and Matisse knew Ingres's yearnings better than he knew them himself. But could they match the stubborn constancy of an artist who worked on certain portraits for decades? The show was a hymn to the elasticity of traditions, to the wonderful ways in which artists can commune with one another and yet remain themselves.

In the back room there was a Picasso etching of Olga from 1923 that was more Boldini than Ingres. It was about the decline and fall of

the society portrait, about how Ingres's brand of perfectionist portraiture fell into a decadence. Some will say that neither Picasso nor Matisse could ever pull off a masterpiece with the polished completeness of Ingres's *Comtesse d'Haussonville* in the Frick or *The Princesse de Broglie* in the Met. (A favorite New York game is arguing which is greater.) But Matisse and Picasso make up for their rough-and-tumble surfacey-ness with the Olympian reach of their imaginations.

————

Ronald Jones. Ronald Jones's installation at Metro Pictures in November was a cool horror show, a horror show you couldn't understand without reading the accompanying text.

In the center of Metro's large, broad space, Jones made a seven-foot pile of plywood sheets, all cut in the same odd, roughly rectangular shape, with curving sides and several indentations. The pile was accompanied by several smaller heaps that gave the effect of things toppling over onto the floor. Eight pieces of plywood, in the same shape, projected off the walls, each secured by four black pipes. These wall pieces were stained a reddish tone; and if you walked around to the back of them, you found, silk-screened there in black, a sort of German Expressionist woodcut of a scene of torture. I actually didn't go around to look at the backs of the panels until I'd read the handout that came with the show. This bore a sketch by Erich Mendelsohn of his Columbushaus, a large office building built in Berlin in 1932, and told a strange story about the convergence of modernist architecture and the Nazi police state. Once you'd looked at Mendelsohn's sketch, you realized that the shape of the plywood sheets was a section of Mendelsohn's building, and Jones's horror show started to have its effect.

In his text, Jones explains that

the Columbushaus was the last building of Erich Mendelsohn's German period. . . . Its functional modern design led the developers of Mendelsohn's building to present it in the image of the American metropolis, and in the same spirit, to name it the Columbushaus. F. W. Woolworth Company, the well-known American dimestore chain, leased the ground floor of the building in January of 1932. On January 31, 1933, the day after Adolf Hitler became Chancellor,

Erich Mendelsohn fled Germany, never to return. [One wonders
how long Woolworth remained in the Columbushaus. Jones doesn't
say.] The next month, impressed with Mendelsohn's free interiors
and hidden rear entrances, the German SS leased the top six floors
to house its Schutz Haft program (protective custody).

The long and the short of the story is that "the modern open floor plan
of the Columbushaus permitted the SS to design the space around the
particular requirements of detention and torture." The prison was closed
in 1936, when the space proved too small; as Jones concludes, "for three
years the SS Columbus prison had operated in total secrecy, hiding its
unspeakable purpose behind the crisp curving facade. During those
years, looking up from the hectic avenues converging onto the Potsdamer
Platz, the Columbushaus could only have been mistaken for the quin-
tessence of modern enterprise."

At a time when many left-wing artists and critics are eager to tell
us that art is incapable of transcending cultural pressures (the terms of
its production, as they say), this story makes a neat fit. Here we have
a Jewish modernist inadvertently designing Nazi torture chambers. The
history of the Columbushaus is ghastly, and bizarre. And Jones makes
his installation memorable through the iciness of his presentation. He
draws us in with an elegant exercise in postmodern Minimalism—and
then he turns the tables on us, telling us that this neat, clean installation
is really about the most appalling atrocities. The list of contemporary
artists who are using or abusing Nazi history gets longer by the minute.
Since I wrote about Kiefer in December, I've heard that Judy Chicago,
Louise Fishman, and Larry Rivers have done Holocaust works. Jones's
installation is one case of a reconsideration of Nazi crimes that's bathos-
free. This is a stunning anecdote cleanly told.

————

Leon Kossoff. The most interesting artist to reach these shores from
England in the 1980s is the sixty-two-year-old painter Leon Kossoff. In
his first New York show, at Hirschl & Adler Modern in 1983, and again
in his show at Robert Miller last November, we saw a realist who is
also an Expressionist, an artist who combines antiromantic subjects
(grimy urban streets, a crowded public swimming pool) and hyper-

romantic paint surfaces (surfaces that are as thick and rumpled as a stucco wall). Some people believe Kossoff's surfaces are an affectation and an obfuscation; they feel that the buildup of paint, which Kossoff sometimes finishes off with a drizzle of white skeins, leads us away from the subject, exhibits too much the agonies of the studio. I have no particular fondness for angst-ridden painting, but I don't find Kossoff's work angst-ridden. His morass of strokes is probably based on Constable's late manner—a morass that falls into place. When I step a few feet away from a Kossoff painting I don't find all the paint distracting. It turns into atmosphere—into a gray, rainy-yet-light-filled English day. Kossoff's screwy, agitated brushwork recalls that of Soutine, another Jewish Expressionist with a yearning for French clarity.

The subjects that Kossoff takes from public life are wonderfully original; they reveal an artist who's really in touch with our times. In the Hirschl & Adler show there were pictures of a public swimming pool full of children (each kid is drawn quickly, made into a lively individual), which gave us a glimpse of a gritty urban democracy we've never before seen in paint. In the Robert Miller show there was an interesting view of A Street in Willesden, with a pair of young lovers shambling along the sidewalk and a middle-aged man sitting on a bench, his head oddly cocked to one side, as if he were off dreaming in a world of his own. These scenes set in public places catch the curious randomness of life and suggest through their odd jumps in space and scale the labyrinthine complexity of our responses.

Kossoff has written about beginning work on a group of paintings of Christ Church, an eighteenth-century parish church designed by Nicholas Hawksmoor. "In the dusty sunlight of this August day, when this part of London still looks and feels like the London of Blake's Jerusalem, I find myself involved once again in making drawings and the idea of a painting begins to emerge. The urgency that drives me to work is not only to do with the pressures of the accumulation of memories and the unique quality of the subject on this particular day but also with the awareness that time is short, that soon the mass of this building will be dwarfed by more looming office blocks and overshadowed." One feels the artist's gathering excitement in the resulting paintings, which have a bluish-whitish brightness. The bulk of Christ Church looms out at us, a dramatic presence on an ordinary city street.

I'm less sympathetic to the paintings Kossoff does of studio sub-
jects—brick-red nudes and, in the new show, a series of paintings of a
middle-aged man named Chaim. These figures, handled in one or two
tones, are a little underdeveloped volumetrically. Still, the faces reveal
an interesting sense of personality and suggest the degree to which, for
Kossoff, characterization and caricature are intertwined. This accounts
for the vibrant individuality of many of the figures in the larger com-
positions.

There are very few artists in the world today who can compose
scenes of modern life. Kossoff is one of them. Two shows are not enough
to suggest the full range and character of the work; too much depends
on the selection. The catalogue of the Robert Miller show included
many paintings that were not hanging in the gallery. I would have liked
to see these, too. The Hirschl & Adler Modern and Robert Miller
galleries have done a great service by bringing Kossoff to our attention.
Kossoff's universe, with its worn-out buildings and shabby figures,
recalls the post-Empire England of another artist, Lucian Freud. Only
what Freud presents as dry documentary, Kossoff transforms through
an individual poetic style. He's an original.

———

Richard La Presti. Bigger is better isn't a rule that often holds in art,
but it's definitely the case with the work of Richard La Presti, whose
paintings of crowd-filled beaches were at the Bowery Gallery in Oc-
tober. La Presti uses broad, flat strokes of the brush to mold his mob
of sun-tanned bathers, his tracks of pink and yellow sand, his blue-
green expanses of ocean and sky. In many of the paintings, which are
broad horizontal compositions a couple of feet wide, those strokes get
in the way, call too much attention to themselves. But when he works
bigger, as in the fifty-inch-wide *Crowded Beach Day*, the strokes start to
build into an engaging impasto, and the staccato calligraphy takes off.
In the larger paintings, which are worked on in the studio over a period
of time, the very thickness of the surface becomes a metaphor for the
overcrowded beach—teeming brushwork stands in for teeming
humanity.

There's an odd mix of impulses that flow together into these beach
pictures. La Presti's approach is in the French plein-air tradition; his

Expressionist color calligraphy recalls Dufy, Marquet, and Vlaminck. And yet there's something about the raucously plebeian subject matter of bronzed hordes at public beaches in Brooklyn and on Long Island that's closer to the mind-set of 1950s beach-party movies—Annette Funicello and Frankie Avalon and the twist-and-shout gang. Though La Presti doesn't quite have those impulses in focus together, it's the good-taste–bad-taste tension that gives these paintings their spark. I'd say that the formalized fluidity of La Presti's brushwork sometimes works against the cartoonish fun; part of what's engaging in the larger paintings is the specificity of the incidents. In *Crowded Beach Day*, the center foreground is held by a dame in shades and lipstick, and you can see that La Presti gets a kick out of her beach-party chic.

Manet, Seurat, and Dufy have all done great paintings of outdoor entertainments. Perhaps these are subjects with which Europeans have an easier time than Americans. Growing up in societies that make no bones about the class system, the European artists are comfortable articulating a class situation: the petit bourgeoisie or lower classes at play. American artists have generally gone soft and sentimental when they represent the American masses. Is La Presti looking at the bathers as others, or does he want to join them? I read him as a loner with proletarian leanings. I think we would get a clearer picture if he'd go further in the direction of spirited parody—loving parody.

La Presti throws off his bold, choppy brush strokes with masterly ease. In a series of still lifes that made up the remainder of his show, he was moving from inanimate objects into a sort of Abstract Expressionist space. Figurative Abstract Expressionism isn't a type of painting I'm particularly partial to; but La Presti does it brilliantly, and as painterly abstractions these were infinitely more interesting than most of what is presented as neo-Abstract Expressionism nowadays. At forty-six, La Presti is a painter with a reputation among the small group of New Yorkers who really follow what painter Louis Finkelstein once called, in the title of a 1975 show he organized, "Painterly Representation." La Presti's show—his second at Bowery, after exhibiting at the First Street Gallery in the mid-seventies—was a must-see in certain circles. Painterly representation continues to be one of the most vital directions in American art. Still, it's economically and critically moribund. The artists Finkelstein included in his show in 1975—among

them were Leland Bell, Nell Blaine, Gretna Campbell, Robert De Niro, and Paul Resika—have never become superstars, but they've done okay. The artists in their thirties and forties who've continued in this line— they include La Presti, Rita Baragona, Temma Bell, Susan Daykin, Esti Dunow, William Plevin-Foust, and Stanley Lewis—are every bit as distinguished a company as that older group, but their fate, critically and financially speaking, has been even worse. In the yuppy eighties, they're simply overlooked.

Being the underdog isn't fun; it breeds an underdog mentality. Things have gotten so bad for the painterly representational crowd— there are so few opportunities—that even their biggest fans are some- times in danger of losing faith. Last season I reported on two shows that were mounted in New York City to memorialize Gretna Campbell, who'd died in the summer of 1987 at the age of sixty-five. This fall, the art school at Yale University, where Campbell taught, mounted the largest Campbell show ever (over thirty paintings), and even her fans were a bit startled at how magnificently the paintings held the space. In a just world, that show would have traveled straight to the Whitney.

The Yale show demonstrated how Campbell's art deepened in the last few years of her life. But such triumphs go largely unsung. La Presti's show this fall was miles beyond his show two years ago at Bowery. He is becoming a more pointed artist.

———

George Negroponte. In his show at John Good in October, George Negroponte exhibited two series of paintings: the larger paintings, in the range of seven or eight feet, were in oil on canvas; the smaller paintings, all sixteen by twelve inches, were in encaustic (a wax-based medium) on wood. The oils are much like Negroponte's earlier work, vapid abstract compositions with amorphous swooning shapes—I can see no rhyme or reason to them. The encaustics, a new medium for the artist, are a breakthrough—something lovely and surprising. I tend to be skeptical about the potential of a particular medium to release an artist's creativity, but that's exactly what has happened here.

Filling the small wood panels with hundreds of inch-or-so-long en- caustic marks, Negroponte creates little pictorial hurricanes and cloud bursts. The density of the wax medium serves to wake Negroponte up to the beauty of the surface. He draws and smears, rubs down and

builds up again. Working in a wide range of pungent colors—from dusky maroons to beach-day yellows to coppery greens—he creates delightful aerial abstractions. (They have a vaguely 1950s look, like miniaturized early Joan Mitchells or colored versions of de Staël ink drawings.) If the color has a tendency to be overly programmatic (complementaries used by rote) there is also a welcome range of feelings and moods. Negroponte evokes different sorts of "weather"—overcast and sunny days—and different atmospheres, from crystalline to claustrophobic. Ranged in two rows on a big wall in the John Good Gallery, these fourteen encaustic compositions announced proudly, "We're various!"

———

Faith Ringgold. When black women get the chance to tell their stories, these stories often seem to be about survival—and even triumph—against all odds. Faith Ringgold invokes the lives of black women in pictorial quilts, some of which were on view at the Bernice Steinbaum Gallery in November. By combining folk-artish figures, fabrics in tackily loud patterns, and bits of narrative prose, Ringgold creates a sweet and sour mood, a mood that we're already familiar with from gospel music and Motown songs. Ringgold's work isn't for people who believe that pictorial values are all—it's not meant for those people. Still, Ringgold's story quilts manage to be sentimental without being cloying, and that's an achievement. At moments, she brings off excitingly populist epiphanies—black history Motown style.

The quilted borders in Ringgold's pictures are done in a variety of fabrics that are gratingly off-key—posh velvets, lurid metallics, blowzy patterns. The comically bad taste sets up just the right cheerfully ironic ambience. The central cycle of quilts in the recent show, called *The Bitter Nest*, takes us back to the "legendary" Harlem of the twenties and thirties and, to quote Ringgold, tells the story of "a young black woman doctor named Celia Cleopatra Prince. Her father, Percel Trombone Prince, whom she loved dearly, was a socially prominent black dentist in the Harlem of the twenties. Celia's mother, Cee Cee Markum Prince, a loving wife and mother, was a marvelous cook and homemaker. Cee Cee was known for her unusually decorative home and the unique pieced and quilted bags she filled it with." Ringgold's five-part cycle illustrates central events from Celia's life—*Harlem Renaissance Party*, one of her father's famous soirées; *Lovers in Paris*, her first experience with a man—

through compositions of stiff figures that recall, no doubt intentionally, the art of Florine Stettheimer. Ringgold's view of the black bourgeoisie is gently and whimsically nostalgic. (It reminds me a bit of the view of 1950s suburban life that McDermott and McGough offered in their cycle of drawings at Massimo Audiello last season.) The basic subject is sisterhood and women's lives; it's a subject to which Ringgold brings a gift for characterization and the telling descriptive detail. She enjoys the appointments of a traditional woman's world—the nicely laid out tables, the comfortably decorated bedrooms. She also enjoys showing us a woman's view of men. She enjoys undressing the men, revealing Celia's first lover in the buff save for his beret. The feminist points are made with a lusty sense of fun. The color here (which often runs to electric blues and shrieking oranges) is an extension of the kicky stories and the lurid fabrics. And there are nice grace notes, as when, on the back of a mirror in the *Lovers in Paris* scene, Ringgold sticks a little sign that reads "Fabriqué en Paris."

Another series, *Women on a Bridge*, offers the George Washington Bridge, with its soaring arches, as an emblem of hope for the black women of Harlem. In one quilt in this cycle, *Tar Beach*, kids are sleeping on the roof of their tenement, looking out at the velvet blue sky punctuated by the lights of buildings, bridge, and stars. In another piece, *Dancing on the George Washington Bridge*, the steel structure becomes the theatrical setting for a messy but jubilant Busby Berkeley routine: women floating in front of the bridge, with its spangles of brilliant light a stand-in for their dreams. Ringgold likes to show women triumphing. The ladies are always outdistancing the men, as in *The Race*, another quilt in the bridge series. But the men are obviously enjoying themselves, too. There's a joie de vivre and a generosity to Ringgold's feminism. Her optimism is infectious.

———

Kenny Scharf. I went to the Kenny Scharf show at Tony Shafrazi in October in hopes of finding some amusing kitsch. Clearly, that's what Scharf had in mind when he painted a hand in a pink glove holding an Admiral portable transistor radio against a backdrop of fifties linoleum drips; or (in *Check-Array*) a crude pink checkerboard decorated with a yellow phone, a Zenith portable radio, a Kodak Instamatic, a Zenith hi-fi, and other such things. Here Scharf is eulogizing 1960s lo-tech;

and his attitude seems to be gently loving—friendly. The problem is that he can't paint the damn things. He doesn't have even the small store of painting craft necessary to carry off this kind of deadpan amusement. When Magritte gently chides us, lightly spoofing bourgeois taste, he has the felicities of brushwork to let us in on the jokes—his pictorial elegance shows us that he has some distance on the material. Kenny Scharf isn't up to the Kodak Instamatic. It's often said that the problem with a lot of today's hot artists is that they're fresh out of art school. Maybe the problem is that they paint as if they've never gone to art school (which may amount to the same thing, considering what's going on in a lot of art schools).

———

Stephen Westfall. Contemporary abstract paintings built out of hard-edged Constructivist forms are to be seen a good deal in the galleries. Much of this work is being done by younger artists—artists in their thirties and forties who can have had little or no direct contact with the earlier generations of Constructivist artists and know their work from museums, historical gallery shows, and books. Stephen Westfall, who used circular and rectangular forms in his show at Daniel Newburg in October, is one of the more visible of these artists, partly because he's written a good deal for the art magazines. Other shows of contemporary Constructivism this fall included Andrew Spence at Barbara Toll in October and Michael Young at BlumHelman, also in October. All the work seeks to recall the cool assurance of Constructivism from 1915 to 1965; the splendid "Contrasts of Form" show that was held at the Museum of Modern Art in 1985 may have been an influence on some of these artists. Malevich, Mondrian, Taeuber-Arp, Herbin, Kelly have had an impact, directly or indirectly. All in all, this new Constructivism is a development of great interest; catchphrases like Neo-Geo don't do it justice. The tradition being invoked is one of the great modern traditions—the pedigrees are impeccable. More than that, the new work is powered by an engaging mix of hi-tech cool and avant-gardist nostalgia.

The most interesting paintings in Westfall's show were a series of three vertical compositions, each divided into an irregular series of mostly rectangular areas by broad bands of black or yellow. In the past Westfall has done a number of paintings inspired by compositions of

the American Myron Stout; the new Westfalls have a family resemblance to some Stout oils from 1950. The irregular network of straight lines, dividing the canvas into a community of separate and distinct compartments, is a convention with roots deep in Bauhaus and De Stijl that Stout, like Westfall, draws upon. Westfall—along with Andrew Spence and Harvey Quaytman (whose work was at the David McKee Gallery in September)—also seems interested in the later Mondrians, the ones where the lines take an increasingly aggressive role and sometimes become prison-bar-like in their weight. Probably the eccentricity and even anticlassicism of some of the later Mondrians appeals now. In any event, a not inconsiderable store of great modernist ideas flows into the clean frontality of Westfall's images. He knows how to vary the intervals to spark attention and keep us looking. A single diagonal makes a special event, a difference within the similarities. The progress of a line from top to bottom is broken by a horizontal, detoured a bit. Westfall is an attentive, thoughtful artist. And yet the paintings lack a cumulative power—they're like exercises, dictionaries of possibilities. This is faceless painting.

The new Constructivism has an odd history. Its beginnings are located in the early eighties, when there was a rebellion against Neo-Expressionism. Initially, conceptually oriented artists were attracted by the large role that theory and polemic played in Bauhaus, De Stijl, and Russian Constructivist art. Constructivism seemed to offer an escape from emotionalism—or, at least, from bathos. Constructivism was seen as the ultimate in theory and cool. But as these younger artists really got involved in the painting process—as they became attuned to the voluptuousness of classic Constructivism—they began to want this art of hard edges and clear forms to be beautiful and emotionally compelling. The new abstraction, which a couple of years ago tended to be discussed "theoretically," is now meant to *move* us. Typical of this attitude is a press release from the Scott Hanson Gallery that speaks of an art that "forsakes the ersatz metaphysics of 'art theory' "—this from the very people who were touting theory a season ago. In the press release for Westfall's show we're told that "the work does not need to be defined as anything other than illuminatingly beautiful painting." This may seem self-evident, except that it's something that hasn't been heard too much in these here parts of late. I applaud this new attitude;

but the artists don't seem to know quite how to make something that's—beautiful. Westfall's paint handling is perfunctory. When he gives us green areas with a red underpainting showing through he probably thinks that he's showing us sensitivity, feeling; to me the technique is programmatic. Andrew Spence is the most convincing *painter* in this group; his flat, opaque surfaces have some density to them; his boomerang shapes have a certain force. Still, we're a long way from the distillation of painting craft and culture that gave the surfaces of the early Constructivist paintings their resonance.

In a sense, Neo-Geo is a form of Neoclassicism. The problems that confront Stephen Westfall and Andrew Spence when they invoke Myron Stout or Mondrian may be rather like the problems that confront contemporary figurative Neoclassicists such as Lennart Anderson and Milet Andrejevic when they invoke Poussin or Puvis. Namely, is the tradition alive enough to add on to? The Constructivist vision of the early modernists was as much a product of a certain time and place as the Neoclassical pastoral vision of Renaissance Europe. These visions have their life spans and their deaths and their resurrections. But resurrections can't be willed, except up to a point. To say that no matter how much Stephen Westfall wants to believe in that clean-lined Constructivist world he can't really believe in it is to raise aesthetics to the level of metaphysics, but I'm not sure there's any other way to put it. The Donald Judd retrospective at the Whitney this fall showed us an artist who stands at the absolute end of the historical trajectory of Constructivism. The most recent work in the Judd retrospective—a wall piece of thirty plywood boxes—is the same good old idea presented once more, with feeling. The moment may be wrong for a return to Constructivism. Of course, it's only wrong until some artist proves it right. In any event, the dryness of Westfall's paintings goes beyond a painting problem. If one feels an intellectual vanity too much in his work it may be because the image before our eyes is the product of an idea that's dissociated from the period we're living in. Painting *is* alive and well. But artists formed in the Age of Conceptualism may be forever cut off from the sensuality of classic European abstraction.

March 1989

LETTER FROM LONDON:
THEY DO IT
THEIR WAY

The Clore Gallery, a new wing of London's Tate Gallery, is devoted to the enormous body of work that J. M. W. Turner left to the British nation. The building, by James Stirling, has been criticized as an example of gratuitous postmodernism, but I must say that I can't quite see what all the fuss is about. The Clore Gallery is designed in a subdued postmodern style, a style that I doubt would have raised eyebrows fifty years ago and will probably look equally appropriate in the year 2039. Here Turner is shown complete, the later, mystically vaporized Turners that were esteemed in the 1960s together with the earlier, more conventionally picturesque Turners that returned to favor in the historically minded 1970s. In special galleries, watercolors and drawings that can't be exposed to light for long periods of time appear in rotating exhibitions. While I was in London in January, the temporary show focused on Turner's "Second Decade: 1800–1810" and included much work done during his visits to the Continent. All in all, the Clore Gallery is a sophisticated solution to the long-felt need for a permanent home for the Turner bequest. The Turner wing is also, so far as I can see, an international anomaly. What other nation has thought to devote an entire wing of a national museum to a single artist-hero?

Viewed at the Tate Gallery in proud isolation, Turner could provide new fuel for those who are inclined to see English art in terms of a series of freestanding, essentially disconnected accomplishments. Hogarth, Stubbs, and Constable may not have separate wings at the Tate; but they, too, impress one as existing outside any historical continuum, neither defining themselves in relation to a particular view of the past nor setting out a line of development along which others can follow. There's something to what Nikolaus Pevsner, in the title of a 1955 series

of lectures, called "The Englishness of English Art." But what the Englishness consists of (beyond a tradition of high-society portraiture) will probably never be succinctly defined. This is a question, in any event, on which I wouldn't presume to offer a thorough view. To my mind, being in England doesn't have the effect of clarifying English art in the way being in, say, Holland clarifies Dutch art. English light and space strike me as having a more literary than pictorial value. But of course Dutch—or French—painting is so much greater, so maybe it all just comes down to a question of quality. Pevsner believes that England missed out on the great age of easel painting, beginning in the sixteenth century, because of "the growing importance in the national character of practical sense, of reason, and also of tolerance. What English character gained of tolerance and fair play, she lost of that fanaticism or at least that intensity which alone can bring forth the very greatest in art." One thing is for sure. London's National Gallery is the only top-flight European picture collection in which the achievement of the host country, though present, is historically irrelevant.

Recent trends in art history, which emphasize a pluralist view of European culture and seek to destabilize or overturn the centrality of Paris, may have the effect of setting contemporary English art in a somewhat brighter light. Whatever the relative virtues of Frank Auerbach, Francis Bacon, Lucian Freud, Leon Kossoff, Rodrigo Moynihan, Victor Pasmore, William Tucker, and the American expatriate R. B. Kitaj, they each make their appeal to the New York audience by offering something other than business as usual. But if the appeal of English art right now has to do with its looking antimodern or postmodern, in England the same art may impress us less as a protest against modern orthodoxies than as a continuation of the cottage industry that English art has always been. What some will call their conservatism others will call their independence; some will say the two amount to the same thing. Let me float a hypothesis: every English artist is a philosopher cultivating his own garden. The solitary gardeners include Sickert, Spencer, Bomberg, Moore, Nicholson, Hepworth; and, further back, Constable, Bonington, Blake, Palmer.

The what-is-English-art? debate perks happily along in the pages of London's handsome new quarterly art magazine, *Modern Painters*. Editor Peter Fuller, who was born in 1947, will be known to some in

the United States for a couple of attacks on the art scene that he pub-
lished in the *Village Voice* a decade or so ago. At that time, his mix of
Ruskinian romanticism and left-wing politics sounded fresh, even if his
advocacy of certain artists (such as the American abstract painter Robert
Natkin, about whom he wrote a monograph) was uninspiring. Happily,
the magazine Fuller edits—issue number four, with a Hockney on the
cover, was on the stands when I was in London—has a reach and an
element of surprise that are challenging and genuinely new. For his
writers, Fuller has turned to England's old-timers, such as Patrick
Heron; to a new generation that's eager to set its own priorities; and to
controversial figures, such as Richard Wollheim, the University of Cal-
ifornia philosophy professor whose work is high profile enough to be
interesting no matter what we may ultimately decide we think of his
ideas.

In *Modern Painters* you never know exactly how the writers are going
to come down. Mega-shows don't necessarily receive mega-praise.
Heron, a respected painter as well as a critic, offers a modulated view
of Gauguin. "Very few paintings by Gauguin," he says, "are completely
successful." He sees the artist's life not as illuminating the oeuvre but
as tending "to drag the painting up, with it, into the supreme limelight."
He calls Gauguin "a great bad painter"—which is pretty good. Brian
Sewell, art critic for the *Evening Standard* and the *Tatler*, gives a stern
evaluation of the recent work of Rodrigo Moynihan, complaining of "a
fumbling hand that can no longer tell the difference between plaster,
plastic, paper, cotton wool and cloth." I think this is just; and the courage
it takes to criticize a favorite son should not be underestimated—either
on the writer's or the editor's part. Nor is Peter Fuller blind to the allure
of the hip. Matthew Collings, former editor of the provocative magazine
Artscribe, offers "Diary of a Celeb," a fondly picaresque account of his
visits among New York's downtown avant-garde. Clearly, Fuller means
to take the measure of those with whom he disagrees. Part of the fun
an American has with *Modern Painters* may have to do with our general
lack of familiarity with the writers and their ideas. But there's something
more here. I suspect the magazine will remain stimulating. This mix of
straightforward writing, critical detachment, and a vigorous engagement
with the current scene is all too rare on either side of the Atlantic.

———

In January the Whitechapel Gallery, a showplace for recent art with quarters in a turn-of-the-century building, was host to an exhibition of work by the sculptor Richard Deacon. The Whitechapel is a friendly meeting place, complete with bookstore and cafeteria, and when I was there on a Sunday, not the peppiest day in London, people were spending the afternoon—ambling through the gallery's boxy yet dramatic downstairs space, lingering over coffee, browsing in magazines.

Deacon was born in 1949. In 1987 he won the Turner Prize, awarded by the Patrons of New Art at the Tate Gallery for an outstanding contribution to British art. No stranger to the United States, he shows in New York with Marian Goodman and was one of six artists featured in a show called "A Quiet Revolution: British Sculpture Since 1965," which toured here in 1987. Deacon works with a variety of materials—molded wood, sheet metal, nuts and bolts—to create skeletal and curvilinear forms that recall, alternately and sometimes simultaneously, biomorphic abstraction and the products of a mildly eccentric machinist. The sculptures range from a few feet to way over life-size and call attention to themselves in a variety of ways: with metal tabs that are riveted to wood or metal supports; with glue that oozes out from between pieces of wood to make creepy, hardened forms. Each of these touches represents some thought about how materials can be put together. Construction becomes an idea—an idea advanced with rivets, glue, Phillips-head screws. Deacon is a post-Conceptual artist: while he creates sculpture in three dimensions, he can't seem to get over a feeling that the idea of making a sculpture is more important than the sculpture itself. His attention-getting surfaces and self-important joinings distract us from any large movement that begins to develop. This very static work is too self-conscious in its effects. One takes in a Deacon bit by bit, but the bits don't add up to a journey—even a little journey— through time and space. Deacon denies us the sensuousness of forms, and what is sculpture without sensuous form?

The Whitechapel has a busy schedule of events. Along with Deacon's show I saw Rob Kesseler's amusing slide presentation, a stream-of-consciousness collage of cartoonish drawings and crisply photographed details of the ordinary world (still-life objects, bits of scenery). A series of gallery talks called "Sightlines" provided prominent English artists with an opportunity to "give their personal views of the Richard

Deacon exhibition." The Whitechapel is also interested in giving contemporary art a historical context. After the Deacon show went down, a big show of Miró, biomorphism's granddaddy, went up.

Meanwhile, Nicholas Serota, who became a well-known figure on the international circuit during his tenure as director of the Whitechapel Gallery, has replaced the retiring Alan Bowness as director of the Tate. London is increasingly being talked about as a big-league player in the international contemporary art scene. Peter Fuller is clearly unhappy about the internationalization—read Americanization/Berlinization—of English art. He's very unhappy about Nicholas Serota. In the current issue of *Modern Painters*, Fuller reminds readers of an editorial in the first issue where he "argued that Serota's experience lay in the field of temporary exhibitions, not in the management of a permanent collection; and his record of contemporary shows at the Whitechapel—including Carl Andre, Julian Schnabel, Malcolm Morley, Gilbert and George, etc.—did nothing to inspire confidence." According to Fuller, Serota wants "to turn the Tate into a 'museum of late 20th century art.'" Fuller offers snippets of an interview that Serota gave to the *Independent*, in which the Tate director "fantasized about bringing changing installations of 'volatile, unstable art'—e.g. by Richard Serra, Mario Merz and Jannis Kounellis—on to centre-stage at the Gallery, while Constable got shunted to the 'edge of the site.'"

Whatever Serota does or doesn't do at the Tate, the New York-Berlin axis has been a strong presence in London since 1984, when the Saatchis opened a private museum devoted to their collection. During the winter the Americans Jennifer Bartlett, Susan Rothenberg, Eric Fischl, and Elizabeth Murray were all featured there. This quartet is far from the first batch of Yankees to fill the Saatchis' enormous space; they won't be the last. It may prove impossible for English art to retain much independence. At the Riverside Studios, a visual and performing-arts complex in the currently being gentrified suburb of Hammersmith, I saw a show of five young English artists, all of whose work was based on a careful reading of New York trends, none of whom would have raised an eyebrow in the current SoHo season. Whatever the dangers of English insularity, they've got to beat homogeneity Saatchi-style. One interesting question, to which I offer no answer, is whether the artists of Leon Kossoff's and Frank Auerbach's generation have spawned

a younger generation sympathetic to their concerns. Visitors—whether to London or New York—only skim the surface.

Back in the fifties, Nikolaus Pevsner commented that "none of the other nations of Europe has so abject an inferiority complex about its own aesthetic capabilities as England." That doesn't seem to be the case in the eighties. With Paris out of fashion, New York overhyped, Berlin past its prime, and jaded sensibilities turning to Amsterdam, Barcelona, maybe Hong Kong—all bets are off. London could happen yet. One would like to believe that every English artist will ultimately benefit from the presence of a vital international art scene. Serota will do his damnedest to provide the "big picture." Meanwhile, Peter Fuller represents the honorable opposition. If Fuller's brand of Ruskinian romanticism doesn't strike me as offering the key to anybody's salvation, I nevertheless give him credit for standing his ground and refusing to develop a guilty conscience. He's determined to prove that in England they still do it their way.

April 1989

Postscript, 1991. Peter Fuller died in a car crash in April 1990. "His death was out of place," Clement Greenberg observed in a tribute. "There were other deaths waiting ahead of his." For the time being, *Modern Painters* continues under the direction of its managing editor, Karen Wright. (A few months after Fuller's death, the magazine formed an editorial board, of which I became a member.)

HOW SIMPLE
EVERYTHING
COULD BE!

"The Pastoral Landscape," a survey of bucolic imagery in Western art from 1500 to the mid-twentieth century, was mounted in Washington, D.C., this past winter as a joint venture of two great museums. The story began in the West Wing of the National Gallery with Giorgione, then moved through Annibale Carracci and Rembrandt to Watteau; at which point one had to hotfoot it across town to the Phillips Collection, where volume two opened with Corot, took in the English Romantics, French painting from Puvis and Gauguin to Bonnard and Matisse, and concluded with Milton Avery and Howard Hodgkin.

The exhibition was very ambitious and very subtle, an interweaving of elusive themes: the urban craving for rural life, often an idealized version of rural life; the survival and revival, from century to century, of the woodland imagery of Latin literature; and the changing ways in which painters from Giorgione to Bonnard have used the translucency of oil paint to express their softly shaded responses to music, poetry, landscape, and love. In this remarkable museological adventure nothing was overstressed. The carefully selected mix of prints, drawings, and paintings ranged from masterpieces to curiosities. When one wasn't bowled over, one was set to thinking. And one was always brought back to the central idea, to the Giorgionesque vision of man in easy relation to nature.

At the heart of it all was David Rosand's fascinating catalogue essay, "Giorgione, Venice, and the Pastoral Vision." Here the fluidity of the Giorgionesque tradition is defined in opposition to the rigidities of what we have come to see as the neoclassical pastoral. Rosand, a professor of art history at Columbia University, moves at a leisurely but purposeful

pace. His revelations aren't underlined; they sneak up on you. As he tells the story, everything revolves around one's understanding of the *Concert champêtre* in the Louvre, a painting that was traditionally given to Giorgione but has often been attributed to Titian in recent decades. In arguing that the painting cannot be a Titian, Rosand sets up an opposition between two varieties of painting and defines an idea of the pastoral that cycles through the entire show. To those who would attribute the *Concert champêtre* to Titian, Rosand responds: "Titian's comparable images with amorous iconography are fundamentally different in concept and realization, more classically structured in composition, insistently respectful of the picture plane. Titian's early palette is chromatically clearer, his forms more crisply drawn, illuminated by a brighter sunlight. Nor are these paintings—the *Three Ages of Man*, for example—conceived in a pastoral mode; their compositional structures correspond rather to an allegorical function, in which clarity of form is essential for the equations of meaning."

It's characteristic of the mysteriousness of the pastoral tradition that Rosand defines it negatively—in terms of what it is not. His summary of Giorgione's structures is given by way of a summary of Titian's. "Titian's articulation," Rosand tells us, "is cleaner, his surfaces firmer, his spaces more deliberately layered; his art sounds a poetic note quite distinct in its clarity and solid realism from the veiled invitation that remains for us the culmination of Giorgione's achievement." This is the closest that Rosand can really come to describing that "veiled invitation." But his circumspect approach works brilliantly, and the show and the book, which is a freestanding scholarly achievement, flow from it. Robert C. Cafritz (he was until recently curator of nineteenth-century art at the Phillips) put the show together over a period of six years; he marshaled the talents of curators at the two museums and wrote the four central chapters of the book, which join Rosand's opening essay to Lawrence Gowing's closing one on "The Modern Vision." It was Cafritz who organized the late Braque exhibition at the Phillips in 1982; now he has come up with another connoisseur's delight of a show.

The freedom of the pastoral tradition finds expression in the off-kilter, idiosyncratic compositions of many of the works that were on display in Washington. In the Giorgionesque world, figures are scattered through the landscape almost casually. Many compositions have the

feeling of happy accidents. A painting such as *Paris Exposed on Mount Ida* (from Princeton) or the drawing of a *Landscape with an Old Nude Man* (from the Woodner Collection), both identified in the catalogue as "Circle of Giorgione," is like informally arranged fragments, bits of poetry excerpted from some larger whole. These works are only partly about nostalgia for a classical past. They're equally about a city-versus-country debate, and a yearning for rustic ease. Often, a couple of buildings perch high on the horizon line—a memory of city life that refuses to leave the sojourner in the country. The motif of a clutch of buildings, either rusticated or elegant, is presented over and over again, with the blunt insistence of a dream-obsession. And it's these strange buildings that survive into Watteau, the eighteenth-century painter who turns out to be the true inheritor of Giorgione's world.

In Rosand's essay a whole cycle of variants on the Giorgionesque tradition is described: a courtly pastoral, a religious pastoral, a satyric pastoral, a pastoral of hard labor. Rosand shows how pictorial themes evolve out of poetic conventions, both Roman and Renaissance. But, more important, he shows how the loose forms of the Giorgionesque tradition are transformed—by a shift in the proportions of a canvas, or by the lowering of a horizon line—to accommodate shades of meaning. And if Rosand cannot explain, for example, exactly why pastorals dealing with hard labor should call forth a deeper landscape space, he gives us enough clues so that we sense the ways in which structural shifts *are* emotional shifts. Thus, "Titian, whose inclination was to energize the landscape, took a leading and influential role in transposing pastoral into georgic"—into a world of Virgilian farm laborers. "The basic structure of [Titian's *Landscape with a Milkmaid*], with its distance between foreground figures and the fortified town on the horizon, may evoke certain pastoral values, but the figures themselves hardly have time to enjoy any escape from the cares of life: no idyllic nostalgia here, no music, no love. The couple—rather, family—must tend the flocks and cattle, feed the goats and milk the cows."

As the show proceeded, we saw the critical role of prints—especially those after Titian and the works of Domenico Campagnola (1500–1564)—in the dissemination of pastoral ideas; the classicizing of those ideas at the hands of Annibale Carracci and Claude Lorrain; the revitalizing of the Venetian pastoral in the Baroque of Rubens and Rem-

brandt. At the National Gallery the show was subtitled "The Legacy of Venice" and ended with the fast dissolve of the Rococo. Over at the Phillips, where "The Modern Vision" section was selected by Lawrence Gowing (who was, until recently, curatorial chairman of the collection), we watched the nineteenth-century artists pick up the story. Older concepts of the pastoral merged with the new, increasingly subjective and self-conscious nature poetry of the Romantics. Like many Englishmen, Gowing is quick to emphasize an English tradition. In my opinion, he took us too far from the essential matter of the show as he focused on Blake and his followers, especially the painter Samuel Palmer. Palmer was absolutely correct when he wrote in a notebook entry, of Blake's Virgilian wood engravings, that "there is in all such a mystic and dreamy glimmer as penetrates and kindles the inmost soul"; but this isn't the mood of the Venetian pastoral. The pastoral of Blake and Palmer is more a matter of graphic expression than of coloristic expression; its literary elements aren't saturated enough in optical experience. As for Constable, his spirit is not that of Venice: early on, he's too prosaic in his realism; later on, too abstractly poetic.

Ultimately, "The Pastoral Landscape" demonstrated what all of us knew: that Paris is the heir to Venice. It's in the art of Corot, Matisse, and Bonnard that an ongoing tradition emerges most clearly. (Cézanne is more Poussinesque than Giorgionesque.) Corot's *Genzano* (from the Phillips Collection), an early Italian landscape with a boy in the foreground and the town a gaggle of buildings just above his head, has the subdued sweetness of Venice. In its casual yet resonant composition we see Corot expressing his own sense of communion with Watteau and Giorgione. And Matisse's *By the Sea* (*Golfe de Saint-Tropez*) (1904) carries into the twentieth century the surprising interrelationships of figure and nature, the melancholy sense of man's lost easiness in relation to the earth. The modesty of Matisse's little figures, who are enveloped in a sunset glow, is triumphantly, almost shockingly Giorgionesque. On the other hand, I find Matisse's *Luxe, calme et volupté*, with its more formal arrangements, less a part of this tradition; its echoes of Puvis, the man who invented what might be called the avant-garde Neoclassical, draw us away from Venice.

So little was this show a matter of fixed assumptions, so much was it a matter of shifting implications, that when we arrive at the end of

the catalogue we aren't at all surprised by Lawrence Gowing's assertion that "it was the element of realism in Claude, as in Giorgione and Bellini themselves, that qualified them to play a significant part in the artistic development that followed." This may, on the face of it, directly contradict Rosand's characterization of Giorgione as something other than "solid realism." But if Giorgione's nature is, as Rosand says, poeticized, it's poetry that keeps bringing us back to the actualities of experience.

Neither in the show nor in the (somewhat overdesigned) catalogue is anything said about what meaning the pastoral might have for us today. Relevance of the obvious sort is, quite rightly, something that Rosand and Cafritz avoid. Their sense of the past is so transparent, their feeling for art is expressed so immediately, that they don't have to plead relevance—they demonstrate it. In a sense, every generation of city dwellers finds a different way to live the pastoral idea; whether it's the "hard pastoral" of early-twentieth-century back-to-nature radicals such as Helen and Scott Nearing; or the softer, vacation-on-Long-Island-or-in-Maine version of the New York poets; or the utopian, let's-change-the-world version of the sixties communes.

Still, the pastoral idea goes out of focus as it approaches the present; our prejudices dim the picture. If Lawrence Gowing doesn't exactly clarify our present position, it may be because he is himself ambivalent about the continuation into the present of a tradition that has as much to do with the natural world as with poetic idealization. By ending with a semiabstracted landscape painting by Howard Hodgkin, Gowing not only affirmed his loyalty to England, he left us in a state of suspension. As it happened, Hodgkin's *In the Public Garden, Naples* (1981–82), which hung at the Phillips next to Braque's *The Shower* (1952), looked better than most Hodgkins I've seen—looked better for a time, until the Braque, which initially cast some of its own poetry across the room, began to upstage the Hodgkin. Hodgkin's poetry is rather leaden; his invocations of landscape in the midst of abstract structures are both obvious and strained. The pastoral cannot, in any event, be an abstract tradition; not, at least, the Giorgionesque pastoral, which is dedicated to a perception of nature and is anti-ideal. To Gowing, Hodgkin's nostalgic mood is the pastoral mood; to my eye, it looks more like a nostalgia for the ability that artists once had to inhabit the pastoral mood.

What the Washington show didn't hint at is the many attempts in recent years to revive some more overt form of pastoral. In January, while the exhibition was up in Washington, the Robert Schoelkopf Gallery in New York mounted a show called "The Modern Pastoral." I saw the Schoelkopf show before I got down to Washington; and only after I'd returned to New York did it occur to me that the sort of classical elegy that artists like Milet Andrejevic and Edward Schmidt specialize in has far more to do with the academicization of the pastoral than with the pastoral itself. Their figures do all the things that Rosand says Giorgione's do not: these contemporary nymphs and shepherds and pipers line up parallel to the picture plane, and they dispose their arms and legs in arrangements that make geometric references to the shape of the canvas. The color here is dusty rather than sensuous—a memory of something that wasn't really experienced in the first place. The only artist included in the Schoelkopf show who might be said to have learned from the Venetians is Paul Georges; his big landscape is a very distant cousin of Annibale Carracci's marshy landscape in the National Gallery. While Milet Andrejevic upholds the letter of the pastoral law, it is probably Paul Georges, Fairfield Porter, Nell Blaine, and other artists of their painterly stripe who uphold its spirit.

The twentieth-century artist who emerges from the Washington show as most essential to this tradition is Bonnard. (Matisse, after all, is pastoral only early on.) Curiously, Bonnard wasn't presented front and center at the Phillips; though his paintings were in the show, they were mostly hung in the stairwell, on the way up to the galleries. What accounts for Gowing's reluctance to place Bonnard at the heart of the pastoral tradition? Perhaps he feels that Bonnard isn't a strict pastoralist, since Bonnard paints a resort town, where we're as often as not looking out the windows of a modern house at a countrified garden. Bonnard's semisuburban scenarios shouldn't blind us to the Giorgionesque character of his odd jumps in scale, or to the Giorgionesque way in which his small, awkward-looking figures fit into the unfolding spectacle. Venice lives on in Bonnard's rejection of classical grandeur and in his eccentric, meltingly innovative color.

One of the loveliest of this season's art books, *Bonnard at Le Cannet* (Pantheon), highlights the late, pastoral Bonnard. The book is in the form of a walk through Bonnard's last house and garden (which have

recently been preserved as a museum), and it shows how different compositions came out of different parts of the domestic environment. These were the years—1927 to his death in 1947—of Bonnard's supreme triumphs: the bathtubs, the studio with the yellow mimosa out the window. (Some of the paintings aren't so well known, including *Getting out of the Bath*, circa 1930, in which the nude is the exact precursor for Balthus's Japanese figures.)

An introductory text by Jean Leymarie, who visited Bonnard on the Côte d'Azur during the years just after World War II, describes the pre-1950s Riviera as a modern Elysium. This is something we already knew from Colette; and if Bonnard is our Giorgione, Colette, stationed in her little house in St. Tropez, is our equivalent of the Renaissance pastoral poets such as Pietro Bembo. "Early this morning," one of Bembo's heroes relates, "when I had parted from my friends and left the castle in order to pursue my thoughts alone, taking a path which climbs the slope behind us, without knowing where I went, I reached the little grove which crowns the charming mountaintop as if it has been planted there by careful measurement." This courtly pastoral mode turns into the bohemian pastoral mode in Colette's *Break of Day* (1927), in which the love affairs are as spontaneous and as surprising as those in Giorgione and Watteau. "Tomorrow," Colette writes, "I shall surprise the red dawn on the tamarisks wet with salty dew, and on the mock bamboos where a pearl hangs at the tip of each blue lance. The coast road that leads up from the night, the mist and sea; then a bath, work and rest. How simple everything could be!"

May 1989

AVIDA DOLLARS

For a few years during the 1970s I had a part-time job with a couple who ran art auctions as fund-raisers for Jewish charities. It was a mom-and-pop operation; we worked in their Upper East Side apartment, or else in a small warehouse downtown, which they rented from a relative for some nominal fee. The stock ranged from oil paintings that were mass-produced by means of stencils in sweatshops in the Far East (we bought them from a wholesaler in Queens) to signed limited-edition lithographs by Calder, Dali, and Miró. The auctions were for the most part held in suburban communities—in the New York area, New England, the Southeast and Midwest. Much of the sales pitch depended on presentation, and we used to get giddy as we worked for hours, sometimes into the night, preparing orders for the framer. Nothing was too outrageous to sell: double and triple mats (red-white-blue!); mats in colored linen and velvet, with the beveled edges painted in contrasting hues. My employers were a smart couple with a good deal of class, and to their credit they found a lot of what we were doing ridiculous. It was a fun (though also sometimes a maddening) part-time job.

The auctions were package deals. We provided the trucking, the posters and catalogues, and the sleaze-ball auctioneers. (The crowds in the burbs loved those auctioneers, gold chains and all.) The charity received a cut of the sales; I think it was between fifteen and twenty-five percent, depending on the gross receipts. Anyone who bought a work for over a hundred dollars could write to us in New York for what we called a letter of authentication. One of my jobs was to reply to these requests, and at times I got to feel a bit like something out of *Miss Lonelyhearts*. I remember a letter from a woman who'd bought a relatively

inexpensive print and ended up in a fight with her husband about it after she returned home from the auction. I was, somehow, supposed to make her feel better. But mostly I wrote a single line, explaining that such and such was an "original lithograph"—or just a "lithograph," if the plate from which it had been printed hadn't been produced by the artist. We were fairly honest about it all. The original lithographs that had been extracted from the magazine *Derrière le miroir*, published by the Maeght Gallery in Paris, were identified as from DLM; but we made no claims about their being from limited editions. On the other hand, we didn't emphasize the fact that the editions were unlimited. We were honest, but of course we tried to make things look good.

Dali prints, which were among our biggest sellers, presented particular problems for me as I sat bent over the old Olivetti portable. Recently, as I read the chapter "Avida Dollars" in Meryle Secrest's biography of Salvador Dali, I was reminded of the honest but evasive letters of authentication that I used to compose. "The sizes of Dali's print editions," Secrest observes, "are nowadays their most derisible aspect. What publishers like to tell their prospective buyers is that they are limited—to 350 or 500 or 1,000—but what they frequently fail to add is that each country has its own edition of that size. Thus the German edition will have an A after it, the Italian edition an I, the French an F, the Japanese a J—with such a system in operation a supposedly limited edition can run into tens of thousands."

This is something I realized when one of our customers wrote in to inquire about the significance of the initial after the limitation number on a print he'd just purchased. I went to the files and found a brochure from the publisher that explained it all very clearly. Then I had to figure out a way to break the news to our high bidder, gently. We justified our obfuscations by saying that we didn't want to upset customers who felt virtuous about buying Dali prints as charity contributions. Nor did we want the charities to hear complaints. Sometimes, a couple of Dalis being bid up through the roof made the difference between a humdrum auction and a terrific auction.

Toward the end of the seventies the oversized signatures on those Dali prints were looking stranger and stranger. Unpacking them, we'd shake our heads and give each other incredulous looks. Was Dali's legendary signature just becoming sloppier as he signed hundreds of sheets

of blank paper a day? (Now he was putting his John Hancock on the paper as he cut the deal, often long before the prints were produced.) Or were the prints actually being signed by someone other than Dali? We didn't know, and nobody will ever know for sure. Yet the people who came to our auctions loved the Dalis—those prints were Joe America's idea of Art.

Dali, who died in January 1989 at the age of eighty-four, doesn't leave behind any glow. Reading about his life is a disagreeable experience, because even the early years in Catalonia—in the city of Figueres, where he was born; and in the fishing village of Cadaqués, where the family spent summers—have become gobbed up by Dali's own mythomania. Dali was named after an older brother who had died short of his second birthday, and so a morbid sense of twinship haunted the artist's childhood. There are these genuinely engaging aspects to Dali's life. He passed across a series of magnificent backdrops: early-twentieth-century Barcelona, which had already nurtured Gaudi, Picasso, and Miró (Miró's first dealer, Josep Dalmau, was Dali's, too); and Paris in the later days of Surrealism. But when we're asked to see everything in Dalivision—blurred, fractured, distorted, and at the same time harshly overlit—it's hard to maintain much interest.

Dali's finest paintings are to be found among his earliest, such as a very plain still life of some slices of bread in a basket, dated 1926. This painting is tight, dry, and severe; it has a desert-climate clarity that we feel in early Miró and that echoes the Spanish art of the seventeenth century—of Zurbarán, Sanchez Cotan, and the early Velázquez. The obviously gifted artist who painted this singular vision and arrived in Paris at the end of the twenties is recalled in André Thirion's charmingly levelheaded memoir, *Revolutionaries without Revolution*. "He wore a fine mustache, like the film actor Adolphe Menjou. Slender, shy, phlegmatic, well-mannered, he had an inexhaustible gift of gab, which his natural humor and his Spanish accent sprinkled with comical effects. But he knew when to hold his peace, and he would hold it for a long time, curled up, attentive and serious, in an easy chair. Enormously intelligent, he was obviously capable of wrecking any mental construct whatsoever simply because he was so marvelously funny; he could make everyone but himself howl with laughter."

Let's remember Dali here, in 1929, at the point where avant-gardism is merging with high fashion, and Surrealism, so far as the fashionable world is concerned, is beginning to resemble Neoromanticism. Within Surrealism itself, phase two has begun, announced in Breton's *Second Surrealist Manifesto* of December 1929. André Masson and Joan Miró, the two greatest painters within the movement, are moving out of the orbit of Breton. Miró simply drifts away, while Masson announces that he's now a "dissident" Surrealist. Automatism—the unfettered linear arabesque that in the hands of Masson and Miró was Surrealism's most radical contribution to pictorial art—isn't mentioned in the *Second Manifesto*. Breton, who around the same time writes an introduction to the catalogue of Dali's first show in Paris, is turning toward a different sort of painting.

While the weirdly accessorized dream worlds of the early Dalis could only have been hatched in the wake of Freud, the artist's technique was premodern and even antimodern—a throwback to the late-nineteenth-century academicians who'd imitated the smooth tonal transitions of photography. (Dali was a great admirer of that archacademic, Meissonier.) The transformation of natural forms into the not-quite-natural or the something-other-than-natural had been an element in art since Cubism; but no matter how outlandish the imagery became in the work of de Chirico and Picasso, their experimental brushwork and lively surfaces preserved the painting culture of the Impressionists and Post-Impressionists. Dali rejected the conventions of modern painting by rendering forms sculpturally and setting them into a very deep space. As much as the strange dream-visions, it was the old-fashioned spatial constructions that gave his early work its air of provocation. Dali's slicked-up surfaces carried a de Chirico-Picasso-Tanguy baggage of dreams into fantasies of unprecedented theatricality. Working on a tiny scale at the end of the twenties, he was making Surrealist Fabergés— toys to gawk at. Parisian culture could no longer support an aesthetic of formal purity; but it remained for Dali to demonstrate exactly how megalomaniacally baroque impurity could become.

The small-size Dalis of the end of the twenties left André Breton "wonder-struck" (Thieron's word), but at the same time, as Thieron explains, their "virtuosity worried Breton." "We wondered," he goes on, "whether larger formats wouldn't make Dali's paintings look like

photographic blow-ups. The year 1931 proved us wrong." I would disagree. I believe they were proven right. Some have claimed to see a Flemish accuracy in Dali's painting of the 1930s and 1940s; but he has none of the clarity of form or of color that gives even the most horrific dreams of Bosch and Bruegel their lyric beauty. Dali's renderings are grimly literal (in the manner of the nineteenth-century *pompiers*) or woozily fantastical (in the manner of Gustave Moreau). Actually, I'd take the best of a nineteenth-century academic like Meissonier over most any Dali. Some of those Meissoniers give a minor pleasure—the pleasure of a dull, consistent virtuosity. Dali isn't a virtuoso. His drawing is lumpish. His color is metallic—like tarnished brass. He presents muddleheaded dreams in a muddleheaded way.

When Breton changed his mind about Dali in the late thirties, he explained his rejection of the by-then-notorious Spaniard in terms of the artist's Fascist sympathies and lust for money. This is a case in which high living does go along with bad art; so Breton, who concocted that dazzling anagram, Avida Dollars, could feel justified in the thought that great art is produced by sober people. Yet Dali's niftiest work of the thirties and forties is often his most unabashedly commercial: the collaborations with the fashion designer Elsa Schiaparelli, the decorations for the pages of *Vogue* and *Harper's Bazaar*. When Dali turned a shoe into a hat or splattered his signature motifs over the glossy magazines, he was showing the world that the only fantasy life worth living was the fantasy life of commerce. And some of those conceits—like the lobster-ornamented organza evening dress he designed with Schiaparelli—are suffused with the hyperbolic mood of Europe on the brink of World War II. Fashion was the perfect vehicle for an artist who never had a very firm grasp on the fantasy life of art. Dali's escapades in haute couture are among the least fussy, most authentically engaging things he ever did.

Dividing his time between New York, Paris, and Spain, Dali careened through the postwar decades, an ever more absurd character. In the biographies, there comes a point where you start skipping pages—it's all such nonsense. When an artist somehow shows us that he really loves art—well, then there's an awful lot of nonsense we'll accept. De Chirico had a grasp of painting, and so even his kitsch attracts us, draws us in. And even Picasso's worst antics, the clown impersonations re-

corded in David Douglas Duncan's *Private World of Pablo Picasso*, are of
some interest, because we know there's a real person somewhere in
there. (We know it because we know that only real people make real
art.) But Dali's craziness doesn't resonate. The oversized work of his
later years is pallid; there's no element of risk. Those Hollywood-scale
religious extravaganzas remain locked up in Dali's mind—mental con-
structs with no pictorial life to them. And the life, the life: how can we
get caught up in the flamboyant clothes, the dinners at Trader Vic's in
New York with the hippy hangers-on, when there's nobody at the heart
of the carnival? And all the speculation about life with Gala—did she
really control him? was she a manipulative monster?—is just star gossip.

For the public that bought his prints, Dali became an adorable
monster. Whatever might have been threatening about his eccentricities
was defused by the publicity mills. Dali is the Liberace of modern art.
His persona was so theatrically overdetermined that it began to look
tame—as tamely domesticated as the pet ocelot, defanged and declawed,
that he led around on a leash. Though Dali wasn't the only artist who
wanted to market his work among the American middle class—prints
by Picasso, Matisse, Braque, Léger, Chagall, and Miró poured off the
presses of Paris after World War II—no one played the commercial
angle so furiously as Dali. And the paying public loved him for playing
to its tastes. Most of the more famous modern artists were unwilling,
beyond a certain point, to put one over on the public or pander to the
public. They insisted that the plates from which their prints were made
be produced by hand—by their own hands. They insisted on some
degree of quality control, on some degree of craft. As for Dali, there's
really nothing original about most of his later prints. They're basically
photomechanical reproductions, no different from the reproductions in
a glossy magazine. But the public loves that photomechanical gloss.
Dali, it seems, respected the public just enough to give it what it could
immediately understand. To the public that sees only crudity in the
craft of modern art, Dali's prints look like the most craftsmanlike of all
modern achievements.

Dali's gift for fashion and commerce and self-promotion can be seen
as foreshadowing the commerce-conscious art world of today. For those
who believe that Andy Warhol is THE END, Dali might be THE
BEGINNING OF THE END. But there's another way to look at this.

Phonies have always flourished in close proximity to the real artists. Maybe our situation always remains essentially the same, which may not be cause for celebration, but will at least silence those who would see the apocalypse around every corner.

Winter 1990

KEEPING THE FAITH

At the beginning of this century the most adventuresome painters and sculptors took it for granted that anything in art that was going to *feel* radically new was also going to *look* radically new. For Picasso, Matisse, and a host of other artists this wasn't a matter of theory, it was a matter of fact. Since the 1860s, when Manet introduced a style of virtuoso informality into easel painting, most of the wonderful art created in France embodied unconventional ideas of pictorial structure. Monet, Seurat, van Gogh, Gauguin, and Cézanne changed the face of painting; Fauvism and Cubism went further yet. We can still argue whether these transformations of tradition were intended as assaults on the past or as renewals of the past (they were probably some of both). But whatever the intent, in practice it amounted to the same thing: art looked different.

Now we're deep into a new period, a period when the best contemporary art expresses feeling through subtle though critical shifts in received structures. What feels radically new doesn't any longer look radically new. At least, this is what I conclude from the art that interests me the most as I make the rounds of the galleries. Postmodern theory is an attempt to deal with this dramatically changed situation, but postmodernism is as obsessed with new styles as twentieth-century art has ever been. The search for radical formal innovations continues, and no matter how quixotic a search it becomes, it continues to absorb vast amounts of energy. Meanwhile, everything in art that's emotionally authentic and plastically vital is made to feel marginal; it's presented as retro-chic or neotraditionalism, or is ignored. This is the central conundrum of our art scene: innovation-for-the-hell-of-it is obscuring the real developments.

It's difficult to say at exactly what point in the century art that looked radically new ceased to feel radically new. In the twenties, while artists such as Mondrian, Masson, and Miró were still turning painting inside out with extraordinary results, Matisse and Picasso were already looking to renew themselves through an engagement with older structures. We have yet to catch up with the significance of Renoir, who achieved transcendent greatness only after he rejected Impressionism in favor of a style of coloristic chiaroscuro based on Titian and Rubens. What fascinated Picasso and Matisse—and Derain, Braque, and Dufy— was that the more "conservative" Renoir's work became structurally, the more explosive it became emotionally. Renoir was going back to the future, and that's where we must go today.

But as the School of Paris led the way in the search for new feelings within old forms, the search for new forms was taking on a life of its own. Duchamp was the first artist to invent forms that had nothing to do with feelings—that, indeed, ruled out feelings altogether. After World War II, the Abstract Expressionists became the last artists to bring forth a new form that actually suggested a new feeling. But with Pollock and de Kooning it was no longer the case that the more radical the form, the more radical the feeling. The Abstract Expressionists turned structure inside out and achieved a small effect; as did Donald Judd, with his new ideas about sculpture. By the 1960s radical formal innovation had become, pretty much, a variety of academic exercise. But nobody knew it outside of a few artists. When Fairfield Porter said that he preferred Vuillard to Cézanne, and late Vuillard to early Vuillard, he was speaking for what was most advanced in American art. Still, his message fell on deaf ears.

The most highly publicized events of the current season are all further episodes in the devaluation of feeling. The Jeff Koons show at Sonnabend, the Warhol retrospective at the Modern, and the Whitney Biennial take us further down a road that was mapped out at least five years ago when the aesthetics of numbness, previously a matter of taste and fashion, were codified in the writings of the Poststructuralists.

A few weeks ago I was having lunch with a painter, and as we got to the espresso he blurted out: "Hey, we haven't even mentioned Koons!" Some claim to have been bowled over by Koons's polychrome

appropriations of souvenir-shop figurines, and Koons is now regarded as a key figure on the scene. Koons takes the imagery for his four- or five-foot-high statues from the merchandising hell of Middle America. His animals and children and sexpots and cartoon characters mimic the bad-taste-by-committee of fast-food-chain promos and megabucks amusement parks. Koons lends the significance of specimens in a freak show to images we don't normally even focus on. He has pushed the gross-out threshold a bit further, and his current brand of kitsch, though Pop Art based, is distinct from anything Warhol or anybody else ever did. Yet the thumbs-up reviews by Peter Schjeldahl (in *Seven Days*), Adam Gopnik (in the *New Yorker*), and Sidney Tillim (in *Arts Magazine*) strike me as intellectual riffs, literary impersonations of an experience that couldn't possibly have taken place at Sonnabend. Critics continue to buy into Pop Art, perhaps because they believe that anything that so many people find enjoyable as art must be good for art. Pop was never formally inventive, and Koons is just another artist who's taken the path of least resistance. His white-faced Michael Jackson is more or less what can be expected from a tradition that's been stuck inside a Brillo box for a quarter of a century.

For a couple of years in the early sixties, Andy Warhol was an original Dadaist wit. The hedonistic cleverness of the paint-by-number paintings, the Marilyns, and the soda pop bottles is something special, whether one calls that something high camp or all-American fun. But Warhol's was a wee talent; and even early on, his Dadaist hipster approach had a nasty and ponderous side—as in the trumped-up theatrics of the Disasters and Electric Chairs. Almost from the start, Warhol was trashing his talent, but that's nothing next to the way the Modern has trashed itself by giving Warhol the biggest retrospective of a modern artist that New York has seen since the Picasso marathon of 1980. Basically, the Warhol retrospective is a Whitney show; it's upscale bread and circuses. It's a Whitney show mounted with the kind of money and scholarly panache that the Whitney has rarely commanded.

Meanwhile, over at the Whitney itself, the Biennial picks up on the subdued mood of the last one, in 1987. The fourth floor includes some artists whose work has interested me in the galleries over the past year. Christopher Macdonald commands a large space with the hunky humor of his wood contraptions, while Andrew Spence's Minimalist abstrac-

tions (especially *Swivel Chairs*) are winning in their combination of brightness and gravity. And there is no denying that the scene as you come off the elevator onto the second floor is elegant, with the pale, virtually black-and-white works of Brice Marden hanging across from the darker, also virtually black-and-white works of Ross Bleckner. Then the second room, with brightly colored abstractions by Cary Smith and David Reed, quickens the senses a little bit. It's not a bad installation; it draws you through the show. Basically the curators' taste is for anything that looks marginally unlike what they've seen before. It's a succession of mild visual impressions. What the artists imagine to be risk-taking is really a matter of surface gestures; there's almost nothing in the show that gets under your skin, that you want to linger over. When I'd gone through the whole show, I wasn't offended; I felt brain dead. So what else is new at the Whitney?

In the 1980s the Whitney has taken an increasingly important role in molding public attitudes toward contemporary art. Until recently this was more or less by default, since our other museums of twentieth-century art were only marginally interested in the present. Now, with new directors at the Modern (Kirk Varnedoe) and the Guggenheim (Thomas Krens), both of whom have made their interest in the contemporary scene a matter of record, the Whitney continues to shape taste, but with a number of other institutions eager to follow in directions where the Whitney has led the way. Both the widespread affection accorded Varnedoe (a professor at New York University and long-time player at MoMA) and the skepticism that has greeted Krens (a newcomer to the city who can sound frighteningly high-tech in interviews) are first impressions. Krens's first major show, "Refigured Painting: The German Image 1960–1988," went down in April after receiving a very bad press. Neo-Expressionism had been old hat when MoMA mounted "Berlinart" two summers ago; and Krens, who wants to make fashion, found himself accused of not keeping up.

One indication of what Varnedoe has in mind for the Modern is the new Artist's Choice series, which gives contemporary painters and sculptors the opportunity to do creative curatorial work with the museum's permanent collection. "Burton on Brancusi," the initial installment of Artist's Choice, is a safe bet. Scott Burton's furniture sculpture—tables and chairs in stone and other materials—has become the

corporate lobby art of the 1980s; and when Burton puts Brancusi's *Bird in Space* and *Cock* on a white Parsons-style table, or takes Brancusi's *Fish* off its base and exhibits the base alone, he's merely observing that Brancusi's genius can be whittled down to the level of Burton's own fairly middling talents. It doesn't do anything for Brancusi; but it makes Burton, who has written a pamphlet to go with the show, look like an intellectual. Burton's noodling around in the collection is reversible, and so in a sense no one is the worse for it. If I were more interested in Burton's work, I'd be more interested in his installation. (Give Leland Bell carte blanche to organize a show at MoMA, and I'd be the first in line to see what he came up with.)

The issues that the Artist's Choice series raises are bigger than Scott Burton. Burton, "Burton on Brancusi," and Artist's Choice are merely instruments through which Kirk Varnedoe means to assert the relevance of the Modern to the contemporary scene. In a conversation with Michael Brenson of the *New York Times*, Varnedoe said that "the Modern has a very well-deserved reputation for scholarship, for securing the dates and sources of modern art. But modern art did not become dominant by that route alone. It also functioned by interpretations and misinterpretations that gave artists permission to do what they needed to do. We are not just a source of scholarly information but a resource for generating the new." In my opinion this last statement—one that reflects widely held ideas both within and outside the museum world—is a phantasm. It might be a particularly American-type phantasm. Since all of New York's major repositories of modern art were formed in direct response to the rise of the modern movement, the curators here have somehow gotten around to believing that they played an integral part in this development. New York curators like to disparage their colleagues and ancestors in Paris, who pretty much refused to buy—or were utterly unaware of—the most exciting art that their city was producing between 1880 and 1950. Perhaps Kirk Varnedoe imagines that he wouldn't have made some of the mistakes that were made on the other side of the Atlantic. But who are we to say that the indifference that French art institutions showed to contemporary French art was a mistake? Has the "relevance" of our museums had anywhere near as vital an effect on art as the "irrelevance" of the Louvre?

When Picasso said that museums were "just a lot of lies," he spoke

for an entire era. What he meant was that museums could barely make sense of the past and certainly knew nothing of the present. I will not deny that European painters from the Post-Impressionists to the Surrealists felt a great bitterness about the indifference of art institutions; but they didn't know how good they had it. Basically, the inventors of modern art evolved their own institutions: independent salons; galleries, from Vollard's and Kahnweiler's to Denise René's and Maeght's; and magazines, such as *Cahiers d'Art*, *Minotaur*, and *Verve*. These are the models that we should be following. The time has come to stop looking to the museums for guidance on contemporary art. History tells us that museums have never guided us in the past; nothing in the 1980s indicates that they can do so today.

Many of the people I talk to these days are looking for something other than Jeff Koons. But if I tell them that an artist they're familiar with has made a breakthrough, or that there's a wonderful new still-life painter out there—well, the reaction I get is often less than enthusiastic. Even though people are sick of the search for something totally new, they're itching for a revolution in style. If only they could get over that, they'd realize that feelings are evolving all the time.

Development—gradual, evolutionary development—is all. It makes the difference between the artist who's just administering shocks and the artist who draws us in and carries us along. Carroll Dunham, in his show this winter at Sonnabend (his first there; he used to show at Baskerville & Watson), proved himself to be an artist who can develop. It was a development that startled me, because Dunham has found a way of giving up what has been most beguiling in his work—the droll doodlings he did on surfaces of wood veneer—and making himself a more convincing artist. Working now on sheets of white ragboard, he's been creating paintings that each contain a single mutant form—a form that's like some biological freak, half Jetson cartoon, half medical illustration of the internal organs. Dunham's graphic elegance (he uses pencil scribbles to create funnellike growths and surround the big form with lots of jittery activity) gives shapes that ought to feel creepy a piquancy that draws you in. And the work is less flamboyantly scattershot than heretofore. Looking at his paintings (which are basically one color each: harsh pink, orange, violet, blue) is like looking at some weird insect;

your reaction is somewhere between discomfort and amazement. There's plastic invention (and, perhaps, a debt to Picasso's single-form semiabstractions of 1927–29) in the way that shapes thrust and bend, giving a sense of torsion to the painting as a whole.

Dunham's work has always brought Cy Twombly to mind; in the new work, there's a connection to the Twomblys of the early fifties that were shown at Sperone Westwater over the winter. I have a fundamental aesthetic difference with both Twombly and Dunham. While they believe that a painting is an inflected surface, I believe that a painting is a self-contained fiction. I don't find Dunham's imagination particularly interesting; and the arrangement of his show, in which each painting was cooked up using the same recipe, didn't give the impression of an artist who has more than one thing on his mind. Dunham is an artist I can't really give my heart to—he's so cool, so controlled. He's an artist I watch going along in another direction. What I wasn't sure of before and am sure of now is that he's *going*.

Some developments are harder to track than Dunham's because they involve smaller, more elusive shades of feeling. Louisa Matthiasdottir is a painter who some people claim has been doing the same paintings for almost fifty years. In a general sense, that may be true. But Matthiasdottir has her low points, which include, these days, most of her landscapes and animals, and her astronomical high points, which included, in her show at Schoelkopf this spring, the *Squash with Blue Cloth* (36″ × 62″). Matthiasdottir is the most important still-life painter at work today. While all of her still-life arrangements contain a similar array of vegetables and kitchen objects, they tend to separate into two groups: the ones in which heavy, saturated colors predominate; and the ones, like *Squash with Blue Cloth*, in which a few objects of relatively subdued color are arranged beneath a great expanse of gray light. Up until now, Matthiasdottir's best still lifes have by and large been the ones with more saturated color: the color locks into the surface and everything holds together. In the paler still lifes, where the formal challenge is to fill space without filling it, there is often a wishy-washy effect: space just seems to float away. In *Squash with Blue Cloth* the pale idea finally comes together—and for those of us who've been following Matthiasdottir's work for years, there's the exhilaration of seeing an artist carry through on an idea that she's never quite managed to carry

through before. One can point to some of the factors that make this paled-out idea work for Matthiasdottir here: the squash are placed in vertical and horizontal positions that move our eyes beyond the object, through the space; and the cool virtuosity of the paint handling opens up the forms without rupturing the very satisfying sense of the painting as a two-dimensional design. There is a brown pitcher here that is as monumental as a still-life object in a Louis Le Nain. The softness of some of the earlier still lifes in this series was a problem; they felt faint. But that wonderful pearly softness now coexists with a clarity of form.

Matthiasdottir is in her seventies, but her work has never been more relevant than it is right now. *Squash with Blue Cloth* is a painting in which nothing new is invented, and yet it feels new, and would look good hanging next to a Zurbarán, or a Chardin, or a Matisse. What more can I say? This is the kind of Matthiasdottir I adore: you can bask in it when you're in the gallery, and you can think about it afterward— think about the way the tabletop becomes a projection of the flat surface of the canvas, a projection into the third dimension of a planar geometry.

Matthiasdottir's still lifes take us to a point where art and nature meet. They grow out of the rich soil of French painting, the same soil that gave birth to modern painting. What interests Matthiasdottir is how the sense of life can be transformed into the idea that is a painting; and how the abstraction of experience that is a painting in turn recapitulates the sense of life. Our century began with exactly these sorts of concerns—not only in Matisse, but also in the early representational work of Mondrian and Kandinsky. While New York is now a mecca for painterly realists, their essential place in art culture is little understood. Or at least that has been the case up until now. There's a widespread desire to get over the fast-forward approach to art, and in some unexpected quarters painterly representation is resurgent. In Darryl Hughto's show at Salander-O'Reilly earlier this year, it was surprising to see that a well-known formalist abstractionist was painting figures. The mythic men and women who fill *Three Muses* and *Hero* are done in the same acrylic gel medium that has long been favored by Color-Field painters. These paintings may be done, as the announcement explains, "from life," but life, in Hughto's terms, is constrained by a concept of flatness derived from Pollock via Greenberg. In this approach, nature isn't a challenge to abstraction; it's just a victim, to be steamrollered.

The flatness of Hughto's figures is a lot less engaging than the flatness of Matthiasdottir's still lifes, where the idea of the plane is derived from Mondrian and Léger.

Painterly representation has its limits; it will never give us the joy of discovering a new pictorial universe or a new idea of what a painting can be. But when ideas in art have become as utterly divorced from experience as they are today, the painter who works directly, transforming what he sees with his eyes, can seem like the rock of sanity we all need to keep in view. When I see a show like Marilyn Lerner's at John Good in February—where the ideas about geometric abstraction are moderately interesting but the painting is dead, like graphic design—I want to tell the artist, "Go and learn from what a terrific flower painter can do!" In April, the two finest flower painters at work today, separated by a generation in age, both had shows. Nell Blaine (at Fischbach) and Rita Baragona (at Bowery) are bourgeois sensualists. They use garden flowers to give us lessons in the fundamentals of painting. When done with their kind of lyric zest, flower painting becomes a metaphor for painting itself: color-as-form, that's all it is. The vase on the table, the tablecloth, the view out the window: in a sense these are proprieties, the manners and conventions that frame what is in essence an exercise in back-to-basics. The excitement one feels before these paintings has to do with the nakedness of the process. That only a half dozen or so of Blaine's voluptuous oils or Baragona's more severe acrylics are totally convincing is perfectly all right. Starting from scratch every time is the flower painter's chosen destiny. Taken together, Blaine and Baragona are the paragon of a living tradition.

One day in April I saw the Blaine and Baragona shows with David Hockney's show at Emmerich sandwiched in between. Hockney seemed to fit. This was Hockney's most restrained appearance in years; it was as if, after the overkill of the Met retrospective, he wanted to prove to doubters that he could get down to business. And—damn it!—there's something to Hockney. Here he was painting variations on a number of Picassoid themes. Hockney's painting of a Malibu beach house echoes those wonderful little trecento-inspired landscapes that Picasso did at Cannes in the fifties, only Hockney has severe problems with color. The most heartfelt of Hockney's homages to Picasso is a small portrait bust of a young man, *Thanasie*, done in the Renoiresque, Pompeiian-

pink palette that Picasso adored. Picasso saw the link between neoclassicism and homoeroticism, and Hockney, following Picasso, produces a Pompeiian youth. Conceptually, Hockney is giving one hundred percent in this painting. Emotionally, he's giving one hundred percent, too: you can feel him taking in that pale skin, dark hair, heart-shaped mouth, those amber eyes. But formally, Hockney is giving, oh, forty percent: the face isn't quite credible; it's not full enough. Looking at this portrait, I wish that Hockney would go the distance, because there's something delicate and penetrating about his imagination. This jazzy illustrator knows a thing or two about life and love. Maybe if Hockney locked himself in the studio for three or four years, he could find a way to put what he knows into his work, instead of leaving it tacked on top. With Hockney everything comes down to a question of character.

The question of character is the essential question right now. Never before in art has talent meant so little, character meant so much. When taste is generally elevated it may be possible for talent to float upward. But when taste is down in the gutter, as it is now, brute talent drowns. Character is all that can save an artist. Gallery-goers have to be willing to discover character, to become connoisseurs of character. Of course character isn't sexy, or at least not until you've let it work on you for a while. We must wait patiently for the moment when character bursts forth and becomes inspiration. Artists today are evolving slowly, finding themselves in their thirties and beginning to paint great paintings only in their fifties and sixties.

To ask patience of the audience is to ask a great deal. But what choice does one have? What does a person do when he's gone to fifteen galleries in an afternoon and seen nothing that he cares to think about afterward? He can give up. Or he can keep going, ferreting out the good things that are to be found here and there. The artists *are* still working. And some of them are marvelous. If we can just get over the irrational desire to be bashed over the head by art that gives us nothing but a headache, then we can leave behind the search for new forms, focus on the evolution of new feelings, and move ahead. History tells us that renaissances often come at the turn of the century.

June 1989

COMEDY OF STYLES

Modern artists make jokes through juxtapositions. Cubism offers the Ur-example: a Victorian tassel hanging in an angular modern setting. This comedy of styles is by no means the only kind of comedy in modern art, but because it is formalist—based on juxtaposing forms in unlikely ways—it's uniquely modern. Examples can be found in the collages of Schwitters and Cornell, the sculptures of Picasso and Calder, the paintings of Klee, Léger, Miró, and Gerald Murphy. Like the comedy of manners, which flourishes in periods when manners are changing but a generally accepted idea of manners is still vivid in people's minds, the comedy of styles flourishes in periods when styles are in flux but the idea of stylistic homogeneity remains credible. Perhaps this is why it has been more difficult to sustain a comedy of styles since World War II. In the early decades of the century such juxtapositions were often meant as celebrations of a new age: by invoking previous styles, artists demonstrated exactly how contemporary the contemporary world was. But as the line separating premodern and modern becomes hazier, it is more difficult to believe in a comedy of styles. The clarifying humor in Saul Steinberg's dizzy drawings of postwar New York has to do with the artist's sense of the city as a mélange of styles in which no clear principle of contrast or construction obtains. But Steinberg's taste was formed in Europe, before he came to America, and so he brings to New York the old sense of unity. The art-historical juxtapositions in the recent paintings of Roy Lichtenstein fall flat because neither the artist nor his audience has a general idea about the value of style against which to measure Lichtenstein's devaluations. When nobody knows anything about style, style can no longer be a laughing matter.

Trevor Winkfield's brilliant comic paintings, which were at the Edward Thorp Gallery last April, make the best of this problematic situation. Winkfield gives his unlikely juxtapositions of styles old and new a freestanding authority. He hasn't gotten himself in over his head in the postmodern style wars, perhaps because he's not a New York art-world insider. For one thing, this forty-five-year-old English expatriate has continued to cultivate a very British brand of nursery humor even as he's lived in New York for the past twenty years. For another thing, he pursued, before he turned to painting full time, a career as a translator (of Raymond Roussel) and editor (of the short-lived literary magazine *Juilliard*, which was named after one of Roussel's characters). Not surprisingly, the people who praise Winkfield's discombobulated narrative paintings are often poets. They respond to the Surrealist twist that Winkfield gives to Edwardian whimsy. John Ashbery has written that Winkfield's "crisply painted concatenations of unlikely objects, which make Lautréamont's famous dissecting table with its umbrella and sewing machine look decidedly underpopulated, have attracted a small but fanatical group of admirers, including myself." That "small but fanatical group of admirers" is cheering on a truly independent artist.

The formal manner with which Winkfield presents his array of eccentric images reminds me of Edith Sitwell's voice racing through the tongue-twisting passages of *Façade*, the cycle of poems with a William Walton score. Winkfield's paintings *are* facades; elegant funhouse facades, composed of sharply colored fragments set against expanses of sparkling white. The figures that tumble around in Winkfield's Flatland are jolly mutants composed of clothespins and assorted oddments. The makeup of somebody's left arm or leg tells you nothing at all about the makeup of the right one. Winkfield's paintings never achieve a magical unity, but they're constructed wonderfully, and it's a pleasure to watch as figures and objects in a range of styles emerge, unfold, and transform. As you look at the paintings, the literary, expatriate, and formalist elements in Winkfield's personality merge to create a sort of Poussin of the Five and Dime. Of a 1930s, Art Deco Five and Dime.

Winkfield paints slowly and exhibits only sporadically, so it's difficult to say exactly how his work has evolved, but my own impression is that this show was a big step forward for him. Many of the earlier

pictures (up to five years ago or so) were done in acrylic on paper in sizes up to twenty-two by thirty inches. The paintings in the recent Thorp show are all bigger and all done in acrylic on canvas. They *feel* painted. Winkfield's conceits take on a more full-bodied presence. The white fields aren't just blank spaces; they have the immanence of white spaces in classic Constructivist art. And the brushwork has an impact. Moving in close, you see the changes in shapes, the pileup of small strokes at the edges of a form. From a distance, all this registers, as it were, invisibly, giving the painting a certain weight as an imagined world.

But what is most exciting in these new Winkfields is their fullness: it's the multiplication of incidents and events that makes them the most consistently engaging pictures he's done. Here you don't find one nerd-like character and a few odd objects per painting. While there's still most always a central figure, you're in effect confronted by multiplying madness. The boy at the center of *The Hunt* has a bell for an eye, an iris for a hat, and is surrounded by a gaggle of things that includes a bus, a feather, a snowflake, a shell, some naval motifs. The figure with the wizened medieval face in *Banishing Bricks and Pills* has a blue-and-white polka-dot bow tie, a skeleton foot, a yellow and green hand, and a clock for a torso. He's surrounded by more naval motifs, cocktail glasses, a skyline that forms the torso of another character who's got wheels instead of legs . . . it goes on and on. And what keeps it all going is the wit with which one form segues into another. Winkfield creates a rippling movement across much—or all—of a painting by repeating the same precipitously angled form again and again. The paintings are patchworks in which everything carries through. Some-times you'll be following the sequence of forms—as form—and suddenly realize, "Oh, gee, that's a cocktail glass." (This is in *Banishing Bricks and Pills.*) And then you realize that there are four of them and that one of them resembles the anchor in another corner of the painting.

All this is realized in flat, posterish color schemes that recall the work of Stuart Davis. It's not great color, but then Davis's isn't, either. While Winkfield's color is too evenly pitched to really generate a sense of light, it has more variety and resonance than one may at first imag-ine. (There are deep-toned paintings, like *Divinity Meadow*; and shrill ones, like *The Hunt.*) The same variety is to be found in Winkfield's

forms. The individual elements—silhouetted objects, faces and frag-ments copied (maybe stenciled) from medieval prints and nineteenth-century illustrations—have a formal interest as well as a narrative one. The inclusion of premodern passages as an element in a modern graphic style brings to mind sophisticated commercial design of the fifties and sixties—the work of Paul Rand, Milton Glaser, and Peter Max. (Those designers, in their turn, had looked at Cubism.) But Winkfield isn't overwhelmed by his borrowings. He knits them into his own cheerful, ever-so-mildly-psychotic vision. Winkfield arrived in New York at the end of the sixties, and the work he's doing now has some of the giddy silliness, and some of the nightmare undertow, of that period. He brings to mind the Jefferson Airplane song "White Rabbit," in which one pill makes you larger and one makes you small. (It goes without saying that Winkfield evokes Lewis Carroll.) Winkfield comes about as close as any artist ever has to the psychedelic fun of the Beatles cartoon movie *Yellow Submarine*.

Trevor Winkfield's paintings amuse without actually making us laugh out loud. It's rare that a painting makes us laugh out loud. Com-edy—which is based on timing, and dramatic juxtapositions—is always a bit uncomfortable when it's trapped in the enclosed, formalized frame of a painting. The painters who are humorists produce a humor that, even when it's based on outrageous caricature, is rather dry in its effect. If you do laugh, it's inwardly. But comedy that makes you laugh in-wardly has its dangers: it can be precious. (Instead of making you laugh, it can make you feel virtuous about the idea that you laugh; it can produce highbrow canned laughter.) The compositional rigor of Wink-field's paintings is part of what gives them their edge against precious-ness—or at least against excessive preciousness. (And the more rigorous the composition, the less precious the humor: Klee is a compositional genius.) Composition is also what makes Winkfield's comedy feel dis-interested, self-contained. Humor in painting must be disinterested; if it's interested, it's graphic art, another thing entirely.

A lot of the comedy in recent art is overly interested: it has an axe to grind. When conceptual art feigns humor—which is often the case with Sherrie Levine, Barbara Kruger, and the relative newcomer Chris-topher Wool—comedy tends to pass over into irony, a corrosive kind

of irony. The artist (and the viewer) is involved in a send-up or send-down of the very idea of the work of art. The pretense may be a comedy of styles, but the subtext is an ideology of styles. Such deconstructions have considerable cultural authority right now; but they give no joy to the gallery-goer, which may be why there is a shifting among artists away from irony and back toward comedy. Though Winkfield is too much his own man to tell us anything much about the scene, the higher profile that his work has achieved in recent years may indicate that people are increasingly sympathetic to a comic vision. Richard Petti-bone, an artist who was known in the sixties for whimsically miniatur-ized copies of Andy Warhols, was again in the limelight last winter with a show of whimsically miniaturized copies of Brancusis at the Curt Marcus Gallery. This is another sign that light comedy, however mis-begotten, is popular. And in April, at the John Good Gallery, Chris-topher Lucas, who's in his early thirties, created a mixed-media environment that was comical in mood.

Lucas's exhibit didn't have a Yellow Submarine, but it might as well have: there was a rowboat with polka-dot decorations, a kiddie slide, and a sled. On the walls there were pictures made of sewn cloth that looked like banners—banners in search of a cause. One finds pieces of a lot of artists here: Mike Kelley and Matt Mullican (in the banners), Jennifer Bartlett (in the boat). But Lucas's work conveys a certain genial innocence that is to some degree his own. The slide, of partly painted, partly stained wood with some nursery decals stuck on here and there, is a case of Dada meets Constructivism. It has charm. The novelist William Burroughs, in a catalogue note, explained that these are "not just pretty bric-a-brac, but means to spiritual journeys and experience." I don't know about that. I'd call Lucas's show a comic Constructivist stage set waiting for the performance to begin.

Constructivism and comedy isn't an entirely unlikely match. There's a comic side to the three-dimensional concoctions of the Russian Con-structivists, and the artists of De Stijl and the Bauhaus, in their more decorative works, can be witty, too. While the comedy in the old Con-structivism was an overflow of the high spirits of idealism, the new comedy of Constructivism is a by-product of the ironic attitude that is currently taken toward all historical styles. If Constructivism once sig-nified otherworldliness, it may now signify rootlessness. At least that

is how it looked to me after I saw the work of some young Russian
artists, members of the Friends of Mayakovsky Club in Leningrad, who
were the subject of a private showing at a townhouse on East Fifty-first
Street in the spring. The painter Sergei Bugaev, who also goes by the
name Afrika, brought over the work of eleven artists including himself.
The members of the Friends of Mayakovsky Club are fascinated by
recent artistic developments in the West (recent for them includes every-
thing as far back as Pop Art), and they're also fascinated by the founding
generation of the Russian avant-garde. They seem to want to hold
Malevich and Warhol in their imaginations simultaneously. Actually,
what is Pop in their work is closer to Europeans like Sigmar Polke than
to American Pop. Many of the paintings are done, Polke-style, on found
fabrics—partly because canvas is unavailable, but partly, one suspects,
for aesthetic reasons as well. Bugaev stencils onto found textiles à la
Polke and achieves some sweet effects. He tickles us by pretending that
he's a little old Russian folk artist who has somehow heard about modern
art. *Winter in the Crimea* is a piece of white lace stenciled with a yellow
sun and a few pine trees. Those flat, single-colored shapes bring the
Constructivists to mind, just as the pose of Giorgi Gurianov's gray *Soccer
Player* brings to mind a pose of Nijinsky in his tennis ballet, *Jeux*. Heroic
modernism is a series of picture postcards for these artists. And why
shouldn't it be? What opportunity have they had to see it firsthand?

Sergei Bugaev and the other members of the Friends of Mayakovsky
Club are trying in their own perhaps necessarily disorderly way to
resurrect an indigenous modern art tradition that was killed off before
it had a chance to take root. That the post-Cubist simplifications of
Malevich and El Lissitzky are now becoming the raw material for one-
dimensional comic routines is at least in part because that Russian mod-
ernist tradition doesn't offer the parodist much resistance. It's a great
but thin style. Even in the supreme form of Mondrian's Neoplasticism,
Constructivism is the riskiest of modern styles, the style that buries its
connections to the past most completely. For Russian artists whose
government has denied them access to the past, and for American artists
who are as ignorant but perhaps more personally culpable, Construc-
tivism is attractive precisely because it looks like the style that came
from nowhere. It's turning into the nowhere style for Nowhere Men.
(Ironically, it ends up being the only historical style that some younger

artists know anything about.) Sergei Bugaev and Christopher Lucas are victims of a late-modern comedy of styles. They're the people for whom Roy Lichtenstein's art-historical pastiches are the entire history of art. They're the nerds in Trevor Winkfield's fantasias, spinning round and round in a Museum without Walls that's been reduced to the dimensions of a Classic Comic.

September 1989

LETTER FROM PARIS:
BICENTENNIAL BLAHS

It's a long time since Paris was regarded as a seedbed for contemporary style in the visual arts. French prestige began to erode after World War II, and by the time Pop Art arrived in the sixties, even the French could see that Paris had lost out to New York. By the seventies, as the spotlight shifted from America to Germany and Italy, France found itself, for the first time in maybe four hundred years, a second-rate artistic power. In the eighties, France has only fallen further behind: along with playing a supporting role to Italy and Germany, France is now overshadowed by Spain, England, Russia, and Eastern Europe as well. Most of the new European art we see in New York is as instantly forgettable as the occasional French imports that do come our way. But the conventional wisdom has it that the French can't innovate and other Europeans can; and American art professionals nowadays visit Paris for the food, the shopping, the cafés—for everything except the contemporary art.

Maybe there isn't any worthwhile art being created in Paris today; but considering the extent to which the curators at French museums are now fixated on international developments, I doubt they could recognize something homegrown and authentic if it did come their way. Parisians are painfully aware that foreigners, American and otherwise, expect no further chapters in the history of French painting. And if the events scheduled in Paris for the bicentennial summer just passed are any measure, the French are now hell-bent on proving to the world that they, too, can refuse to be Francocentric.

Going to look at contemporary art in Paris today, you have the same everything-is-one-thing experience you have in Amsterdam or London or L.A. "Magicians of the Earth" was the title of the big in-

ternational show mounted over the summer at the Pompidou Center and at the Great Hall of La Villette, the new exhibition space in northern Paris. There was nothing French about "Magicians"—it could have been an event at Documenta or the Venice Biennale. Meanwhile, *La Fée Electronique*, a multimedia provocation arranged by the Korean-born, American-bred Nam June Paik in front of Dufy's sublime *La Fée Electricité* at the Museum of Modern Art of the City of Paris, was the oddest bicentennial celebration imaginable: a slap in the face of French art. "Magicians" and *La Fée Electronique* were meant to prove to us that everything is now plugged into everything else: that the distance separating the Pompidou Center from the Whitney Museum in New York is no greater than the distance separating the Pompidou from the artists' studios in the Bastille quarter a couple of Métro stops away. And many people have been seduced by this vision of art as flourishing in a post-McLuhan global village, even though such a vision flies in the face of the most basic facts of artistic experience.

Artists are, with few exceptions, stay-at-homes, and for good reason. A dematerialized world of telephonic communication, magazine reproductions, air travel, and international get-togethers takes them away from the stubborn materialism of what they do. It was Paris that taught Picasso and Mondrian and Gris and Miró and de Chirico how to give their dreams a concrete form. For two hundred years it was Paris that taught the whole world that in art materialism is the key to the sublime. And now the French, of all people, are forgetting their own essential lesson. If French painting really is dead, at least the French could have spent the bicentennial summer showing what French painting had been about. But French officialdom is in no mood for mourning or recollection. (It does not understand that mourning can help us resolve our relation to the past and move ahead.) At the Pompidou Center pride of place is given to the trendy stuff some of us wish we hadn't seen in SoHo in the first place.

Barbara Kruger kicked off the first half of "Magicians of the Earth" with a word picture *en français*. Specially designed for the show, this freestanding structure was emblazoned with the big question—"Who are the magicians of the earth?"—followed by a list of possible candidates, among them secretaries, art dealers, mothers, doctors, politicians, critics, soldiers, movie stars, artists, and taxi drivers. Kruger's oversized

poster was probably meant to provoke thought among the large heter-
ogeneous audience that visits the Pompidou. Any one of you, Kruger
was saying, might be the subject of this elaborate exhibition. The show
itself—which juxtaposed work by current art stars of the Kiefer and
Cucchi ilk with work by folk artists from less developed countries around
the globe—probably left most visitors with more question marks in their
minds than there were on Kruger's poster. The organizers provided the
international art stars and the Third World craftsmen with small one-
person shows. These were interspersed in separate but equal areas that
gave a sense of juxtaposed accomplishments without presuming to make
explicit connections between one artist and another. In presenting this
curious amalgam, the curators explained that they wanted to reveal "a
bond between works of art by demonstrating the universality of the
creative act." The show was the kind of banal, labored mess that curators
with universality on their minds regard as exciting.

With the Pompidou moving into its second decade, it was thought
to be a good time to correct a policy that had tended, in previous years,
to show almost exclusively the work of Western artists. Much was made
of the fact that the artists from Mexico and Haiti and other Third World
countries were presented as individuals—just like the artists from Mary
Boone. Visitors who thought the show went "Thud!" could be accused
of racism. But couldn't the organizers in their turn be accused of prop-
agating the arrogantly elitist idea that the folk artists needed the company
of the art stars to lend them luster? If the Pompidou was so eager to
redress the balance, why not a show just of folk artists? Well . . . because
no one would fund it? Barbara Kruger might have been suggesting that
anybody—a doctor, a secretary, a taxi driver—was a magician of the
earth. But the design of the show told visitors that only an artist could
be one. And the subtext told visitors that only an art star could be one.

Global pluralism isn't a viewpoint that "Magicians of the Earth"
could be said to entertain seriously. Global pluralism is merely a mar-
keting strategy, designed to add new pizzazz to the same old god-awful
art. What diversion there was to be had at the Pompidou Center was
low-level indeed. Kiefer offered a new brand of Kiefer: a piece you could
walk into, a sort of freestanding closet hung with lead sheets. I found
Polke the most engaging of the bunch. *Jeux d'enfants* (1988) is good sloppy
fun: splashes of green and purple run riot amidst a couple of silk-screened

Rococo cupids. The thirty-year-old Julio Galan, whose show at Annina Nosei in New York last season was widely noted, again offered his mild impersonations of Mexican folk imagery: paintings in soft, tarnished colors that evoke hand-painted store facades and provincial religious art and are sometimes encrusted with rhinestones. Of the artists who await their SoHo apotheoses, I noted Dossou Amidou of Benin, who does bright, graphic masks, and Felipe Linares of Mexico, who does amusing fantastical animals in papier-mâché. I suppose the only thing to say about these folk artists is that, in this context, their work was no more or less effective than that of anyone else. Having gone through the show at Pompidou, I couldn't bring myself to take the Métro out to the second half at La Villette.

A French friend remarks of Nam June Paik, who had a place of honor at "Magicians of the Earth" with a humongous vehicle made of video monitors, that his prestige has been inextricably linked with that of Pontus Hulten, the international art impresario who has at one time or another headed the Pompidou Center, the Museum of Contemporary Art in Los Angeles, and the Palazzo Grassi in Venice. "Pontus," my friend says, "brought Nam June Paik along when he came to Paris to take over Pompidou. Unfortunately, Nam June Paik didn't leave when Pontus left." At the Museum of Modern Art of the City of Paris, Nam June Paik was given the opportunity to make a contribution to the bicentennial celebrations. In the catalogue, Suzanne Pagé of the museum remarked, "When looking around for an artist capable of 'bearing witness' both right now and for tomorrow in the context of the Bicentenary celebrations of the French Revolution, it soon became evident Nam June Paik was one of the few truly universal figures in the thinking and creation of today." (The odd English translation is from the catalogue.) As at "Magicians of the Earth," universality is the goal and chaos is the result. Nam June Paik's *La Fée Electronique* is chaos of an especially insidious sort: it is set up in front of the enormous U-shaped mural that Raoul Dufy painted for the Pavilion of Light at the 1937 Paris World's Fair. Significantly, *La Fée Electronique* appeared in Paris at exactly the moment that the Museum of Modern Art in New York had invited Scott Burton to use the museum's Brancusi collection as raw material for his own "Burton on Brancusi" event. Like "Burton on Brancusi,"

Nam June Paik's multimedia extravaganza suggests that our curators believe that the only way left to make museums interesting is by turning their permanent collections into postmodern happenings. Brancusi's reputation as a major modern is able to withstand any assault. Dufy, a twentieth-century artist who has yet to be accorded his rightful place in the history books, can ill afford the wrong kind of attention.

Dufy's *La Fée Electricité* is the most underrated work on permanent display in Paris. This monumental summation of the uses of energy, light, and electricity through history doesn't always sustain the highest imaginative level; this is a problem it shares with many other large-scale painted decorations. But like Rubens in the *Maria de' Medici* cycle in the Louvre, Dufy in *La Fée Electricité* has the pictorial imagination required to render the impersonal personal. Dufy's inimitable combination of transparency and lucidity lights up everything he reveals: fields of sun-ripened wheat, a symphony orchestra, a neon city at dusk. Dufy dazzles with the reach of his imagination: he keeps presenting new sides of his story.

It is in front of this pictorial extravaganza that Nam June Paik has set up his campy fun fest. There are seven robots, named after heroes of the French Revolution, made of old retro-chic TV carcasses outfitted with TV monitors that flash a blitz of images, some revolution-related. Nam June Paik probably imagines that his splattering video collage is an analogy to the pulsation of Dufy's color. But Samsung Electronics (which underwrote Nam June Paik's debacle) is no match for Dufy's oil paint. Never has the keyed-up color of state-of-the-art TV looked so low-key.

The events leading up to Nam June Paik's *La Fée Electronique* are tangled indeed, a case of a contemporary artist using the distorted perspectives of postmodernist revisionism to appropriate and diminish a great creative figure in one fell swoop. It was about a decade ago that the controlled hedonism of Dufy's art began to attract the trendsetters, not in spite of the neglect into which modernism had plunged him but precisely because of it. People who understood nothing of the disciplined artistry that enabled Dufy to carry his paintings of orchestras and race-tracks into the empyrean began to praise him as a fun kinda guy. Dufy *is* a fun kinda guy, though fun is something he is at pains to present not as a life process but as an aesthetic ideal. When the Holly Solomon

Gallery in New York (where Nam June Paik shows) mounted a major Dufy exhibit in 1984, I felt trepidation. Pattern painters such as Kim MacConnel, who also shows at Solomon, might genuinely admire Dufy; but it was important to keep in mind that MacConnel was a funster whose work was all process without resolution, the exact opposite of Dufy. Since that Dufy show, I've had some good moments at Holly Solomon: William Wegman and Thomas Lanigan Schmidt have their winningly goofy flights of inspiration; and as an impresario Solomon can pull off some amusingly rococo effects, as in the "American Baroque" show that she mounted with twenty-one artists, including Nam June Paik, in her gallery last December. But it's one thing to throw together a high-level art party and imagine that you're sending us back to the great days of Bernini and Fragonard (you're not); it's quite another thing for Nam June Paik to set up a happening, high-level or otherwise, in front of a masterpiece like Dufy's *La Fée Electricité*, which actually does recapture for modern art the shimmering effects of what might be called the Ecstatic Baroque. Of course, Dufy carries the day. But why on earth is he being subjected to this onslaught by the very curators whose job it is to safeguard his work?

The identity crisis of the School of Paris dates back more than a generation. A retrospective of the work of the painter Jean Fautrier, mounted at the Museum of Modern Art of the City of Paris alongside Nam June Paik's *La Fée Electronique*, took us to the exact point in the 1950s when Paris began to forget what it meant to be Paris. Fautrier, who was born in 1898 and died in 1964, did some creditable still lifes and landscapes in the late twenties: they're dark, thickish paintings, reminiscent of Braque and Derain, and also of the work of Italian modernists such as Sironi and Campigli. Fautrier's fame, however, came after World War II, when his tan and bluish abstractions, with their great swells of paint, were touted by Parisians, including André Malraux, as the French response to Abstract Expressionism. Fautrier was said to be the French Pollock, an encomium that will sound absurd even to people who believe that Pollock is overrated. Fautrier's small-scale paintings are muffled and aimless. Their *art informel* amorphousness makes a definitive break with the French concern for classical construction; but Fautrier hasn't a clue as to how one might explode French

conventions in order to find something new, which is what the best Abstract Expressionists did, especially Hofmann. Fautrier represents Parisian taste at the point when it loses its nerve in a panic over the impending rise of New York.

"Magicians of the Earth" and *La Fée Electronique* are only the latest manifestations of a French art establishment that's determined not to fall behind New York. The irony is that now, when New York itself feels unsure of its authority, Paris can think of nothing to do except mimic the many ways in which New York expresses its insecurity. On the main floor of the Pompidou there was a Hans Haacke show this past summer. He's an artist who can explain certain things about how power is wielded in the modern world, but an explication of the power politics that gives major museum retrospectives to teeny artists such as Hans Haacke eludes his grasp. Upstairs, in the permanent collection, Jean Hélion, an artist whose work is a virtual encyclopedia of the lessons that New York and Paris should be teaching to each other, was pretty much invisible, despite the very fine and very large group of works that the Pompidou possesses. The only room with good natural light was being wasted on the Dadaist monochromes of Yves Klein. And Balthus, represented by a couple of paintings, including his magnificent *Painter and His Model* from the beginning of this decade, was saddled with the terrible artificial lighting that is the rule in this interior design by Gae Aulenti, an Italian whose Parisian commissions include the hideously overblown Musée d'Orsay.

The School of Paris may have died of natural causes, but the people who run the French museums were in an unnatural haste to inter the body. In France, modern art has passed out of existence as it came into existence—with the museum officials indifferent, hostile, or just plain ignorant. Now the French feel that they have nothing indigenous to offer and go on absurdist expeditions in search of the Magicians of the Earth.

October 1989

SEEING MAPPLETHORPE

I first saw Robert Mapplethorpe's photographs, including some of the sexually explicit ones, at the Robert Miller Gallery on Fifth Avenue about a decade ago. One show included s-and-m scenes that went way beyond anything that had been exhibited in a mainstream art gallery before. Even if you'd looked at hard-core pornography, there were some pictures of bondage and mutilation that could stop you in your tracks. And then there was the surprise of this appearing in an elegantly appointed midtown gallery, between Fifty-sixth and Fifty-seventh streets, with windows looking onto Tiffany and Bonwit Teller. Many of us told friends to go and check out that show. For people who knew the gay leather bars and back rooms firsthand, it was a crossover event—a case of minority tastes moving toward the mainstream. For anyone who didn't, it was at the very least a glimpse into an unfamiliar world. Whether you liked the work or not, it was a show you didn't forget. And as Mapplethorpe's career developed, that was about the farthest out in terms of subject matter that he ever went, at least in his gallery shows. In the eighties he tended to exhibit far less hard-core imagery at Robert Miller. His flowers and portraits and nudes must have been easier to sell. And, after telling all, maybe there was a feeling, on the part of both the artist and those close to him, that there was nothing much left to tell.

Now Mapplethorpe's photographs of s-and-m sex between consenting adult males and of children in erotic poses are the subject of a national debate. Mapplethorpe and his work had been receiving considerable media attention before he died of AIDS last March at the age of forty-two. But it was the decision of the Corcoran Gallery in Washington, D.C. (which is largely supported by public funds) to cancel its

leg of a traveling Mapplethorpe retrospective called "The Perfect Moment" that brought the debate about the photographer's work onto the floor of the United States Senate. In canceling a show that had already been seen in Philadelphia and Chicago, Christina Orr-Cahall, director of the Corcoran, gave the following explanation. The museum wasn't making a judgment on Mapplethorpe's photography, but on the advisability of showing such provocative work at a time of federal budgetary discussion, when the policies of the National Endowment for the Arts (which had put up thirty thousand dollars for the Mapplethorpe show) were under intense scrutiny from conservatives on Capitol Hill. As things turned out, "Robert Mapplethorpe: The Perfect Moment" did go up in Washington, at the Washington Project for the Arts (which is itself in part supported by NEA funds). Soon after, the House of Representatives voted to cut NEA funds by a symbolic forty-five thousand dollars—the amount that the NEA had given for the Mapplethorpe show and for a grant that was awarded by the Southeastern Center for Contemporary Art in Winston-Salem to the artist Andres Serrano, whose work includes a photograph of a crucifix submerged in the artist's own urine. Then the Senate voted to ban funding for five years to the organizations that had supported the work of Mapplethorpe and Serrano. And then, the next day, in a virtually empty Senate chamber, Jesse Helms introduced a resolution barring federal arts funds from being used to "promote, disseminate or produce obscene or indecent materials, including but not limited to depictions of sadomasochism, homoeroticism, the exploitation of children, or individuals engaged in sex acts." The measure passed, though as I write in early August its chances of surviving conference in September are deemed unlikely. All this was going on at the same time as the Supreme Court's decision declaring flag-burning to be a constitutionally protected form of free speech was dominating the news. And since earlier in the year there had been a controversy in Chicago about a flag being trampled as part of an art show, the Mapplethorpe question and the flag-burning question began to merge in people's minds.

By now there seems to be general agreement that in canceling the Mapplethorpe show the Corcoran made a major gaffe. The Corcoran's action had the reverse effect of what was intended: instead of deflecting congressional attention from Mapplethorpe's work, it thrust questions

of art and pornography into the worst possible arena, a near-hysterical public debate. Meanwhile, Jesse Helms has been making statements such as "I like beautiful things, not modern art" that have exposed, if it wasn't obvious already, the grotesquerie of the right-wing position. But even if the NEA manages to elude the most egregious assaults on its autonomy, the long-term effects of pressure from those whose interest in art extends only so far as legislating it are ominous. NEA policy is going to be colored by this controversy for a long time to come.

Congressional intervention in the decision-making processes of the NEA gives renewed credibility to one of the old arguments against any form of government subsidy for the arts: if they fund you they can censor you. But by now the NEA is so deeply knit into American art culture that it can't be done without, and the imposition of politically based standards of decency on the NEA could have a censorious effect on culture at large. To say this, however, isn't to say that the issues raised by the Mapplethorpe controversy are all black and white. Of the many concerned citizens who've gone into print, the painter Helen Frankenthaler, writing in an op-ed piece in the *New York Times*, strikes me as closest to the mark. Frankenthaler speaks as a person who has sat on NEA panels in the past. "I, for one, would not want to support [Mapplethorpe and Serrano], but once supported, we must allow them to be shown. . . . I find myself in a bind: Congress in a censoring uproar on one hand and, alas, a mediocre art enterprise on the other!"

I agree with Frankenthaler that Robert Mapplethorpe doesn't amount to much as an artist. His photographs of hothouse flowers and figures from high society are elegant but facile. His more provocative works hold our attention longer only because of the unexpected disjuncture between the silvery luxe of the style and the unabashed libidinousness of the subject matter. But to say that Mapplethorpe doesn't amount to much as an artist doesn't in any way deny the seriousness of the challenge that he and his supporters have posed to received ideas of what is possible in art. The Mapplethorpe controversy raises important questions about the relation of order and outrage, convention and innovation—in art in particular and in culture in general.

Mapplethorpe made his appeal to a sophisticated modern public, a public for whom events such as Nijinsky's simulated masturbation in *L'Après-Midi d'un Faune* in 1912 are monuments of Western civilization.

When this audience was confronted with the farthest-out Mapple-thorpes, its sense of history told it that it couldn't just turn and walk away. And Mapplethorpe upped the ante by making a very conscious decision to present his public with images that flaunted their obscenity: for example, a diptych in the first panel of which a penis is in some sort of metal restraint and in the second of which the restraint has been moved in such a way that the penis appears to have burst. When Mapplethorpe exhibited a photograph such as this, was he using the public's—our—confidence or abusing it?

Robert Mapplethorpe came before the public at the end of the seventies as an aesthete and a sexual provocateur. At a time when the art scene was shaking off a decade of self-imposed asceticism, his appeal was assured. The smoothly graduated grays of his photographs evoked the high-style fun of the fashion photography of the thirties and forties. His work told the people who were just then abandoning Studio 54 for points south of Fourteenth Street that there was nothing to be ashamed of—neither a taste for expensive hothouse flowers nor for back-room sex. Mapplethorpe's own matinee-idol good looks were a part of the story that his photographs told, and those who got to know him found an arresting personality—a Manhattanite in overdrive, with an appetite for life both high and low. After news spread that Mapplethorpe had AIDS, the artist chronicled his long battle with the disease in photographs of his own increasingly ravaged face; in the last self-portrait Mapplethorpe holds a walking stick topped off with a skull. His death earlier this year occasioned an outpouring of critical encomiums that was unusual, even in this Age of Instant Celebrity, for an artist who a decade earlier had been virtually unknown.

Given how charged his work was and his life ended up being, it would be absurd to expect anybody to respond to Mapplethorpe coolly. But what happened even before his death, around the time the Whitney mounted a retrospective in the summer of 1988, was very strange indeed. People began to act as if Mapplethorpe was exactly what he had never been—a middle-of-the-road guy. There's often something vague and euphemistic about the terms in which this very hard-edged and specific artist is dealt with. When Ingrid Sischy, the former editor of *Artforum*, titles an essay for the catalogue of the Whitney show "A Society Artist,"

it sounds almost coy. And the name of the show that arrived at the Washington Project for the Arts in June is a little odd as well: "The Perfect Moment" suggests the sort of bland hyperbole one would use when readers weren't supposed to know that the subject was very sexy.

Museum people have their reasons for skirting over Mapplethorpe's hard-core side: they don't want to lose the public. But what reason do critics have for sounding so damn blasé? Why does there seem to be this need to demonstrate that someone who held the fashionable world in thrall with his bad-boy behavior was actually just the boy next door? I have a friend who says of political attitudes toward homosexuality: "The radical right might put gays in concentration camps, but the liberals would do worse—they'd force gays to go to psychiatrists." In a way that's exactly what the liberal critics are doing with Mapplethorpe: they sanitize and sentimentalize him, they explain that all the fuss has been about nothing, that we all feel the same way. These are roughly the terms in which Mark Stevens described Mapplethorpe in a review of the Whitney show, published in the *New Republic* last September. "I find none of Mapplethorpe's photographs especially unsettling," Stevens wrote. "Even the picture of Mapplethorpe [with a whip up his anus] is curiously unaffecting; it is so staged that we feel safely distant, part of an audience. . . . Mapplethorpe is easy to like. . . . Except to those who are threatened by homosexuality . . . these photographs will seem cozy. That's the surprise." Michael Brenson, writing about "Mapplethorpe: The Perfect Moment" in the *New York Times* at the height of the controversy, went even further in this direction. He seemed to end up arguing that Mapplethorpe spoke for Middle America. "Mapplethorpe is not a marginal figure. On television, desire is turned loose in a hundred different directions and there is hardly a product that is not sold by arousing a wish for sexual possession and power. American culture swings back and forth between domination and submission— rushing to put people on pedestals and then rushing just as hard to prove they are indeed no different and perhaps worse than you and I." This could be the ultimate put-down of Mapplethorpe and his world: all those people who thought they'd traveled to the outer limits of experience might just as well have stayed with their parents in Floral Park and watched "Dynasty" on the tube.

The real question about Mapplethorpe's work isn't whether it

shocks: it does. Ingrid Sischy is absolutely right to say, "When these pictures first appeared there were shivers and most often people turned away, myself included." And she's right to say that Mapplethorpe aims to reach the stomach, a feeling "brought on by intensified or intensifying sensations, emotions, and perceptions." The real question is: Does Mapplethorpe provoke us in order to discomfit us or in order to draw us in? Does he make us question our values and assumptions and then stop there?—which would make him a sort of social commentator. Or does he shake us up in order to engage us in a new range of experiences?— which is what an artist does. When Sischy says that Mapplethorpe "is an artist who has made a deep incision into our culture," she is really praising him as a provocateur. But that doesn't tell us if the provocation is transformed into art.

There is a modern painter who provokes us in order to open up new expressive possibilities: Balthus. The paintings of girls with lifted skirts that Balthus did in the thirties and forties press our buttons in exactly the same way as Mapplethorpe's photograph of a little girl with her skirt hitched up to her waist and nothing on underneath. Then there are the differences: the age of the model (Mapplethorpe's is younger); Balthus's tendency to keep the underpants on; the particular sorts of manipulations and provocations that photography as opposed to paint-on-canvas sets off; Balthus's virtuoso technique and formal inventiveness as opposed to the prosaic symmetry of Mapplethorpe's composition. What all these differences add up to is a difference in intent. Balthus uses a transgression to pull us into a complex invented world, a world that we're urged to make sense of. Mapplethorpe thrusts a transgression at us—and leaves us to mull over our views on childhood, eroticism, pornography. Mapplethorpe makes controversy; Balthus makes art that stirs up controversy.

Curiously, some of the same people who praise Mapplethorpe have condemned Balthus. A painter I know says of this situation: "What they can't stand about Balthus is the fact that he constructs a painting." Apparently the art world finds pornographic imagery acceptable only to the extent that it transgresses against the idea of the self-sufficient work of art. Balthus's transgressions, which are also imaginative reconstructions, pose a threat all right, but it is not the threat it is said to be.

What is threatening about Balthus is the erotic conviction that the artist brings to an imagined world.

Balthus is the artist to look to right now. In a period of half-baked erotic art his oeuvre is proof that erotic perversity can give new life to old forms. At the same time, Balthus has never overplayed his hand. In certain instances he has even practiced self-censorship. When James Thrall Soby bought *The Street* (1933) a couple of years after it was painted, he found, as he explained in a letter published in Sabine Rewald's book on Balthus, that the section in which the boy puts his hand under the girl's skirt created insurmountable difficulties:

> I hung the picture in the living room in my house in . . . Farmington. I finally had to put it in a vault because my son—then about nine— and his friends would cluster around it and rush home and tell their mothers about the naughty passage they'd seen. I had always wanted to give the picture to the Museum of Modern Art, but I knew it couldn't be hung in a public gallery, and I finally wrote Balthus in despair that this was a very great picture doomed never to be seen. To my utter astonishment, and I'd known Balthus personally for years—he wrote back that if I would send him the picture he would be glad to try to change the passage in question. . . . He kept the painting for nearly two years and in 1955 turned it over to me. He said, "I used to want to shock, but now it bores me."

It is also probably not by accident that Balthus's most perverse painting was long kept from public view. *The Rape*, in which a female music teacher grabs at her girl student, exposing her pubis, was painted in 1934 and kept in a back room, available only to selected viewers, during Balthus's first one-man show at Galerie Pierre. It was not exhibited in public for over forty years, until 1977, when it was part of Balthus's one-man show at the Pierre Matisse Gallery. There is reason to believe that both its obscurity and its ultimate appearance at the gallery of Pierre Matisse, the artist's longtime friend and dealer, were orchestrated by the artist himself. As for the artist's motives, they may well have gone like this. At the time *The Rape* was painted, its subject matter was so provocative that the audience would have been unable to experience it as art (and the gallery might have had trouble with the

police); whereas now, with all that the audience has been exposed to, people will be able to enter into the logic of this work of art.

If the curators who organize Mapplethorpe shows had a tenth of Balthus's or of James Thrall Soby's understanding of the audience, they would understand that the Robert Miller Gallery is exactly the place where Mapplethorpe's s-and-m photographs ought to be seen. The enlarged, heterogeneous museum-going public may be shocked or bemused: they are not ready to deal with this stuff as art.

In a front-page article in the Arts and Leisure section of the Sunday *New York Times* that appeared shortly after the Corcoran canceled the Mapplethorpe show and weeks before the Helms amendment was introduced, Hilton Kramer observed of the controversy: "This is a problem that the art world has brought upon itself." That's a pretty bizarre statement, considering that Kramer wouldn't have been writing an article about Mapplethorpe in the *New York Times* if the radical right hadn't decided it was time to start censoring the NEA. But there is an element of truth in what Kramer has to say. Maybe if people weren't so intent on proving that Mapplethorpe is Every Photographer, there would be a bit more reluctance about sending his photographs on tour all over America. Kramer, however, made the whole question of whether or not Mapplethorpe's sexually explicit work ought to be on national tour sound more open-and-shut than it really is. "Images of this sort," he said, "which are designed to aggrandize and abet erotic rituals involving coercion, degradation, bloodshed and the infliction of pain, cannot be regarded as anything but a violation of public decency." The problem with this construction is that it sweeps aside Nijinsky's *L'Après-Midi d'un Faune* and a whole lot of other works of art that bring a private world of erotic fantasy and experience into public view. If the NEA is going to support the best art of our times, the NEA's judgments must take into account the fact that some of the best art of the last one hundred and fifty years has involved assaults on public decency.

But if the NEA is going to make reasoned judgments about the place of outrage within art, it is going to have to think long and hard about the relationship between audience experience and aesthetic experience. Assaulting people isn't a particularly sophisticated way to assert artistic authority. And the people who see every assault as an assertion don't get the difference. When Richard Goldstein wrote on

Mapplethorpe in the *Village Voice*, he focused on the essential issue: the relation of public morality to art. But he confused matters by bringing in the pornographic paintings that had been included in the Courbet show at the Brooklyn Museum last fall. Goldstein's article opened with a stunning photographic juxtaposition: Mapplethorpe's *Man in Polyester Suit* (1980), with an enormous penis hanging out of an unzipped fly, was set next to Courbet's *Origin of the World* (c. 1866), a close-up look between a woman's spread legs. When Goldstein asked why people could support the showing of the Courbet and not of the Mapplethorpe and concluded, "Homophobia," he missed the point.

Courbet's picture was created for a private patron almost one hundred and twenty-five years ago. It had never before been shown in public. Its most recent owner, the French psychoanalyst Jacques Lacan, had kept it behind a special screen designed by the Surrealist painter André Masson that consisted of an abstract variation on Courbet's theme. In her history of French psychoanalysis, Elisabeth Roudinesco refers to Masson's painting as a "protective covering" and explains that a "secret system" enabled viewers to remove the Masson and view the Courbet. Now if Lacan and Masson, luminaries of the French avant-garde world that made a cult of De Sade, felt some need to frame or set apart the Courbet when it was hanging in a private home, what on earth is Goldstein talking about? The fact is that 1988 may be exactly the time for that Courbet to go public, for people to accept its assault on decency and go beyond it. (And people still wondered about bringing their children.) By the logic of Goldstein's juxtaposition, Mapplethorpe's erotic photographs shouldn't go public until the end of the twenty-first century. I doubt that by then anybody will even remember who Mapplethorpe was.

Important artists do sometimes choose to administer shocks to public standards of morality. An NEA that can't support them when they do so is condemned to prudery and academicism. Yet it will take people who value art as art to understand when an assault on public morals is a matter of importance to art. Helen Frankenthaler is right to say that ultimately we must focus our attention on what goes on within the NEA. Quality is something about which everybody will never agree, but that doesn't make the effort to come to some sort of agreement any less essential. As in every question about art that we confront today,

the real argument is between those who believe in the autonomy of the work of art and those who see the work of art as little more than a message sent out into the world to do battle with other messages. The people who don't believe that art can transcend everyday experience have already made an assault on art beside which pornography's assault on public morals pales. Those who know that art can transcend our everyday experience know that art does this in a number of different ways. Eroticism, perverse or otherwise, can be an element in the equation.

Fall 1989

FOURTH SEASON: 1989–1990

VIVA VELÁZQUEZ

The Metropolitan Museum of Art has done so many problematical and downright awful painting shows in the past few years that the end-to-end perfection of this autumn's Velázquez retrospective may leave museum-goers giddy with happiness and disbelief. By the time "Goya and the Spirit of Enlightenment" rolled around last spring, many of my friends didn't even want to take a look. A museum that had already wasted a big retrospective on the slick tricks of Boucher, stretched Fragonard's delicate genius beyond the breaking point, and turned Zurbarán into a dull and ultimately saccharine artist was certainly not going to know what to do with an eighteenth-century Spaniard who could be playful one day, Michelangelesque the next. And "Goya" did turn out to be another of those messes that you left wondering, "What's it all about?" The paintings and prints were carcasses dragged in to illustrate some thesis about revolutionary Europe, a thesis that you didn't get, or, if you did get it, you disagreed. A show like this sours you on masterpieces: they become pawns in a mega-buster game.

The Metropolitan has fared better with its shows of late-nineteenth-century masters, no doubt because there isn't so much difficulty in establishing a raison d'être. Manet, van Gogh, and Degas are legendary figures—big box office—and the retrospectives of their work are foolproof popular hits. A van Gogh or Degas show puts itself over and thus speaks the only language—the language of crowds and cash registers—that the Metropolitan management can be sure to understand. Meanwhile, recent exhibits of the sculpture of the Pisano family and the painters of Siena have been saved by their very irrelevance. These early Renaissance events, tucked away in the Lehman Wing, are so out of

sync with the Met's mega mentality that they manage to triumph through institutional neglect. Left to find their own level, they become sleeper hits.

The trouble with "Boucher," "Fragonard," "Zurbarán," and "Goya and the Spirit of Enlightenment" is that the Metropolitan, along with whatever other organizers are involved, will neither do right by them nor leave them alone. The museum has conceived these as star-personality shows without any clear conception of what those stars might mean to the people who come and take a look. But these shows aren't merely the product of innocent miscalculation. There is cynicism involved in this transformation of major moments of Western art into box-office fodder. A museum that has frequently been criticized for serving up bread and circuses may believe that scholarly catalogues the size of the New York City telephone book will silence the critics. Having been blasted for "Harlem on My Mind," the Met now offers "Rococo on My Mind"—Parts I and II. These retrospectives are mega-busters for intellectuals—King Tut with scholarly catalogues—but the scholarship just becomes another kind of media blitz: a media blitz that intellectuals are embarrassed to complain about.

The problem over at the Met isn't that they think of museum shows in terms of showmanship; it's that they're often such ineffectual, lowest-common-denominator showmen. Time and again the Met misses the internal logic of what they're presenting: they don't know what to make of it, and so you get retrospective after retrospective where you reach the end and look at your companion and say, "Huh?" Fragonard's butterfly-weight genius deserves butterfly-weight presentation; instead, they clobber him. Goya's variegated achievement deserves an installation that lays out the story without editorializing; instead, they serve up an Age of Reason rationale. All the more amazing, then, that the people who run the museum have allowed Velázquez to work his miracles in peace. In part, it may be that Velázquez is such an extraordinarily great artist that you can't ruin a Velázquez show. But it is also apparent that Velázquez's greatness, his direct appeal, has actually inspired the staffers at the Met. For once they've done without those dark, sepulchral walls and floors they love. Somebody woke up and realized that Velázquez's theatrical sense is so assured that the museum needn't bother with its usual theatrical presentation. Amen. The carpeting is

light gray; the rooms are painted in a series of sandy pale tones—taupe, yellow, gray-blue, green. There's plenty of ambient light. You can see across the rooms and you can see the paintings. (You can, that is, if you've timed your visit early on a weekday to avoid the crowds.) When you come out of the show, you don't feel that you've left a bordello or Plato's cave—you carry the whole experience of this light-filled and effortlessly unfolding show into the clear light of New York in its autumn glory.

"Velázquez" is the perfect autumn-in-New-York show. Even the artist's dark passages have a pearly lucidity. Nevertheless, the world of kings and queens and courtiers and scholar-ambassadors out of which this art emerged is alien and more than a little incredible to us. Diego de Velázquez thrusts this lost universe upon us, gives us the sense of *then* becoming *now*. On leaving the show, one naturally wants to know more about Velázquez's life and times (he was born in 1599 and died in 1660). Reading about him in the very impressive *Velázquez* by Jonathan Brown that came out a couple of years ago (Yale), one enters a fully dimensional world. As a youth in Seville, Velázquez was apprenticed to the painter Francisco Pacheco (author of an important treatise, *Arte de la pintura*), who initiated the young artist into the idea of the artist's life as related to traditions of scholarship and classical learning and worldly refinement. At the court of Philip IV in Madrid, in 1628, Velázquez met Rubens, who was in Spain as an emissary from the Infanta Isabella, governor of the Netherlands, and they became friends, and Rubens encouraged Velázquez to see Italy. There is a great deal that we do not know about Velázquez, but Jonathan Brown has the true art historian's genius for letting what facts there are expand in our imagination. The great, gloomy palace interiors lined with masterpieces by Titian and Rubens come back to life, and we find ourselves inside the elaborately ritualized routine of the court.

Of Velázquez's trips to Italy, in 1629–30 and 1649–51, we have sketchy information; yet through the surviving records of his contacts with officials and ambassadors who were also collectors, we can assume a close acquaintance with the art and artists of Rome's last great age. Velázquez's Europe is the Europe of Bernini and Borromini, Poussin and Rubens; of grandly symmetrical facades and S-curves and ovals; of

velvet and gold and richly veined marbles; of angels and *trompe l'oeil*
decor and ceilings scattered with clouds of powdery pink. It's a world
that we can experience as a fantasy—the kind of fantasy, full of em-
broidered costumes and bizarre characters, that Fellini would gladly
drop fifty million dollars to resurrect on the sound stages of Cinecittà.
Velázquez has a Fellini side to him: both artists see life as a somewhat
inhuman pageant. Only for Velázquez, who actually lived that life, the
combination of the inhuman and the human isn't grotesque.

Philip IV was a considerable connoisseur of painting, and Velázquez
devoted a great deal of time in the later decades of his life to acquiring
works for the royal collections and to designing the rooms where they
would be displayed. Philip would have understood that art can make a
unity that improves upon the unity of courtly life; he was the kind of
man that people are thinking of when they speak of a time when the
hereditary aristocracy was also an aristocracy of taste. In any event, the
collection that Philip IV's predecessors had begun, and to which he
devoted tremendous energy and huge sums, created the conditions for
Velázquez's evolution as an artist. Without the king's collection, Ve-
lázquez could never have gone from the awkward and astonishing mas-
terpieces of his early years—*The Waterseller* and *An Old Woman Cooking
Eggs*, with their dark clarity—to a style that completely overturned the
sculpturally oriented painting of the Renaissance.

Titian's late manner had given brushwork a precedence once af-
forded to modeled form; but Titian organized his late works in a shallow,
stable space derived from classical relief sculpture and so maintained
his classical ties. It was from Rubens that Velázquez learned to under-
stand Titian; but Rubens, who could give up neither the firmly defined
forms of the High Renaissance nor the verismo of northern Europe,
never let the colored brush stroke loose in anything like the way Ve-
lázquez did. It's in Velázquez that the light-dark of the Renaissance
finally gives way to a shimmering silvery-gray world. A new kind of
color emerges: from colored objects, we move to colored air. Fifty years
later, Watteau, also coming out of Titian via Rubens, does something
similar; and although Watteau may in no way have been inspired by
Velázquez, these two artists are the true heirs of Giorgione and Titian.
In his book, Jonathan Brown invokes a modernist interpretation of Ve-
lázquez when he says that "he seems to have arrived intuitively at the

understanding of the dual nature of the art of painting, namely its ability simultaneously to create form and to express its own essence." But I rather think that the miracle of Velázquez is that he does both without making us conscious of the duality. It's the miracle of Watteau, too. This is what accounts for the strange quality of Velázquez's and Watteau's work, that it is both evanescent and absolute. In their pearly emulsions the theater of life and the theater of art hold together. When the portrait of Louis XIV is put in a packing crate in Watteau's *Shopsign* of 1721—the portrait of the king who married the daughter of Philip IV and whose military strength had left Philip IV melancholic, feeling that he had failed his ancestors and his people—at that point the *ancien régime* is collapsing in art as well as in life. We are on the verge of the heroism of modern art, heroic because it involves the invention of a unity in a world that doesn't know from unity.

Part of the pleasure we take in older art derives from our feeling that the great artists contain both the past and the future, that their visions stand at some unique intersection of before and after. The seventeenth century has more of this Janus-faced aspect than any other period, perhaps because from our perspective it marks the point where medieval and Catholic Europe is definitively transmogrified into the modern and secular world that we still inhabit today. When we say that the tiny landscapes Velázquez did at the Villa Medici in Rome contain all of nineteenth-century landscape painting; or that Annibale Carracci's *Bean Eater* could be by Courbet; or that the domestic scenes in Rembrandt's drawings are like outtakes from our everyday lives—what we're saying is that these artists seem to leap forward, that their consciousness seems to contain what is to come.

Velázquez's portraits have this contemporary quality, too, an immediacy that's set into relief by the alien formality of the courtly dress. My God, we think, these royals are like us. (You can't be so sure about that when you look at a news photo of Queen Elizabeth II.) Jonathan Brown believes that the unusual realism of Velázquez's portraits is connected to the very self-conception of the Spanish royalty, who traditionally believed that "only the greatest of the great could afford to dispense with the trappings of majesty and feel the confidence to face the world without the aid of rhetoric or theatricality." (That tells you

why Queen Elizabeth has to fake it.) But the astonishing connections between the Catholic portraits by Velázquez and the Protestant portraits by Rembrandt call for some broader explanation as well. While Velázquez is not mentioned in Arnold Hauser's great *Social History of Art* (the chapter on "The Baroque of the Catholic Courts" centers on France), Velázquez seems to exemplify some of the tendencies that Hauser describes in that gloriously generalizing style of his. "Naturalism," Hauser explains,

> remained by no means the exclusive property of the middle class. Like rationalism, it became for all classes of society an indispensable intellectual weapon in the struggle for existence. Not only business success, but also success at court and in the *salons* presupposed psychological acumen and a subtle knowledge of men. And even though the rise of the middle class and the beginnings of modern capitalism had given the first impetus to the formation of that anthropology with which the history of modern psychology begins, nevertheless, the real origin of our art of psychological dissection is to be found at the courts and in the *salons* of the seventeenth century.

Velázquez is hardly the only court artist in whose painting we see this new, coolly analytical approach to portraiture at work. Even amidst the flamboyance of Rubens's *Maria de' Medici* cycle, the Queen herself is often very acutely, very modestly represented. But Velázquez is the summa of courtly realism.

What ties together his King and Queen and Infanta and Pope and Nobleman and Servant and Dwarf and Buffoon is the artist's absolute refusal to sentimentalize—to claim that one can bare a person's soul. There's something ice-cold about Velázquez's faith in the truth of surfaces: the blush of a cheek, the glint of an eye. And yet this was an age so absorbed in the first promise of empirical truth that the coldness of the naturalist could become very warm, could point toward something divine. A naturalist without skepticism—this is Velázquez, and this is why such a peculiar conception as the casually informal painting of a downcast Mars, god of war, manages to be mythical and psychological and perhaps emblematic without skipping a beat or violating our confidence. I can think of no other artist who knows so precisely the exact line that separates sentiment from sentimentality. Rembrandt, a very

different case, doesn't know the difference; he just puts sentimentality over with so much pictorial conviction that we can't but accept it.

Like last season's Courbet show at the Brooklyn Museum, the Velázquez show does not contain the artist's great synthesizing paintings. Given the danger that shipping poses to works of art, it would have been the sheerest insanity to send *Las Meninas* or the *Fable of Arachne*. But the Met show—which already contains seventeen works from the Prado—doesn't need *Las Meninas*. In this sort of unforced presentation (reminiscent, again, of the Courbet show) the gathering together of a few dozen paintings creates a logic of its own. When next you see these paintings, you will remember them as they were here, and that's a nice thing to be saying about a Met show, which is generally an occasion when you feel that the paintings are being held against their will.

It is common in New York in the fall to answer the telephone and hear friends lamenting the provincial character of New York's museums. "After the Louvre, how can I face a third-rate place like the Met?" a friend will ask. A month later, we have readjusted: we have to work with what we have. But this fall, with Velázquez at the Met and "Picasso and Braque: Pioneering Cubism" at the Modern, New Yorkers are the luckiest museum-goers alive. We deserve it. As "Velázquez" and "Pioneering Cubism" opened at the very end of September, the gallery scene was off to a slow and ambivalent start. The week before I saw "Velázquez," I'd been making the rounds uptown and downtown, and it all seemed so tired, so overblown. News item: lead is the "out" material, gold leaf is the "in" material. Reviewers are trying to work themselves up over Sherrie Levine's Duchampian nonsense at Mary Boone—glass objects in wood vitrines—but does anybody really care? I was held by Spencer Gregory's paintings at the Sorkin Gallery—small, dark abstractions that are mystical and geometric, and in ways that aren't instantly categorizable—I will have to take another look.

In the midst of all this it's good to have two great historical shows, not as some absolute standard against which to measure everything else and watch everything else fail, but as a prod, an inspiration. These shows open out into the artistic life of the city. Frank Stella can do his Frank Stella shtick on Velázquez (in the Sunday *New York Times* on October 1), announcing that "Rothko's U*ntitled*, 1969, a late work in

black and white, has a silver shimmer that makes a good start at recalling Velázquez. Another example is Newman's magnificent *Ulysses*, 1952." How many people will any longer tolerate this shopworn formalism? Others of us will do our own shticks. But lordy, lordy: that big late portrait of Queen Mariana that closes the Met show—it's unstoppable. That black and brown and silver dress, an overscaled volume climbing up from the floor, rises, tapers, to the perfect climax of a little-girl head. It is a commonplace to observe the oddity of those faces stuck in those costumes, but in this most complete of portraits it isn't odd, it's inevitable. Doña Mariana of Austria married Philip IV when he was over forty, she under fifteen. Shortly afterward she had a daughter, Infanta Margarita, who became the subject of *Las Meninas*. From the catalogue we learn that Queen Mariana "was cheerful, fond of luxury and diversion. In 1657, on the occasion of her lord's birthday, Mariana spent no less than four thousand ducats on apparel of *imitation* gold and silver, lest people say she was spending so much in such hard times." But "at the same time rigorous court ceremonial oppressed Mariana's spirits. The lady of the chamber would rebuke her for laughing at the antics of the buffoons." Until January 7, all of New York City is Queen Mariana's court. Viva Velázquez.

November 1989

DIASPORISMS

Pick up a copy of painter R. B. Kitaj's *First Diasporist Manifesto* (Thames and Hudson) if you want to have some sense of the kind of oddball heterodoxy that an artist may feel compelled to invent for himself right now. This is a confusing and challenging time, a time when all the general ideas that were derived from the specificity of Cubism appear to have failed. I say right now, but Kitaj's book is not, to his credit, an I-was-born-yesterday confession. Kitaj, who's fifty-seven, has been at it for decades: painting, exhibiting, and from time to time proselytizing on behalf of his friends, a crowd of more or less representational painters who are more or less based in London. His book is a bit of a postmodern event, but it's also a modern event, proof that even as everything changes there aren't all that many possible kinds of thoughts to have anyway, and in the end is the beginning, and vice versa.

This "affectionate shot across the bows of so much received aesthetic opinion" (Kitaj's words) is short and messy, a combination of miniaturized-personal and overscaled-general that holds, loses, and grabs back a reader from page to page. "Painting," Kitaj begins, "is not my life. My life is my life. Painting is a great idea I carry from place to place. It is an idea full of ideas, like a refugee's suitcase, a portable Ark of the Covenant. Before I run for my train, spilling a few of these painting ideas, I just want to stand still on the platform and announce some of my credentials (more later): I am a dislocated pretender." It's hard to know if the combination of pride and modesty is authentic or put on; perhaps Kitaj himself isn't always sure. Kitaj finds his guiding metaphors of fearful alienation and miraculous self-renewal in the diasporist history of the Jews, who have been without a homeland for thousands of years

and who mostly still live outside their post-World War II homeland. Kitaj is treating a great subject in an idiosyncratic way. He describes a double diaspora: he is both a wandering artist and a Jewish expatriate. The book whizzes along for 128 pages (half of which are illustrations), and I find myself beguiled by his rambunctious Jewishness, as well as by his general feeling that the art of painting "may very well resist harmony and pattern," may resist the "human impulse to resolve ambiguity."

Kitaj is an exhibitionistically quirky writer, brilliant and blustery. And, like his paintings, which are quite specific about people and certain images and then spin off into inchoate expressionistic brushwork, his book hops from topic to topic and in the process skates over some of the places where one wants elaboration. He never makes much of a stab at explaining how all his complicatedly interconnected thoughts can be transferred to paint-on-canvas. The romantic in me gets seduced, while the classicist in me balks; but the *First Diasporist Manifesto* is a true manifesto ("albeit not a very aggressive one," Kitaj observes) in that the artist mediates exactly as he pleases between his private obsessions and the wide world where everything unfolds to our helpless and sometimes appalled astonishment. "I want it to be somewhat declarative," Kitaj says of his *Manifesto*, "because I think art and life are fairly married and I think I owe it to my pictures to put their stressful birth with some idiosyncratic precision."

This may be an age of artist celebrities, but artists have actually been rather quiet, letting others speak for them or else speaking in borrowed language—other people's jargon. Kitaj's book is sui generis: a rambling talk that has some of the casual style of real-life conversation and that, like a lively talk with friends about art, combines big thoughts and naughty jokes, such as Kitaj's teasing reference to "the outer spatial Frank Stella." I prefer Kitaj's self-proclaimed outsider stance to Stella's egotism, which is that of a sort of latter-day Sir Joshua Reynolds laying down the pictorial law. Nevertheless, Kitaj, a celebrity "who feels out of place much of the time," doesn't entirely convince us (at least me) when he describes his feelings of alienation. The writing is so jaunty, so ebullient. "I'm sorry and excited to be so difficult and unpopular" is maybe a little over the top, coming from one who shows regularly at the Marlborough Gallery in New York and London. And what's the

point of a salvo such as "I'm just a poor struggling painter"? But then again Kitaj says, "Much of my life I've been a good bad boy." This, I suspect, is right on the mark. "I've pursued the Spirit of Romance as good bad boys do in Art and Life. I chased it all over Europe, across America, into and out of trouble and assimilations of many kinds." This I believe.

I also believe the self-portrait of the secular Jew who "as a young man . . . was not sure what a Jew was" and was brought up as "a freethinker with no Jewish education." We all know people who started out that way and ended up trying in one way or another to deal with Judaism and Jewishness (two very different things). Kitaj's relationship to these parts of himself strikes me as honest and achieved through a process of self-examination that cannot always have been painless. Kitaj is what he refers to in the catalogue of his 1985–86 show at Marlborough as "an *interested* Jew of some kind." In the *Manifesto* he gives, in passing, a measured liberal view of Arab-Israeli relations. And I'm relieved that he does not romanticize religious orthodoxy, which liberals are wont to do. Too many liberals look at the folkways of the Hasidim (the most visible of the Orthodox) through those tolerant-liberal binoculars and sigh sympathetically, as if that were the real thing, irreproachable and, of course, rigid as anything and practically impossible. Kitaj is easing himself into a world he was born of but not into, and no one can ask of himself anything more.

The *First Diasporist Manifesto* is about Jewishness and modernism, about a people "dispersed, hurt, hounded, uneasy, their pariah condition confound[ing] expectation in profound and complex ways." It's not new to observe that there are tangled connections between Jewishness and the culture of modernism, and Kitaj makes no bones of his debts to writers who have brought a Jewish past into the secular present, among them Walter Benjamin and Isaiah Berlin. He quotes from Clement Greenberg's essay on "Kafka's Jewishness," the essay with which, not insignificantly, Greenberg chose to conclude his 1961 book *Art and Culture*. (Greenberg was saying: "Judaism still matters.") Greenberg's theory about Kafka is that the constricted and terrifying lives of his heroes, which permit neither memory nor hope, reflect the condition of late-nineteenth-century emancipated Jews, who rejected Halacha—

the system of religious law that ordered a traditional Jewish life—but found little solace in the larger Gentile world. Writing in the fifties, Greenberg insisted on the relevance of Kafka's situation for contemporary Jews; and Kitaj doesn't find the situation entirely changed today. When Kitaj says that "the Diasporist lives and paints in two or more societies at once," he echoes Greenberg's observation that "nothing in Kafka is located according to any of the objective coordinates of time, place, history, geography or even mythology or religion."

What separates Greenberg's and Kitaj's views of Diasporism isn't really a matter of facts so much as a matter of what one extrapolates from the facts. (Thus does modern become postmodern.) For Greenberg, "the emancipated Jew exchanges one kind of confinement for another, and perhaps the new kind induces even more claustrophobia than the old did." For Kitaj, despite the Holocaust, the situation of being halfway between the old world and the new provides exhilarating opportunities. His sense of living in a peripheral world yields paintings that "betray confounded patterns." The very lack of clarity is presented as exciting. "As in Cubism," Kitaj explains, "the Diasporist painting I have always done also often represents more than one view. But I am mostly drawn to variably modulated pictures of the mind at work, instinctive *paint-dramas* of incertitude, views wrapped around imagined themes and variations, the contradictions of Diasporic life, apotheoses of groundlessness."

At one point, Kitaj appropriates Picasso's *Guernica* for Diasporist painting. The shattered classicism of Picasso's war work offers a sort of heterogeneity that's to Kitaj's taste. For Kitaj, there are analogies among a variety of modern disasters, dislocations, exiles. The Diasporist extrapolates from his own experience to a general historical condition. Diasporist painting, it becomes evident, is a public kind of painting, a little like Allen Ginsberg's public poetry, maybe, with its wild-man vigor. The cast of characters in Kitaj's work is very large, including all the types one might encounter in a Europe-in-exile George Grosz café. Kitaj counts among his subjects the "Orientalist, Neocubist, Arabist, Remembrist, Cézannist, Sensualist, Communist and Socialist, Kabbalist, Caféist, Hispanist, and so on." He means to tell their stories, which are also, since he sees these types as aspects of himself, his own story. There is considerable risk involved in trying to transform a personal

myth into a public myth and then into a work of art. In Kitaj's case the results often strike me as paintings that are running after life rather than coming out of life. I guess Kitaj would put me with "one of the most recent of my hundred negative critics [who] wrote in his review of my 1986 exhibition that it was 'littered with ideas.' Heavens to Betsy, I hope that's true." The disagreement may come down to my being a classicist, though sometimes a crazed one.

Greenberg ends his Kafka essay grimly and, I think, a bit self-importantly, saying, "But might not all art, 'prosaic' as well as 'poetic,' begin to appear falsifying to the Jew who looked closely enough? And when did a Jew ever come to terms with art without falsifying himself somehow?" Jews do have an uneasy relationship to the visual arts. Brought up in a culture that puts restrictions on the use of the arts, Jews—including those with the most casual connection to a few major holidays—may have a tendency to see the masterpieces of Western art as a forbidden kingdom. But the Jewish disposition toward the life of ideas has ultimately given the idea of art an irresistible appeal. Even if a Jew has to choose art, I think Greenberg—and Kitaj—is a bit much on this seeing-oneself-in-history routine. A generation after "Kafka's Jewishness," Kitaj is making a self-conscious return to the ambivalence of assimilation. One possible response to his *Manifesto* is: Why all the fuss? Don't goyim struggle toward art, too?

Kitaj will strike a sympathetic chord in many readers who are puzzled by the precise nature of Diasporist painting with his observation that "Diasporist painting is the other side of the coin of Intimist painting." To the diaspora of the international wanderer he opposes Bonnard, and who among us, Jew and non-Jew, hasn't looked at Bonnard's Côte d'Azur world covetously, wanting for ourselves that ease, that lyricism? Kitaj writes: "I always keep a picture, tacked to my wall, of the gorgeous little painting of the Almond Tree which Bonnard was working at on his last day, to remind me of another fate, a more sublime and fixed one than that of Jews or my own peculiar Diasporism, where painting marks on canvas may spell peripatetic danger instead of peace in the sun." That Bonnard painting is certainly a brilliant image to invoke if one wants to suggest that we are now alienated from some harmonious ideal of what painting was. That almond tree is a great nature painter's last farewell to the nature-painting tradition of his

people—the French, who defined the terms and did it better than anyone else.

But I'm not so sure that what separates Kitaj from Bonnard is the politics of Diasporism versus the politics of Intimism so much as it is something else: formal incompleteness versus formal completeness. What attracts us in Bonnard—again, Jews and non-Jews alike—is the seamlessness of his expression. But there's nothing natural about that seamlessness. Bonnard himself had to win through to his almond tree. And how he had to win through! There are more bad Bonnards than there are great Bonnards. I worry about a Woody Allen side of Kitaj's argument: the tendency to romanticize the intimacy of non-Jews, to see their composure and sense of form as God-given (by *their* God). Bonnard knew from wars, schlock, distractions. When Kitaj speaks of "host-art"—the art of the culture in which the Diasporist lives—he sounds funny-paranoid, Woody Allenesque. Of course Bonnard believed in "host-art," but it wasn't handed to him: he reinvented it.

So: where do we go from here? That's the question a manifesto asks. (In the early-twentieth-century manifestos the answer tended to zoom off into religiosocial mysticism, but Kitaj is too liberal and prag-matic a romantic for that.) It is possible to continue in Bonnard's way (a possibility that Kitaj isn't denying). But I think that Kitaj's large point—and he uses Diasporism and Jewishness as metaphors—is that artists are buffeted from all sides and want to put the variety of their experience into their art. In the catalogue of his latest Marlborough show, Kitaj observes that "paintings are supposed to be self-contained things. Well, as almost everyone knows, they are and they're not." The *First Diasporist Manifesto* is a plea for breakup and complication, for more rather than less. I suppose we're all (with the exception of a couple of antediluvian formalists) for that. But one of the lessons that we learn from the masterpieces in the museums is that the people who painted them were always willing to simplify, even if it meant throwing a lot of things away. (How much does Titian tell us about his life and times?)

Of course, the sort of false simplification that has dominated painting since World War II is another matter entirely, a matter that has brought us, in justified reaction, to the sort of taste reflected in the *First Diasporist Manifesto*. But if the internal logic of painting seems shot to hell, artists

are only going to have to labor all the harder to recover it. I think of the chorus of a pop song that goes something like, "Break up and make up, that's all we can do." Still, many, including the best and brightest, bristle. It's no fun being left to pick up the pieces. There's a very revealing line toward the end of Kitaj's *Manifesto*, where the artist confesses, "I find myself in uneasy alliance with the natural pleasures of painting, which become conventional even as I do wish to pursue them." That's the comment of someone who really is a painter. All the painters I know worry about not giving themselves over enough to "the natural pleasures," and then again about getting sunk by those pleasures. But is the answer to be willfully unconventional? What is for certain is that no system gives certainty, and perhaps Diasporism is after all too much of a system. May the best breaker-maker win.

December 1989

THE LEGEND
BUSINESS

There are gallery owners (many) who dream of turning living artists into living legends, and there are gallery owners (a few) who won't be bothered with anybody who isn't a living legend. The nurture and maintenance of legends is a tricky, expensive business. Mary Boone is Mary Boone because she knows how to make this year's scandal into next year's old master. But then again, Julian Schnabel left Boone for the Pace Gallery on Fifty-seventh Street because he wasn't becoming an old master fast enough. In the geography of reputations it's easier to pass from uptown into eternity, or at least into the illusion of eternity that a sterling reputation provides. You'll never turn an artist into an old master on the garbage-strewn streets of the Lower East Side. This is one reason why the scene there fizzled. And it's infinitely easier to create a legend if the surroundings themselves are legendary. This is why the Gagosian Gallery, lately of West Twenty-third Street and definitely in the legend business (they deal in both the living ones and the recently deceased ones), moved to Madison Avenue last year.

Gagosian's current space, in the old Parke-Bernet Building on Madison between Seventy-sixth and Seventy-seventh streets, has high ceilings and an oversized skylight. Coming off the elevator, a gallery-goer can feel transported to heaven. I hope that someday Gagosian will hang something of beauty up there: to my eyes, Jasper Johns's Maps and Andy Warhol's Shadow paintings don't do the trick. But the atmosphere at a place like Gagosian's, which is serene yet imperial, is so potent as to neutralize mere opinions—mine, yours, the next guy's. At this point a picture palace like Gagosian's—or Mary Boone's, where Roy Lichtenstein's Mirror paintings from the late sixties and early seventies were given a portentously elegant show last fall—can seal an artist's place in

history more effectively than our museums, which turn even the works of the most widely acclaimed artist into a species of circus decor. Warhol looks a hell of a lot more important at the Gagosian Gallery (whose owner was selling five-dollar posters in L.A. just a few years ago) than at the Museum of Modern Art (which was started by Alfred Barr, who was personally acquainted with many of the masters of early-twentieth-century art). The Modern, despite its distinguished history, is nowadays so full of crowds that the most it can tell us about Warhol is that he's a popular success. This we already knew. At Gagosian, a space with the aura of a secular shrine, the ante is upped. We're told that Warhol can transcend the bread and circuses—that he's a candidate for Parnassus.

These games of presentation look most flagrant when they're played with Pop Art, but I find them in some ways even more disconcerting when they're used to give the Color-Field painters of the sixties and seventies the eternity-here-we-come treatment. The Kenneth Noland show that was at the Salander-O'Reilly Galleries in October and November suggests a slightly different kind of mythmaking process from the one we see operating at Gagosian or Boone; but I don't find the process any less insidious in the way it firmly closes and locks the door on any honest or undogmatic presentation of the history of American art since World War II. The people at Salander-O'Reilly—who have been on the East Side since they opened the gallery in 1976 and have delighted artists and connoisseurs with shows of Constable, Stuart Davis, Arnold Friedman, Alfred Maurer, and others—surely love the Kenneth Noland paintings that they're showing. But the exhibition last fall wasn't an act of love, it was an act of apotheosis.

Salander-O'Reilly, which was formerly located in a rather eccentric but charming duplex space in a townhouse on Eightieth Street, used the Noland show as the opener for its new, improved digs on Seventy-ninth Street on the corner of Madison Avenue. Their new space has a built-in history—a history that cannot but add luster to Noland's already immense reputation. Twenty East Seventy-ninth Street was for many years the location of the Paul Rosenberg Gallery. The first Rosenberg Gallery, founded by Paul's father, Alexandre, opened in Paris in 1878 and showed Cézanne, Degas, Monet, and Pissarro. In the various galleries that the son operated in London and Paris in the early years of

the century, he continued his father's tradition of support for the avant-garde. Paul Rosenberg became very closely associated with Picasso's work and career around the time of World War I, when Picasso lived a stone's throw from Rosenberg's gallery on the rue de la Boétie. In 1940 Paul Rosenberg, fleeing the Nazis, moved to New York, and his gallery once again flourished. A 1962 guide to New York's galleries, published by *Arts Magazine*, said that the gallery remained "an important source of French painting of the nineteenth and twentieth centuries. Major exhibitions of French masters are presented each season." If the Rosenberg Gallery has felt a bit dusty, a bit beside the point to those of us who've wandered in in recent years, it was nevertheless one of the major art gallery enterprises of the century. The Rosenberg family collection, which was sold at Sotheby's in London in 1979, contained masterworks by Picasso and Braque as well as very fine things by Matisse, Léger, Degas, and Renoir. It's in this august space that Noland had his recent retrospective, and Salander-O'Reilly has consciously preserved the good-old-days-of-modern-art atmosphere. They've kept the spacious, old-fashioned entry hall and the curving staircase. The gallery spaces proper have a fresh, white look, and the floors have been scraped; but the one big room downstairs and the two big rooms upstairs send a message of continuity: these legendary rooms will host legends again.

Salander-O'Reilly presented three decades of Noland's work in a nonchronological display, so that each of the three rooms was like a miniretrospective unto itself. If only Noland were up to the gilt-edged local history. All I see in his work are tired effects—these paintings feel as out of date as the designer sheets and pillowcases of a decade ago. Here are the target paintings from 1958 to 1960, each with its single configuration of concentric circles painted in washy hues that bleed into the unprimed canvas. Here are the elongated horizontal paintings of the sixties, with their stripes in go-together colors. Here are the asymmetrically shaped canvases of the late seventies and eighties, with their harsh, flat, poster-paint-toned fields. And here are the newer works, in which the surfaces turn milky with coagulations of acrylic medium. In the newest paintings, named *Doors* after the vertical rectangular elements that Noland uses as modular units, there's a minisurprise: affixed to some of the edges are strips of candy-colored plexiglas. Forget that there's no subtlety to any of Noland's color. There isn't even any punch

to it. He doesn't know how to weight colors in relation to one another; nor does he know how to use colors to achieve a sense of weightlessness. A dull literalness prevails.

All of Noland's work goes together, and all of it goes nowhere. You can't move into these paintings in the way you can move into premodern paintings. And the paintings don't come out at you, as modern paintings often do. The Nolands just hang there, inert and marginally decorative.

Not all legends are possible at all times. It wouldn't be worth bothering to describe the deluxe treatment that Kenneth Noland received at Salander-O'Reilly (when has Noland not gotten deluxe treatment?) if it weren't symptomatic of a new kind of attention that's focusing on the group of artists whose careers first flourished in the sixties under the rubric of formalism. I don't see any mystery as to why artists like Noland and Jules Olitski and Anthony Caro, who early on were admired and discussed by Clement Greenberg, are just now finding their reputations dusted off and given a fresh shine. These artists were championed from the start as purists: they were supposed to be single-minded in their devotion to a rather old-fashioned idea of the Beautiful. As we enter the nineties, that very idea of a work of art presenting a beautiful, self-contained world has eroded terribly. Eclecticism rules, and it isn't a creative or liberating eclecticism. This is a period of constricting eclecticisms—eclecticisms at once ditzy and dogmatic that turn into orthodoxies overnight and produce tired jokes (Koons) and emotional blackmail (Kiefer). I know why some people who are disaffected with the current situation find solace in Noland's stripes: his art isn't eclectic, isn't emotional, isn't a joke. But I feel a little wary of people who are so disaffected that they'll accept the closed-down horizons of an artist like Noland who refuses to risk anything at all.

And it's not just the fuddy-duddies who are climbing onto the back-to-formalism bandwagon. My sense is that this is a cross-generational movement and that the appreciation of younger artists and critics may be giving Noland's reputation a lift without which Salander-O'Reilly's legend-building, no matter how well funded, will never fly. While the Noland show was at Salander-O'Reilly, the Max Protetch Gallery in SoHo hosted the new paintings of David Reed. With their thick yet translucent surfaces and candy colors these canvases look an awful lot

like reruns of the formalist thing. This is significant. Reed may not be a subject of media gossip like Ashley Bickerton or Sherrie Levine, but in SoHo the forty-three-year-old artist is held in far greater esteem than Bickerton or Levine, and his work may actually be as widely discussed as theirs. Reed is a sort of guru to a whole bunch of artists who want to go beyond eclecticism and irony but don't know how.

Reed is currently using juicy, saturated colors, the kind of high-voltage purples and pinks and greens that people like Olitski have long favored. He works layers of paint over the canvas to create overlapping waves or ribbons of color—the kind of 3-D effects with which many of the Color-Field artists (Bannard, Poons, Olitski, Noland) are involved. Reed's surfaces are agitated yet static—this also recalls Color-Field. But at the same time, Reed subdivides most of his canvases into discrete rectangular areas, in each of which different colors swoon against one another. Thus he violates the unity of the field; and Color-Field painting takes on a dialectical dimension. This dialectic is the spice of postmodern irony that Reed mixes with his formalist recipes to make a neat balance between sixties purism and eighties antiformalism. He tells us something about where we are now: the artists who become intellectual heroes in SoHo don't innovate, they mediate. Reed's new-wave formalism is sterile. The downtown deconstruction of eclecticism and irony proves to be as self-limiting as the downtown eclecticism and irony were in the first place.

While Reed won't give up the pose of the eighties ironist entirely, some of his paintings could comfortably hang next to the Nolands at Salander-O'Reilly. One tall, vertical Reed is positively Nolandesque. In the Reed there are three narrow vertical color areas; it's like those Nolands with three or so panels, which also have grayed color—deadened brights. I think Reed makes these connections to sixties formalist abstraction consciously, though he probably doesn't have any particular Noland or Olitski painting in mind. Reed wants history on his side; and, after all, Noland is in the history books, he's *there*. Reed has positioned himself niftily. He has an immense appeal for artists in their thirties who want to reject the anything-goes-if-it-sells ethic of the art schools. Reed is a man who stands above the fray, who makes "beautiful," "sensuous" paintings about painting. Reed is a faux traditionalist, but by relating his work, visually if not verbally, to the Color-Field

painters, who are the original faux traditionalists, he gives himself a history, abets their legend, and puts himself in line for legendary status.

Reed and his friends like to talk up the work itself with a blitz of art-historical references; this process recalls the art-historical talk that often accompanies the work of the Color-Field painters and a sculptor associated with them, Anthony Caro. These artists are shameless about hitching themselves to the stars. In a recent interview in the *Journal of Contemporary Art*, Larry Poons said of Noland: "There is never a Minimalist feeling to a Noland painting. Even though all the means seems to be, superficially at least, all Minimalist, the result is never Minimalist. It's *Maximized*. It's *Maximalism*—like Rembrandt." It's from this kind of outrageously aggrandizing comparison that Reed and company have learned a thing or two. The undulating movements in Reed's paintings are invariably compared to the rhythms in Mannerist and Baroque painting and architecture: Guido Reni came up in connection with the recent David Reeds. These formal connections are schematic at best. It's a mistake to imagine that by recalling a classic composition or a particular style of brushwork it will be possible to summon the power of the art of the museums. Anthony Caro has taken to modeling his compositions after those of the masters. He does works based on Greek pediments, and he caused something of a stir last spring with a sculpture that was based on Rubens's *Descent from the Cross*. But Caro, like Reed, is incapable of inserting meaning into his work by invoking somebody else's compositions. All both artists manage to do is fog their works over with a stale art-historical perfume. In Caro's case, the historical allusions undercut the distinctive sense of form that his welded constructions once had. These artists pursue the old masters the way manufacturers of kitchen products pursue the Good Housekeeping Seal of Approval.

In the legend business, memories can be very short. Amidst the rampant careerism that gripped SoHo in the eighties, no one seemed to recall the stranglehold that the formalists (who were consummate careerists) had on taste fifteen or twenty years ago. Amazingly, there appears to be a certain protectiveness developing around these artists—as if, because the art magazines no longer run interminable features about Noland or Olitski or Caro, the "perfect" taste that they represented has somehow been done an injustice. And now an artist such as

Noland or Caro emerges as a logical cause to be championed by people who think that the art world has gone to hell but who would like to believe that things were hunky-dory not too long ago. What delightfully formidable credentials these underdogs have! Those who spruce up Noland's or Caro's reputation can point to lists of permanent collections and museum exhibitions that include every major venue in the civilized world. Very few people would care to imagine that the museums had already lost their way in the sixties, when they started wasting their money on Color-Field paintings. This is too painful to contemplate. People want to convince themselves that things went a little off in the art scene, but that we can easily get back on track. That tradition that Clement Greenberg and his followers sketched out—it ran from Picasso to Pollock then on to, oh, maybe Noland and Olitski—well, they're going to get it back on track. That's the message at Salander-O'Reilly. That's the tradition that David Reed wants to fit into.

Any call for a return to orthodox modernism has a great appeal. The less rational the art world appears to be, the more desperate becomes the desire to rationalize aesthetic experience. But the people who want to return us to a time when art was described in the absolutist language of papal bulls pose as much of a danger as the people who now describe art as a barometer of psychosexual and sociopolitical trends. When Larry Poons explains to us that Noland and Rembrandt are related, he's constructing a simplified (to say the least) view of historical progression. (The legend-builders at Salander-O'Reilly are doing something similar. After the Noland show went down, a show of works by Delacroix, Constable, and Rubens went up. Those old masters became, perhaps through no conscious intent of the gallery, more glorious relations for Noland.) Poons is a cartoon traditionalist, opposing his values to those of the cartoon avant-gardists. Whichever side wins, art will lose. Art lives off the art of the museums, all right, but it lives in a perpetual state of indecision and awe and despair. Being involved with the past has nothing to do with a Color-Field painter's pieties. It's more of a quest than that. Here's Giacometti, as recorded by James Lord: "My taste gets worse every day. I've been looking at a book in which paintings are reproduced next to photographs. There was a portrait by Fouquet next to a photo of a real person, and I preferred the photo by far. Yet I like Fouquet very much." This is real talk about tradition. But a lot

of tasteful people might be terrified to voice feelings like Giacometti's today. Say you like a photo better than a Fouquet and you'd be accused of succumbing to camp or pop taste. Yet if we can't risk loving what's beyond the museum, whatever will the museum mean?

The people who write about Kenneth Noland, from Clement Greenberg on down, present themselves as a tough-minded lot. They talk in dicta, they bully us with absolutes and near-absolutes—"pure color," "the exclusively visual," "more profound," "this summit of achievement," "a new level of engagement," "like Mozart's, Noland's originality . . ."—I quote virtually at random from the essays in the Salander-O'Reilly catalogue. Yet isn't there something desperate and choked up about all of this tough talk? It is dangerous to look to art for a defense against uncertainty. One can end up defended against art itself. I read Clement Greenberg's essay on Noland (a 1960 piece that's reprinted in the Salander-O'Reilly catalogue) after seeing the show and found it almost surreal. What a torrent Greenberg unleashes in support of these dull paintings. "The insistence on the purely visual," he explains, "and the denial of the tactile and ponderable remain in tradition—and would not result in convincing art did they not. . . . [Morris] Louis and Noland are not only far more fertile in invention [than Sam Francis]; the quality of their art is also more upsetting, more profound." All this pushing, all these aggressive words. Keeping up with the Joneses, passing the Joneses: it adds up to the invention of a legend. There's no end to the fruitless search for the absolute. The drearier the painting, the more absolute it appears: this is why Noland and Johns go to the top of the heap. And yet everything that we have felt in art since World War II has been pointing us away from the absolute. Art keeps critiquing the legends.

January 1990

YUP PUPS
LOVE BABAR

One of the marvelous things about classic children's books is that we intersect with them in different ways at different points in our lives. The book that we first encounter as a young listener we may later read to a younger sibling and later still to our own child or grandchild or to the children of friends. Books that have been out of one's consciousness for a decade or more resurface; we have a chance to see how our reactions stack up against our memories. And sometimes adults are drawn to children's books that they didn't know when they were kids. This can be a way of upgrading one's own memories; by reading Antoine de Saint-Exupéry's *The Little Prince* for the first time as an adult, one can live vicariously the classic childhood one never actually had. How many people who encountered *Winnie-the-Pooh* only when they were too old for it are determined that their kids will have it at the right moment?

Of course, our images of picture-book childhoods change; different children's books suit the moods of different times. If *Alice in Wonderland*, with its druggy transmogrifications and its irrational tyrants, fit the mood of the sixties, can it be any surprise that the Babar books, with their genial rulers and stylish manners, became a favorite in the eighties? This series of books was started by Jean de Brunhoff in 1931 and later picked up by his son Laurent, the author and the illustrator of most of the Babars. It looms pretty large in the eighties nostalgia boom. The Mary Ryan Gallery on New York City's Columbus Avenue, that great thoroughfare of yuppiedom, sells the original drawings; and there are slews of ancillary products, of T-shirts, pull toys, calendars, and so forth. Yuppies like to see their yuppie puppies outfitted in Babar everything.

The Babar stories, with their crystal-clear views of an idyllic pre-World War I world—a world of refined manners and pretty tea parties and amusing outings that have their bad twists but always turn out fine—fit right into the yuppie yen for old-fashioned family living. Some people are offended by what they see as the commercialization of Babar; but I'm not so sure that Babar's aura is diluted by commercialization. It's cheering to see Babar and Celeste popping up in shop windows all over town. So much of what the current back-to-tradition nostalgia boom presents is faceless stuff. The Ralph Lauren outfits and the bleached-pine furniture give a chilly, hollowed-out view of earlier times. And the advertisements for many of these products suggest that it's not the pleasures but the repressions that people are really nostalgic for. Babar carries us into a different past, a past that's not only privileged and refined, but also full-bodied, a past that hasn't had the blood leeched out of it. The de Brunhoffs, father and son, use placid, balloonlike lines to limn their beautifully appointed kingdom. They laugh at this never-never land even as they use it to seduce us. They tap into our nostalgia for order, but theirs is a nostalgia for a natural order, for a world where happiness is possible but is by no means untroubled.

De Brunhoff's first book, *The Story of Babar*, opens with a pastoral vision of the baby elephant Babar living with his mother in the jungle. But almost at once Babar's mother is shot by a hunter, and the little elephant flees the jungle, finding his way to a city that looks a lot like Paris. There he is taken up by an Old Lady who gives him a place to live and sponsors his entrance into society. Babar takes to wearing fine clothes and walking on his hind legs: he enjoys cutting a figure in the fashionable world, though there are moments when he's nostalgic for the life of the jungle. His cousins Arthur and Celeste come to visit him in the city, and he teaches them the sophisticated ways. By the end of the book, Babar is engaged to Celeste and has returned to the jungle, where the King of the Elephants has just died. Babar, who impresses the jungle elephants with his elegant city ways, is crowned king. By the third book, *Babar the King*, which appeared in 1933, the elephant city of Celesteville is being transformed into a model of urban civilization, with compact, comfortable housing developments and grand parks and public buildings. The next major event in Babar's and Celeste's lives—described in the last book that Jean de Brunhoff wrote,

Babar and His Children (published posthumously in 1938)—is the birth
of the triplets, Pom, Flora, and Alexander. By then the basic pattern
of the world according to Babar is in place. The rest of the series consists
of variations on familiar themes: visitors arrive in Celesteville or the
King and his family go on travels; difficulties and disturbances arise
within the kingdom or beyond its borders; life goes on.

With Babarmania at an all-time high, the appearance of a book called
The Art of Babar (Abrams) isn't a surprise. The surprise is that this
coffee-table book on a trendy subject is a real book, an intellectual
accomplishment. Nicholas Fox Weber, an art critic, curator, and ex-
ecutive director of the Josef Albers Foundation, has written a text that
answers all the questions readers may have had about Jean and Laurent
de Brunhoff and their books. He links the imaginary milieu of Celeste-
ville to the real milieu of the French haute bourgeoisie in the early part
of the century, and we end up understanding both a little better.

The Art of Babar is also a big step forward for its author. In a
monograph on the contemporary painter Leland Bell, published a couple
of years ago, Weber's cheerfully enthusiastic approach was a liability.
It's impossible to write about the current art scene effectively if you
believe, as Weber apparently does, that the world is basically a just and
rational place; an hour in the art galleries ought to have told you oth-
erwise. Weber doesn't really understand that an artist now has to be a
sort of monster of self-assurance to keep his integrity intact. But Weber's
upbeat worldview works for him in *The Art of Babar*. I don't suppose
that anybody who didn't believe that the world was a just and rational
place could write well about these imaginary elephants.

Of course the series has its dark side. The death of Babar's mother
at the hands of a hunter in the first book is a primal horror. After that
there are panics and bad moments. Yet when Weber is dealing with
some of the series' less pleasant aspects—I am thinking of the caricatured
depictions of blacks—he acts as if what makes us uncomfortable were
somehow an accident. The truth is that the life of privilege that King
Babar enjoys is rooted in the inequalities of an imperfect world. Why
deny it? The beauty of the Babar books is that they're not totally
insulated from the life we live: this idyll is open-ended enough to register
the impact of the parties of thirties Paris, the supermarkets of sixties

America. The basic theme is one of continuation. The endings are happy. The genial tone of Weber's prose suggests that he has a taste for ease and unpretentious luxury. Weber feels right at home in Celesteville.

Weber's book shows how King Babar, his family, and his subjects emerged out of the collective imagination of several prosperous and artistically oriented Parisian families. Around the turn of the century, Jean de Brunhoff's father was a publisher of illustrated books; he did some opulent programs for the Ballets Russes and produced a book about the set designs of Bakst. Jean studied painting with Othon Friesz at the Académie de la Grande Chaumière. There he befriended Emile Sabouraud, known as Mio, whose father was a well-known doctor and whose family were early admirers of Proust's novel and had paintings by Soutine, Renoir, and Redon hanging on their walls. Mio described Jean as "the most beautiful young man one could ever see." Weber quotes him as saying, "You can't speak of Jean without mentioning his reserve and his aristocratic outlook and behavior. Jean was as tactful as a man could be. He could speak to anyone—from the gardener to the pope—and be completely simple and natural and close to them." Sabouraud's sister, Cécile, became Jean's wife; and they had three boys, Laurent, Mathieu, and Thierry.

"Jean was unable to make a living as a painter," Weber explains, "but both the Sabourauds and the de Brunhoffs supported him and Cécile with a modest allowance. The older generation was happy to subsidize the young creators." The young family's life alternated between an apartment in Paris, the Sabouraud family place in the country in Chessy, and visits to the Alps. Weber's book is illustrated with snapshots of picnics, of family members silhouetted against Alpine snow. The faces are open, casually happy. The Babar books began as a story that Cécile told to her two sons. Jean decided to illustrate a copy for the family; his brother and brother-in-law, publishers, decided to print it; and Jean then produced six other Babars.

The post-World War I world that Weber lovingly describes doesn't sound all that different from the pre-World War I world that we glimpse in the snapshots by the adolescent photographer Jacques Henri Lartigue. The young century found some of its sharpest chroniclers among the young and those who spoke to the young. Lartigue shows how new

fashions and new machines (cars, airplanes) make ripples on the calm surface of Parisian life, ripples that were strong enough to keep things interesting but not strong enough to wreck things. Lartigue's camera catches women in whimsical hats and men playing with kites. People don't grow up: their toys just get grown-up sized. Babar's world has that quality, too. Celesteville is a city of perpetual childhood.

Years later Laurent recalled his parents and their relatives as "a bit like Sèvres figurines: beautiful, unblemished, and more for observation than intimacy." The idyll ended when Jean died of bone tuberculosis in 1937. "The 33-year-old widow did her best to raise three boys, but life would never again be the same. A year after her husband died at the age of 37, her father—the beloved grandfather with the house in Chessy—died as well. Then came the war and the occupation of Paris: years of struggle and privation. But in 1946 Babar was resurrected." Laurent, a painter like his father before him, produced his first Babar book, *Babar's Cousin: That Rascal Arthur.* "Since then he has taken Babar to distant planets, to California, and underground." The final snapshot in Weber's book shows Cécile, now a carefully coiffured lady with several strands of pearls at her neck, accompanying her son Laurent through a Babar exhibit in the Marais in 1981.

Weber illustrates a few of Jean's oil paintings, mostly family portraits. The style, a classicizing naturalism very popular in the twenties and thirties, is modeled on the work of Renoir and Derain. But Jean doesn't bring anything of his own to this work. He is a middle-of-the-road painter, at his best when at his sketchiest, as in a little painting of the Sabouraud house in Chessy. Perhaps he's one of those artists who confuse seriousness with laboriousness; or maybe it's just laziness. Whatever the reason, he only becomes a first-rate artist when he does something that he probably doesn't regard as serious—when he illustrates a story that his wife has written for his children. Weber writes that the style in the Babar books "gives the appearance of both effortlessness and knowledge. It has the naturalness that has made other ingenuous sophisticates—Henri Rousseau, Gabriele Munter, Alfred Wallis—the envy of their compatriots. De Brunhoff painted by instinct. He emerges the master of poignant summation. Well-being, plainly articulated, pervades. Here [in *The Story of Babar*] are quintessential palm

trees, the mark of tropical luxury. Masses of red flowers and a single butterfly, establish the opulence of earthly life. Entering the story, the reader—or child to whom the story is being read—leaves all haze and incertitude behind." Jean leaves behind all the incertitude of his oil paintings, too. He had admired the work of Raoul Dufy when he was a student; and at times the Babar illustrations recall Dufy's upbeat lyricism.

Jean de Brunhoff made his contribution to French art through the side door of book illustration. Maurice Sendak, in an appreciation of the Babar books, relates them to a turn-of-the-century explosion in book illustration. In place of the fixed frame of the painting, the book illustrator works amid a fluid framework of unfolding pages. The turn of a page is the occasion for a surprise; the full-page illustration and the vignette enclosed by areas of text can be juxtaposed with the expansiveness of the double-page spread. Jean, who wrote out the Babar texts in a script that echoes the loops of his drawings, has a genius for the rhythms of the book. He composes across the page and up and down the page and uses the double page for panoramic effects. And his feeling for the big movements is joined to a beautiful poetic sense of the value of small naturalistic details. Here he recalls nineteenth-century French illustrators of daily life such as Gavarni and Guys and, reaching further back, the panoramic vistas that the Limbourg Brothers invented to illustrate a Renaissance Book of Hours.

In both his pictures and his texts, Jean uses the modern taste for simplification to create a quality of naive well-being. There's something of the mandarin simplicity of pioneer moderns such as Jean Cocteau, Erik Satie, and Gertrude Stein in these lush yet severe children's books. Just as Jean de Brunhoff's drawings suggest emotions—anger, anxiety— through a couple of lines, his texts are relatively impassive, alluding to fears or anxieties or joys only in passing. Characters aren't exactly constructed and elaborated: they're just presented, and life goes on. The absence of sentimentality is what gives these books their staying power. They leave us free to feel what we want to feel.

Jean's work in the Babar books is altogether modern, yet it fulfills what we often regard as a premodern desire: the desire to give art the fullness of life. In some remarkable passages of social history, Weber

places Babar within the fashionable Parisian life of the twenties and thirties:

> In the year that Babar was conceived, the great American chronicler of Paris life, Janet Flanner, wrote that "the June season of 1930 will be remembered as the greatest fancy-dress-ball season of all years." Jean and Cécile de Brunhoff were aware of such events even if they never left the quiet rooms of Chessy or the small flat in the 16th arrondissement to attend them. . . . "The 1930 Parisian parties— by being unusually frequent, fantastic, and mostly foreign, were remarkable for representing the true spirit of their time." Women dressed as men, whites as blacks. At a party given by the dressmaker Jean Patou, where each twig in the garden was wrapped in silver paper, three lion cubs were given as grab-bag prizes. At a masquerade many of the guests appeared as shepherds and shepher- desses, and one came as a wolf in sheep's clothing. That same season, Josephine Baker's new Casino show featured trained pigeons, a live cheetah, and a gorilla who rescued her from a typhoon. It was quite natural to have an elephant go to the city, dine in a good house, and dress like an upper-class human. Jungle creatures had never before been so at home in urban settings.

In the Babar books the beau monde is domesticated, crossbred with the quiet family life that for the de Brunhoff and Sabouraud clans must have been a precious link back to the nineteenth century.

Some of Weber's finest pages are devoted to the difference between the work of the father and the son. Where Jean has a refined sense of detail, Laurent, who was an abstract painter in the forties (and a better painter than his father, from the evidence of the work included here), tends toward bolder, more generalizing designs. Jean's color is re- strained: tans and grays set off areas of strong hue. Laurent's color is more eccentric; he revels in surprising sweet-and-sour combinations. Of *Babar's Visit to Bird Island* (the third of Laurent's books), Weber observes that the illustrations have "a second-generation freedom and spontane- ity. Laurent's application of paint is looser, and seemingly less pains- taking, than in his own early work or in any of his father's. . . . Landscape and characters are a bit more fantastic. . . . Jean's focusing on nuance has now been supplanted, even more than in Laurent's previous two

books, by the probing of raw emotion." I happen to have a first edition of *Bird Island*, in the oversized ten-and-a-half-by-fourteen-and-a-half-inch format, and it is everything that Weber says it is. Turning the page onto a two-page spread, one feels a rush of emotion. The rescue of Flora, whose boat has capsized, is lyrical high drama: the curving white sails of the boats, set off by the great expanse of blue sea, create a rocking motion across the page that's as exciting as the movements in a print by Hiroshige.

Laurent isn't just continuing his father's work; he's expanding Babar's dominion. He makes enough alterations in the period details and the plot lines to keep the series contemporary. While Babar remains the sort of monarch that most of Europe did away with generations ago, he's unafraid of new experiences. In *Babar Comes to America* (1965), "He becomes absorbed by baseball games, the supermarket, factories, a barbecue, superhighways, a drive-in movie. In its keen-eyed response to neon, highway-strip America and in its appreciation of commercial culture, [*Babar Comes to America*] is akin to both Pop Art and postmodernist architecture although its tone is far more mellow."

Though some of his formal descriptions go on too long, Weber successfully takes the Babar story from the Roaring Twenties to the Postmodern Eighties and shows us how, at every point, the books turn contemporary style into picture-book idyll. He makes us understand why Babar makes adults happy, too. These books embody one of the essential characteristics of French classicism: they present a complicated world in clarified form. Weber has written what I expect will be an enduring exposition of a classic. *The Art of Babar* is something to read to yourself after your kids have been read to sleep with their Babar books.

December 11, 1989

HALF A DOZEN
CONTEMPORARIES

I'm writing this on a freezing cold day at the beginning of December, as the sun goes down and the sky over New York City's Upper West Side turns an opaque cobalt blue. The moon is up there, a blurred crescent shape; below, the lights are going on across the darkening facades. This is the moment when the city becomes as unreal as a diorama: rushing crowds, massive buildings, and that gorgeously decorative sky. Suddenly, everything we've thought and felt during the day is folded into a big, beautiful romantic vision. The stage manager is nature; but the effect is anything but natural.

Violet Baxter catches something of that moment in her pastels of dusk in New York City's Union Square neighborhood. I didn't know Baxter's work until I saw her show this past October at the Pleiades Gallery. Since seeing the pastels, I've found that they rise up in the mind's eye at the hour when evening comes to the city. Baxter has a studio on Union Square, and in the cycle of *Union Square Variations* that she does in delicate passes of pastel strokes across her paper, she stirs up quite a mood. Her skies are like sheets of velvet: they're blue-violet or orange-red. These never-never-land skies set the romantic tone. At the same time, Baxter is curious about the more prosaic aspects of city life. The ordinary sights that she records from her sky-high window give the full-tilt romanticism its saving caustic edge.

Baxter has a Canalettolike eye for the changing city. In one pastel, Zeckendorf Towers, the apartment complex at the southeast corner of Union Square, is under construction; in another, we see the monster structure finished, with those neomedieval postmodern towers all lit up. (These pastels are an important record of the yuppification of a historic artists' neighborhood.) But you don't have to go from one pastel to the

next to get the sense of change. Baxter's street lights are flickering, as if they've just gone on; and the crowds of people, which look like waves of colored dust specks down there in the street, recall the masses in motion in some of Boccioni's street scenes. The whole city is caught in a fast dissolve. Baxter gets down the particularities of time and place; the lightness of her touch suggests that it all may dematerialize at any moment.

These pastels were the high points of Baxter's show; the rest of the work was weak, weak, weak. Some tiny gouaches of city facades—snow on a fire escape, for example—have a small, genuine poetry; but when Baxter turns to paint on canvas, all her taste and discrimination disappear. Many of her acrylics seem to be done on dark red grounds, and those grounds give the paintings a hard, closed look. The artist's touch, which is airy and fastidious in the pastels, gets clunky in the acrylics. A series of paintings of rocks and beaches is crude and unfeeling; it's hard to believe that they were done by the same person who did the pastels. I suspect Baxter is one of those painters who paint anything they see in front of them. As she works, she may not know the difference between making contact with her motif and just going through the motions. Apparently she can't distinguish once the painting is finished, either: thus the unevenness of her show. But whatever dogged insistence lies behind those overworked acrylics lies behind those lovely pastels as well. What's haunting about the *Union Square Variations* is the absence of contrivance. Baxter just goes deeper and deeper into her motif. In a couple of pastels a leap is taken from earnest documentary into intoxication.

———

The Reign of Narcissism, a room-sized installation with which Barbara Bloom made her New York gallery debut at Jay Gorney in October, is a rather slender conceit. (It was first seen in the "Forest of Signs" show at the Museum of Contemporary Art in Los Angeles this past summer.) Taking off on the thought that in these media-conscious times everyone is his or her own publicist, Bloom has concocted an interior in which every available surface—upholstery, decorative moldings, bookbindings—is imprinted with the artist's signature or profile or dental X-rays. Bloom's designer insignia isn't all that evident when one comes into this

pale green interior, with its dark-toned side chairs and vitrines; one notices more of these insignias the longer one stays.

I imagine Bloom's intention is to allow her monomania to creep up on us. And yet the overall effect isn't one of growing obsession. The individual elements—Bloom yard goods, Bloom's bust on a pedestal— are so unemphatic that they just slide right by. The one element that had a likable twist to it was a series of cameos of Bloom's profile, made to her specifications by craftsmen in Italy. Of all the endless variations that I've seen in recent years on Walter Benjamin's thesis about the death of the original in the Age of Mechanical Reproduction, this has to be the cleverest. The mechanical reproductions that Bloom presents aren't exactly mechanical—they're the work of particular craftsmen— and so Bloom seems to be telling us that even in the mechanical age some bit of personality can shine through. (That cabinet full of cameos is the kind of thing a friend of mine had in mind when she referred to Bloom as "a great shopper.") But that was about it for *The Reign of Narcissism*. I didn't leave the show haunted by Barbara Bloom—which ought to be the effect of spending time in the presence of a megalo-maniacal narcissism. Bloom's narcissism is whisper-soft—a deperson-alized narcissism. Perhaps this is, as they say, the point.

Perhaps Bloom wants to tell us that there's no joy left even in our self-love. By that logic, the dullness of her room should be a reference to the dullness of our lives. But there's something a little screwy about the idea that a work of Conceptual Art can be an impartial mirror held up to our world. Once Bloom has constructed her room, she's used her imagination, and we must respond. What disappoints me in *The Reign of Narcissism* isn't the idea: it's the lack of imagination in the working out of the idea. An artist can begin with a concept, but in the end we have the object. Bloom's book covers and side chairs are bland. I'm not even certain why this narcissistic fantasy was done in a Neoclassical style. Barbara Bloom goes nowhere with her "way out" idea.

———

The painter David Diao, who showed his new paintings at Post-masters in November, is too clever for his own good—his cleverness is a form of nihilism. When Diao juxtaposes a form from a Malevich painting with a form from a Matisse paper cutout, he makes a fairly

nifty point about the overriding purism that connects works as dissimilar as these. But the comparison is made in such a glib and blunt manner that Diao ends up devaluing the very things that he's evaluating. When, in *Black Noise*, Diao combines six clones of a Matisse seaweed form with two clones of a Malevich composition of tilting rectangles, the result is as generic as a corporate logo.

Diao's subject isn't so much modern art as modern taste and the devolution of glorious images into one-dimensional icons. Diao is interested not so much in Matisse and Malevich as in what has become of their work in the design studios of the past forty years. There's no such thing in Diao's world as going back to first principles. Along with the modern icons, he intersperses jokey references to the exegesis of the icons. One painting, of green and red rectangles, is based on the cover of Clement Greenberg's seminal book, *Art and Culture*. Two of the rectangles bear the names "Greenberg" and "Rosenberg"; it's a New York art-crit logo. Another painting is nothing but a blowup of the famous chronology of modern art on the dust jacket of the catalogue of Alfred Barr's 1936 Museum of Modern Art exhibition, "Cubism and Abstract Art." Diao's composition takes us into Warhol land: it's a highbrow version of Andy Warhol's paint-by-number paintings, with the five-and-dime version of art replaced by the MoMA version.

I suppose that Diao's point is that Malevich and Matisse, Greenberg and Rosenberg are, culturally speaking, in the same universe as Marilyn Monroe and Troy Donahue, Ethel Scull and Campbell's soup. (Could Diao's work be a nasty joke on the famous opening line of Greenberg's essay "Avant-Garde and Kitsch"? "One and the same civilization produces simultaneously two such different things as a poem by T. S. Eliot and a Tin Pan Alley song, or a painting by Braque and a *Saturday Evening Post* cover.") But who needs to have Diao leveling everything downward when the everyday facts of life do quite enough leveling down already, thank you? Of course, if Diao did all this with a sense of humor it might be another matter. The late Nicolas Moufarrege's needlepoint paintings did such a gloriously witty job of leveling down that they ended up by leveling up. It's the coldness of Diao's presentation that unnerves me. The coldness and the fact that this artist is widely admired for his rehashes of modern art history. (In the December issue of *Arts Magazine*, a fiftieth-anniversary symposium on Clement Green-

berg's essay "Avant-Garde and Kitsch" was illustrated with Diao's Greenberg/Rosenberg painting.)

Does Diao know that some of the people who went to see his show get a lift from Malevich's paintings and Matisse's cutouts and Greenberg's prose? I think he does know. David Diao focuses on work that we feel passionate about, and then he sets out to prove that our passion is trumped up, that we've been cowed into taking a pious attitude toward neatly packaged cultural stereotypes. Diao goes to work like a sadistic brain surgeon. He zeroes in on our appetite for art, and he tries to cut it out of us. I vote this show the most demoralizing event of the season so far.

———

The paintings in Spencer Gregory's first show, this past October at the Sorkin Gallery, were all rather small (a foot or two in height or width) and rather mysterious. Gregory builds up his surfaces with layers of enamel and oil paint; he dribbles the paint, brushes it, then scrapes it down and starts again. He arrives at such radically different compositions (they range from stripes to craggy configurations to a tiny figure and an ocean wave) that I found myself imagining the artist working improvisationally, not knowing where his paint would lead him. Gregory, who's in his thirties, is caught up in the painting process: this is what impresses me about his work.

Sometimes Gregory's titles begin to tell us something about the paintings. *The Ride* is a landscapelike image, with forms that are geologically layered. The picture with the wave is called *Underneath*, while *Toward Safe Harbor* has a shape that looks like the map of an island. But the titles aren't necessarily an open sesame. *For Jay Phillips* is an inscrutable series of stripes in deep red, black, and green.

Gregory's paintings have a dark, furrowed atmosphere that recalls American abstract painting in the years before and during the Depression—especially the work of the Stieglitz circle. When I was thinking about Gregory, I took Paul Rosenfeld's book *Port of New York* off the shelf and found a description of Arthur Dove's paintings that fits Gregory's work to a T. "He has dark, pungent, gritty hues in his palette; dark subtle schemes and delicate gradations of earth-browns and dull shadowy greens and dirt-grays and intestiny whites that seem to flow

from the body's fearless complete acceptance of itself. Sensitive reali-
zations of metal-tones break through this somber palette; strong vibrant
renderings of coppers and silvers. But the ground-tone remains umbra-
geous and grim and sometimes even dour."

This thing that we call "American" abstraction is characterized by
a moody inwardness, a reluctance to fit one's ideas into some large
design. Sometimes the artist seems reluctant to be clear. There's a thin
line between mystery and obfuscation. (Eventually my mind reverts to
the semiabstract mysteries of a Frenchman like Braque: his enigmatic
Bird paintings are crystal clear!) What keeps Gregory's paintings—for
the moment—clear *enough* is the simplicity of his process. He's following
the logic of his painted surfaces wherever they lead him. But where are
they leading him? What is the goal? Spatially, the paintings are ex-
tremely peculiar: very flat in places, with all sorts of implications of
depth in others. Because of the small scale—and maybe the beautiful
light at the Sorkin Gallery—Gregory's works mostly held together. Yet
one hankers for an internal logic that Gregory doesn't provide. These
are paintings that ask to be loved not in spite of their obfuscations but
because of them. I was in like with them.

———

An artist who's been showing for a number of years and has a
following among people who care about painting can find himself in a
situation full of possibilities and perils. Exhibiting before a public that's
familiar with the strengths of one's earlier work, an artist can be liberated
to take risks, to take off into unexplored areas. But there's another thing
that can happen: an artist can slough off, confident that the good old
audience will give the nod to anything he does.

I suppose that Stanley Lewis, who exhibited his new semiabstract
landscape drawings and paintings at the Bowery Gallery in December,
imagines that he's off on some marvelous new direction. But instead of
going for broke, Lewis (who's in his late forties) is running on empty—
and asking people to come along for the ride anyway. This artist still
has his gift for surfaces: the thick oil paint, in beautifully grayed whites
and plangent greens and purples, still has a presence; and Lewis still
wields a pencil for dramatic effect. There were always some Lewis
paintings—a lot of Lewis paintings—in which the artist seemed to be

leaning on his facility too much, letting it carry him along. But I've never before seen a Lewis show that was hollow in quite the way this one is—hollow all the way through. Among the pictures here (they include a series based on a street in Northampton, Massachusetts, and another based on a parking lot) there isn't a single impressive work. Lewis wearies me with his swashbuckling effects. The effects have no affect. In retrospect, that room full of slam-bang work is just a blank.

Stanley Lewis is part of the art world's serious crowd, the crowd who like to shake their heads and go "tsk, tsk" at the mention of Julian Schnabel or David Salle. Lewis taught for years at the Kansas City Art Institute, which had, under the chairmanship of the painter Wilbur Niewald, the greatest undergraduate painting department in this country. And Lewis remains a frequent visitor at the New York Studio School. At both Kansas City and the Studio School there has always been a great deal of talk about the mysteries of optical perception, the essential place of life drawing in the education of the artist, the glorious traditions of painting, the difficulties of the artistic calling—and I would be the last one to deny the importance of any of this. But there's a preciosity that can sometimes sift into the thinking of the serious crowd. At Kansas City, Wilbur Niewald kept—and still keeps—much of that at bay with his natural authority. Coming into a Niewald class, students learn that there are rules you have to accept before you can express yourself, and students respond to Niewald's toughness, because they know that he's not playing down to them. But elsewhere the insularity and underdog self-consciousness of the serious crowd can breed a kind of soft thinking all its own. The serious crowd produces its share of slob art: it's self-righteous slob art.

I once heard a member of the serious crowd remark, "Every time I go into my studio, I reinvent the wheel." Now, that's pretty rich. Maybe that's what Stanley Lewis thinks he's doing in his new landscapes. These pictures, in which the motif keeps disappearing into the erasures and globs of paint, are heavy on existential struggle—or is it just the existential merry-go-round? Lewis is into the torment of it all: he makes the paint gritty; he lashes out with his pencil and tears holes in the paper. But there's something preposterous about the heroics, because Lewis isn't getting anywhere. He's confusing ideas with notions, inspiration with strategy.

I'd say there are two basic notions that guide Lewis now. One is the notion that there is some a priori importance to drawing from life, that any assortment of neo-Giacometti marks that are made from life tell us something, even if we don't really know what the hell it is. The other notion is that a painting should have a broken, agitated surface— a neo-de Kooning, circa 1950 surface. (For the serious crowd, 1950 was heaven, and you're supposed to wake up every morning and beg God's forgiveness that you were only five years old at the time.) Lewis's two notions don't even really go together, except in a willfully artificial way. He may claim to be working from life, but finally he's working life over, wreaking havoc on the landscape in order to give it that seriously Ab Ex look. Everything hangs on the facture, and the facture is a fiction.

Every painting Lewis has ever done depends to some degree on those neo-Giacometti and neo-de Kooning notions. When Lewis is really getting somewhere, those notions are subsumed in a heartfelt response to landscape, to the particularities of a place. In the past it has sometimes seemed that Lewis, in spite of his notions, would be carried along by the authenticity of his feelings. But there has always been this superficial side to Lewis: it was there in his last show at Bowery, in October 1987, but at least then there were a half-dozen really marvelous paintings. This new show is all superficiality. A painter I know who wrote about Lewis's work some years ago observes that, back in the seventies, when Lewis lived in Kansas City, he tended to show his most fully resolved landscapes in New York. Maybe fifteen years ago Lewis had a sense that the serious crowd in New York would see through his notions: he wanted to put his best work forward. Maybe now he knows how seriously unserious the serious crowd has become (or always was). Maybe now Lewis is playing to their taste for zingy effects, for style (unserious serious style) over substance. Yet younger artists—some of whom were once students of Lewis's—were offended by this show. They came looking for passion and intensity and found Stanley Lewis playing the Young Turk.

———

Every once in a while I see one of the abstract paintings that Joan Mitchell did in the 1950s: there was one at the Jan Krugier Gallery earlier this season, and one has been hanging at the Museum of Modern

Art of late. It's always a lift to see these pictures, because Joan Mitchell takes command of the canvas with such easy assurance. Mitchell's show of recent paintings, at Robert Miller in November, gave me the same kind of lift. A generation has passed, and Mitchell is still the same lyric poet in paint. The paintings are agitated yet calm—all at once.

Mitchell has never pursued a wide range of structures. Her works tend to be made up of a loose network of curvy brush strokes. This network is porous, fluid: toward the center of the canvas the strokes sometimes gather together, press out toward us; at the sides, they tend to hew close to the edge, sometimes following along the edge. Like many of the Abstract Expressionists, Mitchell has had to combat the dangers of stagnation that are inherent in homogeneous structures. (For a time in the seventies she filled her paintings with soft-edged rectangular shapes.) Particularly in her triptychs, there is a tendency for the compositions to become too static, with too-predictable concentrations of color toward the centers of the three canvases. (This is the problem with the two large triptychs in this show.) But considering the number of Mitchell paintings that actually open up and breathe, I think it's fair to conclude that there's wisdom in Mitchell's refusal to pursue a broader range of compositional types. For her, the allover structure is the ordinary business of life. By finding new possibilities in what at first looks old hat, Mitchell makes abstract paintings whose subject is the poetry of the everyday. We go on the same old excursion and find something we never noticed there before.

Three paintings in this show were remarkable: *South*, in which a battery of red-orange-pink strokes rises up from the surface to create a cool frenzy; *Margin*, in which the delicate greens break out of their symmetry into up-and-down and over-and-out passages that hint at a marshy pastoral; and *River*, in which yellows and blacks and blues ebb and flow into vast panoramic effects.

About twenty years ago, the poet John Ashbery remarked of Mitchell's relation to nature—and that of the Abstract Expressionists in general—that "one's feelings about nature are at different removes from it. There will be elements of things seen even in the most abstracted impression; otherwise the feeling is likely to disappear and leave an object in its place. At other times feelings remain close to the subject, which is nothing against them; in fact, feelings that leave the subject intact may

be freer to develop, in and around the theme and independent of it as well." (Ashbery's article on Joan Mitchell is reprinted in his marvelous new collection, *Reported Sightings*, published by Knopf.) Mitchell is still giving us that beautifully shaded view of nature. She may be the only person working in an Abstract Expressionist vein right now who does paintings that aren't objects. The feeling, experienced at some remove from nature that is somehow not a remove from nature, draws us in and carries us along.

These are paintings in which direct experience has been shaded and transformed. The best Mitchells are authentically civilized experiences. Our appetites are focused and clarified. Her colors are the beautiful colors of the world: tans of flesh and greens of landscape, but also the purple of the iris and the tawny yellow of the pear.

February 1990

CLASSICS WITHOUT COMMERCIALS

Art galleries are ruled by the clock: rush, rush; the shows go up and down; "Will there be a review in the *Times* on Friday?"; then the summer hiatus; and the wondering over what to show this time next year. No doubt it is the fast-forward movement (a frenzy disrupted only by the dullness of the days when nobody comes in) that provokes certain dealers, even if their primary interest is the art of the present, to turn back the clock by showing classic or at least pre-contemporary work. Such shows have a serious point: they suggest that the road into the future can also be a road back into the past. If museums present the case that the past is ever present, classic shows in contemporary galleries present the case that the future might just catch the tail of the past. The year is 1937 and the Galerie Pierre (2, rue des Beaux-Arts, Paris), a hotbed of Surrealist activity, mounts a show of the work of Odilon Redon, a fantastical artist sometimes thought of as a proto-Surrealist. The year is 1984, and the Robert Miller Gallery (724 Fifth Avenue, New York), a showcase for contemporary Expressionist figuration, exhibits the late work of de Chirico, a modernist turned anti-modernist who fascinates a new generation.

In these cases, the backward glance is provoked by the dealer's contacts with contemporary artists, with their concerns. No less valuable is the gallery that devotes itself to spotlighting underknown aspects of the past. The year is 1960, and the Galerie Chalette goes against the Abstract Expressionist grain with a show of "Construction and Geometry in Painting: From Malevich to 'Tomorrow.' " The year is 1989, and the Rachel Adler Gallery exhibits the work of Jean Hélion, which at that moment can be seen in no museum in New York. These galleries want to find a permanent berth for the art they believe in in private

collections and, ultimately, in the museums. Galleries can be freshwater springs, feeding into the museums. Ideally, everything flows, and the essential traditions are continually revitalized, broadened.

This season has so far been a remarkable one for exhibitions of modern art, both in the museums and in the galleries. By the time that "Picasso and Braque: Pioneering Cubism," one of the great shows of the age, closed at the Museum of Modern Art in mid-January, people were so used to thinking of its being there that they felt bereft. William Rubin had done what he does best, sublimely. He presented orthodox modernism as a gloriously transparent tradition. He laid out the heroic days of Cubism with such clarity and delicacy that we could all go through the show in our own ways and come out with our own conclusions. We're all in Rubin's debt. Around this essential experience— it's the silver and gold masterpiece at the center of this season's treasure house of modern exhibitions—other, smaller but also distinguished events have occurred. Over at the Metropolitan there have been two top-notch shows. In "Pierre Bonnard: The Graphic Art" we witnessed, step by step, the artist's passage from the naturalistic vignette beloved of *fin-de-siècle* illustrators to his own casually unaffected version of the grand manner. Meanwhile, the Jacques and Natasha Gelman Collection, itself rich in Bonnards, and in Braques, Picassos, and Matisses, too, had the effect of setting the history of Cubism that was being told over at the Modern back into the broader School of Paris context. A few blocks away, Salander-O'Reilly Galleries supplied the prehistory of modernism, in its dream-perfect show of Constable and Delacroix (with a soupçon of Rubens, a master whom not only Delacroix but also Constable had studied very closely). Up at Helen Serger's La Boetie, a small show of Matisse drawings that she had meant as an homage to her old friend Pierre Matisse, who died last summer, became a memorial to a generation of dealers when Mme Serger died last fall. The new Galerie Taménaga on Madison Avenue presented a good exhibition of the underappreciated Vlaminck. The Philippe Daverio Gallery, late of West Twenty-third Street, opened on East Fifty-seventh Street with a wonderful anthology of its specialty, twentieth-century Italian art. This little sketch for a history of Italian art from Boldini to de Chirico was better outlined and more deeply felt than the Italian art extravaganza mounted

in London last season. Jan Krugier exhibited modern sculpture, in a single room packed tight with magnificent things by Brancusi, Arp, Picasso, Julio Gonzáles, and many others. Pace presented Joseph Cornell; Zabriskie, Leon Hartl and Turku Trajan; a show of jewelry by modern artists at Herstand was an interesting idea, though poorly realized. Here are some of my impressions.

Salander-O'Reilly's double show (Constable in one room, Delacroix in another) carried us back to the Salon of 1824, when Constable first exhibited in Paris and Delacroix had the close encounter with English landscape painting that would lead him, and then all of Paris, into the radical confrontations with nature and tradition that inaugurated the Parisian century of miracles. Delacroix is a very difficult artist to appreciate anywhere except in the Louvre. I can't think of another painter whose effects are so closely linked to the actual size of his work. The strange croppings of forms (the cut-off horse at the lower left of *The Death of Sardanapalus*, 1827; the cut-off flag at the top of *Liberty Leading the People*, 1830) feel inevitable and expansive at full scale and yet can look not only reduced but also eccentric and arbitrary in reproduction. Gathering together small paintings, oil sketches, drawings, and prints from public and private collections, Salander-O'Reilly managed to convey some of the amplitude and grandeur of Delacroix's art. This canny selection underlined the centrifugal nature of Delacroix's compositions, their paradoxical combination of weightiness and boundlessness. In particular I treasure the memory of the *Jewess of Algiers* (1852), from a private collection. Seen under natural light, this little figure has the monumentality of a Mesopotamian Gudea.

Michael O'Brian, director of La Boetie, included in his show of Matisse drawings two pencil sketches from one 1928 session. In both drawings we see the same two models lounging amidst the same cushions, the same low chair. *Deux femmes assises* is dominated by a figure that stretches all across the page and draws our eyes up to the right and back into space; the other model, sitting at the left with her arms encircling her knees, is by comparison self-contained, inward-turning. In the second drawing, *Odalisque et femme nue*, the outstretched nude is now seen from the back, still angling sharply to the right, while the second figure, leaning against the little chair, pulls our eyes in the opposite direction, out of the upper left corner of the paper. In the first drawing

the two models, their heads neatly balanced to the left and right of the page, both gaze into an empty foreground where their gazes—or perhaps it is the trajectory of their gazes—meet, as if in midair. In the second drawing the forward gaze of the model on the left is balanced by the denial of the face of the model on the right (almost the whole head is eclipsed by the shoulders). In both drawings the geometric play of mirror images and implied diagonals is opposed to the stately curves of hip and thigh and belly and breast. Taken together, these two drawings reveal much about the working processes of the studio, the here and there and back and forth by which the artist tracks the figures as they make their space: opening space up and closing it down, compressing and decompressing.

The large Joseph Cornell show at the Pace Gallery, consisting mainly of white boxes from the fifties, was opulently presented. At first I was put off by the sight of a gallery papered in blue rice paper to give it the effect of some sort of exotic stone. Yet there was something beguiling about this deluxe installation: it brought out the glamour factor in Cornell's art and heated up the atmosphere around these atmosphere-laden assemblages. Perhaps it is time to admit that Cornell's is a likable and extravagantly decorative sensibility. The stories of his asceticism, of his strange life out in Queens, tend to disguise the fact that he was first and last a man of his time. His idiosyncratic mix of Constructivism and Surrealism and Romanticism is not so much a personal dream as it is the collective dream of the New York art scene of the 1940s and 1950s. Every artist had Europe on his mind. Everybody wanted to get over Europe. The art reproductions and souvenirs of little French hotels that fill Cornell's boxes are fragments of a retreating dream, a dream seen through the blue and white mists of the Atlantic, a dream from which America would have to wake up in order to become itself. No wonder ballet was key for Cornell. At the hands of Balanchine, this nineteenth-century Romantic art form was becoming, before New York's very eyes, the vehicle for the greatest of all American adventures in modern art. Cornell is a nonpareil archaeologist of the modern movement, the master of his own decidedly unscientific methodologies.

In the section of the rather grand catalogue of the Gelman Collection that is devoted to provenances, one can study the essential role played

by certain important galleries in the formation of a great collection. The Gelmans were lucky enough to buy some of their paintings from galleries that had obtained work directly from the artists. This is the case with many of their Braques, which came from Galerie Maeght in Paris. A number of the Matisses went directly from Mme Matisse to Pierre Matisse's gallery and then to the Gelmans. Other provenances offer charming vistas of the history of modern art. The Paul Klee was purchased at the Buchholz Gallery by the painter George L. K. Morris, a key member of the American Abstract Artists group; from there it went to another private collector, then to the Marlborough Gallery, and then to the Gelmans. The Picasso *Head of a Woman* (1927) was bought at the Galerie Pierre in Paris in 1938 by the painter Wolfgang Paalen, a Surrealist who showed at Galerie Pierre, founded the magazine *Dyn* in Mexico, and published a book of essays called *Form and Sense* (1945). The Gelmans, who lived in Mexico, where Jacques had made a fortune in the movie business, bought the Picasso direct from Paalen.

It is not surprising, given the rich social history that can be read between the lines of these provenances, that the collection presents a view of modern art that is lively and unpredictable—that is passionate. I was glad to see Bonnard, Matisse, Picasso, and Léger at various points in their careers; and to see them in the company of Miró, Giacometti, and Balthus. I don't care for the paintings of Yves Tanguy, nor do the works of Modigliani, Dali, and Ernst engage me especially. Yet the installation of the Gelman Collection in three rooms at the Met felt coherent. In one way or another, all the works in the collection reflect the shifts in consciousness that rocked Paris in the half-century between Impressionism and Surrealism. Many of the artists included either instigated or were among the first to respond to those shifts in consciousness. If the Gelman Collection has a subject, it is the many ways in which nature is transformed in the art of the School of Paris. Those transformations, seen in all their variety, make an irregular yet beautiful pattern, a pattern that is all the more beautiful for its irregularities.

Looking at the half dozen or so works each by Matisse or Braque, one sees different aspects of a career (and perhaps they are also different facets of a personality). Matisse is revealed in four phases: the Fauve mosaic work of the *Still Life with Vegetables* (1905–6), where the leap from naturalistic observation into pictorial exaggeration is a matter of

many tiny moves; the consolidation of Matisse's kaleidoscopic color into the reduced designs of *The Young Sailor II* (1906) and *View of Collioure* (1907–8); the introduction of a full spatial illusionism into a space that is constructed out of antinaturalistic color in *Odalisque, Harmony in Red* (1926–27); the development of a space that is generated from natural principles rather than from natural appearances in the paper cutout *Snow Flowers* (1951). Braque, too, is seen in four phases: the decomposition of the old spatial illusionism into the new pictorial illusionism that is Analytical Cubism (and so we're back at "Pioneering Cubism" at MoMA); and then the classical, mannerist, and expressionist phases that Braque's Cubism passes through in the next half century in three exemplary works, *Still Life with a Guitar* (1924), *The Billiard Table* (1944–52), and that sublimely eccentric masterpiece *The Garden Chair* (1947–60).

Picasso, Bonnard, and Miró are likewise presented in the round. And some of the artists who are less fully represented are no less well represented. Here are Giacometti's fine 1961 portrait of *Annette* and several painted bronzes. Neither of the Balthuses in the Gelman Collection would be in my Balthus Top Ten. *Thérèse Dreaming* (1938) is a tour de force that is perhaps too much a matter of willed effects to resolve into a masterpiece. The 1957 *Girl at a Window*, which shows Balthus in one of his self-consciously quiet moods, is interesting for its recapitulation of the Biedermeier conceit of the girl seen from the back looking out the window. The painting is about the girl's consciousness of the landscape, a consciousness expressed through the poetically licensed idea of reversing aerial perspective, so that the distant landscape is more fully realized than the interior foreground.

All in all, the Gelman Collection has a happy logic. Though the paintings and sculptures don't look like one another, they do fit together. We're seeing it all through the eyes of the Gelmans, and boy, do they have *eyes*.

Last December, I received a letter from the painter Albert Kresch in which he explained how "irked and infuriated" he was at the Sotheby's sales the previous spring, "which had the Met, the Philadelphia Museum, the Art Institute of Chicago, the Cincinnati Museum, and the Hirshhorn dumping (for their own inscrutable reasons?) (to purchase

late-twentieth-century 'art') great Matisses, Renoirs, Soutines, Segon-
zacs, Picassos, Arps, Rouaults, and other superb paintings. . . . And
did they ever look good. And that's only *one* sale. . . . The depletion
(ransacking) of the nation's major museums' and galleries' artistic pat-
rimony continues unabated (is accelerating)."

I share Kresch's concerns. There is a winnowing process going on
in the museums. This is merely ill considered or downright sinister—
opinions differ. Many museums are deaccessioning works that are found
to be inconsistent with the current taste of the curatorial staff; and—
presto!—modern art looks utterly homogeneous. Kresch (who paints
dark, somber, panoramic landscapes) is one of the many artists whose
needs are not being served by our museums. (His letter was inspired
by anxieties over the future integrity of the Barnes Collection in Merion,
Pennsylvania, a treasure house of unfashionable moderns, such as the
late Renoir, which some fear may be a future victim of the deaccessioning
binge.) The problem is not simply that some painters and members of
the museum-going public prefer Rouault to Rothko, or may want to see
a broader representation of the Constructivist tradition exemplified by
painters like Joaquín Torres-García and Auguste Herbin. The problem
is that the American public, including the artists, is being denied the
full disclosure of modern art.

Yet the events of the past months suggest that the hyped-up art
market of the past decade cuts two ways. Galleries that want to cash
in on the boom in modern masters may find that it's to their advantage
to engage in a healthy historical dialogue. And museums that are jock-
eying for major collections may be willing to accept works (such as a
Gelman Rouault) that they would not dream of actually going out to
buy (nor could they afford them). With prices for modern art now out
of sight, we will never be able to return to the days when people of
moderate wealth could collect it. This is an unfortunate development,
as it drastically reduces the already tiny number of people who can
engage in the historical dialogue as collectors. (Contemporary art, de-
spite the astronomical prices at some galleries, remains affordable, with
small but beautiful works by significant artists available for one or two
thousand dollars.) Some of the prices at Jan Krugier's sculpture show
were startling, in the multimillions; and yet the Krugier show, which
was open to the public free of charge, was a public service. Some galleries

relatively new to New York such as Krugier and Daverio and Salander-O'Reilly—as well as certain older ones such as Washburn and Zabriskie—don't just sell rarities at high prices; they also enrich the art life of the city through their exhibitions, many of which are beautifully selected and presented. Many of these galleries also uphold a high standard of scholarship and connoisseurship: their clients demand it.

The revelations that the private galleries offer the public are yet another reminder of how hopelessly out of date the current definitions of populist and elitist are when it comes to the arts. These galleries may be driven by the almighty dollar, but they're community-minded as well. By the same token, it sometimes seems that the old "elitist" museums, where anyone could go into the empty galleries and feel like the prince in his palace, were a heck of a lot more "populist" than the new audience-friendly museums, where you can barely get through the front door for the crush of the crowds.

In a beautiful essay in the catalogue of the Gelman Collection, Pierre Schneider remarks on how "between the studio and the museum, the work traverses a number of situations"—he's thinking of collectors, but also of dealers. Later on, he speaks of "a chain of solicitude" that accompanies the work to the point where, with luck, it is viewed "as a moment in art history, a product and a producer of influences, a link in the concatenation of which the museum seeks, through the diversity and presentation of its collections, to serve as a convincing equivalent." But how difficult it is to maintain a diversity of collections and of presentations that really does justice to history. (The question is always, "Whose history?") Obviously, the complete view must be gleaned from diverse sources. And obviously it becomes harder to do this as museums auction off parts of their collections. Now that the Guggenheim, which under Thomas Messer did some important historical shows, has fallen victim to a terminal hipness that is really just a kind of terminal hardening of the arteries, it could be that William Lieberman at the Metropolitan will produce the honorable and essential opposition to the Museum of Modern Art's own honorable history of modern art. Lieberman will never be able to transcend the truly awful design of the Lila Acheson Wallace Wing (how could anyone build on a site on Central Park and fail to produce painting galleries with natural light?); but Lieberman's presentation of, say, the later Braque suggests that he may

offer some of what MoMA prefers not to offer. At MoMA we can look forward, at least in the near future, to more great moments in high modernism: "Matisse in Morocco" arrives in summer 1990. Meanwhile, the private galleries are filling in some of the missing pieces, putting on extraordinary shows and welcoming the public—the artist public and the general public, too. Without the work the private galleries have done over the past few years, how much less we would know of Arp, Derain, Hélion, Torres-García, Elie Nadelman, Burgoyne Diller, Earl Kerkam, Arnold Friedman. This season, we've been feasting on the classics. And the classics would not be on display if there weren't a public that loved them. This is a sign of hope.

March 1990

PARADISE NOW

It was raining when Matisse arrived in Tangiers in January 1912. The days wore on, the weather showed no signs of improving, and the artist, who was holed up in the Hotel Villa de France, began to wonder if he should have come to North Africa in the first place. To Gertrude Stein, back in Paris, he wrote, "Shall we ever see the sun in Morocco?" And to the painter Marquet—who'd suggested the trip—he exclaimed, "Tangier, Tangier! I wish I had the courage to get the hell out."

Then, after four weeks of more or less nonstop rain, the weather turned and the Moroccan landscape was revealed. The severe, punctilious Matisse, who was sometimes referred to by his friends as "Professor" or "Doctor," abandoned himself to pure sensation. His experiences on that first good day probably recalled those of another severe Frenchman, André Gide, a few years earlier in Algiers. "The cloud parts under the pressure of over-abundant blue," Gide wrote in his North African notebooks. "And that street which forms a square, that terrace, that balcony fill with an idyllic and smiling animation." This was the promised paradise—the paradise that had already been immortalized in the paintings of Delacroix. For Matisse the gentle blue skies and vibrant green vegetation and azure seas had a magical strangeness. "At last, charming, sheer delight," Matisse wrote to one friend. And to another, "What decorativeness!!! How new all this is."

Matisse went to work fast, and his expansive mood lit up everything he did. As the weeks flashed by, he found himself moving into a whole new period in his art. On the front of "a tiny Arab stall," Gide had seen the words "LUXE ORDINAIRE." This simple phrase might describe the Matisse of Morocco. The brilliant colors and bold patterns

that Matisse had had to invent back home in France were a reality here: they were *ordinary*. At last, Matisse was at one with his environment. The two dozen paintings from this and a second trip in the winter of 1912–13 that make up "Matisse in Morocco," at the National Gallery in Washington, are the most effortlessly beautiful pictures of this great artist's entire career.

In Morocco, Matisse painted flowers and gardens and gateways and figures in loose-fitting, flowing clothes. He painted all of this in thin, luminous layers of oil paint; yet the ultimate effect is often bold and monumental. These canvases aren't as big as one may imagine them to be from looking at reproductions: the tallest are mostly less than five feet high, and it's a beautiful sort of size for Matisse to work on. He takes control of the surface easily; there's no sense of strain. In *Fatma, the Mulatto Woman* and *Zorah Standing* and *Amido* Matisse sees the slender vertical format as an extension of the slender standing figure. The figure equals the image—an idea borrowed from the icon painters—and the paintings are iconlike in their completeness. These Moroccan paintings evoke the hieratic world of Byzantine art—an art that Matisse had studied in 1911, when he went to Russia to visit Shchukin and Morosov, the two businessmen who were his biggest collectors. It was Shchukin and Morosov who bought the greatest of the Moroccan paintings; and it is only now, in the Age of Glasnost, that they have arrived in numbers in an American museum. Billed as a "USA/USSR Joint Project," "Matisse in Morocco" brings together Matisses that ended up in Russian public collections as well as works from America and Europe. After closing in Washington, the show will travel to New York's Museum of Modern Art for the summer and then on to Moscow and Leningrad in the fall. While a number of recent loan shows (especially MoMA's "Pioneering Cubism") have benefited from the improvement in East-West relations, "Matisse in Morocco" may be the first show in which the glasnost spirit dominates; it's the first show that would have been totally impossible a couple of years ago.

Matisse was forty-three when he arrived in North Africa. While his work had by no means achieved popular fame, the scandals of the Fauve movement of 1905–6 were long behind him, and the banner of the avant-garde had passed on to Picasso and Braque, who were more than

a decade Matisse's juniors and were turning the world inside out with the invention of Cubism. From the trip to Morocco onward, Matisse's evolution was to be very much a private one; he had separated himself from the fast-breaking news of Parisian modernism, in which Cubism would soon be overtaken by abstraction and Surrealism. Nonetheless, when a genius makes a personal odyssey, it inevitably has a larger-than-life resonance. Matisse's taste for the exotic was the product of a historic dream: the dream of uniting the Eastern taste for flat decoration and the Western taste for three-dimensional form. Eighty years before Matisse set foot in Morocco, Delacroix had gone there and filled notebooks with delicate watercolors of people and places, of local customs and luxuriant vegetation. Back in France, he'd created his *Women of Algiers*, the greatest of all memorials to the lure of exotic places, an Orientalist's fantasia painted with red-hot passion and crystalline lucidity. *The Women of Algiers* was one of Matisse's favorite paintings; and Matisse's relationship to Delacroix was peculiarly intimate, one of those connections that artists sometimes strike up with confreres who've been dead for generations. Delacroix, an archetypal nineteenth-century man, could only dream of an art based on abstract decoration. When he had announced that "the most beautiful pictures I have ever seen are some oriental rugs"—well, he might almost have been speaking for Matisse, and not only the Matisse of 1912, but even more so the Matisse of the paper cutouts of 1950. Matisse, who was thirty-one in 1900, would make Delacroix's dream a reality. In old age, Matisse recalled that he'd "found the landscapes of Morocco just as they had been described in the paintings of Delacroix."

The nineteenth-century writer Pierre Loti, whose *Au Maroc* had inspired Matisse and many travelers before him, spoke of Morocco in terms of "the subtlest Edenic shades." The poet Richard Howard has said that Gide's descriptions of North Africa have "the tonality of eros." It's those Edenic and erotic shades that are given body in Matisse's airy vistas and lush gardens. In the *Moroccan Triptych*—from the Pushkin Museum in Moscow: for many people it's going to be the peak experience of the show—what Gide called "the blue-tinged air" suffuses the universe. Blue becomes the earth of Tangier in the *Landscape Viewed from a Window*, the model Zorah and the goldfish bowl in *On the Terrace*, the cross-legged merchant in *The Casbah Gate*. The empyrean hues range

from a deep, lustrous royal blue (it has the density of velvet) to blues that are powdery white or are infused with lemony yellow and greenish turquoise.

As for Matisse's North African figures, they are discrete, inscrutable presences. Once you've been through this show, you will never forget Zorah, who sits or stands with her hands folded, her face dominated by sad, almond-shaped eyes; Fatmah the Mulatto Woman, with her high cheekbones and casual, long-legged stance; and the Ruffian, with his sensitive head mounted on a monumental pair of shoulders and a vast, sculptural torso. Matisse regards each of these figures with an attentiveness that's rather childlike. He's wonderstruck at such powerful alien presences; he refuses to represent them as merely picturesque. Zorah and Fatmah and the Ruffian appear in splendid isolation. These powerful giants stand before us with their secrets intact. For Europeans, the exoticism of North Africa was a beautiful, impenetrable facade—a facade that forced the traveler back into himself. No doubt this is why Morocco and Algiers appealed to cold romantics, to romantics like Gide and Matisse. The masklike faces of Zorah and Fatmah, which have no psychological dimension, recall the figures in Gide's African journals, who may be described as little more than a "handsome face . . . agile fingers on the flute." And just as Gide describes his walks through the cities in terms of brief enigmatic images (light coming through a white curtain, a hidden garden), Matisse's Morocco is a matter of simplified images (a doorway, a curving tree).

The paintings from the Moroccan trips are among the best resolved that Matisse did during his turbulently experimental fifth decade. There's a tendency in some of the work completed between 1910 and 1918 for Matisse to go too far into abstraction for its own sake, too far into pattern for its own sake. And modern taste is too inclined to admire unreservedly the irresolution of paintings like the *Piano Lesson* and *Notre Dame* (both in the collection of the Museum of Modern Art). There are paintings from the Moroccan trips that lack resolution, too—paintings like *The Palm* and *Open Window at Tangier*. In these canvases Matisse departs from nature by blanking out—by leaving things half done. But in a remarkable number of the Moroccan paintings the artist's desire to simplify nature is subsumed in a new idea about the nature of nature.

In Morocco, Matisse found that he could make sense of his impressions of the world without depending on the elaborate stage machinery of chiaroscuro and perspective that was the legacy of the artists of the Renaissance. The natural world is no longer defined by perception so much as by certain laws of growth and form: the bilateral symmetry of figures and trees; the way plants reach up toward the sun. Here decoration, which is derived from the experience of nature, provokes an ideal order, an order that is not necessarily consistent with the order of perception. It's in Morocco, a culture in which decorative art is all there is to art, that Matisse finally distills nature in a way that enlarges our understanding of nature.

Pierre Schneider—the author of a book on Matisse that is one of the major art-historical achievements of recent decades—has contributed a brilliant essay to the National Gallery catalogue. It is called "The Moroccan Hinge" and proposes Morocco as the center of Matisse's career, the place where the lure of the Orient (where naturalism as it is understood in the West is unknown) is internalized and becomes for Matisse a spiritual principle. "After Tangier," Schneider writes, "the flowers returned to their vases, just as the patterns retreated into the carpets. They broke away again, with an exuberance they had not known since the Moroccan sojourns, after the operation Matisse underwent in 1941, which marked the entrance into what he called 'a second life.' Suddenly, veritable beds of the brightest, subtlest corollas flower on the envelopes of letters written by Matisse to his friends. They are the overture to the floral fireworks that constellate the pages of the *Poèmes de Charles d'Orléans*." Schneider sees the paper cutouts of the late 1940s and 1950s, along with the Chapel at Vence that was completed in 1951, as the ultimate fruits of the Moroccan experience.

While the rain was falling in Tangier, Matisse wrote to Gertrude Stein, "Painting is so very hard for me—always this struggle—is it natural? Yes, but why have so much of it? It's so sweet when it comes of its own accord." Little did he know that, a few weeks after he wrote these words, the painting would be coming "of its own accord." This splendid exhibition is about a journey through real time and space that takes its place within the geography of a great imagination. The paintings that Matisse did during his visits to Morocco have the overwhelming power of unforgotten childhood memories. Those exotic faces, that

entrance to the Casbah, that overscaled foliage: they come at us all at once and stay with us forever. Matisse is telling us that we're all children in the great bazaar.

March 1990

MIXED MEDIA

There's no mystery as to why so many contemporary artists want to work with imagery that's derived from the movies. Movie culture is just about the only artistic culture that is capable of bringing together a broad range of the public. Talking about Daniel Day-Lewis's performance as a victim of cerebral palsy in *My Left Foot*, or our reactions to the black comedy of Paul Mazursky's *Enemies, a Love Story*, offers us an easy, lively form of social interaction. As we find out what other people look for in a movie—they may be people we know at work, or relatives, or the parents of our children's friends—we learn about one another's sensibilities and tastes. A movie is an event in the culture at large; this is far less frequently the case with a ballet performance or an art show or even a best-selling novel. The visual artists who reach out to movie culture by borrowing images or iconography or compositional strategies from Hollywood are trying to open up art-gallery art to the larger culture—an honorable objective. But the effect more often than not is to close down art-gallery art: the one-on-one experience of looking at a painting or a sculpture is diluted. The references to movie culture carry with them a freight of allusions that is difficult for the artist to control. You can't see the pictures for the popcorn.

No contemporary artist is quite so saturated in movie culture as Cindy Sherman. She is a hit with the part of the public that wants to believe that gallery going equals movie going. These days that's a considerable public. Sherman's show at Metro Pictures last January was one of those rare occasions when a SoHo gallery is actually crowded on a weekday afternoon. The work consisted of a series of photographic self-portraits based on old-master paintings. But what these color pho-

tographs recalled wasn't old-master paintings so much as the historical costume dramas that Hollywood used to produce in great quantities, with settings based on old-master paintings. Sherman is an artist who can't see the paintings for the movies that have mimicked the paintings.

In these color photographs Sherman dresses herself up to look like everything from a fifteenth-century Flemish Madonna to the hostess of a nineteenth-century Parisian salon. We always know it's Cindy Sherman, just the way we know it's Charlton Heston in *The Agony and the Ecstasy* or Charles Laughton in *Rembrandt* or Bette Davis playing Queen Elizabeth I. When filmed costume dramas work for us, it's because the mismatch between a mise-en-scène derived from old paintings and a contemporary acting style is fused by the forward movement of the drama: actors bring it all to life. The effect of Sherman's photographs is very different. Her poker-faced expressions, which are often accented by funny noses or wigs, deaden whatever drama is implicit in the setups: she brings out the tackiness of ye olde props and costumes. Sometimes, she flaunts the fakery: a fake bosom is photographed with the strings that attach it to the shoulders showing, or the edge of a bald pate is as clear as day. Sherman belabors the ludicrousness of costume drama; and the audience takes this for a revelation. She doesn't offer the exhilaration of a historical drama that pushes costumes and action into an unpredictable unity; she deconstructs Hollywood. She takes us through a good swath of the history of European art, peeping out from her sackcloth and crinolines with that dopey look of hers, as if to say, "Here we are in another great moment of Western art, and, guess what, it's just Hollywood pasteboard and greasepaint, too." This is the latest thing in postmodern criticality. You study up with the movies on late-night TV and then put together your I-hate-the-history-of-Western-art show.

Few contemporary artists have as loyal a following as Cindy Sherman: people go to her shows to see their current preoccupations hanging on the wall. Sherman's early work, in which she often played a sort of surreal version of Doris Day, jibed with the beginnings of the downtown nostalgia for fifties style—the style of the baby boomer's childhood. Sherman's horror-movie phase, in which she groped around in the dirt, was coordinated with the "Primitivism" show at the Museum of Modern Art. Her last show, which included images that focused on puddles of vomit, was a dare addressed to her paying public ("See if you'll buy this!") and represented a very au courant confession of discomfort with

one's own art-world stardom. The new show fits neatly into the taste for lavish period effects that's been a dominant trend in home decor and fashion for the past decade. A year ago, Stephen Frears's movie *Dangerous Liaisons* brought historical drama back to life in Hollywood; and I would not be surprised if *Dangerous Liaisons* was one of the inspirations for Sherman's new show. The disjuncture of the accoutrements and the affect in Sherman's new photographs could be inspired by the odd effect that Frears achieved by putting such American actors as Glenn Close and John Malkovich in period dress and settings. The Frears movie was held together by its pacing and the wickedly obsessive rapport of its stars: their behavior bridged the gap between Laclos's epistolary novel and the twentieth century. In *Dangerous Liaisons* the period costumes built up an atmosphere that the actors carried with them. Sherman, with her unreadable, inexpressive face, is mired in her settings.

As I went through her Metro Pictures show, I found myself thinking more and more about all the trouble (and expense) that had gone into Sherman's costumes and period backdrops. The mechanics of the work are very much exposed. And, of course, Sherman wants that exposure. It's her way of suggesting the unreality of it all. Looking at these photographs, one passes in rapid succession from the spit and polish of the uptown antique store to the moldiness of the touring company's prop room to the drag act in the downtown club—and then back to the uptown antique store. Everything refers to the movies and the old masters. It's all served up in the form of overheated color photographs. Especially when they're very large, they have fuzzy, indistinct surfaces that some may take for "painterly." No wonder people describe this trendy hodge-podge as a great synthesis: it's got "everything." Sherman works the art-gallery audience as shamelessly as Steven Spielberg works the audience at the Sixplex in the mall.

There have always been artists who want to use the conventions of traditional easel painting as the starting point for a modern portrait style. When contemporaries such as Leland Bell, Paul Georges, Louisa Matthiasdottir, and Temma Bell use the immobile poses of the old masters as a foil for modern psychological insights, they're labeled traditionalists and reactionaries. Yet there's more risk in any one of the portraits that Paul Georges does in a Velázquez style than in all of Sherman's photographs put together. While painters who are involved in a living dialogue with the past are dismissed outright or patronized

as unpleasant anomalies, Cindy Sherman's rip-off act is hailed as an original reinterpretation of the old masters. It's situations like this that make art lovers want to go home and pull the covers over their heads.

——

I have walked through the contemporary section of the Museum of Modern Art at the Pompidou Center in Paris and thought that a painting by Shirley Jaffe, an American abstractionist who's lived for many years in France, is the only creditable thing on display. I've walked in and out of the commercial galleries in the streets around the Pompidou Center and thought that a Jaffe painting in the Galerie Fournier made everything else look like pretty sorry stuff. Jaffe's paintings, which consist of hard-edged shapes, by turns whimsically biomorphic or dryly geometric, arranged without overlaps, usually on a white ground, have purity and authority. It was a good thing when Artists Space gave her a show last year. The Holly Solomon Gallery followed it up, this past January, with an uptown exhibition. So far as my friends can recall, these were Jaffe's first appearances in New York. It's about time.

There's a great deal of color in Jaffe's paintings. Her shapes, each in a single color, comprise a rainbow of sherbet hues: lemons and tangerines and lime greens. Yet the effect isn't exactly zestful. The color, partly because it's set in a neutral ground, is a bit muffled. And the shapes themselves give the effect of an ebullience that's been reined in. These shapes—which range from plantlike to machinelike—aren't expansive and don't seem to interact very much with one another. A Shirley Jaffe painting is an arrangement of forms. But the arrangements aren't necessarily compositions: they're considered and yet somehow arbitrary. The arbitrariness introduces an element of mystery or surprise that Jaffe may want. She may not want us to know exactly why this form is close to that form. Perhaps the peculiar mélange of Jaffe's forms is a conscious risk; it can also leave a viewer bemused.

Jaffe's work is in the purist line of modern art: looking at her paintings, one thinks of Arp and the Matisse cutouts, of Taeuber-Arp, Herbin, Mondrian. Some of the unemphatic force of Jaffe's work comes from her allegiance to that glorious tradition. She's attuned to the pictorial power that's inherent in an unmodulated plane of color or a razor-sharp contour. She loves the empyrean universe that the European abstractionists dreamed up. I do, too. And yet Jaffe's work doesn't quite

have the quality of ultimate distillation that I expect from purist art. Her forms are a little too random to feel inevitable. Her compositions don't quite embody some overarching logic. The best paintings in the Solomon show—they included *Betwixt and Between*, *Square in Square*, *Moroccan Dream*, *Four Horizons*, *Bagatelle*—are the sum of their parts. And a viewer can leave feeling a bit cheated, cheated of the moment when the forms in a painting stop adding up and start multiplying— when a painting goes over the top.

The elements in Jaffe's compositions are quirky; they jangle against one another in odd ways. Emotionally, Jaffe is an impure purist. There's a cartoonish edge to some of the shapes; they're pared down, but oddball anthropomorphic readings keep cropping up. Perhaps this is all intentional. Nevertheless, I can't help feeling that Jaffe is reaching for elaborate comic effects that she doesn't quite bring off. (When Arp and Brancusi do something funny, they do it with elegance but also with innocence: their jokes have the saving simplicity of a Josephine Baker dance.) Despite the refinement of some of Shirley Jaffe's forms, I don't turn away from a Jaffe painting feeling as if I've drunk champagne. But I want to feel that way. What she leaves me with is the sense that I've been in the presence of an accomplished, knowledgeable artist. That's a hell of a lot. The paintings hold the wall (how many contemporary painters can do that?), and I don't forget them after I've seen them.

————

Joan Snyder's show at Hirschl & Adler Modern last February contained thirty-seven paintings. These new works range in size from seven inches to sixty inches and recapitulate the full panoply of 1980s Neo-Expressionist effects. There are paintings done on colored velvet and paintings collaged with, in addition to velvet, twigs and nails and bits of rusty metal. There are emblematic figures submerged in waves of paint and grit; there are howling faces, one of which sports a droopy red velvet tongue. Snyder's colors veer abruptly from hot-hot to ice-cold; her paint is often handled without a brush—squeezed out of the tube and smeared around the canvas or scratched in to make deep engraved lines. At least half of the work in this show was rip-snortingly awful. The little canvases that have been draped in velvet to create uneven shapes, like sloppily wrapped packages, are boutique stuff; and most of the figures or figure fragments look like tired reruns of ideas

that were already tired when people like Asger Jorn were doing them in the fifties. There's no excuse for this kind of work; but at least Snyder refuses to take an ironic attitude toward her material—she doesn't produce prepackaged histrionics, like Julian Schnabel or Elizabeth Murray. Snyder carries her heart right there on her sleeve (her shows have this incredible energy level); and when she does something lovely, like the collage called *My Endangered Field* in this show, the pungent surprising color and weird mix of elements come straight out of the artist's no-holds-barred emotional extravagance.

In a statement in the catalogue of the show, Snyder explains that, "emerging from a debilitating case of Lyme Disease last year, I found myself, after not thinking about painting for many months, bursting with ideas. I had a need to work with velvet and rust, with cloth and metal, with wood and nails, with sticks and wire and with paint. Images which I hadn't been in touch with for many months began flooding in. I decided not to edit myself. I painted every idea I had." This show, with its many small, irregularly shaped canvases, had the effect of a scrapbook. Hung close together, the paintings were a mix of nature images (moons and fields and ocean waves) and nightmares (those horrifying faces, those scorched plains). In the best work, the natural world becomes a sort of mirror of psychic states. This is Caspar David Friedrich redone after Hans Hofmann.

It has always been clear that Snyder is a modern Romantic; but never before has her connection to an early-twentieth-century Romantic tradition that found its geographical center in Germany come so much to the fore. *Red Cymbals/Sounds* uses color as an analogy to the emotional impact of music in a way that is meant to invoke Kandinsky, who published a book called *Sounds*. *Black Wellspring Mask*, with the face emerging out of a grid of dark lines, is a self-conscious (overly self-conscious) homage to the faces of Paul Klee. A taste for Klee and Kandinsky is very clear in Snyder's work; but Snyder's emotional heat refers mostly to the earlier work of these artists, when they were involved in the *Blaue Reiter Almanac*. Snyder's work has none of the classic lucidity and graphic clarity that become more and more a driving force with Klee and Kandinsky in the twenties. Snyder's works, with their collaged bits of metal and wood, have a Dadaist air, which is probably why, among the Expressionists, she recalls most of all Kurt Schwitters—

who'd been influenced by Kandinsky and Franz Marc before World War I. Snyder leaves a viewer with a tumbled mix of emotions that's reminiscent of Schwitters. In *Moons/Velvet/Mud*, eleven bits of velvet are each painted with a phase of the moon. Over this collage are arranged some twigs and bits of wire. This is a scrappy pastoral. In the horizontal work *My Endangered Field*, the center is filled with a flower-dotted field painted in a multitude of greens, with touches of alizarin and purple. Around this verdant glade are blots and swirls of brown and yellow and orange paint, together with gnarled branches, wires, and a weathered hunk of wood with an angular, cubistic shape. *My Endangered Field* is a chaotic rush of images; and yet it builds, with the rhythm of the twigs echoing the rhythm of the paint. Here Snyder sums up a charmed Long Island farm life, now encroached upon by suburbia, as accurately as Schwitters sums up the inflation-riddled cities of pre-World War II Germany. Snyder's rusty wires are, like Schwitters's ticket stubs, poetic refuse.

In her statement, Snyder says, "I needed to paint requiems for our losses, to meditate and chant and to once again paint the fields sur- rounding my home which were now being threatened by developers." By now confessional art is such an established genre that many of us have a sort of immediate mistrust of anything that's unabashedly au- tobiographical. We're fed up with canned confessions, with artists whose lives seem to come out of central casting. Snyder's story is not more unusual than anybody else's; but she tells it as a painter; she invents forms that jibe with her feelings. She's a messy artist; she has her bombs (and when Expressionists bomb, they bomb bad). But there's something very real here, too. As with Schwitters, the unstable mix of elements somehow holds. *My Endangered Field* goes on the list of Snyder successes, along with some of the *Field* paintings of the mid-1980s and the big *Morning Requiem (For the Children)* from her last Hirschl & Adler show. Combining her old themes in new ways, Snyder draws us into an unfolding story.

———

John Cheim, the director of the Robert Miller Gallery, was making a point when, last December, he paired a large show of works by the painter Robert Greene with a smaller show of Andy Warhol's photo-

booth portraits. Greene's softly romantic oils are full of willowy figures who wander amidst the lawns and alleys of some F. Scott Fitzgerald Long Island of the mind. The harsh and casually comic five-and-dime photos that Warhol sent his friends out to do as the basis for his silk-screen portraits show New Yorkers who are totally wired. Greene and Warhol are giving two sides of the same glamorously bohemian world. This is a world to which a lot of people would like entrée; many more are anxious to view it from the sidelines. Greene satisfies a voyeuristic curiosity.

Technically, Robert Greene isn't much of a painter. He doesn't know how to weight his colors in order to move objects back into space; he juxtaposes impastoed areas and thinly painted areas in ways that are awkward and pointlessly stylish; and he can't really work his figures and his settings together into a convincing whole. The work is fundamentally amateurish. But by now Greene has been at it for a decade, and his mix of references is well under control. Greene's inspirations include Fragonard, Guardi, Florine Stettheimer, the Neoromantics, the murals you see in Italian restaurants, and what Pauline Kael once called the "come-dressed-as-the-sick-soul-of-Europe party movies" of Fellini and Antonioni. Greene manages to cobble his kitschy sense of the past together into some deftly lyrical effects.

Like Warhol's photo-booth portraits, Greene's paintings will no doubt mean more to those who know the dramatis personae at first hand, but even an outsider can get the general lay of the land. Greene's immense landscape spaces are elegant stage sets. His figures—a wedding couple, youths in bathing suits or the buff, pedigreed dogs, figures in commedia del l'arte costumes, bare-chested gardeners—mingle together in a democracy of the beautiful people. Beaches full of cabanas recall Visconti's *Death in Venice*; a party on a lawn dominated by a tremendous American flag looks Felliniesque. Nothing ever happens; but that's part of the pleasant suspension of this world. The artist himself, with his dark romantic looks, appears frequently: he's a passive impresario, the most beautiful of all the beautiful ones. Something about the odd scale of Greene's landscapes holds in the mind. Greene's paintings, like the turn-of-the-century paintings of Boldoni and the thirties paintings of Leonid and Eugene Berman, have a weak but unusual perfume.

———

I caught up with "Image World," the Whitney Museum's survey of art's thirty-year-old love affair with video culture, on closing Sunday. The galleries were pretty crowded. The crowd was a mix of uptown, downtown, and out of town. People congregated around the video monitors: around Nam June Paik's wall-sized jamboree, which welcomed you as you walked off the fourth-floor elevators; and around a monitor showing some tongue-in-cheek documentaries about Jeff Koons and other downtown art stars. So far as I could see, the "still" pictures on the walls held people to a lesser degree: they ranged from Pop Art by Robert Rauschenberg and Roy Lichtenstein to 1980s work by David Salle and Cindy Sherman. Perhaps after being razzed up by all that video action, museum-goers found immobile images a comedown. The crowd at "Image World" was a kind of crowd we've seen for decades. I remember a very similar mood back in 1968, at the Museum of Modern Art's "The Machine as Seen at the End of the Mechanical Age," where Jean Tinguely's audience-friendly *Rotozaza No. 1* tossed big beach balls into the crowd. (That show, organized by Pontus Hulten, had a catalogue with a stamped-metal cover that must by now be a Pop Art classic in its own right.) But whether the year is 1968 or 1990, the audience doesn't seem exactly happy at these technologically minded shows: people walk through, curious, amused, and a little bored. They can't get a handle on it all—and who can blame them? They're in the clutches of what the cultural reporter David D'Arcy calls the trendocracy.

"Image World" was supposed to be a show of democratic art, of art that celebrates the world around us. Yet the range of photo- and video-derived imagery on display had a glazed-over, self-referential aura that left little room for any easy play of the imagination. The imagery was cut off from human desires. (And who gives a hoot if we're told that that's the point?) The problem is that this technology has a life of its own—a life that's not particularly interesting to contemplate as an aesthetic object. I also wonder whether the museum is the place where this stuff can look its best. Earlier this season, at the Farideh Cadot Gallery in SoHo, I saw a show by Jakob Mattner that used technology—admittedly primitive technology—in a poetic way. In a darkened room, Mattner placed several mirrors, each mounted on a metal stand. By

shooting light at these mirrors he created a series of ghostly, moony white images on the walls. It was a magical installation, especially when seen in the middle of a sunny day. Nothing at "Image World" had that kind of poetry, but then again I don't really think I'd have wanted to see Mattner's installation in an art museum. The fun of the Mattner was in its being presented as a *pièce d'occasion*, in one's happening upon it. Nam June Paik's video wall might look good in a club; it's not anything you would want to go to a museum for. There can be no question that shows like "Image World" sidetrack a museum from its primary function as a place for contemplation and connoisseurship. But the question one wants to ask the video people is why they feel the need to infuse their particular brand of excitement into the museum context. Shows like "Image World" are meant to whip up a museum; but whatever is vital in pop culture gets stifled. The effect isn't wild-and-crazy, it's debilitating and dull. "Image World" was trumped-up excitement. The glitz gave off no light.

April 1990

BEING BALTHUS

Balthus, who turned eighty-two in February, has lived through a period that turns all manner of artists into media stars and yet has managed to stay out of the public eye. He never grants interviews and is rarely photographed. In the 1960s, when the critic John Russell was preparing the catalogue for a retrospective at the Tate Gallery, he wrote Balthus for some biographical information. The telegram he received in response has been quoted many times: "No biographical details. Begin: Balthus is a painter of whom nothing is known. Now let us look at the pictures. Regards. B."

From what we do know of Balthus's life, we know it has been a very full one. As a boy, he was acquainted with Bonnard, Gide, and Rilke (who wrote an introduction to a book of drawings, *Mitsou*, that Balthus published when he was thirteen). In the thirties he made a sensational reputation for himself with sexually explicit paintings, was a friend of Artaud, and moved in the fashionable circle of the Vicomtesse de Noailles. Balthus had the distinction of having his work collected by Picasso—perhaps the only artist of his generation so honored; and, in the sixties, he became director of the French Academy in Rome, where he supervised a celebrated restoration of the academy's crumbling Villa Medici.

This slow-working artist, who over the years has had two major museum shows in New York City and many more in Europe, strikes many of us as the greatest painter alive. He is also an immensely enigmatic artist. Balthus shows his work perhaps once in ten years, and he is content to have many of his paintings disappear into private collections before they have been exhibited in public or even reproduced. He has never done limited-edition graphics, although the quick money to be

made from such editions holds an almost irresistible appeal for contemporary artists. His aversion to publicity, his fondness for châteaus, his pursuit of aristocratic titles, his taste for subjects that many see as out of step with our sexual politics—all of this, taken together, has given him the reputation of a dandy, a reactionary, a snob.

Certainly, Balthus has gone his own way and cultivated his own view of modern times. But I suspect that he has always known what more and more of us have been forced to see: that in the postwar art world, no sane or serious person dares to be an insider. Holding himself apart from the passing parade, Balthus has managed (is it a paradox?) to respond to the modern world with more originality than most of his au courant contemporaries. For fifty years he has been offering up his inimitable views on city life and country life, on childhood and history, on sex, love, and romance.

Something of Balthus's marginal situation has attracted Guy Davenport, himself an artist who cultivates a studied out-of-itness. Davenport's *Balthus Notebook* (Ecco), which slipped into bookstores a couple of months ago with a Balthusian lack of publicity, is a collection of sentences and paragraphs, arranged *pensées* style, with a lot of white space around them. Davenport—who has written some marvelous stories about children and their erotic and intellectual awakenings ("Robot," "The Death of Picasso")—is quite naturally sympathetic to the Balthusian idea that an adult can moon over the glories of childhood without illicit intent.

In this book, which is an expanded version of an essay that Davenport originally published in 1980, he connects Balthus's children to the children in Baudelaire, Gide, Proust, Colette, Montherlant, and Cocteau. "Modern French writing," Davenport observes, "has been interested in childhood and adolescence in a way that American and English writing have not. The French see an innocent but an experienced mind in the child. . . . The child in Alain-Fournier, Colette, Cocteau inhabits a realm imaginatively animated with a genius very like that of the artist. Children live in their minds." A page earlier Davenport has commented that "Balthus's children have no past (childhood resorbs a memory that cannot yet be consulted) and no future (as a concern). They are outside time." Balthus without the melancholic kinkiness

would not be the artist we adore; and like some of Balthus's admirers in France, Davenport probably labors too hard to deny the artist's voyeuristic dimension. Still, Davenport is right to reject the psychological second-guessing that seeks to treat every imaginative foray as a sign of pathology. Davenport suggests—I think he's correct—that Balthus's imagination is nourished as much by historical precedent as by personal obsession.

It's refreshing to read an American who sees the world of Balthus from a Balthusian vantage point. Davenport makes some friendly bows to Lévi-Strauss and Barthes, but he persists in an older kind of French idea, namely that an artist retains power over his own fictional worlds. Davenport isn't censorious about these paintings that are carefully constructed to stand out of time. In fact, he gets a kick out of this brazenly elitist artist, who would apparently prefer that his meanings be clear only to those who occupy his own supersophisticated circle. "Balthus," Davenport writes, "has worked not with spiritual substrata where civilization and barbarity have common roots, but with the high surfaces of civilization (the ancient farm, the studio, well-furnished rooms, the streets of Paris). A commentary on any of the paintings will extend deep into history, biography, and rich iconographic detail."

A passion for the "high surfaces of civilization" is central to Balthus's poetic realism. This passion is also, perhaps even more than Balthus's provocative subject matter, what makes him such a controversial figure today. The people who run the art museums and the art magazines are positively paranoid about any artist who gets high on old-fashioned high culture; they believe that an artist is only as good as his zeitgeist readings, and Balthus, of course, has turned his back on the zeitgeist. Davenport understands that part of the delight we feel in Balthus's art is the delight of watching an artist tie into the history of art. To look for illumination in those "high surfaces"—what (marvelous) nerve. I think Balthus expects his audience to make the historical connections. In a beautiful discussion of *The Nude with Cat and Mirror* (1977–80), Davenport observes: "The girl is from Simone Martini, and the cat, exactly quoted, is from Hogarth's *The Graham Children*, an engaging painting in which a boy, entertaining his three sisters, thinks he is making a caged canary flutter by playing a music box, whereas the bird is fluttering because the family cat is staring at it and trying to mesmerize it. . . . Balthus's

painting is about virginity and desire as all its iconography attests: bed, nudity, billet-doux, the brazier, the mirror, the transfixed cat." Davenport is good at revealing historical parallels. "Balthus, like Daumier," he remarks, "allows caricature beside traditional academic rendering. So does nature. Velázquez's dwarves and midgets serve to place an infanta or king in the chain of being as his society understood it. There is a profounder meaning to Balthus's ogres: they belong with the voluptuousness of his girls, for sex, when it comes, will be goblin as much as it will be Eros." In a few sentences Davenport can open a vista, stereopticon style, through which we see far-flung works of art composing together in new ways.

Still, there's something overly writerly about Davenport's approach. When he compares Balthus to the English realist Stanley Spencer, I can't help but cringe: whatever the psychological power of a few of Spencer's nut-brown nudes and portraits, he's an artist who's incapable of making the surface of a painting open up and breath. The literary and iconographic interpretations of Balthus, no matter how marvelous, cannot illuminate the extent to which his genius rests in *pictorial* inventions: the invention of forms and spaces and color relations that give body to a literary imagination.

Especially in the work of the past thirty years (which is the least admired of his work), Balthus's pictorial imagination has overtaken his literary imagination. In the great nudes of the 1970s and the 1980s, whatever might appear untoward in the artist's taste is dissolved in the exemplary and very strange harmonies of green and gray and gold. Sometimes it seems that Balthus's literary imagination is a response to his pictorial imagination: this is only true of the greatest artists. *The Artist and His Model* (1980–81), in which the figure of the artist turns his back on his model, can be seen as a literary commentary on the freedom that Balthus's nudes achieved in the seventies, when they took on a dreamy softness, as if they were no longer viewed through the sharp-focus eye of the artist-voyeur.

Balthus is a painter who fulfills himself within the terms of his medium. Yet this is not always easy to see. Due to the generally tonal nature of his color and the gravelly surfaces of many of the paintings, it is essential to see these works in natural light. While the color in a Matisse or a Bonnard or a Picasso tends to hold fairly well in artificial

light (which is the light in most exhibition spaces), Balthus's paintings can make little sense in anything but the mixed ambient illumination of daylight. Balthus's impasto surfaces, like those of Braque, are distorted by artificial light, which tends to turn all texture into a generic chiaroscuro photograph of the surface of the moon. The powdery high-keyed color in Balthus's *Landscape with a Tree* (1958–60) looks mannered under artificial light (as it did in the retrospective at the Metropolitan Museum); under natural light (as it is sometimes seen at the Pompidou in Paris) it's a miraculous, lyrical painting. A full appreciation of Balthus can only be acquired over years of looking, since these rarely exhibited paintings are usually exhibited poorly.

When I first saw Balthus's Japanese figures, at the Pierre Matisse Gallery in New York in 1977, I was bemused by them. A painter who'd been looking at Balthus for decades remarked, "The new Balthuses are always hard to assimilate. It takes time." After nearly two decades of Balthus looking, I've concluded that the way into Balthus isn't through his iconography, it's through his sense of form. The dark, self-consciously crabbed exactitude of the pre-World War II work was a bold assertion—a romantic Surrealist protest against modern times. It was also a protest that Balthus, as he developed, had to move beyond. The story of his fifty-year career is the story of how the antimodernism of the early paintings was absorbed into a full embrace of the modernist canon of antinaturalistic color and flat, decorative design.

Some of the paintings that Balthus did after he left Paris around 1950 for a château in the Morvan region of France are overly decorative: there are too many repeating patterns; there is too much of an insistence on sweet-and-sour juxtapositions of green and red, yellow and purple. And yet the unabashed decorativeness of these paintings came out of a pictorial necessity. Balthus, in his own good time, was falling deeper and deeper in love with Bonnard, the lost hero of his youth. What has been so marvelous, in the paintings that have come out of the studio since the sixties, is how Balthus has managed to enrich and to deepen his color while achieving a broader and easier sense of design. The series of paintings of nudes in beds, of which *The Nude with Cat and Mirror* is one of the masterpieces, unites the flat, decorative style that Balthus adapted from Bonnard and Braque with the quattrocento illusionism of his 1930s and 1940s paintings to achieve a poetic completeness unprec-

edented in his work. To compare the girl holding the mirror in *The Golden Days* (1944–46) with the girl holding the mirror in a painting of thirty years later is to witness a process of distillation. Some of these nudes of the late seventies and early eighties bear comparison with figures by Correggio and Titian, the greatest of them all.

But if the canvases that Balthus did in the early eighties might have led one to believe that the man was achieving serenity, the one painting completed since then that I have seen (admittedly in reproduction) suggests otherwise. In a characteristically Balthusian twist, this painting first appeared not in an art magazine but in a photograph of an interior in the magazine *HG*, in which it was partly obscured by a potted flower and a large sculpture of a lion. (Apparently Balthus has a fondness for interior decoration magazines: this month *HG* includes a photographic portrait of Balthus and shots of his Italian mountain retreat.) The painting is called *Nude with Raven* (1983–86) and is probably based on the Poe poem, or perhaps on Baudelaire's interest in Poe. It is a return to the melodramatic hysterics of the forties. Above, the raven, a dark shape, stares down from his perch. Below, a nude girl—elongated, almost mannerist in her proportions—reclines on a bed. Her right arm flies up into the air; her mouth opens wide, as if she were letting out a cry. This is one of the most bizarre of Balthus's visions. It's a romantic horror story: the ghostly figure is a sort of doppelgänger, the opposite of Balthus's honey-dipped nudes of recent years. This painting suggests a darkest-hour-is-just-before-the-dawn twist in the life of an artist who has for some years been sending us reports on what looked like a paradisiacal old age.

Back in the early seventies, when I first heard about Balthus, there were perhaps three Balthuses hanging in New York museums. There were no books on him in print. In a secondhand bookstore one could find a copy of the Museum of Modern Art catalogue of 1956 (that show went up simultaneously with the Pollock retrospective, and, as a friend says, New York made its choice); one could collect what old catalogues the Pierre Matisse Gallery, which had represented Balthus since the thirties, had in stock; one could buy, at art bookstores, some of the European catalogues that dribbled in. As the seventies progressed, Balthus's work came out of the shadows. In 1977 Pierre Matisse had a show

of the new paintings. Day in and day out, the gallery was jam-packed with artists and art students. Then, in 1979, Rizzoli published a monograph by Jean Leymarie, the first book devoted to the artist. In the winter of 1983–84, the Metropolitan Museum mounted a great retrospective. Balthus did not attend the opening in New York, apparently out of consternation at the catalogue, which offered much more biographical information than the artist felt was appropriate. This refusal marked the beginning of a curious turn in Balthus's fortunes. While there were a number of positive reviews of the Metropolitan show, feeling ran very much against the artist and the paintings. Some were offended by the subject matter, and many complained about what they called the overly decorative quality of the recent work—there were comparisons to greeting-card art, things like that. Balthus was reportedly offended by the reception, which is, some say, why he has chosen not to show in New York since then.

Why did the retrospective kick off a backlash? Leaving the show at the Met, many people came to the conclusion that the paintings did not fulfill the artist's high ambitions. But I tend to feel that Balthus's sunken reputation has more to do with the character than the quality of his art. It's impossible to judge or to experience Balthus's work in relation to any of the dominant trends of the day, and that is how most people insist on experiencing contemporary art. Before the retrospective, lacking hard evidence, people could invent their own Balthus. In one way or another, his work was seen as prefiguring postmodernism: this explains his inclusion, along with Picasso and Jean Hélion, two other old-timers who'd been tagged proto-postmodern, in the "New Spirit in Painting" show at the Royal Academy in London in 1981. In the late seventies, Balthus had been taken up by some critics and curators as a kindred spirit to the Neo-Expressionist figurative painters who were just then arriving on the scene. For others he was an avatar of a new, tradition-conscious figure composition. Then came the Metropolitan retrospective. It demonstrated the extent to which Balthus is none of these things. He's too much of a classicist, too absorbed in an old-fashioned idea of pictorial completeness, to relate to the new Expressionism. And he's too much of an eccentric, too absorbed in his own very idiosyncratic themes, to give support to any move toward a generalizing classicism. Balthusland, people began to feel, is no man's land.

Of course, Balthus has cultivated this sense of insularity. His work often represents windowless rooms, or landscapes that are boxed in by high horizon lines. He has also underlined his isolation by exhibiting so rarely. Yet for those who have followed his incredible journey, his isolation is now tied into the heroism of his career. We've become used to artists who show every eighteen months and can't take up a new color combination without having it written about in the art magazines. We're in danger of forgetting that many of the greatest developments in modern art have gone on far from the public eye. This is the case not only with artists like van Gogh and Cézanne and Seurat, who could not have had access to a large public if they had wanted it. It is also true of artists such as Picasso and Matisse; even after their fame was assured, they often chose to exhibit at irregular intervals and to keep whole bodies of work out of the public eye. No doubt the reasons why artists show or do not show are complex and are often affected by external circumstances. One factor we often overlook is that artists may find strength in working alone. This need not reflect disdain for the wide world; indeed, it could be a form of respect, grounded in the sense that one must know oneself before one expects others to know one.

As we move into the 1990s, many gifted artists are unable to get the attention of a large public. This is painful and even devastating in an era that celebrates celebrity above all other things; but it may, in some cases, enable artists to follow a logic of their own. Right now, every essential vision is an eccentric vision. The postmodernists are right to argue that modernism is in disarray. Where they're wrong is in proposing a coherent response to modernism. I believe that every contemporary artist of consequence is a late modernist, a refugee (to borrow the painter Kitaj's metaphor) who departs modernism carrying what precious baggage he or she can. Balthus, who grew up in the Paris of modernism, is one of the first—and the only survivor among the first—of the great refugees.

Guy Davenport's *Balthus Notebook*, an art book unlike other art books, fits an artist unlike other artists. This painter who chooses to operate at the margins is an inspiration and an example to those artists who have been forced to live at the margins. Balthus would not want to be a leader of others. But by expecting both everything and nothing of his public, he's shown us how to create at a time when art is at once

widely disseminated and dissected and little appreciated and absorbed. Balthus—that snob, that dandy, that elitist—is a prime mover in our hidden avant-garde.

April 16, 1990

Postscript 1991. Six months after I wrote about Davenport's *Balthus Notebook*, Rizzoli published a revised edition of the 1979 monograph by Jean Leymarie, a longtime friend and confidant of the artist. This includes a few new reproductions, mostly of recent paintings, and a few new pages of text. The painting I had seen in *HG* and had been told by Balthus's dealer was called *Nude with Raven* was presented in a large-format color plate and titled *Large Composition with Crow* (the French *corbeau* is variously "crow" and "raven"). In an era when paintings are routinely flown all over the world it may seem odd that we are reduced to studying the work of a contemporary artist in reproduction. But we have no choice, since Balthus apparently has no intention of exhibiting his recent work in public.

The revised edition of Leymarie's monograph includes two new additions to the series of girls in bed that preoccupied Balthus during much of the 1980s. The theme here—a girl waking up (as the title of one of the paintings tells us), or entertaining a cat with a mirror or a toy bird—evokes the blurred consciousness of moments when one is waking or falling asleep or daydreaming, when one doesn't have a clear sense of time and place. *Nude with Guitar* (1983–86), in which the girl's torso and the guitar are presented as parallel instruments, may be a bit too hard in some of its forms, may lack the melting poetry of the greatest paintings in this series. In the most recent variation, *Cat with Mirror II* (1987–90), the girl is clothed, and the insistent frontality of her limbs, each of which seems to move off in its own direction and yet remains fixed in a single parallel plane, suggests the formal elegance of a figure on a Romanesque tympanum. My feeling is that this is another Balthus masterpiece.

In addition to the cycle of paintings of nudes, the 1980s brought us Balthus's two most personal statements about his relations with his models and muses. *The Painter and His Model* (1980–81) is in the permanent collection of the Pompidou Center and is exhibited there from

time to time but far from frequently. In this painting there is something diffident about the artist's relation to the young woman who kneels before a chair, leafing through an album. The artist has his back to her; he has gone to the window to pull the curtain aside. Leymarie, in describing this painting, says that the girl "is the sphinx and deity of the painting, [the artist] its everyday officiating priest." In the *Large Composition with Crow* the artist is another kind of attendant. Here, again, we see a girl on a bed. The room is darkened, somber. She laughs and gestures at the crow, who looks down at her from a shelf. In front of the bed stands a slender naked figure, who is the size of a very small child but has the proportions and physique of an adult male. He carries a green cage. We have Leymarie's word that this figure is a self-portrait. As in *The Painter and His Model* and the earlier *Passage du Commerce Saint-André*, the artist is seen mysteriously, from the back. Leymarie explains that the bird is, in the Eastern tradition that Balthus is thinking of even as he is thinking no doubt of Baudelaire and Poe, "a divine messenger and a bird of knowledge." Leymarie also comments that it is in the cage that the man carries that "the bird ought to be lodged." Thus, perhaps, it is the artist who attends both bird and girl, facilitating their enigmatic encounter. When I first saw this painting, partly obscured in the photograph in *HG*, I took the girl's expression for a howl, and the painting for a nightmare. In this new, roughly 8½-by-11¾-inch reproduction, the painting takes on a gentler character.

The more Balthus reveals about himself, the less he resembles the manipulative voyeur of his critics' imaginings. In *The Painter and His Model* he seems distracted, he turns away from the girl. In *Composition with Crow*, he is her attendant, her servant. Leymarie is careful to make the point that both the man and the girl are naked in the *Composition with Crow*. This equality of undress is significant: it suggests that Balthus does not want the girl to appear to be more vulnerable than he is. This reading of the *Composition with Crow* is supported by a related reading of *The Painter and His Model*. Here, in the only other painting in which Balthus appears with one of the girls, the suggestion of voyeurism is again avoided, now because both artist and model are clothed. Apparently Balthus does not want the girl to be vulnerably undressed while he stands to the side with the protective covering of shirt and pants. These are not, to say the very least, the considerations of a dirty old

man. Indeed, Balthus approaches his girls with a certain discretion. There is a hint of sadness, of the unbridgeable distances that separate us, one from another. Courtliness, which is an acknowledgment of distance, comes into play here. And in his courtliness Balthus recalls another lover of young women who is a romantic in an unromantic age: George Balanchine. The pedestals are crumbling, but these men keep believing.

SUCCESSES

An artist can never have too many ideas. But an artist who has a lot of ideas had better have an imagination that is large enough to give form to those ideas. The painter Leland Bell, who is sixty-seven, has always had plenty of ideas; he has a full-bodied imagination, too. It says nothing against Leland Bell to point out that he is an artist whose work and career have been led by his ideas. As a lecturer and teacher, he has been one of our most eloquent spokesmen for classical pictorial values. And a Bell painting—whether it's a self-portrait or a portrait or a figure composition—strikes us first as a conceptual tour de force: no other painter has such fertile ideas about how to wed a premodern view of pictorial completeness to a modern taste for abstract form.

It is not strange that over the years Bell's finest paintings have been the ones in which the ideas were relatively simple—simple enough to allow his imagination to carry them up to the heights. In the self-portraits, Bell's imagination blossomed. The *Standing Self-portrait with Drums* (1980) is a great painting, and some of the portraits of family and friends are extraordinary. It is also not strange that when Bell has grappled with more complex structural ideas—generally in his figure compositions—his imagination has often lagged behind. Two compositional motifs—the *Butterfly* series, with three figures, man and wife and daughter, ranged around a table; and the *Morning* series, with a man and a woman and a cat that's just killed a bird—have preoccupied him for decades. In the past ten years these motifs have seemed to preoccupy him almost to the exclusion of all others. Yet I have often left the shows of *Butterfly* and *Morning* paintings with the feeling that, while no one could do this kind of simplified figure composition any-

where near as well as Leland Bell, even Bell didn't have the largeness of imagination to put over all the ideas.

I cast my reservations about the figure compositions in the past tense because something amazing has happened in the paintings that Bell exhibited at the Robert Schoelkopf Gallery in March. This artist who has stuck to his guns all these years has made the imaginative leap. All of a sudden, in three new paintings—*Butterfly Group* (1986–90) and two further versions of *Morning* (1988–89)—the ideas are realized. Bell is still dealing with the same subjects in rather the same way that he has for four decades: he's still using black outlines and flat color shapes. But in the *Butterfly Group* he has achieved, for the first time, a combination of weightiness and buoyancy. This painting is a masterpiece that ought to hang on a museum wall alongside one of the great Légers. What was tamped down and potential in Bell's work has come out—all the way out.

Three years ago, reviewing the Bell retrospective at the Phillips Collection in Washington, D.C., I wrote that "Bell's figure compositions don't really deliver the goods." Bell's quantum leap can only be described as the sum of many small changes, no one of which on the face of it would seem to make the difference. The versions of the figure compositions that Bell painted five or ten years ago are like patterns for the current versions. The curving contour of an arm or the relation of two color planes reappears, virtually unchanged. There is this diagrammatic aspect to the Bell paintings; and it has been, in the past, what made them both so intellectually fascinating and so emotionally unsatisfactory. This time, though, Bell inhabits his structures; he animates them from within, so that the experience of the painting isn't just blocked out, it's felt through.

There's a new ease in the way Bell handles the brush: this is part of it. The paint (it is acrylic) is thinner, so that the surfaces have an animation about them. The drawing has more point and vigor than heretofore. And the color, which in the past tended to be overly tonal, now includes many surprising fluorescent jolts. Taken together, these developments give Bell's work a new dramatic power, so that each element can function on two levels simultaneously: abstractly (as an event at a given point on the surface) and metaphorically (as the action of a figure in a space). Not that this isn't what Bell always intended.

In the past, though, the abstract and representational meanings of a form tended to register serially, or as an "either/or" equation. And over the years, Bell tended, in an effort probably to get over the serial or "either/or" effect, to push the forms too far in a representational or abstract direction. The effortfulness tended to turn the figure compositions into arrangements of conceits: some forms were like little quotations from the abstractions of Arp or Mondrian; others were like shorthand versions of Titian or Rubens.

By finding the proper balance among all the elements, Bell has achieved emotional completeness. We flow through the sequence of forms into a simulacrum of movement. The brilliance of the flat colors (they tend to push forward) and the eloquence of the drawing (it tends to lock forms into the plane) are joined so as to create a sense of continuous movement (in the figures) and a sense of charged stillness (in the spaces between). Spatial locations are extremely specific—we register them as points on a plane. But because we experience the space between those points kinetically, the points end up by functioning, simultaneously, as planets in a fluid universe. The result, in the *Butterfly Group*, is a painting that breathes as no Bell painting has before, a painting that is both perfectly locked into the rectangle and perfectly porous. Oh, there are weak spots—the still life on the right side of the table is a bit perfunctory—but it hardly matters. For as Bell has loosened up his puzzlelike configurations, he has also given his iconically simplified figures a psychological legibility. There used to be something muffled about the players in these domestic dramas; they were Bell's pawns. He has now not so much released their emotions as sunk their emotions so deeply into the paintings as to allow the drama to reach us as the sum of the painting. The emotion affects us viscerally, in our response to the form. The implacable presence of the woman in the *Butterfly Group* is lodged in the very weight of her red figure: her psychological presentness is expressed through the presentness of the form.

Bell's show was beautiful from end to end. As one entered the gallery, one was greeted by four marvelous, nearly monochromatic self-portraits; they made a connection to triumphs past and provided a foil to the orgy of color to come. Moving around the show, one found the major paintings balanced by smaller versions of the same subjects: everything had room enough, everything rang out. Standing in the back room,

which contained the two great versions of *Morning*, and looking through the doorway at the *Butterfly Group*, I felt exhilarated in a way I can recall feeling before only in a room full of Légers or Hélions. This feeling has to do with the way one responds to a certain kind of distillation of figurative form. Standing there, I wanted to thank not only the artist who had painted the paintings, but also the art dealer who had exhibited the artist for the past thirty years. Perhaps the only thing rarer than an artist like Leland Bell, who goes the distance, is a dealer like Robert Schoelkopf, who goes the distance with an artist. The Bell show is the most recent in a series of triumphant turns in contemporary careers that Schoelkopf has sponsored. In my mind, Bell's new work goes next to the work that Louisa Matthiasdottir and Gabriel Laderman have shown in this gallery in recent years. The many still lifes that Matthiasdottir has produced in the 1980s are, taken together, the purest expression of a classical utterance in easel painting that we have today. And the figure compositions that Laderman exhibited in 1986 are America's first original response to Balthus—the first compositions to move beyond Balthus's vision of French adolescence to a vision of American adulthood. The art gallery that has brought us Bell, Matthiasdottir, and Laderman has brought us as much as any American gallery ever has.

To those who worry whether artists of originality can feel expansive and grow in the midst of our current dreckathon, Bell's show comes as wonderful news. Bell has insisted on an unfashionable idea of painting, and he has insisted on it with such grace and force and lucidity that he has made it relevant. Bell has taught himself to paint better and better, and now he has gone over the top.

———

Anyone with even a tangential connection to the art world has some story about the day that he or she went to ten or fifteen galleries and saw nothing of interest. I will not be the one to cast doubt on those experiences—since I've had them myself, in spades. If you go to the galleries you know that the ratio of valuable work to work that's utterly without value is pretty scary. I'm not sure, however, that the situation is quite so scary as it sometimes seems. I suspect that there's as much good work being done in New York City as there ever was. What has increased (geometrically) is the number of galleries showing bad art and

the number of artists doing bad work: the process of sifting through it grows more tedious all the time. Nevertheless, we cheat ourselves if we don't sift through it, because every once in a while an engaging artist with whom we're unfamiliar appears, and if we're not there for those experiences, what is it all about?

When I saw Bruce Helander's show of collages at Carlo Lamagna in February I'd never heard of Helander before. (From the gallery I learn that he was born in 1947, studied at the Rhode Island School of Design, has shown in New York from time to time, and lives in Palm Beach, Florida.) I walked into the gallery cold, and Helander's collages did something to me—they had a rhythmic pulse and a quirkiness of incident that got under my skin. I do not know what Helander is capable of beyond that room full of collages, nor (for the moment) do I care. What is sure is that he has an eye, and some taste, and a flair for putting odd bits of stuff together.

Helander's collages are made of found materials, many of which seem to date from the 1920s and 1930s. There are fragments from the Sunday color comics, as well as torn pieces of maps and wallpapers and advertisements, much of it with lettering in foreign languages. This is a gently wacko array of elements that we know from the dean of American collagists, Joseph Cornell. Helander, though, doesn't moon over a particular collage element in the way Cornell does. Helander presents similar material in a less deliberate, less slowly paced manner. He introduces modern speed—something like the cinematic jump cut—into the world of Surrealist nostalgia.

All of the works are vertical. Helander takes the viewer on the visual equivalent of a roller-coaster ride: the movement through each collage is curvy and unpredictable, a back and forth and over and under, with faster and slower passages and a lot of jerky little events. Elements push in from all sides, and your eye swerves around them. Or they push out toward you, and you seem to swerve around behind them. Helander keeps us on the move. He also has a color sense that pulls it all together. He orchestrates each of his collages into a harmony of reds or blues. And he gives the collages, over all, a paled-out yet aniline color that one associates with old-fashioned color newspaper supplements. Helander is a camp-it-up comedian, a shameless romantic, and an intelligent abstractionist: this is an unusual combination.

What the collages tell us—beyond the fact that this artist has a taste for odd, charming bits of lettering and imagery, and that he likes to offer us little peeks into lost worlds—I can't really say. No one collage stands out. Looking at the show, I didn't feel compelled to make notes on specific compositions. Writing about them now, I find myself sitting with two postcard reproductions of works from the show, both of which illustrate Helander's strengths. *Storm Showers* includes an umbrella, a bit of rain, an old-fashioned metal bathtub spritzing heavenward, a clown's face. *Private Passage* has fragments of maps, leaves, a house: clearly its subject is travel. What the reproductions don't show is Helander's delicate sense of color and texture. Helander follows the semiconscious logic of an imagination nourished on Surrealism and Dadaism without overintellectualizing the results. He's cheerfully nostalgic. From the evidence of this small show, he's not on the level of Trevor Winkfield or the late Nicolas Moufarrege; but like them, he knows how to combine the absurdist fun of classic Surrealism with the best of the sixties psychedelic mindset. He gave me something to look at and I had a good time.

————

Jacqueline Lima, who called her show at the Blue Mountain Gallery in February "Perspective as Symbolic Form," is one of a number of artists of the past twenty years who have given the age-old science of perspective a modernist coloration. Lima is an eccentric artist and a not-always-satisfying one: her work can get gimmicky when she paints on spherical surfaces and then mounts them on wrought-iron stands. But there's always a winning intensity to her depictions of what I assume is her loft—a big space crammed with the baggage of the artist's life in all its grimy proliferation. I was particularly interested in one painting in the recent show: *Unholy Matrimony* uses an idiosyncratic perspective system to thrust a man and a woman into a scene out of a house of mirrors. Knowingly or not, Lima uses perspective for antinaturalist effect: her efforts are part of an interesting and largely buried evolution out of Cubism.

Perspective was first used in fifteenth-century Italian painting as a tool of the naturalists: Masaccio used it, in coordination with a new, softly sculptural sense of form, to give his religious scenes immediacy

and credibility. But by the time Uccello, a couple of decades later, was crying out, "Oh what a sweet thing this perspective is!" he spoke as an artist obsessed not with perspective as a tool of naturalism so much as with perspective as a tool of conceptual thought. Cubism, which was the West's great reconsideration of perspective, also turned out to have both its naturalistic and conceptual sides. Just as the strongest development from fifteenth-century perspective was toward naturalism (things seen), the strongest development from Cubism was toward a naturalism of materials (things seen: paint, canvas, color, brush stroke). And just as there was an underlying development from fifteenth-century perspective toward conceptualism (Piero, Uccello), there was an underlying development from Cubism toward conceptualism (de Chirico, early Morandi). Lima's work lies somewhere down the road of post-Cubist conceptualism.

Jacqueline Lima, who was born in 1949, came into the New York scene at the end of the sixties, when interest in representational art was stronger than it had been in some years. This included painterly representation of a kind that had been encouraged by Hofmann's teachings and been popular in New York since the fifties (Leland Bell fits in somewhere here) as well as a new interest in a tighter kind of realism, which often involved reconsideration of the value of traditional disciplines such as perspective and anatomy that had been rejected by the younger generation before World War II. Sharp-focus realism returned to serious painting in the work of Philip Pearlstein and Gabriel Laderman. While Pearlstein painted without recourse to perspective theory, the seemingly exaggerated recessions into space that he arrived at in his paintings raised old questions about the nature of perception. Laderman, meanwhile, made a conscious attempt in his still lifes and landscapes to incorporate the pre-one-point perspective ideas of Giotto and the eccentric perspective ideas of (for example) Fouquet. Out of the work of Pearlstein and Laderman came, in the seventies, work by younger artists, artists who seemed to give their naturalistic yearnings an anti-naturalistic and even Surrealist turn. Richard Chiriani, who studied perspective with Laderman at Pratt, is nowadays the most visible of these younger artists (he used to be associated with the Tibor de Nagy Gallery and now shows at Robert Schoelkopf): in his best work the city and the countryside are presented as toylike vistas, with each plane

showing hard and clear. Arthur Kleinfelder (who also studied with Laderman) exhibited (at the First Street Gallery in the seventies) some remarkable paintings in which the space is rendered in a warped, non-Euclidean manner . . . and then, unfortunately, Kleinfelder stopped showing, leaving his best painting, *Hyperbolic: Portrait of Doris*, as a vivid memory. Lima, who has shown consistently at the Blue Mountain Gallery, fits into this group of artists. Her connection to the older generation is through her studies at Brooklyn College, where Pearlstein taught for years and where she took perspective with Joseph Groell, a brilliant and demanding teacher who is also a gifted painter of classicizing figure compositions (which he has almost never exhibited). I go on about this history at some length because it is so little known, and because Lima's work cannot really be appreciated except in relation to a history, a tradition.

The central question that Lima raises in her paintings is: "How can an artist describe the roving eye of the viewer within the fixed universe of a painting?" Some of the answers that Lima gives are a bit too clever for my taste. When she paints on a sphere—where the artist's 360-degree view as she turns around the concavity of her room is transformed into a seamless convexity—I find the solution pat. If the only way to truly represent the artist's roving eye is by denying the two-dimensional nature of painting, then the price of verisimilitude is too high. Looking at Lima's spherical works—and at the canvases that are shaped like orange-peel maps—I have the feeling that I'm witnessing some weird twist on sixties process art. These gimmicks are unbecoming in an artist who clearly has an allegiance to painting. Yet something holds me even in Lima's failures: the methodical, ever-so-slightly grim way in which the artist works through the piled-up stuff that fills her studio.

Lima is a damn good painter: she paints with a clear, unprepossessing hand; she uses small, delicate brush strokes that bespeak a respect for appearances; she doesn't slick everything up, the way a lot of our realists now do; and her color, which looks dull and brownish at first, turns out to have a lovely blue or violet cast to it. There's a gravity to Lima's work, and when she galvanizes herself to put that 360-degree vision of hers onto a flat rectangle, she can be a compelling artist.

Unholy Matrimony—her best yet—is a long horizontal painting (almost a double square) that shows the length of a studio room and contains

a crowded work table, a coffee table, a woman reclining in a chair, and a man standing across the coffee table from the woman. Lima seems to have begun by looking at the floorboards, which run parallel to the sides of the painting and carry us to the back wall. She concentrated on one of those floorboards, allowed her eye to jump from foreground to background, then repeated the process with the next floorboard. She has created a fractious view, in which the coherence of foreground yields a background that is broken up into dozens of vertical shards. This is an exercise in willful eccentricity; but Lima is a painter who goes so deep into her eccentricities that what starts out as a nutty conceit ends by transcending strategy and approaching poetry. The figures aren't all that convincing—Lima doesn't quite know what to do with anatomy; but the refracted vision through which we see the man and the woman is unpredictable enough to tell us that things aren't as they should be in this relationship. In *Unholy Matrimony* Lima manages to be clear about matters that are unclear. As our eyes move toward the background, where things go out of focus, Lima's brush doesn't let us down. The message is calculated to disturb: there is no vanishing point, Lima is telling us, and the center will not hold.

May 1990

FALLING OUT OF LOVE WITH PHOTOGRAPHY

The hundred-and-fiftieth anniversary of the invention of photography has hardly passed without celebration; and yet this year of commemorative exhibitions and appreciations has turned out to be rather sedate, at least if we compare it with the period a decade or so ago when photography held the educated public in its thrall. From the late 1960s until the early 1980s photography's variegated past attracted people who followed developments in Pop, Minimal, and Conceptual Art but found much of the work overcalculated and unimaginative. Photography answered a very natural desire to feel romantically engaged with the look of the world. This was a coolly romantic medium, moreover, a medium that fit in with the hi-tech chic of the 1970s. While there had been people, since the Surrealists of the 1920s, who recognized photography's haunting mix of the mechanistic and the empathetic, it took the late 1960s, when high culture assimilated so many of the ambitions of pop culture, to turn photography into the medium of the moment. There was a wave of new books, articles, and exhibitions; new galleries opened that were patronized by new collectors; and the collectors went off to the auction houses and paid unheard-of prices.

In retrospect, the collector Sam Wagstaff, who died in 1987, looks to be the emblematic figure of the photography-infatuated 1970s. Wagstaff, who had been a curator at the Wadsworth Atheneum and the Detroit Institute of Arts, was already middle-aged when he came into a family fortune in the 1960s, moved to New York, and became, with his good looks and elegant bearing, one of the aristocrats of the downtown scene. Wagstaff had collected Pop Art; but he soon gave that up to devote himself to photography, partly under the influence of his friend

Robert Mapplethorpe, whose flower photographs Wagstaff in turn helped to give some of their earliest public exposure. Collecting photography provided Wagstaff's sensibility, which was both dandyish and patrician, the widest possible range of expression. Wagstaff loved the multilayered pleasures of photography: he collected all kinds of nineteenth- and twentieth-century images, by both prominent figures and unknowns. He gloried in the idea of photographs as comprising a universe that one could collect the way Andy Warhol (who was a friend) collected crazy characters at his Factory; only Wagstaff's world had, at least as an imaginative construct, a far broader range. Wagstaff put together a great collection, which he sold to the Getty Museum in 1984, when his interests began to shift to late-nineteenth-century American silver.

I recall running into Wagstaff the day after he'd finished reading Susan Sontag's *On Photography*, and he was fired up about that brilliant book. He seemed to feel that Sontag was underplaying the formalist side of photography. But Wagstaff's was too agile and kaleidoscopic a mind to be pious about the relationship between photography and art. He loved the multifariousness of photography, the way it escaped the museum definitions of art: that was photography's appeal in the 1970s. This connoisseur of photographs was a voyeur who liked the opportunities photographs afforded to study the famous, infamous, and unknown at leisure. He could enjoy photographs for the beauty of the things they represented, or for the presentation, or as examples of an evolving technology. Or he could take the totality of a photographer's work as the artist's self-portrait. (And, hell, photographs were affordable!—at least before wealthy collectors, Wagstaff among them, started buying.) For someone like Wagstaff, who wanted to immerse himself in sensation, photography was pure sensation—maybe it was better than painting.

Now, a few years later, people who were once preoccupied with photography are walking through the beautiful one-hundred-and-fiftieth-anniversary show at the Museum of Modern Art, "Photography until Now," and finding that they have trouble connecting with what's up there on the walls. The signs of diminishing interest in photography are all around us. Writing about photography doesn't have the urgency

that it had fifteen years ago, when Hilton Kramer was making the case for the art of the camera on the art page of the *New York Times* and Susan Sontag was using photomania as the occasion for her most sustained exploration of contemporary sensibility in a series of essays first published in the *New York Review of Books*. In the second half of the 1980s photography galleries have had a hard time of it; some have closed their doors. And there are no longer brilliant, provocative collectors—collectors of Wagstaff's caliber.

Even John Szarkowski, the curator of photography at the Museum of Modern Art, who organized "Photography until Now," seems at pains to explain that our appetite for photography has abated. In his catalogue text—which is a rather laconic history of photography in the form of seven brief chapters—he talks cautiously about the end of an era, an era that he is anxious not to overrate, probably because he doesn't want the present to look too bleak by comparison. Szarkowski comments that "during the 1960s and for much of the 1970s photographic education was a growth industry, and the work of its star performers was of interest even to those who were perhaps not deeply interested in photography, but who were interested in trends." He mentions the Witkin Gallery, which opened in 1969 and was "notable for the wide variety of contemporary and historical work that it showed and offered for sale. Although the gallery's standards were high, it could hardly be said to have an aesthetic position, and if this relaxed perspective made the place seem more like a superior jumble shop than a modern art gallery, the fact perhaps worked to its advantage. Witkin and his clientele were interested in photography as a distinct and independent issue. . . . A few years later the character of photography's presence in commercial galleries had changed; often photography had come to seem not an alternative idea but merely an alternative medium."

Szarkowski's approach to what was without a doubt the golden age of photographic connoisseurship is measured and realistic. (Some have argued that Szarkowski, who may be near retirement, is speaking of his own golden age.) In support of the health of the current scene it can be said that auction prices are sky-high and that photography has never before been taken so seriously in the academy and the museums. But all this may only serve to underline the extent to which the revelations are in the past and the excitement has died down. Of the situation of

contemporary photographers, Szarkowski remarks that "during the past generation [they] have worked without a clear sense of a communal role, that they might either serve or revise." The hundred-and-fiftieth anniversary comes too late: the celebrants have gone home. And so the rather odd title that Szarkowski has given to his show sets the right tone. "Photography until Now," at once definitive and casual, suggests that we have reached an endpoint and that the future is not exactly part of a continuum with the past.

Given that the boom is over, there could be no better place than the Museum of Modern Art to come together for a celebration that's an occasion for stocktaking as well. So much of what we've seen of the art of photography originated at this institution, which established its department of photography (the world's oldest) fifty years ago. For a lot of people, their first impressions of classic photographs were the ones they had at MoMA, and this show turns out to be a homecoming. The black-and-white images of Stieglitz and Walker Evans and Cartier-Bresson and Irving Penn, hanging for all those years on the walls of the Museum of Modern Art, have come to be associated with the black-and-white drama of New York City itself. And so photography at the Museum of Modern Art is by now knit as deeply into the fabric of the city as the chestnut vendors on the corner of Fifty-seventh Street and Fifth Avenue.

Looking at an Atget or an Edward Weston in those white, squarish MoMA galleries is something we've been doing (practically) forever. Szarkowski likes us—wants us—to regard photographs as objects for delectation. He also wants us to think of the evolution of photography as technology: this is in part a healthy response to the scholarship of recent years. "Photography until Now" evokes the revelations of the past twenty years: the exhibitions of early French photography in general and of Charles Marville in particular; of the photographers of the American West such as Charles Weed, Carlton Watkins, and Eadweard Muybridge; of nineteenth-century architectural photography; of the seemingly un-self-conscious images by anonymous or near-anonymous workers and how they often resemble (strikingly so) the most self-conscious works of modern art.

"Photography until Now" represents the history of photography as

capacious, going from the elaborately lyrical ambitions of Julia Margaret Cameron and Frederick Evans to the documentary works that sometimes turn out to be the more richly poetic ones. At "Photography until Now" we're invited to revel in a great variety of colors and textures: old photographs aren't all black-and-white. Szarkowski takes us from the delicate gray mirror that is the daguerreotype to the soft opaque darks of the Talbotype to the perfect resolution of the later prints from glass negatives and the inky blacks of twentieth-century silver prints. He weaves together landscapes and portraits and genre scenes and still lifes into a meandering progress that is both idiosyncratic and exciting. Perhaps he has labored overly much to avoid the textbook classics. Yet who can blame Szarkowski for being bored with the icons (if that's the case)? And if some of the exclusions are odd (where is the American gothic Surrealist Clarence John Laughlin?) and the balances are off (one Walker Evans to five Marvilles?) this may have more to do with Szarkowski's sense of who's been overexposed of late than with a desire to present the last word on the subject.

The show is full of small, concentrated pleasures. Szarkowski is not averse to photographs that hold us mostly through the beauty of their subject matter. He likes the odd and the piquant. When we see worn stones and bits of graffiti in the architectural photographs of the 1850s and 1860s, we smile with pleasure at the thought that even then life had its delightful minor blemishes. By deemphasizing masterworks—and including a great many works by anonymous or virtually unknown photographers—he has produced a history that is true to our experience of a medium that revels in the variety of the world. It's the variousness of photography—the far-flung subjects, the curious perspectives—that attracts people to the medium. But this variousness may also be what ultimately drives some people away. The camera, which draws no conclusions, is content to present the world as cobbled together out of fragments.

In place of a history based on great photographers, John Szarkowski proposes a history on the technological evolution of the medium. "I have attempted," he writes, "to sketch out a history of photographic pictures, organized according to patterns of technological change." Szarkowski sees particular photographers as responding to the changing

characteristics of the medium: the different qualities inherent in pho-
tographs on metal (the daguerreotype) and on paper; the relative clarity
obtainable with the early paper and later glass negatives; the possibilities
for catching movement that are triggered by faster shutter speeds; the
particular demands that are placed on photographers as their work be-
comes a staple of the pictorial press. With each of these developments,
certain artistic possibilities are opened up and closed down. Szarkowski's
idea that technology is the guiding force in the development of photo-
graphic art has considerable appeal. Contemporary taste tends to favor
a history that deemphasizes the role of inspired individuals; and this
contextual view of history intermeshes neatly with an older modern idea
that the driving force in art is the medium itself. When Szarkowski says
that photographic art is the "work that embodies the clearest, most
eloquent expression of photography's historic and continuing search for
a renewed and vital identity," he speaks as both a materialist and an
idealist.

Alfred Stieglitz was the first American photographer who educated
his taste by studying the medium's plebeian nature. Stieglitz began
around the turn of the century as a pictorialist—as a photographer who
wanted to give his work the high-gloss effects of museum art. But he
eventually turned away from pictorialism to an appreciation of the
straight photograph, and in doing so he presented photography with a
stripped-down aesthetic that mirrored the aesthetics of Matisse and
Picasso. Stieglitz's later works, such as the studies of clouds that he
called *Equivalents*, are an aesthete's version of snapshot art—a hyper-
sophisticated look at what the medium can do in its most fundamental
form. The later Stieglitz was a romantic contemplating the ultimate
realist art; and this has turned out to be the line along which an aesthetic
of photography has developed in this century. Both the Surrealists (who
gave Atget high-art status) and the Constructivists (who built a pho-
tographic style out of the straightforward manner of technical photog-
raphy) were involved in one way or another in a romance of the real.

Within photography the nineteenth-century conflict between the
Romantics and the Realists lived on long after it had ceased to be an
issue in painting. The photographers who think of themselves as artists
are involved with the connoisseurship of realities: photography's reve-
lations are sensuous, dandified. The greatest photographer is, I suspect,

Walker Evans, because he alone could turn photography into a sustained meditation on the styles of the world, on the varieties of reality. Evans loads his sophistication into his images. *Church Organ, Alabama*, the 1936 Evans photograph included in "Photography until Now," is many things, all at once: a meditation on late Victorian furniture design; a factual report, in part via the signs posted on the walls, about Sunday school attendance and behavior in the Alabama of the 1930s; and an essay in Cubist aesthetics, in which the platform to the right of the organ sets up a second ground plane, so that the small chair exists in its separate pocket of space. Each of these levels of meaning is something that other photographers have dealt with. But only Evans has the synthetic imagination to see it all at once. In Evans's work the kinds of curiosity that draw us to photography in the first place are put under the magnifying glass, and curiosity becomes revelation. Walker Evans is a Flaubertian artist: he takes pieces of realist detail and draws them together into a perfectly etched classical whole. That Evans has been an icon at the Museum of Modern Art for fifty years is absolutely right.

"Photography until Now" is not a show that makes many bows to the fashionable present. At a time when much of the art that is being shown in SoHo is photo-derived, or includes photographic material, Szarkowski acts as if he rarely ventures below Fifty-third Street. Though he includes examples of work by Warhol and Rauschenberg (perhaps he couldn't get away without them), in general Szarkowski resists the idea that photography is a technological resource to be used as painters see fit. His taste is not for photography as some element in a larger, pictorial collage. He wants photography on its own terms, and who can blame him? Cindy Sherman is here: perhaps she strikes Szarkowski as almost old-fashioned, a self-portraitist who dresses up. But the many contemporary artists who use the impersonality of photographic technology as a metaphor for the impersonality of modern life—people like Barbara Kruger and Sherrie Levine and Richard Prince—are not in evidence. I gather that Szarkowski sees their work as a criticism of photography rather than an extension of photography. I agree. These artists are denying photography its richness of illusion, its ability to show us the wonders of the world. And Szarkowski has little interest in work that is influenced by television, video, film. His selection in

the latter part of the show has been attacked on the grounds of old-fogeyism. But surely it takes some guts to exclude the downtown Mafia from a major museum show.

So in Szarkowski's view photography goes on, and keeps going back to the world. Szarkowski is right to stress photography's capacity to bring us back to the world: this is what photography does best. But in his loyalty to the medium Szarkowski also suggests what photography cannot do—he defines the limits of the medium. Over the course of the history of photography the techniques change; and photographs that have been done at different periods, taken together, tell us that the world has changed. But the photographer is always left looking out at a world that it is beyond his capacity to change. I have a friend who says, "Nobody who's really intelligent ever thought that photography was art. Photography is iconography. Photography makes it possible for figures of the past—Liszt and Margot Fonteyn and one's grandmother—to live on into the present." This is by no means a philistine attitude. In 1938, Lincoln Kirstein observed (in the introduction to Walker Evans's *American Photographs*, published by the Museum of Modern Art) that all the early photographic masters wanted to do "was to render the object, face, group, house, or battlefield airlessly clear in the isolation of its accidental circumstances, . . . to create out of a fragmentary moment its own permanence." In this sense photography is rather far from what we think of as art, from the complex metaphor that is created through the actions of a powerful imagination. But when we look at photographs we can see that the transformation of a moment into something permanent does have to do with a process of selection—and so something like art comes into it. Photography objectifies our experience of the world, the experience of our eyes. So does painting (even abstract painting).

At a hundred and fifty, photography is still casting its mechanical eye on a world we would like to know better. "Photography until Now" is about the camera's love affair with the world. But Szarkowski wants this exhibition to be about a great deal more: he wants us to confront the self-consciousness of the photographer, the artfulness of the photographer. I do not believe that the times are especially conducive for serene contemplation of the relations between art and technology, the imagination and the machine. Szarkowski, a good old modernist in the

good old Museum of Modern Art tradition, wants us to think of pho-
tography as the technological imagemaker that is always there in the
modern consciousness as painting's sunny-yet-shady competitor. From
the days of the Surrealists and the Constructivists in the 1920s to not
too very long ago it was fun to feel the tug of that competitor—and,
sometimes, to allow oneself to be seduced. But by now the technological
imagination, often in the form of the photographic imagination, has
come to dominate contemporary art. Cindy Sherman, Sherrie Levine,
Richard Prince, Barbara Kruger, Louise Lawler, Doug and Mike Starn:
they and countless others are using photography as a tool with which
to dehumanize art, to distance us from experience. They tell us that we
are all reproducible, that we live in a world of reproductions. Photog-
raphy is no longer the mechanical imagination that we can contemplate
serenely; instead, we feel that we must keep it at bay. This could be
why the past decade—when the definitions of art have all gone to hell
and many artists have been telling us that technology is rendering art
obsolete—hasn't been the happiest period to think about the relation of
photography and art, or to think about photography at all.

It's all the more amazing, then, that John Szarkowski has managed
to put together this very impressive, even brilliant show. "Photography
until Now" mixes the nostalgia that is at the heart of the photographic
enterprise with our nostalgia for our own long-lost love affairs with the
medium. Once upon a time, we looked upon photography as a vacation
from painting. It's through no fault of Szarkowski's that our hearts are
by now a little hardened to the world according to photography. The
lenses may be polished to perfection, the photosensitive papers may be
capable of picking up every nuance of light; but the magic of times
past—ours and the medium's—is unrecoverable, at least for now.

July 2, 1990

THAT WAS THE
SEASON THAT WAS

The 1989–1990 art season was crowded with alarms and controversies and banner headlines. By the time that Manhattanites began to gear up to go to galleries in September, they'd already spent the summer months preoccupied with the Corcoran's cancellation of a traveling Robert Mapplethorpe show (which the museum director had feared would inflame right-wing opinion on Capitol Hill) and the decision by the Washington Project for the Arts to provide a last-minute venue for the exhibition. Eight months later, when the galleries in Manhattan were winding down their one-person shows, the very survival of the NEA (which had given a small grant to the organizers of the Mapplethorpe show) was in question. The arts community was organizing a letter-writing campaign to counteract campaigns already in place from antifunding forces on the right. And if cuts in government funding and questions of censorship weren't enough to worry about, the museums and the auction houses were endangering the very idea of the art museum as a public trust. Thomas Krens, the new director of the Guggenheim, announced that he was going to deaccession several of the most important works in the collection—a 1914 Kandinsky, *Fugue*, and a 1923 Chagall, *Anniversary*—in order to buy 1960s Minimalist Art. Later in the spring, they went for $20.9 million and $14.85 million, respectively. During the same round of auctions, works by Renoir and van Gogh—the latter died a hundred years ago, having sold a single painting—sold for over $80 million apiece to a Japanese industrialist, who said they would most likely spend the next few years in storage. One painting that just missed being auctioned was Thomas Eakins's *Swimming Hole*. E. A. Carmean, Jr., director of the Modern Art Museum in Fort Worth, Texas, was going to deaccession it in order to beef up a capital fund for modern art; the painting was already scheduled for

sale at Sotheby's when irate citizens in Fort Worth, where the painting had long been exhibited at the neighboring Amon Carter Museum, managed to gain time to buy the painting and keep it in Fort Worth.

The art world had perhaps never before been so much in the headlines. The issues—as debated on the TV news programs and in the museum and college lecture series—were jumbo-sized: freedom of speech and government support of the arts, the museums as a public trust and the effect of a runaway market on public access to the arts. For a national audience, these controversies had the effect of taking art out of the realm of the ineffable. Much of what had previously seemed mysterious turned out to come down to matters everybody could understand: pornography, high finance, subjects that the newspapers had dealt with all along. And within the art world the response to fast-breaking events wasn't much more shaded. Many art professionals seemed thrilled by all the attention—they were glad to get out of their offices and onto TV. A modest exhibition, like "Witnesses: Against Our Vanishing," the show about responses to the AIDS epidemic that was mounted at Artists Space in lower Manhattan, became a cause célèbre.

The firestorms over government funding, freedom of speech, deaccessioning, and the rest of it had the effect of making some people feel that the season in the New York galleries—where the incremental developments that make up any career, even the greatest one, are often first presented to the public—was a little dull, not quite worthy of attention. Though the 1989 season had its share of remarkable shows (shows that were remarkable for their high quality as well as those that were remarkably shoddy or self-indulgent), nothing that happened in the galleries kicked off a big reaction in the public, even within the small, committed gallery-going public. The one-person show—even the big, clear compelling statement by a well-known artist—seemed to be too particular, too self-absorbed to hold the audience's attention at a time when the entire art world was felt to be in a state of emergency.

The art audience is, politically, a liberal audience; and for years it has supported the expansion of arts funding and expanded access to the arts as integral elements in its vision of a democratic society. For most liberals, even those who've never really analyzed their ideology, there is some vague idea that funding and programming aimed at minorities will ultimately bring more people into a community that shares certain

ideas of tradition, of quality. Until quite recently, the social relevance of art was not something that liberals were really called upon to examine; it had seemed enough to say that art was a good, equal opportunity was a good, and a just society would give all people an opportunity to participate in the arts, either as members of an audience or, if they had the wherewithal, in a more active way.

During the 1989–1990 season, it began to look as if what liberals regard as the social good and the aesthetic good were not merely different from one another, they were—so far as those on the left and the right were concerned—irreconcilable. For both the left and the right, the virulence of the art debate reflected broader frustrations: this was a time when the federal government was reluctant to implement any social changes through major new domestic spending, and the electorate was shy of all extremist stands on issues of morality. At a time when the Republican party was backing off on the abortion issue, the right wing found the antipornography campaign a relatively sure thing. Meanwhile, the left confronted a decade of Republican administrations and shrinking social welfare budgets . . . and felt that public funding for minority art and artists, despite the tiny dollar amounts, was *something*. The right-wing assault on freedom of speech had to be taken seriously—not only in terms of the visual arts, but perhaps even more so in terms of popular culture. But if the specter of censorship was very real, much of the response from the left had its own elements of demagoguery. This was the season when nobody who was just doing paintings could hope to garner the kind of publicity that politically oriented installations or performances received. Much work was justified in terms of its social intent; but when the clarity of the statement or the propriety of pre-senting certain works in certain venues was questioned, the artists re-treated to the old art-for-art's-sake argument—they justified their work in terms of its symbolism, in terms of its compositional ideas. Thus the unaesthetic aspects of the work were justified in terms of serving social imperatives; and the incoherence of the work or the antisocial aspects of the work were justified on aesthetic grounds.

The biggest disappointment of the season (some would say it had been coming for decades) was the way the liberals, who'd been appalled by right-wing assaults on the arts, began to subscribe to the mechanistic correlations of social and aesthetic forces that were presented by the

left. If art lovers abandon their belief in the transcendent meaning of art, if they insist on finding the ultimate value of every work of art in the social matrix—well, then we've all been robbed of one of the few places in contemporary experience where people can actually free themselves from social realities. The liberals have become almost ashamed of believing that the artistic good can be in advance of the social good. Yet isn't this part of the exhilaration of art? Isn't it the very dissociation of art from society that has allowed new feelings and new ideas to find expression in works of art?

Aesthetic victories will not change the world, but they are what we go to the galleries for, and when they occur, whether they are large or small, they're incomparable. Just the other day, a week and more into June, I went down to the Bowery Gallery and saw the best sculpture show of the year: the first show, no less, of an artist who is forty-seven. Geoffrey Heyworth's small clay pieces, with their circles within squares and volutes and insistent symmetries, are highly refined—maybe a tad too refined—but their very elegance is the key to their intensity. Heyworth knows how to use the delicate pinkish clay color and the marks of the clay tools, which he doesn't stress overly much, to give his forms weight and authority. These pieces, which are for the most part meant to be viewed from the front, evoke an architecture that is not yet detached from its origins in nature: early Ionic capitals, the Mycenaean Lion's Gate. The one large piece in the show, a series of wood constructions called *An Architecture*, was an homage to Brancusi, whose bases are often about architecture's connection to natural form. Brancusi is key here. Though Heyworth's show included several pieces that were extremely sophisticated in their use of Cubist structure to express movement through a succession of overlapping planes, the work is, in spite of its cubiness, un-Cubist in its sense of stasis and gravitational pull. Heyworth is in some sense a primitive in relation to the language of Cubism—a sophisticated primitive, who uses Cubism as the key to an iconic abstraction.

Ranged around the rectangular space of the Bowery Gallery on bases of varying heights, Heyworth's small works (often under a foot high) had been produced over a period of more than a decade, and together they comprised a self-contained universe. The small nodules reaching

toward one another in the boxlike space of *Enid*; the winglike forms of *Katie II, Standing T-Rex*, and *To Lipchitz*; the inverted apostrophes of *Carmen*; the cloudlike forms of *To the Left* and *The Sky*: elements of this iconography are hardly unfamiliar to us in the modernist tradition. But almost nothing in Heyworth's work feels secondhand: whether he is going to nature or to the curved forms of topology, he has a direct response. If some of the work is static, this is no doubt a function of the insistent symmetry. A certain kind of conflict and asymmetry is simply banned from this work; and although Heyworth's sculpture might be enriched by breaking the symmetry, I'm not sure it's possible: symmetry is a limit, but also an essential. In this, Heyworth recalls, perhaps more than any other artist I can think of, the American painter Myron Stout. Like Stout's, Heyworth's is a small and self-contained achievement, a matter of a few forms invoked with a cool obsessiveness that we recognize as authenticity. Heyworth has no desire to play out some great evolutionary process in art: these sculptures are about stopping time, about modernism as timelessness. But anyone seeing Heyworth's show in New York in the spring of 1990 could not fail to see this as a small victory achieved in time: it's not easy to demonstrate timelessness as a contemporary value.

Though I'd seen one or two of Heyworth's sculptures before his show, the coherence of the exhibition was an unexpected bright spot during an end-of-season period (May, June) that was short on engaging work. Within a few blocks of Heyworth's show, the art scene could be viewed at its most spectacularly pretentious and empty. The Pace Gallery of Fifty-seventh Street had opened a downtown branch, in large part to show the work of Julian Schnabel, the key contemporary among the Pace artists. Schnabel had filled the big ground-floor space at 142 Greene with bronze behemoths, many of which were little more than casts of pieces of furniture and hunks of wood; they were like the overscaled props for some grand opera, only there wasn't any romance about their jumbled proliferation. Even closer to Heyworth's show, at the corner of Prince and Wooster, a new building had opened, stacked with galleries, one over the other, like pancakes. One began at the top, with the dealer Tony Shafrazi, who gained his first fame by spray-painting Picasso's *Guernica*, then exhibited graffiti art, and is now, like the mobster who retires and goes legit, showing "American Masters" of the Wesselmann-Johns-Warhol-Stella ilk. Down, down one went, through

the Perry Rubenstein Gallery, where classic moderns, which apparently include David Salle, are shown; and the Petersburg Press, where the *poète maudit* of the East Village, Rene Ricard, made his debut as a painter with messages hastily scrawled on canvas and whatever else was at hand. Everything, from Shafrazi's "Modern Masters" to Ricard's messages, was shown to whatever advantage it could be, in spectacularly appointed spaces. And yet none of it could bear comparison to the Heyworth show, which was mounted in a gallery where there were, to say the very least, none of the advantages of upscale interior decor.

The range of gallery shows in 1989–1990 was, in short, like the range during many a season in the decade that has just passed. All too often, we were reduced to sinking our heads into our hands at the sheer effrontery of what we saw. Yet when I think back on the shows I have written about during the past season, how can I feel that it wasn't worth it? Leland Bell, at sixty-seven, was a painter who could bear comparison with that giant, Léger; Joan Snyder continued to find an authentic vein of feeling within the conventions of a Neo-Expressionism that no one else had ever known what to do with; Joan Mitchell had her best show in years; and the clean-lined, coolly witty compositions of Shirley Jaffe were seen in a New York gallery for the first time. And there were many, many more shows that compelled a critic to put pen to paper. Going through my notes, I find exhibitions that held my attention but that I somehow didn't find it possible to get into print about at the time. Here are notes on two.

Peter Hujar's retrospective of photographs at the Grey Art Gallery included the pictures of male nudes and downtown celebrities that Hujar, who died last year of complications from AIDS, is best known for; but what held me was a room full of animal photographs that are lyrical and knowing and yet somehow naive. Hujar photographed animals front and center, so that the square-format images look rather like illustrations in children's chapbooks of the nineteenth century. The dogs, prancing horses, ducks are plain yet somehow fantastical—like the animals in stained-glass windows or in the paintings of Franz Marc. Hujar revels in the physicality of these animals. He dotes on the handsome, glossy coat of a dog, with its marvelous swirling fur. Hujar also dotes on the young men whom he photographs in the unmade beds or against the unadorned walls of Lower East Side apartments; yet here (and in his photographs of transvestites) his viewpoint becomes both more complex

and less satisfactory. The East Village, where the street was an extension of the bedroom—an expanded theater in which to act out hyperbolic dramas of narcissism and lust—doesn't seem to fit into the viewfinder of the photographer all that well. Hujar's show included one memorable night shot of a young man leaning against a tree in Central Park, waiting for something to happen; but most of his photographs of guys in various states of undress have a formalized remoteness that seems to stifle Hujar's feelings. What Roland Barthes, in his essay on photography, called the "punctum"—the sting of the photographic image—is missing. When Hujar photographs a great transvestite performer such as Divine, who carried his ridiculousness lightly, comically (Pauline Kael spoke of his "what-the-hell" acting), Divine looks maudlin, sentimental. Yet Hujar's work, taken as a whole, reflects a dramatic sense of life. There are some fine shots of the night city, with its depopulated surrealistic vistas. And there are easygoing scenes of foreign places. And there are those animals, with their natural elegance and emblematic authority.

The show at Zabriskie of abstract paintings by Pat Adams, who's been exhibiting in New York for thirty years, had a slow-building intensity that held me and drew me back to the gallery for a second look. Paintings by Pat Adams don't look like paintings by anyone else; it could be argued that they don't look like paintings at all. To the extent that Adams works on rectangular supports and uses paint, she plays by the rules. Still, a Pat Adams painting is not a totality in which each discrete element plays its part; a Pat Adams painting is a series of discrete elements that we take in one by one. Looking at her big paintings, where she stencils flat shapes over sponged or soaked areas of color, or at the smaller paintings, where she incrusts areas with bits of mica or shell, a gallery-goer is forced to think about the artist as a fabricator of odd events. Adams operates sometimes in the sandbox, sometimes at the draftsman's table. The results are visually elegant and highly idiosyncratic. Adams's show at Zabriskie in March contained twenty-seven paintings and drew a viewer a long way into her mind. Her paintings are full of circles and fragments of circles, tiny starlike dots and wavy lines, all of which invoke a sort of macro-micro metaphor—a world of sea plants and ocean currents, of planets and galaxies. This underwater–outer-space metaphor isn't the whole story with Adams. Her colors, which include many brass and orange and earth tones, don't invoke the exaltation that we feel when we look up at the stars; her colors are gritty

and matter-of-fact, and her thick textures, often created by working
various acrylic media on the surface, keep bringing us back to the lit-
eralness of the materials. It's as if Adams must literalize her yearnings
for transcendence. Her work seems at once to urge us to look toward
the stars and the oceans and to insist on a more prosaic reality. There's
something archetypally American in the way that idealism and practi-
cality bump up against one another in a painting by Pat Adams.

The season that opened the 1990s and brought the art-and-politics
debates of the 1980s onto the floor of the U.S. Senate was bracketed
by two of the greatest shows of modern painting to be seen in the United
States in a long time. In the fall the Museum of Modern Art presented
"Picasso and Braque: Pioneering Cubism," which was organized by
William Rubin, who had recently retired as director of the Museum's
Department of Painting and Sculpture and become director emeritus.
In June, "Matisse in Morocco," which had opened at the National Gal-
lery in Washington in March, arrived at the Modern. Both shows
brought us back to the years around 1910 and thus had the effect of
framing the winding down of the century with a close-up look at its
start. "Matisse in Morocco," a rather small show, focused on a brief
period in Matisse's career, 1912–13; it was a period that Pierre Schnei-
der, in a catalogue essay that was a rare example of deluxe intellectual
fireworks, argued as key to the entire career. "Morocco" was blissed
out, a hit of light and air and easiness. "Pioneering Cubism" was darker,
bigger, more complex in its implications.
 After spending a couple of hours at "Pioneering Cubism" one felt,
overwhelmingly, that the invention of modern art was a private matter.
Picasso's and Braque's intimate-scaled paintings, with their cracked view
of the Parisian ateliers, disheveled café tables, and minor summer re-
sorts, turned everything upside down and inside out—but serenely,
without any sort of presumption. Those who dreaded the show or found
it onerous or overlong or boring were responding to something that was
there: to the quietness of the artists' demeanor, to the sense of discretion
that filled this work. William Rubin's monumental exhibition (it formed
a triptych with his "Late Cézanne" and his Picasso retrospective) took
us so completely into seven years of Parisian art that Cubism lost its
historical dimension and could be recaptured as lived experience. The
show took us back to the sense of Cubism that one has if one reads

Apollinaire's collected criticism end to end: as in Apollinaire's present-at-the-creation account, at "Pioneering Cubism" invention turned out to be a process that was ordinary, everyday. People painted paintings, and changed painting, and life goes on.

Taken this way—as lived experience—"Pioneering Cubism" may not have been exactly the show that William Rubin meant it to be. As told by Rubin at the Museum of Modern Art, the history of twentieth-century art is focused on the artists' rejection of nature and narrative and three-dimensional space. The invention of flatness, the turning away from reality: of course these were there in "Pioneering Cubism," but they were there as part of a far more complex artistic process, a process through which many new kinds of space were revealed, and reality kept reemerging, in ways that promised much for the future. The beauty of the Cubism show—and we're in Rubin's debt for this—was that it was so transparently organized that it allowed light and air to circulate through the rather stale view of modern painting that Rubin has limned at the Museum of Modern Art. According to "Pioneering Cubism," abstraction and representation were twin impulses that flourished side by side in the imaginations of two supremely gifted artists.

"Pioneering Cubism" pulled us into the paintings, inch by inch. Of course the here-and-now of Cubism had become, with the passage of eighty years, a there-and-then. But "Pioneering Cubism" kept breaking down orthodoxies: botched paintings rubbed against great paintings, and there were many paintings about which one wasn't sure. It all came to life, a life full of uncertainty and adventure. "Pioneering Cubism" made hash of the theoreticians who can think of nothing better to do than freeze all the confusions of here-and-now into some particular view of there-and-then. Neither the formalists nor the Marxists could account for more than a piece of what was going on in this show. In the way that Picasso and Braque eluded all the set definitions there was a lesson to be learned. When in doubt, forgo the overview, go deeper and deeper into the individual work of art. This was the utterly unprepossessing lesson of the most prepossessing museum show of the season.

Fall 1990

INDEX

NAMES

GALLERIES, MUSEUMS AND EXHIBITIONS

All galleries and museums are in New York City unless otherwise indicated. Exhibitions that took place in New York are followed by the museum or gallery where they took place. Exhibitions that took place elsewhere are followed by the city. Exhibitions of a single artist are not listed here unless they focus on a particular aspect of the career. For one-person shows and retrospectives, see artist's name.